OUT WEST

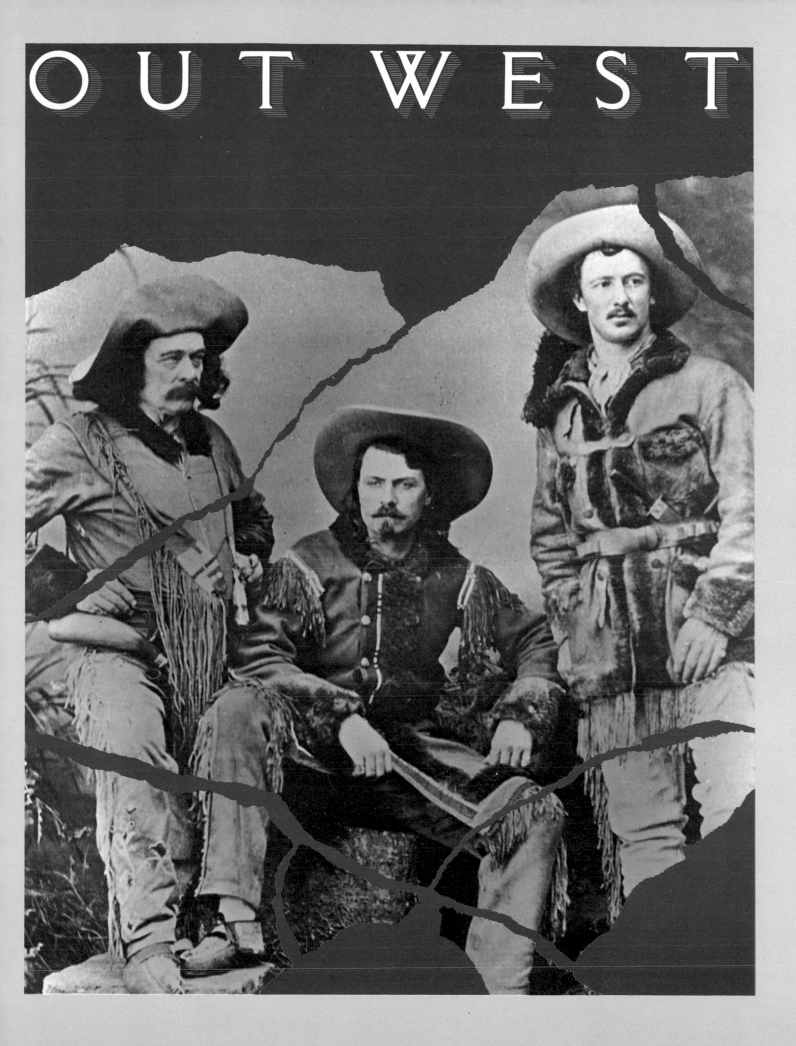

O U T

W E S T

BY MIKE FLANAGAN

HARRY N. ABRAMS, INC., PUBLISHERS, NEW YORK

CONTENTS

For Nancy and Sarah

Project Director: Darlene Geis
Editor: Charles Miers
Designer: Bob McKee
Rights and permissions: John K. Crowley

Library of Congress Cataloging-in-Publication Data
Flanagan, Mike.
 Out West
 Bibliography: p. 204
 1. West (U.S.)—History. 2. West (U.S.)—Biography.
3. Heroes—West (U.S.)—Biography. 4. Outlaws—West
(U.S.)—Biography. 5. Folklore—West (U.S.) I. Title.
F591.F54 1987 978 86–17221
ISBN 0–8109–1409–3

Acknowledgments for permission to reproduce excerpts in the text
are on page 207
Times Mirror Books

Printed and bound in Japan

ACKNOWLEDGMENTS

From idea to print, *Out West* received several helping hands along the way. For my research, the Western History Department of the Denver Public Library has been a godsend. Indeed, for over fifty years now their staff has been helping people—from historians and writers to family-tree climbers—along the trails of the West. Without their guidance and encouragement, particularly their help researching photographs and locating old newspaper clippings, this would have been a very short collection of articles. *The Denver Post*'s library staff, which manages to keep track of everything that was ever printed in the paper, has been of important assistance. Credit must also go to my patient wife, Nancy Flanagan, who helps turn my prose into English and works out many fine details before my copy is ever turned in. After Nancy's revisions, my manuscript goes to *The Denver Post,* where it is made ready for public consumption. My three editors have been Robert B. Wallace, Michael H. Rudeen, and Victoria Cooper, three diverse and brilliant individuals who have nursed the column with love and blue pencil. They in turn have been aided by the *Post*'s staff which over the past five years has included Johnna Young, Bill Hemingway, Sandra Widener, Stephen Singular, Howard Klein, Marilyn Olsen, Richard Johnson, Jack Kisling, John Farrell, and Jack Atkinson. A special show of gratitude must go to Karlin McCarthy and Priscilla "Pete" Names, editorial assistants who manage to keep a million details coordinated with grace and style. Finally, I would like to thank the readers. With letters and phone calls, they have provided a wealth of ideas and suggestions that are an important influence on my column. All these people have afforded me a unique opportunity to return to those thrilling days of yesteryear.

M. F.

INTRODUCTION

My beat is the Western past. Every week in my column "Out West," which ran in *The Denver Post*'s *Empire* magazine and is now in the Sunday *Post*, I have tried to shed new light on a person or thing that was associated with the region. The attempt in this collection is not to write a complete history of the West, but rather to offer individual glimpses into a not-so-distant past. I don't confine my territory to the era that ended in 1890, when the West was officially declared closed, for cowboys and Indians were not the only ones Out West.

Out West is one of the four great American directions. Along with Back East, Up North, and Down South, it points to no specific destination, yet tells you everything you need to know. Though no map has ever been divided into such picturesque quadrants, Out West generally designates all land west of the Mississippi River. To residents of the nineteenth century, it meant wide-open spaces, filled with a colorful cast: explorers, trappers and traders, cowboys and Indians, lawmen and outlaws, sodbusters, pioneer women, and miners.

The initial reality was this: the public imagination had been captured by the West since the early explorations of Lewis and Clark, Zebulon Pike, and others. Still, the area was filled with such dangerous uncertainties that only a fool would want to go, much less live, there. The West was the forbidden zone. If the savages didn't get you, the cruel weather would.

Then, Westerners struck gold at Sutter's Mill. Fears vanished overnight in a great national rush for riches. The odds against the big strike were high, but there was always that one chance of finding gold glistening in the stream. The madness that hit California spread throughout the West. With the gold seekers came the appurtenances of civilization—doctors and lawyers, prostitutes and bank robbers.

Gold was not the only lure. There was land enough for everyone, and it was teeming with abundant riches. First there were buffalo, then cattle, then oil. The Mormons even found religious freedom. It was the nineteenth century's end of the rainbow, a rawhide renaissance for anyone sturdy enough to survive. Romance and reality meshed in a patriotic frenzy of manifest destiny that seemed to resemble a last gasp rather than a new beginning.

Of course, something would have to be done about the previous tenants in paradise. For perhaps as many as thirty-five thousand years the American Indian had had the land all to himself. He was proud, strong, religious—and doomed. In those many thousands of years, he had never encountered anything to prepare him for the white man.

In the end, the West was not won, it was taken. The genocide of the native Americans was seen as a holy rite. In less than four decades, their food supply, the buffalo, was nearly wiped out, and those Indians who were not slaughtered as well were herded onto barren reservations.

So much for the reality. The romance of the West was another matter. While the Wild West itself was in remission, a trusty but boozy scout, William F. Cody, the one true Buffalo Bill, put together a cowboy and Indian circus that had Eastern audiences clamoring for more. Dime novels made outlaws into pulp superstars. The West was the rage. Celebrity status was acquired by a rowdy lot that included Wyatt Earp, Bat Masterson, Wild Bill Hickok, Calamity Jane, the James Gang, and Billy the Kid.

When at last the great Wild West shows faded (in 1913, *The Denver Post* attached a lien on the last big one, *Buffalo Bill's Wild West and Pawnee Bill's Far East,* as payment for a $20,000 loan to Cody), another art form emerged. The first dramatic motion picture was a grainy Western entitled *The Great Train Robbery.* Bronko Billy Anderson and William S. Hart gladly assumed the mantle left behind by real heroes. For a nickel, a kid could sit in a cavernous movie house and toss himself back in time to the Old West. It was all there, the guns and horses, ladies in distress, bad Indians, and gallant heroes. A cowboy Camelot emerged. America had never been so simple. Silents learned to talk, cowboys to sing. Scrubbed heroes such as Tom Mix, Ken Maynard, Gene Autry, and Roy Rogers defended Mom and apple pie on the silver screen. Television expanded the myth of the West to dizzying proportions. Psychologists would point to a need for romance after the horrors of World War II; sociologists would say our society had just gone plain cowboy-crazy. By the late 1950s, nightly prime time was one big cattle drive.

The romance cooled after this electronic overkill, then enjoyed a slick rejuvenation with the urban cowboy craze of the 1970s. The legacy of the Old West was transformed into a world of citizen-band radios, Nashville strings, mechanical disco bulls, and rhinestone cowboys. The West was in vogue once again, although it was hardly recognizable.

If nostalgia is remembering only the good times and history is remembering the bad, then *Out West* is a combination of the two. It is an unfinished love song, not to the wilderness, but to the people who came there seeking whatever it was they sought. Bringing "civilization" to the West was a brief and fragile episode in the making of America. Within a century, the new society endured countless growing pains, yet a certain character flourished. Call it pioneer spirit if you wish. It all happened at a destination called Out West, a region that became a state of mind.

WESTERN WORDS

They had a name for everything Out West. Although the cowboy prided himself on making his deeds louder than his words ("The bigger the mouth the better it looks when shut"), when it came time to be verbally expressive, he could be mighty effective. The jargon came about much like a pot of son-of-a-bitch stew: it was a concoction of normal English and other languages, mixed with trail dust and laid on thick. With his own words and meanings, the cowboy was able to communicate—and also to spot pretenders in his territory.

Some of the words were evolving long before 1867, when Joe McCoy first advertised for stockmen to bring their longhorns up from Texas to Abilene, Kansas, for shipping by train to the East. Forty dollars a head was the incentive, ten times the rate south of the Red River. The cowboy had to get it there first, though, and along the way a lot of language was necessary.

The term "cowboy" first appeared in Revolutionary War times, when Tory guerrillas worked the area of Westchester County in New York. They rang cow bells when they were about to attack patriot farmers. Years later, a cowboy was a Texan who rustled cattle south of the border. Today's definition of the word stems from the name given to those who participated in the great cattle drives of the nineteenth century.

Sometimes, a cowboy was called a *vaquero,* the Spanish word for his Mexican counterpart, formed from *vaca* (cow) and *ero* (a suffix indicating one who works with a *vaca*). This term came into use just after 1800; its bastardization, "buckaroo," followed in 1827. "Cowpuncher" and "cowpoke" were different creations, arriving in the 1880s and used mainly to describe cowboys who urged cattle onto railroad cars with prods.

Many terms were Spanish in origin. A "bronco" was a wild or semiwild horse, from *bronco,* meaning rough or rude. That usage originated around 1850, with "bronco buster" coming around 1888. Derivatives included "bronc fighter," "bronc peeler," "bronc scratcher," "bronc stomper," and "bronc twister."

Vaqueros usually wore *chaperejos,* or leg protectors, over their pants. The cowboy shortened the word to "chaps," sometimes referring to them as "twelve-hour leggings." "Corral" came from a Spanish word meaning "yard" or "enclosure." "Rodeo" came in 1844 from the Spanish word for "roundup." "Ranch" came from *rancho,* a soldier's mess. "Mustang," first used around 1808, is from *mesteno* (a stray). "Sombrero," from 1823, came from *sombra,* which means "shade."

The food of the range was another source of great Western words. The cook himself might be called everything from a "belly cheater" to a "grub spoiler," "bean master," "biscuit shooter," or "old woman." The "chuck" (slang for food, derived from a specific cut of beef) was called "axle grease," "dip," "grub," "horse thief's special," "Kansas City fish," "potluck," "spotted pup," and "wool with a handle on it." The soup of questionable ancestry—mentioned in the beginning of this article—was another favorite, a mixture of calf's brains, sweetbreads, and other body parts. As a ranch hand once said, "You throw everything in the pot but the hair, horns, and holler."

After such a delicious meal, a cowboy might take a cup of "belly wash" (weak coffee) over to a "black spot" (a piece of shade), take out a "book of dreams" (rolling papers), then fire up a "brain tablet" (cigarette) with a "hell stick" (match).

A lot of new words came from guns and the people who used them. "Revolver" first appeared in 1835; "six-shooter" following in 1844. These usually were the names for Colts, or Colt .45s, developed by Samuel Colt (1814–1862), who received his first patent in 1835 and by 1842 was manufacturing his weapons assembly-line style in Hartford, Connecticut. The 1873 Colt single action was called "The Peacemaker." Oliver Winchester began marketing his repeating rifle in 1871. Other competitors were Remington and Smith and Wesson.

Guns gave us a slew of other words, including "gunfighter," "gunslinger," "gun-happy," "gun-shy," and "Old Reliable." When that gun went off, someone usually got "dry gulched," "bedded down," or "bit the dust." The loser in the battle, who probably had a "case of slow," had just "taken the big jump," "bucked out," "cashed it in," "emptied the saddle," "passed the chips," or "sacked his saddle," then "shook hands with St. Peter."

The cattle business required its own lexicon. A "dogie" was a motherless or weak calf; the term first appeared after the bad winter and dry summer of 1886–87 wiped out up to 90 percent of the West's herds. "Brand" was used as early as the seventeenth century, an Old English term for torch. A "high-roller" was a high-leaping, bucking horse.

Personalities were not without their colorful tags. "Dude," meaning an Easterner in the West for kicks, first appeared in the early 1880s, while "dude ranch" followed around 1910. A dude traditionally wore a "hard-boiled hat" (derby) and was sometimes called a "tenderfoot," a word coined during the California gold rush.

Women could be "calico queens" (honky-tonk women), "cookie pushers" (waitresses), "live dictionaries" (school teachers), "painted cats" (prostitutes), or "cow bunnies" (wives of ranchmen).

The American West, besides providing history with a host of incomparable characters, gave our language a few twists and turns. Like its traditions, some of its words have lived on, while others have gone the way of the tumbleweed.

HEROES

WILD BILL HICKOK

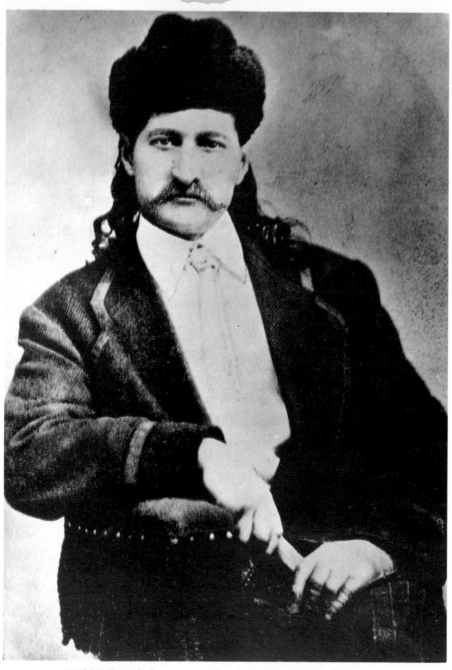

Wild Bill Hickok, c. 1871, when he was marshal of Abilene.

James Butler Hickok was born in Homer, Illinois, on May 27, 1837. Homer would later be renamed Troy Grove, and James, too, would become known by another name. Apparently, people needed to tell him and his brother Lorenzo apart. Lorenzo became Tame Bill, and history doesn't say much about him. Wild Bill Hickok, on the other hand, would become bigger than life before being consumed by his fame.

As a boy, James was a great help to his father, William Alonzo, working by day on farm chores and at night on the Underground Railroad, a network of abolitionists who aided slaves to escape to the North. The Hicock family had a secret basement in which they hid fugitive slaves. Papa Hickok died in 1852, and four years later James journeyed to Kansas to help in the Free State movement. There, he met future legends Kit Carson and William F. Cody.

Hickok's prelude to frontier stardom came in 1861 in what was known as the McCanles Massacre. One David McCanles became embroiled with the pony express in Rock Creek, Nebraska, over back payments for land he had sold to the newly formed mail company. Trying to retake the land by force, McCanles and two of his employees crossed Wild Bill, who was working at the Rock Creek station. When the smoke cleared, McCanles and his men were dead. After being acquitted of murder charges, Hickok headed for Missouri to join the Union forces in the Civil War.

He served until Appomattox, excelling in all duties: spy, wagonmaster, and, of course, sharpshooter. His speed and accuracy with pistols during the war lent a great deal to his future reputation as the fastest gun alive.

Out of work after the war, Hickok became a resident of Springfield, Missouri, where he supported himself with his passion: gambling. On the night of July 20, 1865, the suave Hickok cleaned out Davis Tutt in a poker game. They argued over past debts, then Tutt grabbed Wild Bill's prized Waltham pocket watch from the table, claiming he'd wear the trophy on the square the next day.

The following dusk, Tutt made good on his promise. It was the last thing he ever did. In a dramatic face-off, the classic duel was given a Western flavor. Folks were amazed at how Wild Bill put a bullet through Tutt's heart, then wheeled and held Tutt's henchmen at bay before they could draw. Even though the two men had fired simultaneously, a jury returned a verdict of self-defense for Wild Bill.

For the next two years, Wild Bill served as scout and guide for a range of people, from dudes to General George Armstrong Custer. In 1867, newspaperman and adventurer Henry Morton Stanley journeyed Out West, met the long-haired hombre, and catapulted him to stardom. (Stanley's own greatest claim to fame would come later, at his famous meeting with Dr. David Livingston in Africa in 1871.) Stanley's far-fetched stories for the *Weekly Missouri Democrat,* the *New York Tribune* and *Harper*'s cemented the Hickok persona.

But Western heroes in those days could not live on fame. Wild Bill, like everyone else, had to work. In the late summer of 1869, he became sheriff of Hays City, Kansas. After he killed two people in the name of the law, local voters decided he was trigger-happy and dumped him. After a brief spell with Colonel Ginger's Circus in Sherman, Texas, Hickok signed on as the lawman of Abilene, Kansas, for $150 a month.

The cattle business had given birth to Abilene, then turned it into Babylon-on-the-Prairie. The previous sheriff had been decapitated. On the night of October 5, 1871, Hickok put down a disturbance involving drunken Texas cowboys. Hickok shot their leader, then blasted a figure leaping from the dark. Sadly, he had killed his own friend, Mike Williams, who'd come to help. Bill was so distraught he got drunk and ran every cowpoke out of town. On December 13, the community decided it had had enough of cattle drives *and* Wild Bill, so they banned the former and fired the latter.

In 1872, Hickok toured with *The Grand Buffalo Hunt,* but received bad publicity when he backed down a group of Texans demanding that the band play "Dixie" at the Kansas City Fair. His theatrical debut followed when he performed in a melodrama with Buffalo Bill and Texas Jack. He also may have fathered a child with Calamity Jane at this time, though many of his biographers deny it. He did marry Agnes Lake Thatcher on March 5, 1876, in Cheyenne, Wyoming, honeymooned in Cincinnati, then left her so he could prospect for gold in Dakota's Black Hills.

Deadwood was an illegal town, founded in Indian country in Dakota territory. Wild Bill's presence only stirred the lowlifes, and he knew he was in jeopardy. "Those fellows over across the creek have laid it out to kill me," he said, "and they're going to do it or they ain't. Anyway, I don't stir out of here unless I'm carried out."

During an afternoon poker game on August 2, 1876, Bill kept asking other players to switch seats with him so he wouldn't have his back to the door. The players only scoffed. Just after three o'clock, one Jack McCall strolled in, shouted "Damn you, take that!" and blew Wild Bill into history. Hickok's last poker hand of aces and eights would forever be called the Dead Man's Hand. The bullet that passed through Hickok's brain lodged in the wrist of player William R. Massey, who never had it removed.

For over a hundred years the stories about James Butler Hickok have continued, enhanced in modern times by motion pictures and television. Some were true, others weren't. All, however, were wild.

CALAMITY JANE

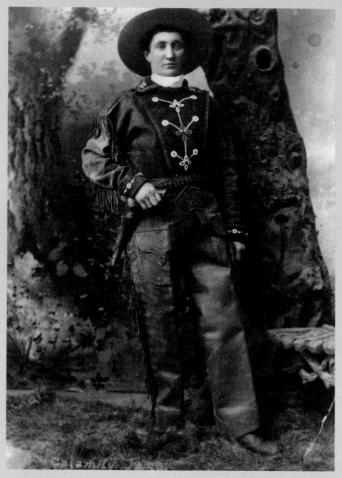

Martha Jane Canary decked out for a studio session.

When Jane Hickok McCormick of Billings, Montana, produced a stack of letters from her mother in 1940 as evidence that she was the daughter of Wild Bill Hickok and Calamity Jane, she caused an uproar among historians. The letters, glowing sonnets of motherly love, shed a different light on the famed pistol-packin' mama, a rough-and-tumble, authentic Western character whose real life was not nearly as glamorous as the dime novels portrayed.

Martha Jane Canary was born on May 1, 1852, in Princeton, Missouri. In 1865, just weeks after the Civil War had ended, her father moved his large family to the promised land of Utah. Her mother died on the way, and her father died shortly after they reached Salt Lake City. The children were given to foster parents, and young Martha was on her own.

From there, anything might have happened. We do know that she learned to shoot a Springfield rifle with the best of them, was an expert rider, and backed down several men in face-to-face confrontations. By age eighteen, she'd been a nurse, a dishwasher, an ox-team driver, a waitress, and a cook. Out West, people knew it would take one hell of a man to lasso this buckskin princess.

Jane first laid eyes on James Butler Hickok when she was a scout for General George Armstrong Custer in Laramie, Wyoming. She could handle the rugged employment, but when Wild Bill strolled into the barracks, the man and the myth were too much for her to resist.

The two were introduced. According to one account, Wild Bill said: "You're the Jane that's always on hand when somebody's sick or wounded. I figure you're always there for a calamity. I'm going to call you Calamity Jane!" Another story says Jane got the name after rescuing her commander during an Indian raid, but her own letters to her daughter credit Hickok.

The friendship became serious in 1870, after Jane tipped off the then Marshal Hickok to an assassination plot against him in Hays City, Kansas. After gunning down the three conspirators, Wild Bill disposed of the bodies, then made love to Calamity. The letters describe a "wedding" performed on the prairie by two roving ministers on September 1. Bill insisted that their union remain a secret, the first strain on the relationship.

Jane gave birth to their daughter, in a cave somewhere between Abilene, Kansas, and Benson's Landing, Montana, on September 25, 1873. Moments after the joyous occasion, the new mother was sobbing to the sounds of Wild Bill's departing hoofbeats. She wouldn't see him again for years.

Heartbroken and unable to support her new daughter, Calamity Jane arranged for Janey to be taken in by trusted friends, wealthy mariner Captain James O'Neil, and his wife, who promised not to reveal to Janey her mother's identity. Then she began her diaries in the form of letters to her daughter which Janey wasn't to see until after her mother's death. Jane was a proud mother, filled with love for her absent offspring. Once, Jane cleaned up at a poker table and sent the O'Neils $10,000 for a trust fund.

The summer of 1876 brought Jane double tragedy. She wrote of finding her brother's remains after he was

killed at the Little Bighorn disaster. Later, in Deadwood, she found herself in the arms of a remarried Wild Bill, not long before he drew his last hand of aces and eights.

On her child's fourth birthday, Jane wrote: "You are the dead spit of myself at your age and as I gaze on your little photo tonight I stop and kiss you and then remembering tears start and thank God to let me make amends somehow someday to your father and you."

Jane married Charlie Burke in 1891 and joined *Buffalo Bill's Wild West* show the following year. "I suppose you will wonder what I will be doing there," she wrote. "I ride a horse bareback, standing up, shoot my old statson [sic] hat twice after throwing it in the air before it falls back on my head."

At one of the *Wild West* shows, in Richmond, Virginia, in 1893, Jane saw her daughter, who was blossoming into womanhood, sitting in the grandstands unaware that the wild, sharpshooting cowgirl riding bareback was her mother.

Just after that encounter, Buffalo Bill canceled a European tour, and Jane was crushed; O'Neil and Janey had been slated for a simultaneous European cruise. Undaunted, Jane left the show, booked her passage on the same ship, the *Madagascar,* and even dined incognito with her daughter and O'Neil. In London, she worked as a practical nurse and housekeeper for eight months to earn her fare back to America.

In 1902, Jane logged that her eyesight was failing and she was out of money: "I hate poverty and dirt and here I shall have to live in such in my last days." On August 1, 1903, Martha Jane Canary Hickok Burke died a few miles from Deadwood and was buried near Wild Bill.

On his deathbed in 1912, O'Neil gave Janey a rawhide box containing her mother's letters, two six-shooters, Jane's wedding ring from her marriage to Wild Bill, and the dress she wore to dinner that night on the *Madagascar.* Janey kept the mementos secret until much later, when *Calamity Jane Exposed* was published.

On Mother's Day, 1941, sixty-eight-year-old Janey said on a radio program: "My heart burned to think that my mother lived out her life in loneliness so that her daughter would have a better fate. I only wish she could know how proud I am to be the daughter of Calamity Jane."

Were the letters genuine? If so, was what they said true? Most people accept them as accurate, but some doubt remains. History left Jane with a reputation for toughness and valour. She might also have been the West's most famous secret mother.

BAT MASTERSON

On the streets of Dodge City, Kansas, one afternoon in 1878, a stranger asked a resident how he could recognize the fabled twenty-four-year-old sheriff of Ford County. "Look for one of the most perfectly made men you ever saw," said the Kansan, "as well as a well-dressed, good-looking fellow, and when you see such a man call him 'Bat' and you have hit the bull's-eye." But Bat Masterson's guns, not his style, created the reputation that helped him survive.

Though several biographers swear our hero came originally from Illinois, Bartholomew Masterson was born in the province of Quebec, Canada, on November 26, 1853. His parents, Thomas and Catherine McGurk Masterson, migrated with their large family to New York, then to Illinois, and finally settled near Wichita, Kansas, in 1871. At seventeen, Bartholomew changed his name to William Barclay and left home with older brother Ed.

After working briefly for the Santa Fe Railroad, Masterson became a free-lance buffalo hunter, earning upwards of $100 a day for his skills slaughtering the shaggy beasts roaming the prairies near Dodge City. While stopping for provisions at a Texas outpost called Adobe Walls on June 26, 1874, he, thirty-seven other hunters, and one woman became involved in one of the most famous Indian battles of all time. The small group defeated five hundred Indians who tried to level the settlement.

After the Battle of Adobe Walls, Masterson became a civilian scout for Colonel Nelson Miles. His reputation as a cold-blooded killer began in Sweetwater, Texas, in 1876, when he got into a fight over one Molly Brennan. Sergeant Melvin King, her former boyfriend, spotted the dance-hall beauty with the suave scout in a saloon one evening and flew into a rage. King aimed for Masterson's groin, but as he fired Molly ran between them and was killed instantly by the shot, which passed through her into Masterson's pelvis. From the ground, Masterson fired one shot through the heart of his attacker. Sweetwater had two funerals the next day, and Master-

son walked with a cane the rest of his life.

Still, he was a dashing sort, five feet nine with broad shoulders, a carefully trimmed mustache, and grayish blue eyes. He returned to Dodge City, where he served briefly as a frontier policeman. In 1877, he ran for sheriff of Ford County and won by three votes.

Masterson earned his nickname as he preferred to use his cane to his Colts when it came to quelling a disturbance. The citizens of Dodge bought him a gold-headed version that became his most famous trademark.

Considered by many the best peace officer Kansas ever had, Bat didn't like the profession as well after brother Ed, the marshal of Dodge City, was killed by a drunken cowboy. Bat avenged his brother's death but lost his reelection bid. He moved to Leadville, Colorado, for some serious faro. In 1881, he joined friends Wyatt Earp and Luke Short in Tombstone, Arizona, and became a very successful gambler. For a while Bat divided his time between Denver and Creede, Colorado, and Dodge City.

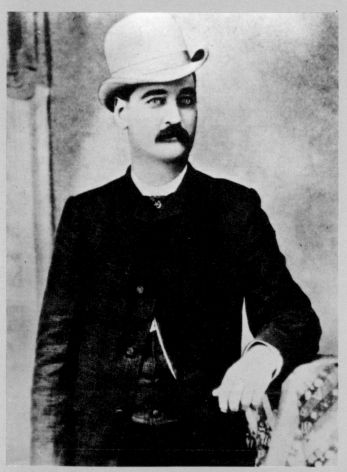

The West's best-dressed list always included Masterson. This photograph was taken c. 1881.

Though Bat may have killed only two men, legend had twenty-six notches on his gun handles (although Bat questioned who would be fool enough to carve up a good gun handle). One story said that to claim a bounty on two killers, he cut off their heads and carried them back in a gunny sack.

There were enough to believe the tall tales to provide Masterson a wide berth wherever he went. In Creede, con man Soapy Smith collected protection money from every establishment in town, except where Bat Masterson gambled.

After an 1882 stint as town marshal of Trinidad, Colorado, Bat cashed in on a lifelong interest in sports. He promoted several boxing events and even became a sportswriter. The fight game could be just as nasty as dealing with outlaws, however. Popular Denver columnist Otto Floto had the nerve to question the authenticity of Masterson's bouts, calling them "jug-handled matches." Bat spotted the portly Floto coming out of a cigar store at Sixteenth and Champa streets in Denver one morning and whacked his detractor with his cane. Ten-year-old future journalist Gene Fowler witnessed the event.

In 1891, while managing Ed Chase's Palace Theater and gambling house in Denver, Bat fell in love with and married blond singer-dancer Emma Walters and lived with her the rest of his life. In 1902, when a new mayor actively campaigned against gambling, the Mastersons were asked to leave the Mile High City, so they moved to New York City.

Upon their arrival, Bat was made deputy U.S. marshal for the Southern District of New York by his friend President Theodore Roosevelt. After he was booted from the job by President Taft, he became sports editor of New York's *Morning Telegraph*.

Besides writing about sports, Masterson recounted several of his Western exploits for various publications. On October 25, 1921, he philosophized in his column: "There are many in this old world of ours who hold that things break about even for us. I have observed, for example, that we all get about the same amount of ice. The rich get it in the summertime, and the poor get it in the winter." After completing those words, he had a heart attack, slumped over his desk, and died.

The death at sixty-seven of this hunter, scout, sheriff, gunfighter, gambler, promoter, and sportswriter made page-one news across the country. Friend Damon Runyon called him a "one-hundred-percent, twenty-two-karat real man," a fitting epitaph for the West's best-dressed tough guy.

JUDGE ROY BEAN

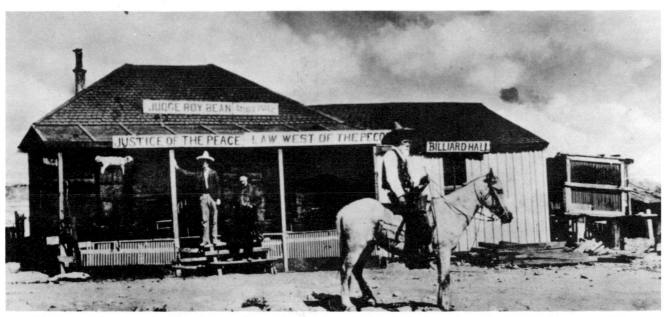

The judge takes time from his busy docket to pose on horseback outside the only tourist trap in Langtry, c. 1902.

When the law came to parched Texas country in the last century, it did so in the form of a cantankerous old shyster who dispensed liquor and justice in equal doses. For his impartial actions, Judge Roy Bean became a legend as the "Law West of Pecos."

The son of Francis and Anna Bean was born in Mason County, Kentucky, around 1825. His first fifty-six years were a series of false starts and miscues. He left home with brother Sam in 1847 on a wild scheme that brought them to Mexico, where he killed a man in a Chihuahua brawl. Escaping to San Diego where brother Joshua lived, he paraded around town like a caballero, got into another fight, and had to break out of prison.

After Joshua was killed by noted badman Joaquin Murietta, Roy took over his San Gabriel saloon (near Los Angeles), learning a trade that would stay with him forever. He soon got into a quarrel over a woman with a Mexican officer, killed him, and was lynched by the officer's friends. He was cut down in the nick of time, but the rope had so injured his neck that he was never able to turn his head again.

After a stint at Sam's New Mexico bar, Roy held a series of crooked odd jobs in San Antonio, Texas. As a dairy operator, he watered the milk. If his butcher busi-

ness was in need of some quick cash, he would go out and slaughter a convenient cow. On the personal side, however, he married Virginia Chavez on October 28, 1866; they had four children.

Deep in debt by 1882, Bean sold his land for $900 and set off to follow the sun. The railroad was building westward now, and Bean correctly assumed that such desolate country could use a proper watering hole. He set up a tent saloon at Eagle's Nest, then relocated in Vinegaroon, a hoodlum haven in a crook of land carved out by the Rio Grande and the Pecos rivers. On August 2, Texas Ranger Captain T. L. Oglesby appointed Bean justice of the peace.

Judge Bean moved his quarters at the end of the year, setting up in a town he named Langtry, after the famed English actress Lily Langtry. He called his saloon the Jersey Lilly (Roy was never much of a speller), and he kept an 1879 book of Texas statutes as his only reference source. When updated laws arrived by mail, Bean used them to build fires.

For twenty years he ruled the roost in western Texas—with an iron hand and his own wacky reasoning. When a railroad worker was found dead with a pistol and $40 on his person, Bean fined the corpse $40

for carrying a concealed weapon. One murderer went scot-free when Bean "couldn't find a law against killing a Chinaman." Another time, he nearly hanged a lawyer for using profanity in the courtroom. The dirty words in question were *habeas corpus*.

Bean's jurisdiction allowed him to conduct weddings, but he was not granted the power of divorce. The judge couldn't understand that, figuring he had a "right to correct his mistakes," and went on about his business. After charging two Mexican couples two dollars apiece for their divorces, he noticed the couples changing partners as they left the Jersey Lilly. Bean threatened to arrest them for fornication if they didn't get married right then and there, for five dollars a couple.

Elections were held every two years, and Roy won every time except in 1886 and 1896. To insure his election in 1898, he stood outside the schoolhouse polling place with a sawed-off shotgun, taking an informal survey of voter preferences.

Bean was such an imposing figure that many of the train riders traveling Out West would disembark at Langtry just to see him. Usually, they were not disappointed. Sitting on his front porch with tobacco stains in his white beard, the potbellied old coot could often be seen passing the time in the Texas sun with his pet bear, Bruno. (Some visitors were disappointed. One story tells of a New Yorker buying a pint of whiskey for 35 cents and paying with a $20.00 gold piece. Bean refused to make change. The Yankee called the old man a bastard and was fined $19.65 for disturbing the peace.)

Still, there was a soft spot in Bean's rough old heart. No one knows for sure when he first flipped for Lily Langtry, but flip he certainly did. A huge framed portrait of her hung on his wall, and cowboys never drank to a woman in his presence, unless it was to Miss Lily. The high point of Bean's life was when he saw her perform in San Antonio. With his hair greased back, he was seated in the front row. He wrote many fan letters to her and sent her live turkeys at Christmas. His one dream was that she would visit Langtry, Texas.

Perhaps Bean's greatest coup came in 1896. The Bob Fitzsimmons–Peter Maher championship fight had been banned in Texas, New Mexico, Arizona, and Chihuahua. (Prizefighting was illegal at the time.) Bean got the match moved to Langtry, actually to a sandbar on the Rio Grande, outside ranger jurisdiction. The ballyhooed brawl went off on February 21, with Fitzsimmons winning in the first round.

After a long and feisty life, Judge Roy Bean died quietly of heart and lung complications in the Jersey Lilly on March 16, 1903. Ten months after he was buried in Del Rio, Miss Lily Langtry stepped down off the train to see her city. With a tear in her eye, she accepted Bean's pistol. It was a dignified coda to the outrageous life and times of Judge Roy Bean.

ANNIE OAKLEY

Though she never saw the far side of the Mississippi River until well into her stellar career, Annie Oakley was the best-known Western woman at the end of the last century. She dressed the part, from the cowboy boots which hid her slender ankles to the wide-brimmed hats that covered her girlish curls. Her reputation and legend, however, came from a certain magic that appeared every time Annie got her gun.

Phoebe Ann Moses' wretched childhood began shortly after her birth in Darke County, Ohio, on August 13, 1860. Her father, Jacob, died when she was four, and her mother, Susan, found herself farming out the majority of her eight offspring. Annie was shuffled back and forth between institutions and foster homes.

Annie hated her name because of schoolyard taunts such as "Annie Moses, where'd you get those clothes?" Historians have found that she went to great lengths in adulthood to obliterate her real name. From the family Bible to her father's tombstone, she changed the name to "Mozee," even calling herself that in her autobiography.

The cruelest foster family seemed to pride itself on abuse, forcing the girl to begin her days of servitude at four in the morning and tossing her, shoeless, into the snow over the smallest infraction. After two years she ran back to her mother, who had remarried and was trying to get in touch with her.

At age twelve, she not only paid her own way but she took care of the family mortgage. Learning that eateries paid top dollar for game birds, she took her father's shotgun from the wall and made herself known to the local quail population. One of her customers, Charlie

Katzenberger, was so amazed by her marksmanship that he involved her in a contest that changed her life.

Frank E. Butler, a twenty-five-year-old professional sharpshooter, had wagered that he could defeat all challengers. Katzenberger convinced the fifteen-year-old huntress that it was a chance to pick up a little extra cash. Annie was hesitant, but ultimately agreed to the match, to be held in Cincinnati just after Thanksgiving Day, 1875. It was to be love at first shot.

Butler was surprised as the petite teenager strolled up, but a bet was a bet. Annie had never shot at clay pigeons before but found them much slower than quail. With the score tied at 24–24, Butler missed his last target. Annie yelled her final "Pull!" then blasted the winning shot. As the throng cheered, a match of a different kind began; a year later she and Butler were married.

The honeymoon was spent fulfilling Frank's theatrical obligations. Annie Oakley, as she was now called (after a lovely Cincinnati neighborhood), moved up quickly in the show, from stagehand to partner to star, while Frank

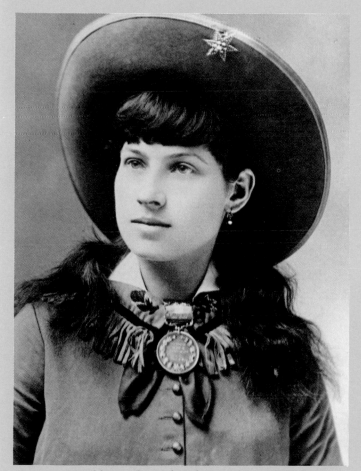

A publicity photo of Little Sureshot, c. 1880.

took over the management of his phenomenal bride.

Their big break came a decade later when they were participating in the World's Industrial and Cotton Exposition in soggy New Orleans. In town for the same season was a show on the edge of bankruptcy, *Buffalo Bill's Rocky Mountain and Prairie Exhibition.* Cody himself didn't see the audition: Annie stood in the mud in a downpour, blowing glass balls out of the air, dimes from Frank's hand, and a cigarette from his lips.

Annie became the top attraction of Cody's renamed extravaganza, *Buffalo Bill's Wild West.* Another big name signed that season, Sioux Chief Sitting Bull. He had been about to quit in disgust after being introduced as "the murderer of Custer." Walking from the arena, he saw Annie shoot the spade from the center of an ace while holding the gun over her shoulder, sighting on the reflection in a bowie knife. Sitting Bull not only remained with the show, he adopted Oakley in a special ceremony, naming her "Little Sureshot." Annie was fond of the tag, which she preferred to Cody's "Missy."

International fame came during an 1887 tour of Britain. Grand Duke Michael of Russia, who fancied himself handy with a rifle, challenged Annie. Cody tried to persuade his headliner to throw the contest, so as not to dash the duke's male ego. Annie would hear nothing of it. After a hundred ceramic birds had flown, she'd thrashed the duke 47–36.

Tragedy struck in the night on October 28, 1901; the *Wild West* train collided with another train near Lexington, Kentucky. Frank found Annie in the twisted wreckage and carried her to safety. She awoke seventeen hours later in pain from internal injuries, her left side partially paralyzed. Her auburn hair had turned snow white.

Two years and five operations later, she walked. She also managed to shoot again, and even to perform, but it was never the same. As an added hardship, she was involved in fifty-three lawsuits with newspapers across the country after they falsely reported that a drug addict arrested in Chicago was "the true Annie Oakley." True to form, she won fifty-one of the cases and $800,000.

In 1922, Annie was in an automobile accident so severe that she never walked or fired a gun again. An autobiography was never completed; she died in her sleep on November 3, 1926. Frank sank into depression and died less than three weeks later.

"Anniemania" swept the country, culminating in the 1946 production of Rodgers and Hammerstein's *Annie Get Your Gun.* Annie Oakley was a performer without peer, who shot old stereotypes full of holes long before it was fashionable.

ESTHER MORRIS

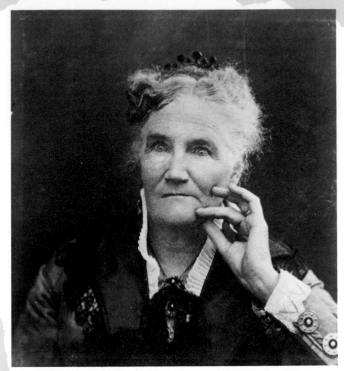

America's first female judge, photographed in 1870.

It was only natural that the American quest for women's suffrage would have its first taste of reality Out West. In this wild region, the equality of the sexes was an accepted fact. Women had tamed the frontier alongside men. Allowing them to vote was another matter, however, and some say it all came about thanks to the friendly persuasion of Esther Morris.

Esther Hobart McQuigg was born in Spencer, New York, on August 8, 1814. Orphaned at age eleven, she went to work as a milliner in Oswego, New York, for the next seventeen years. At age twenty-eight, she married civil engineer Artemus Slack, who passed away soon after the birth of their first child, Archibald. The will left her little hope but a small tract of land in Peru, Illinois. Arriving there with babe in arms, she was greeted with a male horselaugh, for women enjoyed no property rights in the state whose name came from an Indian word meaning "tribe of superior men."

Esther soon married merchant John Morris and bore him twin sons, Edward and Robert. In 1868, Mr. Morris took Archie with him to the Wyoming territory to hunt for gold. Esther and the twins followed in 1869, and she set up housekeeping and flower gardening in wild South Pass City.

Some historians say Esther's interest in women's rights came about after her brush with red tape in Illinois; others say she was influenced by a Susan B. Anthony rally. Regardless, her first contribution to the movement came at a social gathering she hosted just before the territory's first election on September 2, 1869. Esther's tea party was nearly as revolutionary as the one in Boston nearly a hundred years before.

For the occasion, Mrs. Morris had invited twenty upstanding members of the community as well as two candidates for the territorial legislature, Republican H. G. Nickerson and Democrat Colonel William H. Bright. (Most accounts say Bright was an ex-Confederate, though recent findings say he was a Union man.) At the appropriate moment, six-foot, 180-pound Esther rose to her feet, cut the chitchat, and got to the point.

Referring to the two candidates, she said, "One of them is to be elected, and we desire here and now to receive from them a public pledge that whichever is elected will introduce and work for the passage of an act conferring upon the women of our new territory the right of suffrage." Both gents wholeheartedly agreed and were applauded.

Bright was elected and, true to his word, began in

November to carry the torch Esther had handed him. Sitting in a Cheyenne hotel room in the flickering light of a kerosene lamp, he drafted the first document in history to guarantee political equality for women. The next day he introduced the bill on the Wyoming Senate floor to an amused, all-male gathering.

After fretting that the bill would "ruin the home," the Senate passed it on November 30. It went to the House, where more ridicule followed. Ben Sheeks tried to get the voting age raised to thirty because "what woman would admit she was thirty?" They passed the measure as a joke on Republican Governor John A. Campbell, sensing he would have to make an embarrassing veto. Campbell turned the tables on his opponents and made political history by signing the bill into law on December 10, 1869. "To the lovely ladies," toasted one lawmaker, "Once our superiors, now our equals!"

Meanwhile, in South Pass City, Justice of the Peace R. S. Barr sent the following telegraph to the board of county commissioners: "I therefore make this my resignation . . . to take effect whenever some lady elector shall have been duly appointed to fill the vacancy." The commissioners accepted it and appointed the world's first female justice of the peace, Esther Morris.

Dressed in a calico gown, with a green necktie and ribbons in her hair, Esther wielded the gavel from her home, serving out the nine-month term with supreme dignity. She presided over twenty-six cases (removing herself from only one, when Barr tried to get his job back) and never had a decision overturned. According to one lawyer, "to pettifoggers she showed no mercy though her decisions were always just." She retired in November 1870.

Documentation for one incident is inconclusive, but it is in character with the strong-willed Esther. Wyoming was beginning the push for statehood in 1871, and several legislators sought to have the controversial suffrage law repealed in hopes of bettering their position. Supposedly, one W. R. Steele held the floor with remarks such as "Women were made to obey men," "A woman can't engage in politics without losing her virtue," and "No woman ain't got no right to sit on a jury no how, lessen she is a man!"

Waiting in the corridor for Mr. Steele was fifty-seven-year-old Esther Morris, who knew of only one way to deal with such an attack. After he got a few good whacks with her parasol, she wrapped the dainty sunshade around his neck.

Wyoming was admitted to the Union on July 10, 1890, the first state with women voters. Esther Morris unfurled the new forty-four-star flag, stitched by proud Wyoming women. The "mother of woman suffrage" died in a Cheyenne hospital in 1902 at age eighty-eight.

Though questions have been raised in recent years as to how much influence she wielded in the initial suffrage movement, her place in history is secure. In 1955, she was chosen as the state's outstanding deceased citizen. She was honored with a bronze statue in Statuary Hall in Washington, D.C., and an identical one outside Cheyenne's capitol building. With well-placed determination, Esther Morris left the man's world in the nineteenth century, where it belonged.

NELLIE TAYLOE ROSS

The triumph of Nellie Tayloe Ross in Wyoming's 1924 gubernatorial election signaled another first in that state's accomplishments in the area of women's rights. Back in 1869, Governor John A. Campbell had penned a measure giving women the rights to vote and hold office.

On January 5, 1925, the state swore in the first female governor in the country. Such a noble achievement was accomplished by a woman with little, if any, political ambition, who didn't lift a finger on her own behalf.

Nellie Tayloe was born on November 29, 1876, in St. Joseph, Missouri, to a family with deep patriotic ties. They boasted George Washington was one of their ancestors and claimed her father's family had built the house in McLean, Virginia, where Dolly Madison had stashed the Gilbert Stuart portrait of George Washington during the War of 1812.

Nellie grew up in Omaha, Nebraska, attended private school, and married William Bradford Ross of Tennessee in 1902. After a visit to Wyoming, Ross moved to Cheyenne to set up housekeeping with his new bride. Soon, they had four sons.

William's political career blossomed; he was elected governor in 1922. The governor's mansion seemed to ring with enthusiasm. William became immensely pop-

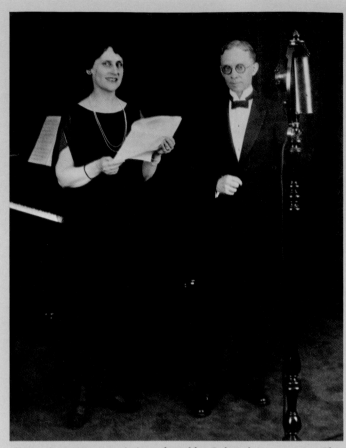

Wyoming's governor is introduced by Colorado's governor, Clarence J. Morley, during a 1925 broadcast from Denver's KOA radio.

ular and Nellie enjoyed the role of first lady of Wyoming. All was well, if not idyllic. Then, on October 2, 1924, William's appendix ruptured and he died.

Mrs. Ross sank into a pit of grief. Her husband's death had occurred only a month before the general election, and the Democrats sorely wanted to keep the governor's office. Thus the widow Ross became the Democrats' standard-bearer. Up to this point, her only official dealings with the public had been as a kindergarten teacher twenty years earlier.

For three weeks, GOP candidate Sullivan beat the bushes while Nellie refused to interrupt her mourning. "I shall not make a campaign," she said. "My candidacy is in the hands of my friends. I shall not leave the house."

Nellie's noncampaign was a successful one: she thrashed Sullivan 43,323 votes to 35,275. She would share national headlines that election day with Miriam A. "Ma" Ferguson, who had won the governorship of Texas, filling her impeached husband's seat, but whose inauguration followed Nellie's by fifteen days.

Insisting that her inauguration be a solemn occasion, Nellie Tayloe Ross saw to it that festivities were held to a minimum. Dressed in full mourning, she took the oath of office at noon from Chief Justice C. N. Potter of the Wyoming Supreme Court. Thirty-five years earlier, Potter had drafted Wyoming's equal rights clause at the state constitutional convention.

The Denver Post painted the event in lavish shades of purple: "Then she lifted her head, a smile of determination dawned on lips just faintly colored, and her blue eyes were filled with the light of courage." In an interview on her one-hundredth birthday, she would say, "The best thing I could do for the women's cause at the time was to do a good job as governor."

In her smooth transition from forty-eight-year-old housewife to public servant lies the charm of the Nellie Tayloe Ross story. Her administration proved to be one blessed with intelligence, common sense, and dignity. An effective public speaker, she served notice on a male society that the twentieth century had indeed arrived.

She lost the election of 1926 by just over a thousand votes, not because she was a woman, but because she was a Democrat. In 1928 and 1932 she campaigned vigorously for Alfred E. Smith and Franklin D. Roosevelt, respectively. FDR in turn named her the first female director of the U.S. Mint, which was in a shambles as a result of the Great Depression. To make things worse, the government had not made a gold purchase since 1893.

Nellie admitted it "sounded cold, dealing with metal," but she attacked the job at age fifty-six and held it for twenty years. During her time in office, coin production leapt from a paltry 3.5 million pieces in 1933 to over 4 billion at the end of World War II.

The years following her 1953 retirement were spent traveling, lecturing, and granting interviews. She lived in Washington, D.C., but came back home in 1972 for Yellowstone National Park's centennial festivities.

Nellie Tayloe Ross celebrated her one-hundredth birthday on November 29, 1976, by going through stacks of birthday cards. The most warmly received were good wishes from Wyoming schoolchildren. She died in a Washington nursing home on December 19, 1977, at the age of 101. Long before it became popular, this reluctant pioneer had championed a movement.

SITTING BULL

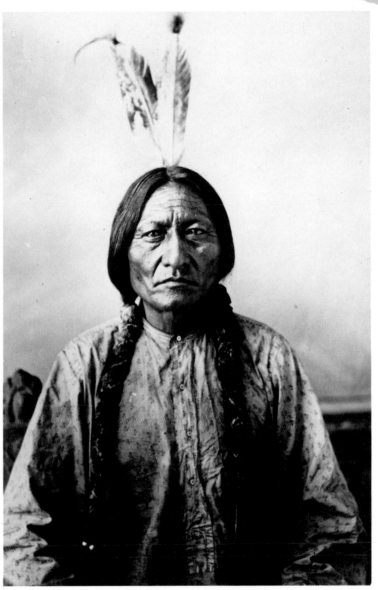

Noted photographer David F. Barry's classic portrait of the Sioux chief.

His mission was not to become the most famous American Indian. Sitting Bull merely wanted a good life for his people, the Hunkpapa Sioux. Had he belonged to an earlier generation, success would have been guaranteed to such a leader. In the latter portion of the nineteenth century, however, a dark destiny awaited the native American, and nothing this mystic warrior could do could prevent the inevitable.

He was born on the banks of the Grand River, near today's Bullhead, South Dakota, to Jumping Bull and Her Holy Door in March 1831. His original name was Slow. Even as a baby, all decisions were weighed seriously; he pondered buffalo meat carefully before eating.

The name change came fourteen summers later. During a battle with an enemy Crow tribe, Slow charged fiercely with his *coup* stick. (*Coup,* or "blow," came from French traders, their name for the Indian custom of honor being gained by the first to strike the enemy.) His only weapon a jousting pole, he fought like a madman. After the fight, his proud father, boasting of the

courageous performance, led him through camp on a pony. From that day on, he was known as Tatanka Iyotake, "Sitting Bull."

For the teenager a whole new world opened, filled with excitement, battle, and women. When it was time to take a bride, Sitting Bull chose two, Light Hair and Snow On Her, but lived to regret the decision, complaining of lost sleep.

The exploits of young Sitting Bull gained him an early reputation for bravery as well as recklessness. In hand-to-hand combat with a Crow chieftain, he was shot in the foot but still managed to claim the life of his opponent. Another time, Sitting Bull adopted an Assiniboin boy after members of Sitting Bull's expedition had attacked the boy's tribe. He claimed the fourteen-year-old was "too brave to die." Criticized widely for the move, he named the lad Kills Often and never regretted the action.

Sitting Bull's first skirmishes with whites came in the mid-1860s, as soldiers began moving into the Sioux hunting grounds. On July 28, 1864, General Alfred Sully attacked a Teton camp. The young brave witnessed a new kind of warrior, whose bloodthirstiness included killing Indian women and children. Though he claimed that fighting the white man was "just shooting," instead of traditional Indian combat, he realized that times were changing.

It would not be long before the leader of the Midnight Strong Hearts, a society of two hundred top warriors, was ready for a bigger job. In an unprecedented move, Sitting Bull was made chief of the Sioux nation in 1868, in the hope that centralized leadership could pull together the factions for the coming war of survival.

Sitting Bull wanted peace, but he'd smoked the peace pipe so many times with representatives of the Grandfather (the president of the United States) that he was afraid of perjuring himself with the Great Spirit when he had to turn and defend himself against the ones with whom he had made treaties. In the summer of 1876, the largest congregation of Plains Indians in history met at the mouth of the Greasy Grass River to decide how to deal with the white menace. The white man had another name for the Greasy Grass: the Little Bighorn.

General George Armstrong Custer's foolhardy attack was no surprise to Sitting Bull. In an effort to contact his god, the chief had a hundred slices of flesh cut from his arms and chest, bleeding himself into a vision while doing the sun dance for the rest of that day, all night, and into the next day. He saw soldiers falling into camp with their heads down, like grasshoppers from the sky.

Sitting Bull did not participate in the historic battle with Yellow Hair, as his subordinates Crazy Horse and Gall had the situation well in hand. His warnings not to steal from the corpses went unheeded. Sitting Bull took that as a bad sign and knew the Grandfather would send more soldiers.

Sitting Bull led his people into Canada, and for five years they lived a precarious existence. Buffalo were scarce, and winters were bitter. Faced with starvation and a campaign to oust them from Canada, plus hostility toward them in the United States, the great chief cut his best deal, surrendering on July 19, 1881. Newspaper accounts report he said, "Let it be recorded that I was the last man of my people to lay down my gun," but witnesses heard no such statement. He did say to his eight-year-old son, Crowfoot, "If you live you will never be a man in this world because you can never have a gun or a pony." The proud mystic was a broken man.

During the summer of 1885, after being paraded by the army at a number of exhibitions, Sitting Bull toured for one season with *Buffalo Bill's Wild West* show, and was jeered at as the "murderer of Custer." Cody gave him a gray performing horse, which was allowed to return with the old man to the Standing Rock reservation.

To many Indians, the ghost dance seemed a last chance, a new religion that promised to raise the buffalo and fallen warriors from the dead. It was a messianic movement among the Indians that spread rapidly during the latter part of the nineteenth century. It originated around 1870, but a resurgence was promoted by Paiute Wovoka. He convinced others that he had seen the Great Spirit, who had told him that by performing the ritual of the ghost dance they would be reunited with their dearly departed and that the whites would vanish.

Sitting Bull scoffed at the dance but was singled out by the police as an instigator of this subversive ritual. On December 15, 1890, Sioux police sent by the Indian Bureau awoke the fifty-nine-year-old chief in his log cabin and arrested him. Over a hundred dancers rushed to his aid, and in the confusion Sitting Bull was shot dead by Sioux Police Lieutenant Bull Head. Sitting Bull's horse, thinking he was in a Wild West show, began to perform, causing witnesses to believe Sitting Bull had entered his body. Also killed in the skirmish were Kills Often and Crowfoot.

For Sitting Bull, the long, confusing war with the white man was over; promises had been written on the wind. A compassionate and humble leader was gone.

GERONIMO

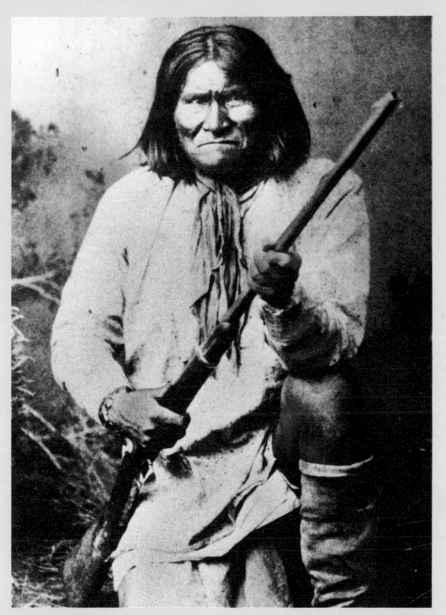

Apache Chief Geronimo in his later years.

In the summer of 1904 at Fort Sill, Oklahoma, an interesting friendship began. S. M. Barrett, a white superintendent of schools in nearby Lawton, acted as an interpreter for a raisin-faced Apache who was selling his war bonnet. The Indian had been a prisoner of war intermittently for over twenty years, but wisdom swam in the old man's eyes; they had seen a lot. They were the eyes of Geronimo.

The white man became enchanted with Geronimo's tales of bravery and treachery. He thought these memories should not disperse with the prairie tumbleweeds, so he asked Geronimo if he could write his biography, just as the old Indian wanted. Geronimo agreed, if payment was involved and his captors approved.

His captors, the U.S. Army, did not approve, claiming the "attention would go to his head" and that he only

"deserved to be hanged." Fuming, Barrett went over the army's head and wrote to President Theodore Roosevelt, who acquiesced.

Geronimo told Barrett he was born in June 1829 near the headwaters of the Gila River in a place known as Nodoyohn Canyon, just inside the border of present-day Arizona. His people kept no written records, and historians have argued that he must have been born earlier. His father's name was Taklishim ("The Gray One"), the son of Bedonkohe Apache Chief Mahko. His mother was full-blooded Apache but with the Spanish name Juana. They named their baby Goyahkla ("One Who Yawns").

Though his youth was a time of relative peace for his tribe, some major shufflings took place as he reached manhood. Raiding was a fact of life along the Mexican border, and atrocities were counted on both sides. In 1837, the state of Chihuahua offered a bounty of 100 pesos for Apache warriors' scalps, 50 pesos for females' scalps, and 25 for children's. Many unscrupulous white men found butchering Apaches more profitable than seeking gold in this barren country.

Practices such as these enraged and confused the Apache. Geronimo felt the cold hand of treachery himself. Married to a slender beauty of the Nednai tribe named Alope and father of three tiny children, Geronimo set out about 1859 for a peaceful trading mission into Mexico with his tribe, led by the beloved Chief Mangas Coloradas.

Returning from a morning of haggling in a town they knew as Kas-Ki-Yeh, Geronimo recalled, "We were met by a few women and children who told us that Mexican troops from some other town had attacked our camp, killed all the warriors of the guard, captured all our ponies . . . and killed many of our women and children."

Geronimo's worst fears were confirmed: lying in the blistering sun were the lifeless bodies of his family.

At a night council, Mangas Coloradas pointed out that with their diminished numbers it would be fruitless to attack the Mexicans. He suggested that they go home and seek revenge the following spring. A heartbroken Geronimo returned home.

Geronimo would remarry and have other children, but he would never quite shake this pain. The following year he did return with his tribe and fought as if possessed. The Mexicans nicknamed him "Geronimo," Spanish for Jerome, and the name stuck. (We should note here that Barrett became a little confused and in his biography promoted Geronimo to chief.) After the battle at Arispe, Mexico, most felt their losses avenged, but Geronimo himself said, "I desired more revenge." For several more years, he would lead raiding groups south of the border.

While Geronimo was plundering in Mexico, the white hold on Indians in Arizona became stronger and stronger. Armed with rifles and legal papers, American soldiers tightened their grip on this untamed people.

After seventeen years of war with the white man, characterized by brilliant guerrilla tactics, Geronimo surrendered for the first time in April 1877. He seemed a happy agrarian on the San Carlos Reservation in present-day Arizona until he escaped for the Sierra Madres in 1881. He surrendered a year later with several horses and cattle he'd stolen in Mexico, determined to have a little backing in this new white world of the almighty dollar. The livestock was, of course, confiscated. In 1885, he left again, this time with two companions, Chihuahua and Naiche. Outnumbered and tired of running, the band soon returned.

The doughty warrior escaped again, then surrendered in 1886. This time he was put on a train for Florida. After eight years there and in Alabama, he and several other captured Apaches were deposited in Fort Sill.

While in captivity, Geronimo was placed on exhibition—with his consent, of course. Personal appearances made money, and with that money Geronimo could buy a little peace. He posed for pictures, appeared at fairs and in Wild West shows, and even rode in Theodore Roosevelt's inaugural parade. On train trips he sold his autograph for fifty cents. He sent constant appeals for pardon to Washington, hoping, in his own words, that Roosevelt would say, "Go, good old Geronimo; you killed heap white folks, but Jesus man made you good; be good man all time and war men hold you no more."

Geronimo never got his freedom, but his memoirs were completed. After acquiring some whiskey in Lawton one night, the old man fell off his horse and laid out under a winter sky until morning. He contracted pneumonia, and on February 17, 1909, surrendered for the last time.

QUANAH PARKER

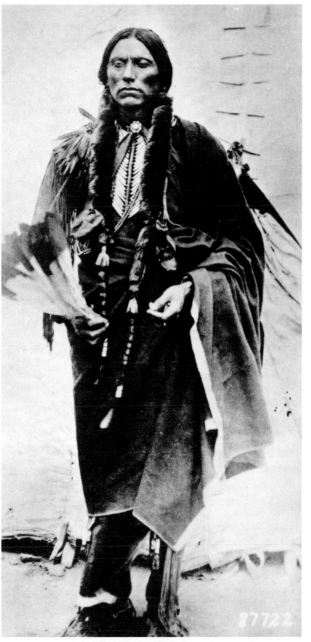

*Quanah Parker, last chief of the Comanches,
at a tribal meeting, c. 1891.*

On the morning of May 19, 1836, Comanches and other Indian warriors attacked Parker's Fort, a stockade in what would become Limestone County, Texas. The massacre of the Virginia settlers was swift and brutal. Among those captured was nine-year-old Cynthia Ann Parker, ripped from her mother's arms by a Comanche brave.

Cynthia would remain with the tribe for twenty-five years. At age eighteen, she became the bride of Peta Nocona, a valiant young chief, and in 1845 she bore her first child, Quanah ("Fragrant"), on the shores of Cedar Lake in the southern Texas panhandle. From recorded accounts by white traders who saw her, Cynthia was happy with her life among the Indians. Two other chil-

dren followed, a son and daughter named Pecos and Topsannah.

Quanah's idyllic boyhood ended with a tragedy in which he lost everything in just under an hour. On December 18, 1860, Texas Rangers and a U.S. Cavalry unit attacked a Comanche camp near the Pease River. Peta Nocona was mortally wounded. Cynthia and Topsannah were taken prisoner and later returned to the Parker clan. Quanah and Pecos escaped to an uncertain future. (Four years later, Topsannah died of a fever. Her grieving mother then starved herself to death.)

The brothers were taken in by the Quohada branch of the Comanches, but Pecos died soon after of pneumonia. Quanah's adjustment would be considerable; he had gone from being the son of a chief to an orphan waif, a ward of the camp. If he were to enjoy any success in life, it would have to be fought for. Such was the case with his wooing of the beautiful Weakeah, daughter of Chief Yellow Bear.

Quanah loved the maiden, but she was also desired by Tennap, the son of rich old Ekitaocup. When Quanah brought ten horses as a gift to the father, Tennap brought twenty. Finally, Quanah, Weakeah, and twenty-four braves stole away in the night, celebrated the elopement, and formed a new tribe. The group prospered and returned to the Quohada in good standing a year later. Quanah was recognized as the new chief.

With the conclusion of the Civil War, the white soldier presence in Texas increased, and times again were tough on the "red raiders." Many Indians surrendered with the signing of the Medicine Lodge Treaty in 1867, but Quanah refused, saying, "Tell the white chiefs that the Quohadas are warriors and will surrender when the blue coats come and whip us." The raiding parties continued.

In 1870, the United States decided to fight fire with fire, giving thirty-year-old Colonel Ranald Slidell Mackenzie the task of driving the Comanches to reservations. Mackenzie would blitz Comanche camps without warning, Quanah would strike back with guerrilla maneuvers, as a brutal chess match developed on the Llano Estacado.

By 1874, another factor was working against Comanche freedom. The buffalo hunters were eliminating their prime food source. A conclave of Comanche, Kiowa, Cheyenne, and Arapaho war chiefs picked Quanah to lead an attack on the hunters at Adobe Walls, a trading post on the South Canadian River. Thirty hunters (including the young Bat Masterson) were able to hold off five hundred attackers, thanks to powerful Sharps rifles that enabled them to pick off riders a mile away.

On September 28, 1874, Mackenzie struck the final blow. Through an informer, he found Quanah's secret canyon encampment at Palo Duro, in the Texas panhandle. The chief was away on a hunt. In a surprise attack, Mackenzie's men killed a handful of people and captured over a thousand horses. The animals were then slaughtered to prevent their recapture by the Comanches. Without horses or buffalo, it was now only a matter of time.

Quanah held out for nearly a year, but on June 2, 1875, he and the last of the diehard Comanches surrendered to Mackenzie at Fort Sill in Indian territory. The two adversaries stood face to face for the first time, and said nothing.

Soon after, the Indian chief assumed the name of his mother, and began calling himself what the Texans had been calling him for years, Quanah Parker. In 1878, due to delayed rations, he obtained permission for his people to go on a buffalo hunt. He then made a trip to Texas to find out what had happened to his mother, and was welcomed by the Parker clan.

Quanah Parker's dealings with Texas cattlemen were shrewd. Besides charging a fee for herders to move their cattle across Comanche land, he leased great expanses of pasture that translated into ready cash for his people. With his own investments, he built a twelve-room home near Cache, Oklahoma, where he lived with Weakeah and seven other wives, and his twenty-five children. As for religion, he stayed with the rites of peyote, explaining: "The white man goes into his church house and talks about Jesus. The Indian goes into his tipi and talks *to* Jesus."

On several occasions, Quanah journeyed to Washington, D.C., to lobby on behalf of his people. With a troop of lawyers, he battled the dissolution of 3 million acres of tribal land for ten years. In 1902, he was elected the deputy sheriff of Lawton, Oklahoma, and in 1908 he became president of the local school district. He also served as a judge for the Court of Indian Offenses, reverting to Comanche law when the white man's statutes were not applicable.

When a new Texas town was named Quanah, he spoke at the dedication ceremonies: "May the Great Spirit always smile on your new town. May the rain always fall in due season. May the earth yield bountifully for you. May peace and contentment dwell with you and your children forever." It was a plain wish from a proud warrior. Quanah Parker died of pneumonia on February 22, 1911, and the title of chief was never bestowed on another Comanche.

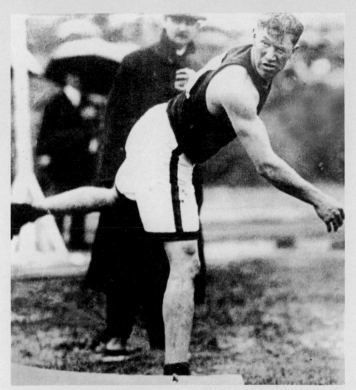

Jim Thorpe shot-putting in the rain during the 1912 Olympic Games.

The fifth olympiad, held in 1912 in Stockholm, Sweden, will forever be remembered for the incredible heroics of a native American. At age twenty-five he was at his physical peak, standing five feet eleven and weighing 181 pounds. His impact on the games and the controversial censure that followed left the door open for permanent debate on the "Jim Thorpe Olympics."

The greatest athlete of modern times was born Wa-Tho-Huck, or "Bright Path," on May 27, 1887, in the Oklahoma territory near present-day Shawnee. He and his twin brother, members of the Sac and Fox tribe, were also christened James Francis and Charles. To their half-Irish, half-Indian father Hiram, who would sire nineteen children with five women, the event was hardly extraordinary.

The brothers were inseparable, roaming the wide prairies, hunting, fishing, and swimming. Tragedy struck when Charles died suddenly of pneumonia at age nine. The grief left Jim with a diffidence he would never shake.

His physical prowess was evident at an early age. A classic anecdote tells of Jim leaving the reservation boarding school one morning, walking and running twenty-three miles home. Hiram promptly marched his son back to school. Jim took a shortcut through the rough country and was waiting when Hiram got home, having covered over sixty miles that day.

Following this episode, Thorpe enrolled in the Haskell Institute in Lawrence, Kansas. He was introduced to football there, but his fame in that sport would come a few years later when he enrolled at Carlisle, an Indian school in southern Pennsylvania.

Thorpe was discovered in the spring of 1907 by another larger-than-life sports figure, Carlisle football coach Pop Warner. The gridiron innovator was watching a group of boys high jumping one afternoon. Some could make the five-foot-seven mark and one topped five-eight, but all knocked the bar down at five-foot-nine. Thorpe happened by in overalls and clubby shoes, stood back a few paces, then sailed over the bar.

Warner was amazed at Thorpe's ability, but he perceived in Thorpe's confidence a dangerous lack of humility. In practice one day Warner scattered fifty players across the field with instructions to bring the prize pupil down. Thorpe took the ball and scooted into the end zone untouched. Pop blasted his troops, lined them up again, and got the same results. Thorpe loved it.

After his 1908 season, in which he received all-American honors, and a stellar track-and-field performance the following spring, Thorpe took some time off from school to play baseball in the bush leagues for two dollars a day. Warner convinced Thorpe to return for the 1911 football season, and another year of glory followed.

In the spring of 1912 it was time to prepare for the Olympics. Although Thorpe did train, most accounts say that he slept his way across the Atlantic on the *Finland*. One story has it that Jim got out of his hammock one day, paced off the twenty-three feet he would have to cover in the broad jump, stared carefully at the span, then went back to sleep.

On the second day of competition, the great-grandson of Chief Black Hawk was ready to take on the world. Competing in the pentathlon on July 7, 1912, Thorpe finished first in the broad jump with a leap of 23 feet 2 7/10 inches. Borrowing shoes because he'd misplaced his own, he won the 200-meter hurdles. Warner chided him when he finished third in the javelin, so an incensed Thorpe won the discus and the 1,500-meter run. The

crowd of twenty thousand was overwhelmed that one man had won four out of five grueling events.

The decathlon was held on the final three days of the Olympics. Thorpe had four first-place finishes and 8,142.96 points (which would remain the record for sixteen years). Besides two gold medals, Thorpe received a bronze bust of Sweden's King Gustav and a jeweled Viking ship from the Czar of Russia. Said Gustav, "Sir, you are the greatest athlete in the world." Thorpe spread an Irish grin across his Indian jaw and replied, "Thanks, King."

Following the 1912 football season (in which Army's Dwight Eisenhower injured his knee trying to tackle Thorpe in a 27–6 shellacking), the news broke. Thorpe had accepted money for playing baseball. Although it was common for collegians to play for pay under assumed names, Thorpe had used his own name. Thorpe was an Indian, and he was the best, so he was a target.

Warner tried to help by drafting a letter with Thorpe that read, "I hope I will be partly excused by the fact that I was simply an Indian schoolboy and I did not know all about such things."

The decision by the Amateur Athletic Union was quick and severe. Thorpe was stripped of his amateur status, his medals, and his trophies. The Norwegian and Swedish athletes who had finished behind him in the Olympics refused the honors, however, saying that Thorpe was the greatest athlete in the world.

Thorpe weathered the disgrace and went on to play professional baseball and football. He married three times and held a string of jobs (including playing an Indian in the movies opposite Tom Mix). In 1950, the Associated Press named him the greatest athlete of the half-century. He died of a heart attack on March 28, 1953.

Following years of public protest, Thorpe's amateur status was restored in 1973, paving the way for the return of his medals to his daughter Charlotte in 1983. It came a little too late for America's finest athlete, the first victim of Olympic politics.

IRA HAYES

The sands of Iwo Jima looked like something from another world to twenty-two-year-old Ira Hayes, compared with the sand he'd left back on the Gila River Indian Reservation forty miles southeast of Phoenix. After seventy-two consecutive days of naval bombardments, the tiny volcanic-ash island had absorbed seven thousand tons of shells and uncounted tons of bombs over its eight square miles.

The task assigned to the young Pima Indian and the rest of the Fifth Marines Division in the area was a dirty one: to flush out the remaining Japanese forces from the island's catacombs and pillboxes. It was to be the costliest territory in the 168-year history of the Marine Corps, exacting a price of 6,800 dead and 18,200 wounded. The Japanese defenders would number 20,000 dead. One reporter said that going through the Japanese fire unscathed was as easy as staying dry in a thunderstorm.

On February 23, 1945, four days after the initial landing, the marines took Mount Suribachi, a 550-foot dormant volcano. The order was given to hoist Old Glory so the remaining defenders would know the end was near. Associated Press photographer Joe Rosenthal, making his way up Suribachi, was disappointed to learn that he'd missed his shot of the flag being raised. Fate would soon intervene, however, for Rosenthal and for Ira Hayes.

Lieutenant Colonel Chandler Johnson was not satisfied with the planted flag. It was too small and could easily be grabbed as a souvenir. In storage on one of the ships was an eight-foot by four-foot-eight-inch Betsy Ross special that had been found in a salvage depot at Pearl Harbor. Reaching the summit, the officer delivering it announced: "Colonel Johnson wants this big flag run up high so every SOB on this whole cruddy island can see it."

Hayes watched as Mike Strank and Harlan Block struggled with the massive flag they'd attached to a twenty-foot pipe. He saw René Gagnon and John Brad-

ley go over to help. But the wind whipped the flag and the men couldn't manage. Hayes and Frank Sousley rushed in, and the flag was raised.

Perched nearby on sandbags, Joe Rosenthal didn't miss this one. He snapped the most famous war photograph in history. In 1/400th of a second, he won for himself the Pulitzer Prize and earned Ira Hayes a life of grief.

Two weeks after the photo ran on the front page of every American newspaper, President Franklin D. Roosevelt fired off a telegram demanding the names of the men and requesting their participation in a bond drive. Strank and Block had been killed on March 1. When the call came to the foxhole of Sousley and Hayes, Sousley was shot dead by a sniper as he took the message.

Hayes returned home a confused and depressed young man. A tour with Gagnon and Bradley began in Washington, D.C., but Hayes only lasted on it for two weeks. Free booze temporarily erased the memories of his dead buddies, and Hayes began to drink heavily. Things were moving too fast.

Shipped back to Japan for the cleanup, Hayes had a run-in with an officer and was discharged December 1, 1945. Trying to pick up the pieces in Arizona, he was constantly confronted with the famous photograph. Tourists would stop to ask where they could find that Indian in the flag-raising picture. He never could understand the fuss; he didn't feel like a hero. The drinking got worse.

Arriving unshaven and unkempt at an American Legion convention in 1947 in Niagara Falls, Hayes drank constantly, missing most of the festivities. In 1949, he played himself in the film *The Sands of Iwo Jima,* adding to the legend by taking orders from John Wayne. This led to a great job with Columbia Pictures' Indian Education Department, but drinking and erratic behavior quickly ended that.

A regular in Phoenix police line-ups, Hayes was arrested fifty-one times for his merry-go-round alcoholism. *Newsweek* ran a story in October 1953 called "Suribachi to Skid Row" that told of Hayes being picked up in Chicago wandering the streets drunk and in tatters. He was quoted later as saying: "I guess I was about

Joe Rosenthal's stirring photograph from Mount Suribachi. Hayes is third from left.

to crack up, thinking about all those other guys who were better men than me not coming back at all, much less to the White House. . . . Sometimes I wished that guy had never made the picture."

For Ira Hayes, the war finally ended January 23, 1955, when he was thirty-two. After a drinking and card party on the reservation, he stumbled out of his adobe, wandered for awhile in the frigid desert night, then toppled headlong into the Arizona sand. He was found the next morning frozen to death.

The tragedy of Ira Hayes was recounted in a book by William Huie, *The Hero of Iwo Jima,* a song by Johnny Cash, and a movie starring a stained-skinned Tony Curtis, *The Outsider.* He is buried in Arlington National Cemetery near the Iwo Jima monument, haunted in death by the image that had ruined his life.

THE CISCO KID

The Kid's most famous incarnation, Duncan Renaldo, in South of the Rio Grande.

The Cisco Kid was born in 1904, the year O. Henry invented him for a collection of short stories published by Doubleday entitled *Heart of the West*. That was also the year in which actor Duncan Renaldo, the most popular of the cinema Ciscos, was born. Although the two men—who never met—were the most important influences creating the character, their interpretations were as different as night and day.

Unlike the movie and television versions, O. Henry's Cisco Kid, who appears in the story "The Caballero's Way," is a cold-blooded, gun-happy murderer, as we learn from the opening sentence: "The Cisco Kid had killed six men in more or less fair scrimmages, had murdered twice as many (mostly Mexicans), and had winged a larger number whom he modestly forbore to count."

A closer look at O. Henry's story explodes another myth: the original Cisco Kid has not a drop of Spanish blood. A character refers to him as Goodall and, in O. Henry's words, "it had been one of the Kid's pastimes to shoot Mexicans 'to see them kick.' "

The literary Kid does have a Mexican girlfriend who "lived in a grass-roofed *jacal* near a little Mexican settlement at the Lone Wolf Crossing of the Frio." While

riding through the tall prickly pear toward her hut one day, he heard her plotting his demise with a young lieutenant. Instead of confronting her with his knowledge, the Kid plays it dumb, but he sends a messenger to the lieutenant with a note supposedly penned by the senorita. It says that the Cisco Kid and his less than faithful girlfriend will switch outfits before they leave her home because the Kid fears capture. The lieutenant mistakenly blows Tonia away in the moonlight and our hero rides off, singing in a voice resembling "a coyote with bronchitis."

Ten years after the story appeared, Cisco jumped into celluloid in a one-reeler of the same title. The short story also served as the plot for a longer film called *The Border Terror,* made in 1919. In 1929, director Raoul Walsh decided to make a sound version with himself as the Kid. While scouting for a location one day, he took a shot at a jackrabbit. The bullet ricocheted and put out his right eye. Warner Baxter took over the role and starred in the hit *In Old Arizona* in 1929. A sequel with Baxter called *The Cisco Kid* appeared two years later.

After one last Baxter vehicle called *Return of the Cisco Kid,* Latin sensation Cesar Romero took the role of the bloodthirsty *vacquero.* In 1939, Romero starred in *The Cisco Kid and the Lady,* and followed it with five other sequels.

In 1944, Duncan Renaldo was approached about donning Cisco's gaucho outfit. A producer as well as an actor, Renaldo had gained popularity in the *Three Mesquiteers* movie series before becoming the dashing Cisco Kid. He claimed to have six birth certificates, some Chinese, some Russian, and said he never knew his parents. His real name was Renaldo Duncan, and his birthplace is listed as the unlikely city of Camden, New Jersey.

As he told Jon Tuska for the book *The Filming of the West,* Romero had caused quite a stir in Latin America by playing the Kid as a vicious bandito. Said Renaldo, "Why not base the character on the greatest book in all Spanish literature, *Don Quixote*?" Cisco would be a modern knight, and instead of a Sancho Panza, he would have a Pancho.

The first two Renaldo films were called *The Cisco Kid Returns* and *The Cisco Kid in Old New Mexico.* His original sidekick, Mexican opera star Martin Garralaga, was soon replaced because he was allergic to horses.

Renaldo played the Kid in 1945's *South of the Rio Grande,* then he was replaced by Gilbert Roland in *The Gay Cavalier.* Roland made three pictures before the series was dropped in 1947.

Soon after, a group of three producers formed The Cisco Company and obtained rights to the Kid. One of them was Duncan Renaldo, who was more than happy to be back in the saddle. Leo Carillo became the new Pancho. Images of the two on horseback soon flickered across America on television as "The Cisco Kid" hit the tube in 1951. It still runs in syndication.

In all, Duncan, Leo, and Cisco's horse Diablo filmed 176 half-hour episodes and 5 features for United Artists. Renaldo's only regret, he said in his interview with Tuska, was that Carillo had played Pancho as a buffoon: "He overdid it, but everyone liked him. His accent was so exaggerated that when we finished a picture, no one in the cast or crew could talk normal English anymore."

Renaldo retired to his Rancho Mi Amigo in Santa Barbara, California, where he could bask in memories and let his two Diablos run free. In 1973, he donned the black costume again to film a promotion for a song by the rock group War that began "The Cisco Kid was a friend of mine." In 1978, a reporter noted that "wrinkles of age etch his face, the once coal-black hair is now snow white and the Argentine gaucho costume no longer fits. But the Cisco Kid still lives within Duncan Renaldo." Renaldo died in 1980.

As happened many times Out West, when the images of O. Henry's scoundrel and Duncan Renaldo's Don Quixote dueled, the good guy won.

Clayton Moore and Jay Silverheels on the trail of another bad guy.

"Nowhere in the pages of history can one find a greater champion of justice," intoned the radio announcer as he introduced the daring and resourceful "masked rider of the plains," the Lone Ranger.

Those same pages would be hard pressed to chronicle the exploits of the masked man, and his "fiery horse with the speed of light, a cloud of dust, and a hearty hi-yo Silver!" He was a prime example of how the West was fun. Return with us now, to those thrilling days of yesteryear. . . .

In the summer of 1932, radio executive George W. Trendle of Detroit's station WXYZ severed his association with the CBS network to go independent. At a staff meeting shortly after Christmas, he outlined his new vision. What he wanted to create was a Western hero who combined the best features of Robin Hood and Zorro. He would be a clean-living, correct-speaking, tall-in-the-saddle type whose main purpose for living was to do good deeds, righting the various wrongs Out West. One staffer suggested a mask, another an affiliation with the Texas Rangers. Trendle wished his Don Quixote to be a "lone operator," and before the gathering adjourned, the Lone Ranger was born.

Trendle next called free-lance writer Fran Striker in Buffalo, New York. He had created "Warner Lester, Manhunter." Striker reworked some scripts he'd entitled "Covered Wagon Days," and in the process came up with some great character "hooks" including silver bullets, a white horse called "Silver," and a faithful Indian companion. Tonto's nickname for his best buddy came from director James Jewell, whose father-in-law had established Camp Kee Mo Sah Bee on Michigan's Mullet Lake in 1911.

"The Lone Ranger" debuted January 30, 1933, with George Seaton as the lead. Rossini's *William Tell* Overture became the theme for the program because the 1829 composition was in the public domain, and WXYZ had a copy on hand. The show was a smash. Three months later an announcement offering popguns to the first 300 letter writers brought 24,905 requests.

Striker, who in his spare time had created the Lone Ranger's grandnephew "The Green Hornet," enhanced his character with an unbeatable inauguration. In the scenario, Lone Ranger John Reid was left for dead after an ambush by bad guy Butch Cavendish wiped out five other rangers, including Reid's brother Dan. Tonto came along before it was too late, dug six graves to fool the murderers, and nursed Reid back to health. Tonto then told him about a great horse ("him look like silver") galloping around in Wild Horse Valley. Reid fashioned a mask out of his dead brother's vest, and it was open season on the cowboy criminal element.

The Ranger's radio ride lasted twenty-one years. By 1939, the show was heard on 140 stations. Parents appreciated the wholesome hero, and kids loved the action as well as the show's tangible assets. Sponsor-oriented premiums were offered on a regular basis: masks, decoders, even a "Lone Ranger atomic-bomb ring" to celebrate the end of World War II.

A Republic movie serial appeared in 1938, with bizarre results. Trendle had not demanded that the details of the original story be retained, and the end product was a mesh-masked Ranger (Lee Powell), a stone-faced Tonto (Chief Thundercloud), and a plot that had little to do with the radio version. An ill-advised sequel even showed the star—gasp!—without his mask.

The radio Ranger managed to keep his credibility. Actor Brace Beemer assumed the role in 1941; he was acknowledged the best of the bunch. Striker penned the daily newspaper comic strips as well as eighteen novels. By 1949, the Lone Ranger was ready for the screen again; but this time the TV screen.

Beating out the hundreds who auditioned for the television role was thirty-four-year-old Chicagoan Clayton Moore, an actor in peak physical condition with perfect voice and diction. A heavy in films such as *G-Men Never Forget,* Moore took to the Lone Ranger role better than most ducks to water. Jay Silverheels, a twenty-nine-year-old Canadian Mohawk and ex-professional lacrosse player, was chosen to play Tonto.

After two seasons, Moore requested more money, and Trendle balked. John Hart donned the mask for a time, but lacked the charisma of Moore, who returned to the role in 1954. On August 3 of that year, Trendle sold the Ranger rights for $3 million to Texas entrepreneur Jack Wrather, who began shooting the series in color. Two feature films received favorable reviews.

The second of those movies, *The Lone Ranger and the Lost City of Gold,* shot in Tucson, Arizona, in 1958, heralded the masked rider's silver anniversary. Publicity experts came up with astounding figures: in his time, the Lone Ranger had nabbed 21,734 outlaws with a total of 12,684 silver bullets, though he never killed anyone. Moore hung up his guns after a thirty-three-city tour. The television series ceased production, passing into the never-ending world of syndication. David Rothel's definitive work, *Who Was That Masked Man?*, appeared to be the last word on the subject.

A legal shootout ensued in the late 1970s when the aging Moore was unmasked in court. The Wrather Corporation wanted the public to identify with a younger man, Klinton Spilsbury, in the upcoming *The Legend of*

the Lone Ranger. Moore sued them. He was ordered not to wear his mask (so he put on dark glasses) while the 1981 film came and flopped. On January 14, 1985, he was informed by the Los Angeles Superior Court that the Wrather Corporation "had requested a dismissal of the entire action," clearing the way for him to resume personal appearances.

And so, the "fight for law and order in the early western United States" never ended. The committee-created character became one of the most recognized American personifications: mask, silver bullets, tight breeches, and all. Time alone will tell whether or not the Lone Ranger rides again.

PECOS BILL

The Disney Pecos finds love in the Texas moonlight.

Invariably, the cattle-drive campfire conversation would drift like the stars overhead. The cowboys would swap their jokes and stories. If a greenhorn betrayed his inexperience with an innocent but stupid question, he might be treated to a tall tale of the one and only Pecos Bill, the "toughest critter west of the Alamo."

As in all American folklore, the roots of the original tales of the sagebrush superman are about as easy to trace as the tracks of a horse through a winding stream. The first Pecos Bill stories were told during the 1870s, when the mythical cowpoke was introduced as a direct competitor to the larger-than-life lumberjack of the north, Paul Bunyan.

The history of Pecos Bill remained strictly oral during the cowboy heydays. One of the first written accounts of his daring deeds appeared in *Century* magazine in October 1923. The publication in the 1930s and 1940s of his wild escapades in the West culminated in 1948 with Pecos Bill's big-screen debut as a cartoon figure in Walt Disney's *Melody Time.* Through all this, we are able to piece together the story of the greatest cowboy who *never* rode the range.

Bill Hunt was born the seventeenth or eighteenth child of Texas settlers who would forever be known to literature simply as "Bill's maw and paw." (Indeed, Bill's surname never appears in his collected tales. We

assume it was Hunt from a story in which his brother Bob Hunt appears.) His date of birth is usually given as "about the time Sam Houston discovered Texas." Bill cut his teeth on a bowie knife, a present sent to his maw by Davy Crockett when he heard she had swept forty-five Indians out of her back yard with a broom.

As the story goes, Bill's frontier family life came to an abrupt halt when he was a year old. His parents decided to relocate after another family settled just fifty miles away. The Hunts were not about to live in such cramped conditions. While the covered wagon was crossing the Pecos River, baby Bill tumbled out and was not missed for "four or five weeks." As luck and legend would have it, Bill was found by Grandy, the granddaddy of all coyotes, who raised him as a coyote.

The first human to lay eyes on Cropear, as Bill was known to the coyotes, came along after the wild child had grown to manhood. Whether his finder was in fact his brother, or just a nameless, convenient cowboy, is unclear. What we do know is what Pecos Bill looked like at the time of his discovery. He was 1,329 coyote paws high with a thick, red, flea-infested mane and sun-baked skin. He argued bitterly with his rescuer, but finally conceded his coyote citizenship when the stranger pointed out that Cropear had no tail. Stripped of his varmint status, Bill quickly adapted to the world of men, dabbling in just about everything that ever happened Out West.

With his hair slicked back with panther grease, a twelve-foot snake wrapped around his arm for a lariat, and a roaring cougar for a mount, he made his public debut in the roughest camp imaginable, the Hell's Gate Gulch outfit. Stepping down from the great cat, Bill sauntered over to a pot of boiling beans and swallowed the contents without a blink. Next he gulped down a few gallons of scalding coffee straight from the pot. Wiping his mouth on a cactus, he then bellowed, "Who the hell is boss around here?" An eight-foot-tall trail boss adorned with seven pistols and nine bowie knives stood up and said, "Stranger, I was, but you be."

With the outfit (called in some accounts the "boys of the I.X.L. Ranch"), Pecos Bill invented modern cow-punching. He taught the cowboys how to throw a lasso, how to brand, and how to yell "yippeeee." To keep his cattle from straying, he fenced in Pinnacle Mountain and called his creation the Perpetual Motion Ranch. Then, he staked out New Mexico and used Arizona as a calf pasture.

Pecos Bill enjoyed riding his mountain lion, but he knew every cowboy had to have a horse. His was Widow-Maker, an animal he raised on nitroglycerin and dynamite. Pecos was the only one who could ride him. When a hapless friend attempted to do the impossible, Bill had to rope the cowboy from the top of Pikes Peak.

There was never a dull moment in the life of Pecos Bill. Once, he wagered a Stetson that he could ride an Oklahoma cyclone. While he did, he even managed to roll a cigarette and light it with a lightning bolt. When the tornado saw that Bill could not be thrown, it rained until it washed out the Grand Canyon. Bill came down in California, and the imprint of his big behind can be seen today in what is called Death Valley.

Other Western landmarks were created by the abundant buckaroo, including the digging of the Rio Grande and the forming of the Painted Desert, a feat that merely required shooting warpaint off Indians.

Pecos Bill's true love came in the form of Slue-Foot Sue, a beautiful enchantress he first spied riding a giant catfish down the Rio Grande. The wedding day was set, but it became the saddest day of Bill's life. Sue insisted on riding Widow-Maker while wearing a steel-spring bustle. When the horse threw her, she became a bouncing bride, bouncing higher and higher for three days and four nights. She eventually landed on the moon, and Bill howled like a baby. His fellow coyotes picked up on it, which is why they still howl at the moon to this day.

The demise of Pecos Bill is a genuine cattle-country controversy. Some say he overdosed on a strychnine-and-barbed-wire toddy. Someone else says after a stint with a modern rodeo he saw what was happening to the Old West and "became so filled with sorrow that he pined away to nothing." Perhaps the most believable theory is that a tenderfoot asked him such fool questions about the West he couldn't stand it any longer. He simply laid down and died laughing—a fate barely escaped by all who ever heard the wild tales of Pecos Bill.

VILLAINS

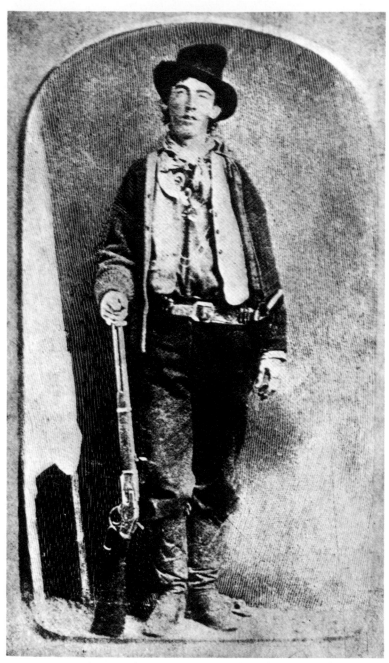

An itinerant photographer was getting ready to leave Lincoln County when the nineteen-year-old Billy ran up to get his picture taken.

Lauded by some as a ranchstyle Robin Hood and by others as a juvenile delinquent, Billy the Kid would have loved his controversial place in American letters. With a casual sneer and a cold disregard for human life, he rode from life to legend at a very early age.

Born in the slums of New York City on November 23, 1859, he was named Henry McCarty by his parents, William and Catherine McCarty Bonney. His father died toward the end of the Civil War, and Catherine took her two sons to Indiana. In 1873, she married Wil-

liam Antrim in Santa Fe, then relocated the family of four to Silver City, New Mexico. Catherine died of tuberculosis the following year.

By the time he was fourteen, Henry was working for room and board in a local hotel while his stepfather was out prospecting. The hotel owner remarked that Henry was "the only kid who ever worked here who never stole anything." The boy's law-abiding ways were due for a change, thanks to an unnecessary trauma.

Duped by an older prankster into stashing stolen laundry, Henry Antrim was caught holding the bag. He was tossed in the slammer as a lesson. The teenager hated the confinement and escaped after two days, squeezing his way out through a chimney. His outlaw days had begun.

In 1877, he worked at a local sawmill in the Camp Grant army post. Blacksmith Frank "Windy" Cahill enjoyed poking fun at the five-foot-eight "Kid Antrim," and one August afternoon made the mistake of calling him a "pimp." Antrim returned the insult, labeling Cahill a "son of a bitch," and the fight was on. During the scuffle, the lad sent a bullet through his brawny attacker. Thus, Cahill became the first man to die at the hands of Billy the Kid. The guardhouse couldn't hold the seventeen-year-old prisoner; he escaped and journeyed to Mesilla, New Mexico, where he took the name of William H. Bonney.

He soon got involved in the state's bloody Lincoln County War, a power struggle between cattle baron John Chisum and a local faction of entrepreneurs. Billy rode with the Chisums, supervised by a young Briton, John Tunstall. Following Tunstall's murder, Billy vowed vengeance. While riding with a posse known as the "regulators," he gunned down two of the killers after they were disarmed.

As the war got uglier, so did Billy. He participated in the ambush and murder of Sheriff William Brady and an aide on the streets of Lincoln. In July 1878, he fought a five-day battle from the adobe home of Tunstall's attorney. The Kid escaped the burning hacienda alive, but this skirmish signaled the end of the war. From there he led a band of range thugs who preyed on local ranchers as well as Apache and Mexican settlements.

In the fall of 1878, New Mexico got a new governor, General Lew Wallace, who divided his time mending political fences and writing *Ben-Hur*. Wallace issued a pardon for the Lincoln County War participants, but that did not include the Kid because of his part in the assassination of Brady. At nineteen, Billy was ready to give society another chance, and, in a clandestine meeting with Wallace in March 1879, he did some intensive plea bargaining.

Billy surrendered, testified against a few killers, then got bored waiting for his pardon. Waving goodbye to his friends, he nonchalantly returned to his rustling ways.

Billy made friends with a Fort Sumner bartender, Pat Garrett, shortly after killing Joe Grant, a saloon braggart. A murder in White Oaks was also blamed on Billy. When Garrett was elected sheriff of Lincoln County in 1880, it became his prime goal to bring in the Kid.

The sheriff managed to do just that. After a raging gun battle at Stinking Springs, Billy was tried and convicted for the Brady murder and sentenced to hang. On April 28, 1881, while Garrett was away shopping for wood to build a gallows, Billy surprised his two guards, blew them away, then taunted the town for an hour before riding into the sunset. "The Kid was all over the building," said one report, "on the porch, watching from the windows. He danced about the balcony, laughed and shouted as though he had not a care on earth."

On July 13, 1881, Garrett rode to the ranch of Pete Maxwell near Fort Sumner, searching for his nemesis. Around midnight, Billy returned from a dance and went to the main house for a snack. Spotting two deputies, he slipped into Maxwell's bedroom to find out what was going on. He heard breathing and asked, *"Quien es?"* Pat Garrett spoke not a word, but opened fire. At age twenty-one, Billy the Kid was knocking on heaven's door.

Within a year, no fewer than ten books were published on the peach-fuzzed desperado, including Garrett's ghostwritten *An Authentic Life of Billy the Kid.* Dime novels insisted he killed twenty-one men in his twenty-one years, which was pure conjecture. A 1906 tale even claimed the Kid was killed by Buffalo Bill Cody.

Hollywood got the Kid in 1930, in a film with Johnny Mack Brown. Other actors who portrayed him on the big screen include Robert Taylor, Audie Murphy, and Kris Kristofferson. Aaron Copland wrote a ballet about him in 1938. In 1960, he was played by Clu Gulager on television's "The Tall Man," and in the 1970s he was sung about by Bob Dylan and Billy Joel. In the avant-garde play *The Beard,* Billy the Kid romanced Jean Harlow, and he was even the subject of a horror film, *Billy the Kid vs. Dracula.*

The reasons for Billy-the-Kid mania have confounded historians for over a hundred years. As an outlaw he wasn't nearly as successful as Butch Cassidy. As a murderer he was outclassed by many. Perhaps the real attraction is his youth, frozen forever on the threshold of manhood by the West's most famous shot in the dark.

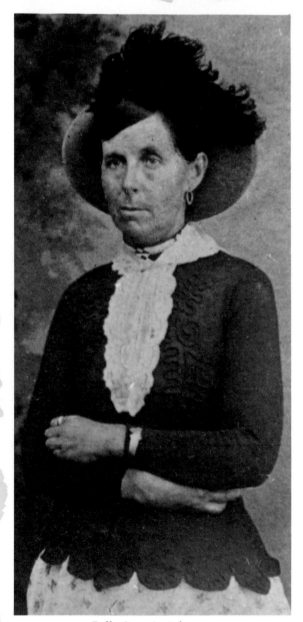

Belle Starr in Arkansas.

Myra Maybelle Shirley was born to farmer and inn-keeper John Shirley and his wife, Eliza, on February 4, 1848, near Medoc, Missouri. In 1852, the family moved to nearby Carthage to open a hotel. John sent his only daughter to a private school, where she received a classical education, including lessons in music and Hebrew.

During the Civil War, Myra began her first daring escapades. She was thought by some to be a spy for William Clarke Quantrill; her older brother Bud Shirley did ride with Quantrill's Raiders, a gang of Confederate guerillas, but it is probable that his little sister never met his ruthless boss. Once detained by a Yankee major in search of her brother, Myra was released with the officer's observation: "she was a beautiful sight as she rode away through the fields; her lithe figure clad in a closely fitting jacket, erect as an arrow."

Myra managed to save her brother that time, but he was killed in a skirmish not long after. Her war-weary father then moved his family to Scyene, ten miles east of Dallas, Texas. The first of a long line of Belle Starr lovers, twenty-year-old Cole Younger, arrived on the scene during the long, hot summer of 1866.

Younger was on the lam, after joining up with his brothers and the James Gang for a $60,000 bank robbery in Missouri. In his autobiography, he denied any liaison with the beautiful eighteen-year-old Texas princess, but others claim that Belle conceived her first child during a week-long tryst with the handsome desperado. Her daughter may have been fathered by her first husband, James C. Reed, who Belle married in November 1866, though all her life the child was called Pearl Younger.

Soon after the wedding, Reed murdered the killer of his brother and became a wanted man. When it was reported that no less a lawman than Wild Bill Hickok was on their trail, the Reeds departed for California. A son, James Edwin Reed, was born there in early 1871, and he accompanied his family back to Texas later that year.

Reed was now a professional thief, and Belle reportedly ran a clearing house for stolen horses. Her biographers say she accompanied her husband during the Watt Grayson robbery in Indian territory, when a woman dressed like a man supposedly slipped a noose around old man Grayson's neck and hoisted him "six or seven times" up a tree until he told where he had buried $30,000 in gold. Author Glenn Shirley, whose *Belle Starr*

One of the many Belle Starr legends maintains that the notorious bandit queen galloped into a livery stable one afternoon and ordered her horse's shoes to be nailed on backwards. That way, she could make her getaway by confusing a pursuing posse. Like other Wild West outlaws, Belle Starr pulled a similar trick on historians: she left behind a volume of escapades, but with only an occasional fact among many fictions.

and Her Times is the best documented study, doubts seriously, however, that Belle was present during the crime.

Reed was killed by a bounty hunter in a double cross in 1874 in Paris, Texas. But Belle duped his assassin out of his reward money by refusing to identify the body. The widow Reed adopted an independent lifestyle, gambling in Dallas dressed in velvet skirts.

Belle married a dashing Cherokee, Sam Starr, in 1880, and they moved to a log cabin on a government allotment south of Eufala, Oklahoma. She called the area "Younger's Bend." Often, famed outlaws—including Jesse James—would cool their spurs with the Starrs, secure in the lawless badlands.

Belle and Sam were arrested for stealing an $85 horse in 1882 and sentenced by famed "hanging judge" Isaac Parker in Fort Smith, Arkansas, to a year in a Detroit, Michigan, house of corrections. Upon release, Belle returned to the wild times at Younger's Bend.

She was a striking figure, usually decked out in gold earrings and a sombrero. Stars adorned her boots and saddle, and around her waist hung a Colt .45 she called "my baby." No man would cross her. Indeed, when one cowpoke refused to retrieve her hat, she held "baby" on him until he did, then said slyly, "The next time a *lady* asks you to pick up her hat, do as she tells you."

Sam managed to stay away from home, terrorizing the countryside with his banditry. Belle found time for a brief fling with the murderer John Middleton, who in May 1885 drowned on a stolen horse that happened to be wearing Belle's saddle. She avoided a second prison stay with a successful defense and celebrated with a Fort Smith shopping spree.

The Starrs attended a Christmas hoedown in 1886, where Sam encountered his nemesis, lawman Frank West. In the ensuing brawl, the two men shot each other dead. Cherokee authorities tried to take away Belle's property, since she was no longer married to an Indian, but she quickly skirted the issue by entering into a common-law agreement with twenty-four-year-old Creek Bill July, whom she renamed Bill July Starr.

In February 1889, Belle accompanied Bill July on the first fifteen miles of a trip to Fort Smith. On the way home she was gunned down, shot in the back by an unknown assailant with a shotgun. In two days, she would have celebrated her forty-first birthday.

A neighboring rancher was acquitted of the murder for lack of evidence, and rumors that Belle was killed by her son, following an incestuous relationship, quickly died out. The killing was never solved.

A hungry free-lance writer named Alton Meyers picked up on the story, and by March had a manuscript accepted by the *Police Gazette.* Publisher Richard Fox soon after released the torrid paperback of the summer, *Bella Starr, The Bandit Queen or The Female Jesse James.* There would be more. The freewheeling, free-loving Belle was gone, but in her place a Western legend was off and running.

ALFRED PACKER

Their first mistake was listening to Alfred Packer. Talk of gold had made the men in a Provo, Utah, boardinghouse hungry. Twenty were ready to leave that night for Breckenridge, Colorado, the center of gold-digging action in the fall of 1873. Packer, a thirty-one-year-old mountain "expert," had convinced them that he knew Colorado "like the back of his hand."

In his whiny voice, the six-foot former Union soldier and native of Pennsylvania painted a pretty picture. He would have to be "grubstaked," meaning his companions would provide food and other necessities while he led them to the big strike. Little did they know how literally Packer would take the term.

On January 21, 1874, the group reached the broad valley of the Uncompahgre River, near modern-day Delta, Colorado. They were ill-prepared to continue their trip. They had run out of food and were surviving on chopped barley.

A group of Utes found the hapless party and took them before Chief Ouray, who replenished their supplies but suggested they stay at his lodge until spring. Some agreed. Others listened to Packer.

On February 9, Shannon Bell, James Humphrey, Frank Miller, George Noon, Israel Swan, and Packer tromped out of the camp and into a Colorado blizzard. Sixty-six days later, his long hair matted beyond recognition and

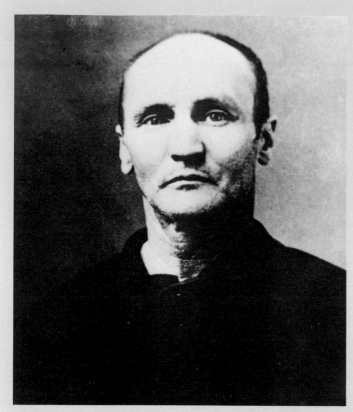

The prison portrait of the United States' only convicted cannibal.

his Charles Manson eyes smoldering from the nightmare, Packer staggered into the Los Pinos Indian Agency near Saguache. Some accounts say he was ravenous; others say he gagged at the sight of meat. All say he asked for whiskey.

How had he survived? The small group had taken provisions for only a week. Packer's story was a woeful tale of separation from his partners, of eating moccasins and frozen berries, of offering wretched prayers for salt and warmth to a desolate sky.

Contacted by Preston Nutter, a member of the original party, Packer agreed to return to the scene and search for the bodies of his companions. Then he set up shop in Larry Dolan's saloon and started in on some hard drinking and gambling.

Other members of the original party soon arrived in Saguache, and suspicions arose about what really had happened out in the wilderness. General Charles Adams, an Indian agent, was enlisted to hear Packer out.

Packer's story began to change on the road back to Los Pinos with Adams when they encountered Frenchy Cabazon, another of the original adventurers. Frenchy called Packer a liar and Packer threatened Cabazon, saying he'd kill him the next time he saw him.

Packer's famous first confession to Adams was that everybody except Noon had died of hunger or exposure and that Bell had killed Noon. Packer said he found Bell roasting a piece of Noon's leg, a scuffle ensued, and he killed Bell in self-defense, then enjoyed a flesh filet.

Packer was jailed in Saguache during a search of his picnic grounds. In August, a *Harper's Weekly* artist discovered what was left of the five bodies. It seemed that four of the five victims had been killed in their sleep and the fifth had struggled before meeting his end. Saguache went into an uproar, but it was too late. Packer had bribed the sheriff's sixteen-year-old son and escaped.

Nine years later, Packer, who had taken the alias "John Swartze," was arrested in a LaPrele Creek, Wyoming, boardinghouse after Cabazon recognized his high voice. He was returned to Denver, where a thousand people turned out to greet the "ghoul of the San Juans." His second confession said that Bell had done all the killing and he'd killed Bell in self-defense before settling down for a blizzard smorgasbord. Recalling the end of his fast, Packer smiled and said, "I felt perfectly happy. Slept and slept and slept."

In his Lake City, Colorado, trial in April 1883, Packer was found guilty of murder. Barkeep Dolan, reporting Judge Melville Gerry's sentencing words to the locals, misconstrued them as: "Stand up, y'man-eatin' sonofabitch! They was seven Dimmycrats in Hinsdale County and you et five of 'em, goddamn ye. I sentence ye to be hanged until yer dead, dead, dead."

A loophole in the law forced another trial, which ended with the same verdict. Packer was sentenced to forty years in prison and was moved from the Gunnison jail, where he'd been selling autographed photos, to the state penitentiary at Canon City.

Thirteen years later, *The Denver Post*'s famous owners, Harry Tammen and Frederick Bonfils, decided that a Packer parole would give their readers something to sink their teeth into. Columnist Polly Pry preached his innocence and collected three hundred signatures on a petition. Lawyer W. W. Anderson tried to get in on the act, ending up wounding both Tammen and Bonfils with a .38 during an argument.

Packer was released from prison with a new suit and a train ticket to Denver on January 10, 1901, in Governor Charles Thomas's last official act. The cannibal of Slumgullion Pass walked into *The Denver Post* offices and thanked all who had worked on his behalf. History does not record whether a luncheon invitation was extended.

His final years were spent prospecting for copper in Littleton, living for a time in Sheridan, then moving to

Deer Creek Canyon for more prospecting. In Sheridan, he was a favorite of the children, plying them with candy and tales of life Out West. He died after a long illness on April 23, 1907, and was buried in Littleton.

Confusion over his first name has risen in recent times. Historians, his army discharge papers and checks, all newspaper accounts of the day, and his tombstone call him "Alfred." Some of his signatures read "Alferd." The signature on our photograph reads "Alford." Packer was illiterate, but some still insist that the "Alferd" spelling is correct. In the world of letters, as in Packer's winter of leftovers, there's just no accounting for taste.

BLACK BART

For two years, Wells Fargo Chief of Detectives James B. Hume had been on the trail of a nameless highwayman. Hume was considered tops in his field; he often could tell who had committed a stage robbery just by examining the scene of a crime. The biggest headache of his career was no ordinary criminal, though. Three California robberies had curious similarities: they were pulled off by a deep-voiced man in a Ku Klux Klan-type mask who never fired his shotgun or rode a horse.

A stage heist in the hills between Point Aremas and Duncan's Mills on August 3, 1877, had left an important clue: a note found in the empty green Wells Fargo box. Sitting in his San Francisco office, Hume eagerly unfolded the crumpled waybill and read silently:

> I've labored long and hard for bread
> For honor and for riches,
> But on my corns too long you've tred
> You fine haired sons of bitches.
> —Black Bart the Po8

The scrawled piece of sassy doggerel seemed to be in four disguised handwritings. The sentiment raised Hume's blood pressure to a point that worried his personal physician. At least now the demon had a name—Black Bart.

Newspapers picked up the story of the frustrated detective and the "Po8" robber and began to speculate openly where the "Shelley of the Shotguns" would strike again. Hume had his best men work on the case, but the culprit could not be found. A year passed.

The Quincy-to-Oroville stage made an unscheduled stop on July 28, 1878, when a masked gunman appeared from a clump of bushes, stopped the stage, and demanded, "Throw down the box!" That done, the bandit reached inside his duster, produced a small hatchet, and chopped his way in. After filling his pockets with $379 in cash, a watch, and a diamond ring, he deposited a poem. The third stanza read:

> Let come what will I'll try it on,
> My condition can't be worse;
> And if there's money in that box
> 'Tis munny in my purse!

At this slap, Wells Fargo, the state of California, and the U.S. Postal Service chipped in to put an $800 price

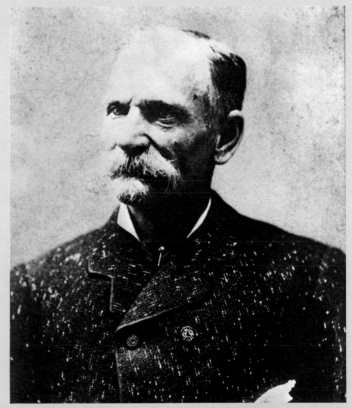

They couldn't photograph the "Po8" until they got him behind bars.

on Bart's head. But over the next five years he pulled off twenty-three more robberies that left the authorities baffled.

Black Bart usually robbed stages that carried bounty and no passengers, but in at least one instance a pretty traveler had to throw down her purse. Bart was most gentlemanly, returning the pocketbook unopened and commenting politely that he only wished to rob Wells Fargo and the mail.

Hume began to add things up: Bart used no horses, but he was a walker of the first degree; he once pulled back-to-back robberies in one day, thirty difficult miles apart. By interviewing ranchers, Hume found that on a few occasions a kind, witty old gent had stopped for dinner and coffee about the time robberies had occurred nearby. The stranger had deep-set eyes and a drooping mustache and could tell a fine joke.

On the cool Saturday morning of November 3, 1883, Nevada Stage Company driver Reason McConnell picked up nineteen-year-old Jimmy Rolleri for the run from Sonora to San Francisco; Jimmy hoped to shoot a jackrabbit with the rifle he'd brought along. As the stage pulled up a hill, Jimmy jumped off to walk through the woods, agreeing to meet McConnell on the downhill side. At the top of the incline, McConnell met Black Bart.

When McConnell informed him the box couldn't be thrown down (it was bolted to the floor and contained $550 in gold coins, $65 in gold dust, and $4,200 worth of amalgam), Bart ordered him to unhitch the horses and leave.

With Bart inside hacking away at the treasure, McConnell spotted Jimmy and the two returned to the coach. Jimmy's gun blazed away, Bart dropped his bag and hightailed his way through the underbrush.

Back in his office, Hume examined the contents of the bag with great interest. Besides crackers and sugar, it contained a handkerchief with the laundry mark of "F.X.0.7." A week later, a special operative, Harry Morse, found the appropriate record at the ninety-first laundry he visited in San Francisco.

The mark referred him to C. E. Bolton, resident of a hotel at 37 Second Street. According to Morse, Bart "was elegantly dressed, carrying a little cane. He wore a natty little derby hat, a diamond pin, a large diamond ring . . . and a heavy gold watch and chain."

Biographical details remain scant. Born Charles E. Boles around 1830 in New York, he'd served in the 116th Illinois Volunteer Infantry and left a wife behind in Hannibal, Missouri, when he went to seek his fortune Out West. He may have taught school in California but tired of the academic life and perfected a way to rob stage coaches. A frequenter of the police and Fargo agents' favorite coffeehouse, he always knew when the richest shipments went out.

Hume made a deal in which Bart would confess only to the last robbery and receive a light sentence. After four and a half years in San Quentin, he walked out and was never heard from again. Rumors that Wells Fargo kept him on the payroll to keep him from old practices were most likely unfounded, according to Bart historian Joseph Henry Jackson. For a while, nearly every unsolved robbery was laid at the feet of the gracious, poor-spelling bandit.

A fitting epitaph came when a piece of rhyme surfaced, attributed to the Po8:

> So blame me not for what I've done
> I don't desrve your curses,
> And if for any cause I'm hung,
> Let it be for my verses.

ROBERT FORD

That dirty little coward, who shot Mr. Howard,
laid poor Jesse in his grave.

It was the song Robert Ford hated the most. He had rid the West of the most feared outlaw who'd ever ridden and what did it get him? A reputation for being the most vibrant shade of yellow. He was a marked man. But there's a slim chance that the world might have been wrong about Bob Ford, that instead of a coward he might have been one of the bravest men around.

At thirty-four, Jesse Woodson James had progressed from mere thug to popular legend. By the spring of 1882, tales of the American Robin Hood, both fact and hogwash, abounded. Folks spoke of him and his brother Frank as swashbucklers who fought the evil railroad, always sticking up for the little guy. The fact that Jesse probably had murdered upwards of sixteen men and had lined his pockets with over a quarter of a million dollars in the process didn't seem to matter.

Time was running out for Jesse, however. A $10,000 price on his head had made life very complicated, considering the company he kept. According to legend, he was ready to pull one more job before retiring and hired the Ford brothers to help.

Evidence indicates a liaison between Bob Ford and Thomas Crittenden, the governor of Missouri (where Jesse hung out), and that Crittenden pulled the rug on Jesse. It seems the governor thought he was bad for business.

To plan Jesse's last hurrah, the Fords were guests for a few days in the Thomas Howard household outside St. Joseph, Missouri. Howard, of course, was Jesse's alias. On the morning of April 3, 1882, Jesse noticed that either a picture of Stonewall Jackson or a "God Bless This Home" sampler (historians disagree) needed dusting. He took off his gunbelt for the first time in twenty years, climbed up onto a chair, and, according to most accounts, stepped into history. A single shot entered the back of his brain.

Twenty-one-year-old Bob Ford surrendered to local authorities, and his story made the sort of headlines that hadn't been seen since the assassination of President Garfield the year before. Ford was tried for murder, convicted, and pardoned immediately by Crittenden.

The man who shot Jesse James might have thought he would be hailed as a hero. But the code of the West held

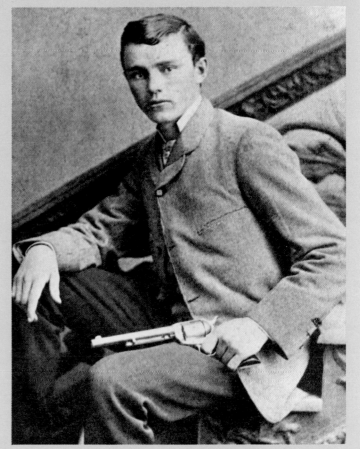

The "dirty little coward," c. 1884, with the gun that may or may not have killed Jesse James.

strong. The Fords were portrayed as cowardly assassins and Crittenden was criticized for assuming the roles of judge and jury. As for the reward, records show the Fords may have received as little as $500 apiece, with Crittenden and others getting the lion's share.

Ford toured the West in a production called *How I Killed Jesse James* but was nearly lynched in more than one city. Whenever he was low on funds, he'd sell one of several versions of "the gun that shot Jesse James." Bob eventually set up a saloon in booming Jimtown, Colorado, which later became Creede. The populace wasn't overjoyed to have him living among them, but whiskey was whiskey and there was ore to be dug.

His destiny came in the form of an ex-lawman from Pueblo named Ed O'Kelley. Some say the two never liked each other, others claim the idea was planted. Whatever the motive, Ed walked into Ford's tent establishment early on June 8, 1892, said "Hello Bob!" and discharged two sawed-off shotgun barrels five feet from Ford's throat.

O'Kelley was tried and convicted of murder. He was paroled in 1902 but was killed two years later in a scuffle with Oklahoma City police. Thankfully, history does not record the name of the man who shot the man who shot Jesse James.

In 1948, Jesse James authority Rudy Turilli traveled to Lawton, Oklahoma, to debunk the story of a hundred-year-old man, J. Frank Dalton, who claimed to be Jesse James. Turilli was astounded by the old man's appearance and his ability to recall intimate details. Two of Jesse's centenarian cronies swore that Dalton was Jesse. The *Police Gazette* produced Pinkerton files of the scars on Jesse's body, and medical examiners found them all on Dalton.

Turilli further discovered that Bob Ford was a first cousin of Jesse, in a very close family. A spectator at the 1882 funeral quoted Frank James as saying, "If Bob Ford had shot Jesse, he wouldn't have lived till sundown." Some stories indicate that Frank loaned Bob money to start his club Out West.

Was Jesse's murder faked? He supposedly sang in disguise at his own funeral, then headed for South America. Dalton died in 1951, just short of his 104th birthday.

There is no proof that Bob Ford didn't kill Jesse James, but an impersonation scheme definitely was in character; Jesse, who was tired of running, never would have just "laid his guns down." If the final episode was a hoax, "that dirty little coward" Bob Ford might have been one of the West's bravest men, putting himself on the line so that his notorious cousin might live in peace.

JAMES REAVIS

James Addison Reavis first discovered his devious talent as an eighteen-year-old Confederate soldier. With a little practice, he was able to duplicate his commanding officer's signature, thus ensuring himself long furloughs.

When the going got tough, Reavis got going. The skill would come in handy later in life when this seasoned forger nearly pulled off one of the strangest schemes in American history. With a stack of "ancient" documents, Reavis laid claim to a huge chunk of land Out West.

After the Civil War, Reavis returned to his native St. Louis, where he became a conductor on a mule-driven streetcar. From there, he got into real estate. If a property title was unclear, he could make the necessary "alterations" and the problem was solved.

In 1872, George M. Willing came seeking assistance. Willing had purchased a series of yellowed parchments in 1864 from a Mexican, Miguel Peralta, for $1,000. The documents supposedly contained a 1748 land grant from the king of Spain to an ancestor of Peralta. The "Peralta Grant" was a great rectangle extending through the heart of Arizona and into New Mexico. Its dimensions were 75 miles north and south, 235 miles east and west. It included the city of Phoenix, the Salt River Valley, and the rich Silver King mine. Here were 7,500 square miles of land, some 12 million acres, valued at $250 million.

The only problem was that it was not worth the paper it was written on. To Reavis, of course, this was a minor setback, as he prepared a twenty-year plot to make the document jibe with history and to make him the true heir—the future Baron of Arizona.

Under the terms of the 1848 Treaty of Guadalupe Hidalgo and the 1853 Gadsden Purchase, the United States had agreed to recognize all former titles in the new territories. This was the crux of Reavis's plot. Bit

by bit, he fit the pieces into his phony jigsaw puzzle.

Reavis began to tutor himself in Spanish—specifically, the way it was written two hundred years ago. Completing his education, he left for California and got a job at the *San Francisco Examiner*. While there, he learned that Willing had died in Arizona the day after recording his deed in Prescott. Reavis took the first stagecoach to Arizona. Upon arrival, he claimed the belongings of the deceased, saying that he had purchased them all for $30,000. Willing's widow later recalled the amount to be closer to $600. Nevertheless, the wheels were turning. It would be much easier now for the secret to be kept.

Working in the interests of journalism (or at least that's what he told the monks in charge of ancient Spanish records), Reavis began to thumb through the dusty files at his leisure in Arizona, New Mexico, Mexico, and Spain. With an incredible eye for detail, Reavis made changes here and there, sometimes removing whole sheets and replacing them with his fiction. One scroll was forty feet long.

His story was a whale of a tale. Altering birth records, Reavis fabricated the ancestry of one Don Miguel de Peralta de la Córdoba, Baron de Arizonac and Caballero de los Colorados, Gentleman of the King's Bedchamber, Grandee of Spain, Knight of the Military Order of the Golden Fleece, etc. Some one hundred thousand Spanish words recounted this false branch on the family tree. The next problem for Reavis was producing a living heir to the Peralta fortune. But this was no big deal.

Reavis chose a teenage waif with an untraceable heritage. Some have said she was working as a maid for famous rancher John Slaughter, but others have discounted this tidbit. He adopted her as his ward and had her raised in a California convent. He filled her with stories of her spurious lineage. At the appropriate time, the renamed Doña Sophia Micaela Maso Reavis y Peralta de la Córdoba became his bride. In August 1877, the Baron of Arizona arrived by carriage in Tucson to lay claim to the massive Peralta Grant.

The territory went into an uproar. Who was this guy, anyway? All of a sudden, the baron was the prime topic of conversation. Already, he was posting placards in Phoenix, to "all persons now situate on La Baronia de Arisonac" that it was time to deal with the property's rightful owner. The best attorneys examined the evidence and advised their clients to settle as cheaply as possible.

The money rolled in. The Southern Pacific Railroad coughed up $50,000 for right-of-way. Silver millionaire

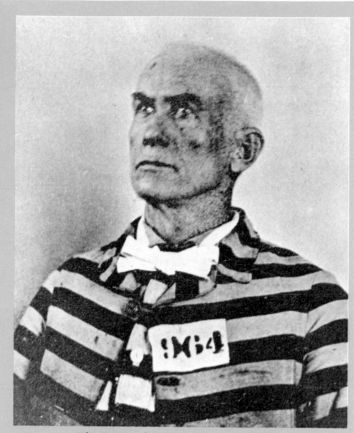

The Baron of Arizona in exile, c. 1895.

H. A. W. Tabor made a down payment of $25,000. Homesteaders lined up to have their titles validated at a fair market price. Uncle Sam had a plan in the works to let the citizens of the Peralta empire off the hook with a lump payment of $25 million.

A special attorney for the Court of Private Land Claims was suspicious. He hired a Mexican-born, New York attorney, Severo Mallet-Prevost, an urbane perfectionist, as a bloodhound. In San Bernadino, in Guadalajara, even in Spain, Mallet-Prevost uncovered the dastardly deeds. With chemicals, he could tell the originals had been written in iron ink, the substitutes in dogwood ink. Before long, Don James Addison de Peralta-Reavis was jailed.

Reavis was convicted in January 1895 and sentenced to six years in the Santa Fe prison. The baroness, shattered by the findings, divorced him and moved with her two sons to Denver, where they lived in poverty on Larimer Street. Convict No. 964 served his time, then published a written confession in several newspapers. When he died in Denver in 1914, destitute and broken, few remembered the circumstances behind the high times of the West's greatest impostor.

THE DALTON GANG

The corpses of Bob and Grat Dalton are displayed shortly after their botched raid on Coffeyville.

The Dalton Gang was a group of range thugs that usually included the three worst sons of Adeline Dalton's fifteen children. Their heads filled with childhood tales of the Youngers (distant relations) and the James Gang, Bob, Grat, and Emmett Dalton saw their drift toward crime as a natural progression. They were brave, mean, and had the ability to ride and shoot. They showed a remarkable lack of wit, however, a fact that would be painfully evident in their downfall—the result of one of the dumbest stunts ever attempted Out West.

The boys in question were the sons of hard-drinking Lewis Dalton, who, when not fathering children, was

moving about Indian Territory and Kansas in search of elusive riches. Son Grattan was born in 1861 in Lawrence, Kansas; he was followed by Robert and Emmett soon after, as well as brothers Frank and Bill. Frank, "the good Dalton," died battling bootleggers in 1887 in the service of "hanging judge" Isaac Parker. Bill dabbled in California politics before being ruined by fraternal association. Ultimately he was killed by Oklahoma police in 1894.

Both Grat and Bob tried to make it as lawmen, but the work was strenuous, and it was easier for them to collect illegal fines from sooners (pioneers who tried to claim land in Indian Territory), giving those settlers unexpected welcomes to the new country. Bob even used the authority of his badge to justify the murder of a rival.

The Dalton Gang coalesced in the summer of 1890. While Grat vacationed in California, Bob, Emmett, and three saddle tramps robbed a Mexican gambling hall near Santa Rosa, New Mexico. A series of train robberies were next, producing only modest returns. Brother Bill joined them for a while, until talk of hitting Coffeyville, Kansas, the last home of Lewis Dalton, caused him and another group member, Bill Doolin, to form their own splinter gang.

For calculating Bob, simple Grat, and young Emmett, Coffeyville seemed the topping on the cake. No one had ever tried to knock over two banks at the same time, yet there they sat, the First National and the C.M. Condon, right across the street from one another. No guards were employed by either bank in the sleepy town of thirty-five hundred people. It was decided that a family reunion would be held at the commencement of business on October 5, 1892.

Just after 9:00 A.M. on that day, the five best-dressed men in Coffeyville rode into town wearing silly theatrical whiskers. The farm folks figured them to be lawmen from parts unknown and proceeded with their work. Whether authorities were tipped off in advance has been a matter of historical conjecture. What is known is that when the gang tied their horses at the end of an alley (farther from the banks than they wanted because of road construction), the word was out. Hardware-store owners began passing out rifles, shotguns, and ammunition. The boys were back in town. The Battle of Coffeyville was about to begin.

Bob and Emmett burst into the First National Bank, cursing and ordering grain sacks to be filled with cash. A banker told the two that the vault could not be opened until a certain time; Bob informed him that the time was now. After withdrawing some $21,000, the boys were fired upon from the street as they tried to leave. Bob moved back inside and cooly fired into the square. Guns answered from every direction. The Daltons ordered the back door open and ducked down the alleyway. On the way, they killed three armed citizens who stood in their path.

Bob and Emmett were laughing by the time they reached their horses, but not for long. There was no sign of Grat or the other two. They should have been waiting for them. What could have happened?

In the Condon, poor, dumb Grat had been told the safe was on a time lock, so he sat back to wait patiently. When shots started ripping through the windows, he asked for the back door and was told there wasn't any. At that, he and the other two from the gang decided to make a break into the street, which was, by now, swarming with God-fearing, gun-toting townsfolk. As the lead flew from every direction, Bill Powers was shot dead. Dick Broadwell found his horse, but was wounded and died on the outskirts of town. Grat was hit twice, but managed to blast Town Marshal Charlie Connelly out of existence.

Now the three Daltons were pinned down in what soon would be known as Death Alley. Bob stepped out to check the rooftop gunfire and was shot squarely through the chest. Grat turned and took a fatal shot to the throat. Emmett reached his horse after being shot in the arm and groin. Rather than escape, he spurred Red Buck back into the war zone to save his dying brother in the one heroic act of the day. "It's no use," called Bob before he died. Just then, Emmett felt two shotgun rounds empty into his back.

In twelve furious minutes, the Dalton Gang had been broken up. Over eighty bullet holes were counted in the walls of the Condon. Broadwell's corpse was brought back into town to be displayed as a hideous centerpiece for the town's macabre street festival. Trainloads of curiosity seekers arrived to tear pieces of clothing from the bodies and mock the dead.

Emmett survived over twenty bullet wounds and a town eager to lynch. He served fourteen and a half years of a life sentence, obtained parole, then married and went to Hollywood. There, he dabbled in the movies and in construction.

In 1931, Emmett returned to clear the weeds from the graves of his brothers. "The biggest fool on earth is the one who thinks he can beat the law, that crime can be made to pay," he said. "That's the one big lesson of the Coffeyville raid." With that, Emmett got behind the wheel of his sedan and rode off into the sunset.

BUTCH CASSIDY
AND THE
SUNDANCE KID

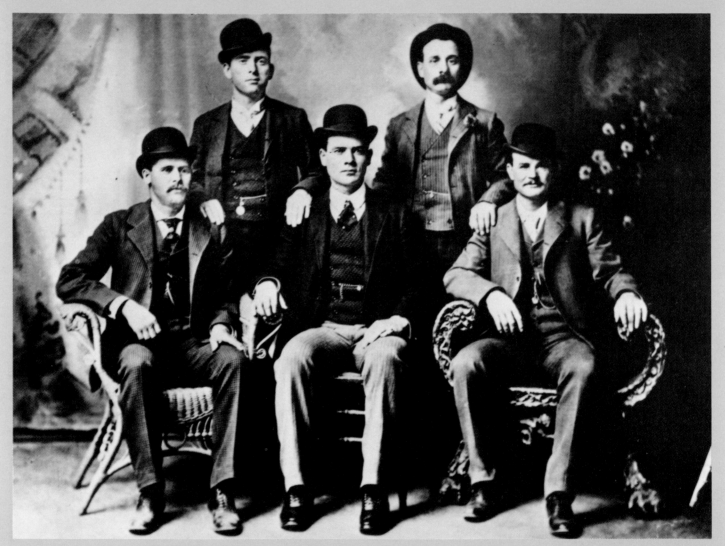

The Wild Bunch poses in Fort Worth, Texas, in 1901. From left: The Sundance Kid, Will Carver, Ben Kilpatrick, Harvey Logan, and Butch Cassidy.

Robert Leroy Parker and Harry Longabaugh came from regions as diverse as their spirits. Parker, whose parents were pioneer ranchers, was born on Friday, the thirteenth of April 1866, in Beaver, Utah. Longabaugh was born in Phoenixville, Pennsylvania, in 1870, to a family of ranchers. By the time the two met Out West

several years later, they were already known as Butch Cassidy and the Sundance Kid.

Butch took his name from two different sources. "Cassidy" came from a childhood idol, a local outlaw by the name of Mike Cassidy who took a shine to the young Parker and showed him all he knew: how to shoot, how

to ride, how to "relocate" livestock for fun and profit. "Butch" came from Parker's brief stint as a butcher in Rock Springs, Wyoming.

Longabaugh arrived in the West at the age of sixteen. A year later he was arrested for stealing a horse and pistol. The gun charge was dropped, but that $80 horse was a serious matter, and Harry was sentenced to eighteen months hard labor at the Crook County Jail in Sundance, Wyoming. Paroled on February 4, 1889, he headed straight for the badlands of Hole-in-the-Wall country in central Wyoming. One of the fastest, most accurate shots ever seen in those parts, he was a wanted man again as of May 18, this time for threatening to blow a man to kingdom come.

So much for the names. The fame is a different matter, one that Western historians still quibble over. Even William Goldman, the screenwriter who would immortalize the pair in the smash 1969 motion picture, started his story with: "Not that it matters, but most of what follows is true."

Horse thieving was not supporting Butch in the manner he would have liked, so he formally changed careers on June 24, 1889, when he and two cohorts robbed the San Miguel Bank in Telluride, Colorado, getting away with $20,750. Butch hid out in Wyoming after the caper and later was arrested on a holdover rustling charge. In January 1896, he was pardoned by Governor William Richards after promising to "leave Wyoming alone."

Shortly after, Butch met up with some old professional acquaintances known as the Hole-in-the-Wall Gang. Arguments in the group had caused several members, among them the Sundance Kid, to search for greener pastures, so they joined Butch and became known as the Wild Bunch.

Business blossomed for the new franchise. On April 21, 1897, in Castle Gate, Utah, Butch shoved a Colt .45 in the face of the Pleasant Valley Coal Company paymaster and made off with nearly $9,000. Rail robbery followed, and it proved most profitable. It also gave Butch a chance to experiment with dynamite to gain access to Union Pacific Railroad safes—with mixed results.

On June 2, 1899, at Wilcox, Wyoming, the Wild Bunch stopped a train, and a guard, C. E. Woodcock, refused to open the baggage-car door. The Wild Bunch promptly blew it off. Butch had used too much of his new toy and blew $60,000 in cash high into the Western sky. The gang managed to scrape up much of it before riding on.

Another $70,000 was garnered in Folsom, New Mexico, later that summer, but accounts disagree about whether Butch and the Sundance Kid were there. They definitely were present in Tipton, Wyoming, on August 29, 1900, when they built a fire on the track and again encountered Woodcock. C. E. was much more agreeable this time, and another $55,000 was collected.

Following this robbery, things began to get warm for the Wild Bunch. A posse was organized and the Union Pacific declared that the raids must cease once and for all.

The constant running began to wear on the gang. In February 1901, the Sundance Kid and his truelove, schoolmarm Etta Place, met Cassidy in New York for a break. After flashing their bundle of cash around Tiffany's, they made plans for a long-discussed change of scene. They reasoned the banks in South America would be easy pickings. Etta and the Sundance Kid took a slow boat to Argentina, and Butch joined them after one last visit to the West to accrue some capital.

The story then gets muddy. Holdups by the *Banditos Yanqui* are documented in Argentina, Bolivia, Chile, and Peru. Evidence also shows the pair were successful ranchers from 1903 to 1906. The most popular conclusion has it that they robbed the Aramayo Silver Mine in early 1909, then rode into the little town of San Vincente, Bolivia. After a leisurely lunch, they found themselves surrounded by a Bolivian cavalry unit. In a fierce battle, the Sundance Kid was seriously wounded. Not wanting either of them to be taken alive, Butch supposedly put the Sundance Kid out of his misery, then took his own life.

Reports that the two escaped and returned to the States have persisted over the years. According to Butch's sister, Lula Parker Betenson: "Seeing is believing. He came home in 1925." (Lula also met Paul Newman on the film's set. When he asked her if he looked like Butch, Lula said, "Yes, but Butch was better looking.")

Author Larry Pointer's *In Search of Butch Cassidy* reports that old Wyoming friends were surprised when Butch visited them in the summer of 1935 under the alias of William Phillips of Spokane, Washington.

The son of the Sundance Kid, Harry Thayne Longabaugh, said he visited his father in 1940 in Spokane, that the Sundance Kid died in 1957 aged ninety-eight, and that he is buried in Casper, Wyoming, under the name Harry Long. (That story conflicts with his documented birthday. Also, several historians have doubted the ancestry of young Longabaugh.)

But we cannot doubt that Butch Cassidy and the Sundance Kid kept things exciting in the twilight of the Old West. However they made their getaway, they gave history the slip.

TOM HORN

Do you know how raggedy-ass and terrible the Old West really was?—Steve McQueen in *Tom Horn*

Tom Horn awaits the final sentence in his Cheyenne jail cell.

Murder was a way of life for the notorious Tom Horn. His reputation as a scout, top ranch hand, and hired gun preceded his arrival in Wyoming in 1894. He had come to put down the dreaded cattle and horse rustlers. His way was simple, his justice complete. The times were closing in on his way of doing business, though; the rope

that hanged Tom Horn also drew the curtain on the Old West.

Born on a farm near Memphis, Missouri, on November 21, 1860, Horn learned to hunt and shoot accurately at an early age. Following a bullwhip beating by his father that left him unconscious, the boy fled home for Kansas City at fifteen. There he found work as a railroad laborer. Over the next few months he cowboyed in Texas, drove a stagecoach in Arizona, and mined in Leadville, Colorado.

Drifting south, he learned to speak fluent Apache and soon got a job as an interpreter at the San Carlos Indian Reservation. In his autobiography, Horn claims to have arranged the surrender of Geronimo to General Nelson A. Miles in 1886. This was his first step to notoriety.

The surrender led to Horn's lack of employment as an Apache scout, and he was forced to go from one odd job to another, sometimes participating in rodeos—he won a steer-roping event in Phoenix in 1891—to supplement his income.

Horn turned down a request to join *Buffalo Bill's Wild West* show. He preferred a job as a Pinkerton agent. Chasing badmen proved a worthy vocation for the prairie-wise Horn, and he held this position from 1890 to 1894. His next big assignment came as a mule packer in Cuba in the Spanish–American War. Three weeks after his arrival he contracted malaria, however, and was shipped home without having fired a shot.

Following his recovery in New York City, Horn decided to head Out West. A series of secret meetings with wealthy members of the Wyoming Cattlemen's Association promised to make him a rich man—or at the least better off than he could become cowpunching. Nesters, squatters, and rustlers were a dangerous hindrance to the stockmen, and Horn's bloody assignment was made absolutely clear during these meetings.

To the trespassers and thieves, Horn was a ruthless combination of judge, jury, and executioner. Placing himself a great distance from his victim and using a scope on his carbine, he could send a rustler to kingdom come at a distance of three hundred yards. He had an invoice ($600) and a trademark: he placed a rock under the head of each victim. Horn's mere presence in an area soon caused a sharp decline in thieving.

Kels Nickell, a disagreeable cuss who'd done the unforgivable by bringing his sheep to feed in cattle country, was one of Horn's marked men. On the morning of July 18, 1901, Kels's fourteen-year-old son, Willie, put on his father's coat and hat to do some work in their pasture, located in the Iron Mountain district of southern Wyoming. The first shot hit the boy as he dismounted to open a gate. Staggering to seek shelter from the ambush, he was finished off by another blast from a Winchester .30–.30. He was found with his head resting on a cold stone pillow.

Local folks were sickened by the cold-blooded deed, though speculation had it that Horn might have been framed. Deputy U.S. Marshal Joseph LeFors began snooping around while the prime suspect proceeded with everyday life, even competing in the Cheyenne Frontier Days rodeo. Horn celebrated with his winnings in Denver.

LeFors lured Horn back to Cheyenne, promising that some Montana ranchers had a job for a pest exterminator. On January 12, 1902, the two met, presumably to discuss Horn's resume. During the conversation, Horn boasted about the clean job he'd done in the Nickell assassination: "Killing men is my specialty. I look at it as a business proposition, and I think I have a corner on this market."

Horn was arrested the next morning by Sheriff Edward J. Smalley. While the prisoner awaited trial, he braided ropes and worked on his autobiography. On the witness stand, LeFors recounted the "confession," and on October 24, 1902, despite the efforts of a $500,000, anonymously funded legal team, Horn was found guilty.

Appeals kept Horn from being "jerked to Jesus," as one editor put it, but after eighteen captive months he wrote, "To hell with my lawyers, I must get out of here, or I will be hung." His escape attempt was aborted when he couldn't release his stolen pistol's safety mechanism.

As a team of carpenters arrived to build a specially designed scaffold with a trap door that could be released by flowing water—no one would agree to serve as executioner—cattleman John Coble and Horn's girlfriend, schoolteacher Glendolene Kimmel, pleaded with the unsympathetic governor. Horn remained steadfast and silent, refusing to name his employers. Meanwhile, Cheyenne was like a circus as it got ready for the hanging.

On the morning of November 20, 1903, Tom Horn stood strapped and noosed, trying to wisecrack while listening to the trickling water. After a cruel forty-seven seconds he dropped. His neck did not snap, but the knot on the rope knocked him unconscious. Sixteen minutes later he was pronounced dead.

One of his brothers laid him to rest in Boulder, Colorado, but the controversy over his entrapment never died. Tom Horn remains an enigma, an enforcer who failed to change with the times.

*Orville Harrington displays his modus
operandi for a photographer from
The Denver Post the day after his arrest.*

At age forty-three, Orville Harrington was dissatisfied with his lot in life. His wooden leg had kept him from pursuing his goal to be a mining engineer. Instead, he had a routine job in a refinery, earning a meager four dollars a day. However, Orville had a plan to turn it all around. He would use his reputation as a trusted worker to his advantage in a diabolical scheme to rob the U. S. Mint in Denver.

Orville's bad luck had started at a tender age. At eleven, he was shot in the leg during a hunting accident. His sciatic nerve was severely damaged. In attempts to alleviate the pain, his toes, then his foot, and finally his right leg below the knee were amputated. Overcoming the handicap, he graduated from the Colorado School of Mines in 1898 with an engineering degree.

During a 1903 hospital stay, he fell in love with his nurse, Lydia Melton, and later married her. He was employed for a brief stint with the Colorado Fuel and Iron Company. In 1909, he went to work at the Mint, then left for Cuba around 1916 to supervise a copper-mining project, later calling it "a good job I was forced to leave on account of my leg."

In September 1919 he returned to the Mint. Life had progressed for the Harringtons; they had a four-year-old daughter, a five-month-old son, a home, and ten lots of land at 1485 South University. Orville loved spending time with his fruit trees. It would be another crop that would be his undoing.

Harrington had a plan for quick advancement. As a minor foreman in the Mint's gold and silver refinery, working from 3:45 P.M. to 11:45 P.M., he was surrounded each night by $5 million in shiny, gold bullion. It came in all shapes and sizes, but the most convenient was the twelve-pound bar.

On the night of September 2, Orville lifted his right trouser leg and slipped one of the gold bars through an opening in his hollow prosthesis. It fell to his shoe with a clunk, and Harrington was thrilled. That night, he limped casually past the security guard, caught the trolley at Fifteenth and Court, and smiled all the way home.

The scheme would be a complete secret. Lydia could never know the sinister proceedings. He would pay himself a daily bonus of pure gold up to a certain point, then quietly resign from the Mint. They would hate to see such a valued employee leave, but they would respect his wishes to proceed with his engineering career. Orville would then lease a mine in the mountains, melt

down his precious stash, and say he had struck it rich Out West.

And so, every night, before punching his time card, Orville Harrington swiped another gold bar. His collection was quite sizable by January, the same month U. S. Mint Superintendent Thomas Annear held a secret meeting with Denver Chief of Secret Service Rowland K. Goddard. Annear was furious; someone was stealing Uncle Sam's gold right out from under him.

Goddard immediately placed the fifteen refinery workers under surveillance. That list was soon narrowed to three employees, including you-know-who. One winter afternoon, too early for spring planting, two Secret Service operatives watched South University's greenest thumb do the unthinkable. With shovel in hand, Orville Harrington ambled outside and buried a gold bar beneath the sidewalk.

Now the authorities knew who was going for the gold, they just didn't know how he was getting it. Goddard never caught on, though one employee informed him that he had seen Orville slip a bar off a desk, then return it nervously, as if he had been noticed.

Finally, on the evening of February 4, 1920, Goddard decided to terminate the employment of the Mint's highest-paid staff member. He followed Harrington to the trolley stop. The two men spoke briefly, then when Goddard revealed his ties to the Secret Service, according to *The Denver Post*, "Harrington fairly crumpled. A grunt fell from his lips, as from a man shot."

They returned to the mint and Goddard formally accused Harrington. At that point the suspect hoisted his pant leg and produced his latest trophy.

Lydia was shocked when her husband arrived home later than usual, flanked by Goddard and another agent. Tears were running down Orville's cheeks. He was wearing handcuffs. Downstairs, behind a fake wall, and in the backyard, the feds found over fifty gold bars, worth roughly $80,000. Before the sun came up the gold was back at the Mint and Orville Harrington was behind a different kind of bars.

Headlines of the Midas thief who lost his touch filled the early editions of the Denver papers. The only good news Orville got that day was that his son's pneumonia seemed to be better. Lydia was interviewed, complaining that "Orville's leg dragged us down always."

On May 12, 1920, "the man with the golden leg" pleaded guilty to embezzlement charges, as Judge Robert E. Lewis noted that the stack of bullion was "the greatest quantity of gold ever placed in evidence in court in the United States." For his case of sticky fingers, Orville received ten years in Leavenworth.

Harrington won parole after three and a half years in the pen, returned to Denver, and did not try to get his old job back. Instead, he worked for a construction company on a paving project. Soon after, he deserted his family for business opportunities in Arizona, and reportedly died years later at the home of his sister in New York.

Today, security is much tighter at the U.S. Mint in Denver. The celebrated diggings of Orville Harrington are no more; a Korean church now stands in his garden. Crime did not pay for Orville, leaving him with the reputation of a dishonest flunky who failed to get a leg up in the world.

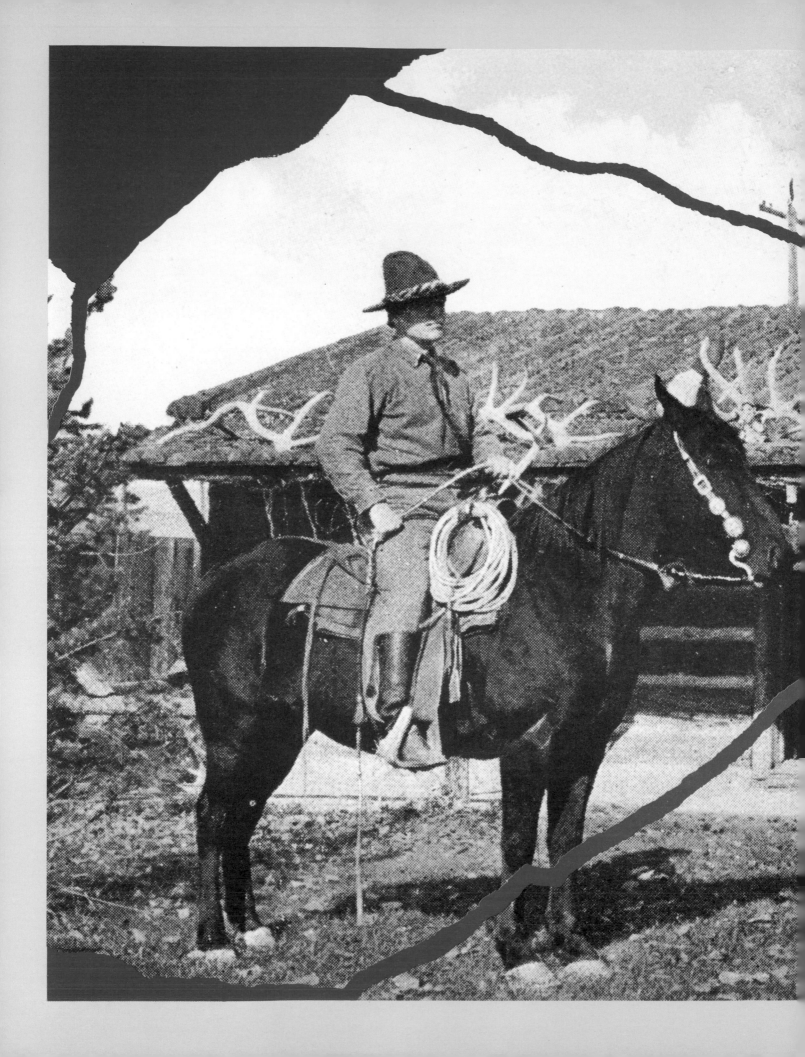

FROM OUT
OF THE
WEST

LEVI STRAUSS

The founder of the denim empire, c. 1880.

The world seemed full of opportunity to the wide-eyed, seventeen-year-old Bavarian immigrant as he stepped off the boat in New York City in 1847. Though he spoke little English, Levi Strauss was the optimistic type. He had come to America to seek his fortune, and he would work for his two older brothers as a peddler of fabric and housewares until he discovered his niche.

The following year, some shiny sprinkles were discovered at Sutter's Mill in California, and a wave of gold fever hit the country. In 1850, San Francisco boasted a population of twenty-five thousand, and would grow to fifty thousand three years later. Young Strauss sensed the action and recognized his calling: he would make a fortune selling tent canvas to the miners. Immediately, he booked a passage on a clipper ship to make the long journey around the tip of South America. Arriving in San Francisco with bolts of his brother's finest stock, the young entrepreneur set out to corner the tent market.

There was one slight problem: everyone already had a tent. "Should have brought pants," one crusty prospector said. "Pants don't wear worth a hoot up in the diggin's."

So it was that in 1853, Levi took his unsold canvas to a tailor and told him to fashion a pair of pants. Word spread quickly among the miners that "those pants of Levi's" were damn near indestructible, and they were an immediate hit. Levi smelled gold in them there slacks. Setting up shop on Sacramento Street, the newly successful Mr. Strauss began mass producing his "waist high overalls."

The next major development was a fabric switch in the 1860s. Strauss began importing from Nimes, France, a tough cotton cloth known as *Serge de Nimes*. Strauss's company dyed this new material, nicknamed "denim," a deep indigo, then stitched it into pants. The product was guaranteed to "shrink, wrinkle, and fade." Miners could assure themselves a perfect fit by donning a pair and jumping into a trough of cold water. Then they'd sit in the hot sun, letting the britches "shrink to fit." It was the birth of the blue jean; Strauss dropped the canvas trousers altogether in the 1870s.

The year 1873 saw another important addition to the miners' favorite garment. A tailor in Nevada named Jacob Davis came up with the idea of repairing ripped pockets by studding the stress points with tiny copper rivets. With the help of the town druggist, Davis sent a letter to the gents at the Levi Strauss Company, and a beautiful friendship was born. Patented under both names (Davis and Strauss), the rivets soon appeared on all Levi's 501 Double X overalls, at the pockets and on the crotch. There was a slight problem with the latter innovation, as we'll see later.

Strauss also introduced in 1873 a stitched double arc on his back pockets, calling it an "arcuate" design. This would set his blue jean apart from the competitors'.

Strauss never married, but he lived well and spent a lot of time with his nephews and their families. Known for his philanthropic efforts, he provided twenty-eight scholarships to the University of California at Berkeley in 1897. When he died in 1902, the *San Francisco Call* devoted a large picture and three columns to his obituary, and he left a $6 million estate to his four nephews.

The Levi Strauss Company prospered after Strauss's death. The factory was destroyed in the great earthquake of 1906, but all 350 employees continued to draw salaries while temporary quarters were set up across the bay in Oakland. A new plant soon opened.

In the late 1920s, Walter Haas, Sr., who had married a daughter of one of Strauss's nephews, took over the helm of the company. The Great Depression followed shortly thereafter, but jean production continued and no one was laid off, though inventory was piled to the ceiling—even in the men's room.

Then, luckily, dude ranches began springing up in the West, and Easterners started to take home Levi's, introducing them to the other side of the Mississippi for the first time.

It was Haas who found out about that problem with the rivets. More than one cowboy had been a victim of "hot rivet syndrome." If you squatted too close to a campfire, the copper rivet in the crotch became a terrific conductor of heat. Camping in the High Sierras in 1933, Haas found himself hopping and screaming after staying a little too long at the fire. When he asked professional wranglers if they'd ever had the problem, they just smiled. Returning to San Francisco, Haas signed an order, and the crotch rivet went the way of the dodo.

The basic Levi's design has changed little since the Gold Rush days. The government decided that the stitched arcuate design was unnecessary during the austere days of World War II and ordered them to be painted. (Indians in Arizona suspected the painted arcs were fake Levi's, and promptly returned their allotments.) The 1950s saw this country's first rock 'n' rollers adopt the blue jean as a mandatory part of their dress code, followed by the counterculturists of the 1960s.

Today, the Levi Strauss Company shows yearly sales of $2.5 billion, employs forty-eight thousand workers, and ranks high in the "*Forbes* 500." Plants are located around the world, manufacturing more than just blue jeans. A pair of original "501s" can be seen in the Smithsonian Institution, an honor that would have made patriotic Levi Strauss quite proud. Whether you go Back East, Down South, Up North, Out West, or anywhere else on this planet, you'll see people in blue denim, a fact *New Yorker* writer John Brooks called "an event without precedent in the history of human attire." This jean not only won the West, it won the world.

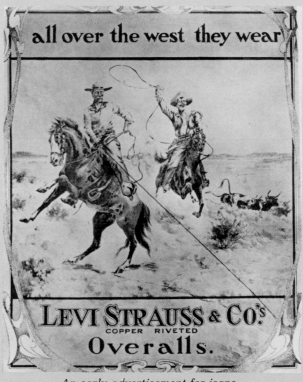

An early advertisement for jeans.

MATTIE SILKS

The notorious madam in retirement at her North Denver stables.

In 1866, the year following the bloody Civil War, Springfield, Illinois, was as hectic and wild a city as this country had ever seen. It was there, in this year of both crushed dreams and high hopes, that one Martha A. Silks began her business career at the tender age of nineteen. She was a young executive in the world's oldest profession.

Officially, her establishment was called a "boardinghouse for young ladies," but the hours of operation and the stories that emerged left no doubt in anyone's mind what went on there: Mattie Silks had love for sale.

What is known about Mattie is a collection of tales, mostly wild, about the plumpish blonde who always managed to organize the best little whorehouse in whatever frontier town she happened to inhabit. Usually setting up shop in the summertime and vacationing in the winter, she moved from Springfield to Olathe, Kansas, and from there to Abilene, Kansas. Unlike most of her

competitors, who operated under discreet red lamps, Mattie always hung signs. At one Kansas brothel, the marquee read "Men Taken In And Done For." To weary wranglers, those were the sexiest six words Out West.

While in Abilene, the story goes, Mattie was taught to shoot by the city's trigger-happy sheriff, Wild Bill Hickok. Next, she moved to Hays City, Kansas, where she again encountered Hickok and other luminaries of the day. More than one customer made his way from Tommy Drum's saloon, a popular spot for celebrities like General George Armstrong Custer and Buffalo Bill Cody, to Mattie's commercial passion pit, where the sign said "General Outfitting."

Mattie found the love of her life at a Chicago footrace. In her time, it was common to arrange a friendly race for fun and profit. These affairs were well attended, providing a reason to socialize and gamble. Mattie bet on a swift, fair-haired Texas scoundrel, Cortez ("Cort") Thomson. She won the bet and the man.

The next site in line for Madame Silks's brand of entertainment was the booming community of Georgetown, Colorado. Here, she may have been married on a common-law basis to a professional gambler named George W. Silks, although she already had her last name by the time she met him. (One story is that she borrowed the name of her favorite adornment; another is that she'd been married to one Casey Silks during her early professional days.) The facts are fuzzy; we do know that Cort lived in Georgetown at the same time.

Denver's Holladay Street, a pulsating arcade of brothels, was her next and last destination. Mattie looked upon Denver, a city of twenty-five thousand people, as a place with a future, just the spot for a twenty-nine-year-old businesswoman in the centennial spring of 1876. Mattie set up shop, interviewing only the most beautiful candidates.

Cort was way too proud to work, so he began to gamble. When he ran out of money, this former member of Quantrill's Raiders would ride into Mattie's parlor, demanding cash and promising that his horse would foul her Oriental carpet if money wasn't delivered immediately. Mattie would laugh her head off and pass over the dough.

Her love for Cort, as well as her love of champagne, involved her in a dubious historical first: Mattie and Katie Fulton fought history's first duel between women.

The fight began after a footrace won by Cort, on which Mattie had collected a $2,000 bet. (She loved money, saying once, "The sweetest music in all the world is the jingle of gold coins.") Postrace drinks were on the house at the Olympic Gardens on the west bank of the South Platte, near today's Colfax–Larimer viaduct. Conveniently located on the outskirts of town, away from the law, the worst of the West found it a relaxing place to hang out.

At the party that night, August 25, 1877, Katie Fulton made more than one obvious advance at Cort, who looked quite dashing in his pink tights and blue, star-spangled jogging shorts. Mattie saw blood red and challenged Kate to a duel, right then and there. Pistols were the chosen weapons, and Mattie used her own personal equalizer, an ivory-handled number she hid in a special pocket. The ladies paced away from each other, turned, and fired. Cort let out a scream and fell to the dirt. Mattie had missed her opponent completely, and Cort had taken a shot, probably from Katie, in the back of the neck. It was only a flesh wound, but a brawl ensued. Katie left on a train for Kansas City the next morning, nursing a broken heart as well as a broken nose.

By 1880, Mattie held title to a parlor house at 500–502 Holladay (1916–1922 Market today) and would operate there until 1912. Other locations were also used briefly by her business, but this house was her mainstay. After the death of her chief rival, Jennie Rogers, Mattie bought the fabled House of Mirrors at today's 1942 Market Street from Jennie's estate. She put above the front door her famous last sign in large tiles which proclaimed: "M. SILKS." Clearly, the name now sufficed for the game.

Her later years were highlighted by a trip to London in 1897 during Queen Victoria's Diamond Jubilee, when Cort and Mattie posed as oil millionaires, and one last adventure in the virgin Yukon, which would net Mattie and her crew $30,000 in three months.

Cort died in 1900, and Mattie had him buried in Denver's Fairmount Cemetery. She continued her business until 1915, when the threat of Prohibition and strict crackdowns on vice put a damper on the brothel business. The House of Mirrors was sold in November 1919, and Mattie retired to a quiet life, raising horses and watching Denver boom. In 1924, at age seventy-six, she married Handsome Jack Ready, one of her former bouncers.

Mattie Silks died at Denver General Hospital on January 7, 1929, two weeks after she had fractured her hip in a fall. Until the end, she insisted she was never a prostitute, only a proper "madam." Her true identity died with her. Today, this pioneer of pleasure rests under a headstone that reads: "Martha A. Ready," next to the unmarked grave of Cortez Thomson.

MARY ELITCH

Mary Elitch plays with her pet lion cubs on the Elitch lawn in 1890.

The purchasers of Mrs. Chilcott's sixteen-acre apple orchard five miles north of Denver could not have been more optimistic. Restaurateur John Elitch and his wife, Mary, had a vision for the tract of land, a Gay Nineties paradise of enchanted gardens. Little did Mary realize on that day in 1887 that making the dream come true would be left up to her.

Mary Elizabeth Hauck was born in Philadelphia in May 1856. When she was young, her father moved the family and his livestock and fruit business to California. At age sixteen, she shocked her family when she married twenty-year-old John Elitch, Jr., from Mobile, Alabama, whom she'd met in church. On their honeymoon, Mary attended the theater for the first time in her life.

John's dream was to become a famous vaudevillian, but his early success came from his culinary skills. Arriving Out West in 1880, the two opened an eatery in the boomtown of Durango. With the profits, they set up a similar establishment in Denver two years later, called Elitch's.

John originally bought the apple orchard to grow fresh vegetables for the restaurant, but the lure of show business was still strong. Over two years of painstaking preparation transformed the apple orchard into Elitch's Zoological Gardens, a Western wonderland patterned after a favorite spot in San Francisco. On May 1, 1890, John and Mary awoke with trepidation, however. Clouds hung over their Shangri-La on its christening day, threatening to dampen spirits, wild animals, and imported foliage.

The sun broke through, however, and Denverites by the thousands flocked to experience opening day. Luminaries from the silver millionaire Tabors to the Thumbs (Mr. and Mrs. Tom Thumb were Mary's houseguests opening week) were greeted with live bands, dancing bears in a pit, and a review in the "theatorium." As evening drew the curtain on the day's festivities, Mary Elitch recalled later that she and John "looked about our trampled domain, recalled ludicrous and heartening incidents, and sighed with satisfaction over a dream well launched toward fulfillment."

The first summer must have been idyllic: Mary riding around the grounds in a small coach drawn by a single ostrich; an albino buffalo and other animals roaming freely; John gorging himself in a pancake-eating contest under a shade tree with editor-writer Eugene Field and circus impresario P. T. Barnum; even regular vaudeville acts. But tragedy was just around the corner.

At the close of the first season, John was bitten by the theater bug as never before. With the $35,000 the park

had cleared the first year, he helped organize The Good-year, Elitch, and Schilling Minstrels and toured with the group up and down the Pacific Coast. Playing the Alca-zar Theater in San Francisco, he contracted severe pneumonia, lingered two weeks, then died in Mary's arms on March 10, 1891, in San Francisco.

Strapped for funds, the thirty-four-year-old widow sold the majority of her gardens' stock to a group of Denver capitalists but remained in an organizational capacity. She regained total control in 1894.

Under her watchful eye, the frontier fairyland thrived. Amid the chatterings of birds and monkeys and the whistling of the miniature railroad engine, Mary ruled like Glinda of Oz. In a time when children were revered, she set up Tuesdays as their day; they could run free with only herself as a supervisor. Once, she later remembered delightedly, four-year-old Antoinette Perry (long before her Broadway career) tramped fearlessly into a goldfish pond to "det her fiss to pay wif."

In 1897, Mary exchanged vaudeville for the legitimate theater, creating a legendary stock company that would feature the top thespians of the day. The opening pro-duction starred actor James O'Neill (father of play-wright Eugene O'Neill). One early anecdote tells of a twelve-year-old Denver waif named Douglas Fairbanks (Sr.) scrubbing the stage in return for a complimentary ticket to a Shakespeare production.

In 1906, Mary scored her greatest coup by luring Sarah Bernhardt for a performance. On the morning of her arrival, the "divine" actress named a lioness "Sarah Bernhardt," played the title role in *Camille* that after-noon, and wrapped up the day by starring in *La Sorcière* that evening. The year also saw the tragic death of Mary's second husband, Thomas Long, whom she had married in 1901.

Soon after Long's death, J. K. Mullen and Jim Berger came to Mary's assistance, running the nontheater oper-ations and helping with financial details. By 1916, how-ever, the park fell on hard times, and the entire property was sold to John Mulvihill, who would take the opera-tion to new heights despite a two-year shutdown during World War I.

Mary's sale contract allowed her to live rent-free in her cottage on the grounds and receive $50 a month until she died. The "Lady of the Gardens" stayed there until 1932, receiving children and enjoying her accomplish-ments. She spent the last four years of her life with relatives and died at age eighty on July 16, 1936.

Mary Hauck Elitch Long dedicated her life to bright-ening a small corner of the earth, and she accomplished that in the garden of Elitch.

JESSE SHWAYDER

Jesse Shwayder's business guidebook came in basic black: he was an avid fan of the Bible. The golden rule served as his philosophy. In climbing the Jacob's ladder of corporate success he displayed the patience of Job and the wisdom of Solomon. When it came to building luggage, he used Yankee ingenuity to give it the strength of Samson.

Polish immigrant Abraham Ratchofsky was the first of Shwayder's ancestors to arrive in Central City, Colorado, in the 1860s. A prosperous peddler, he used his profits to bring relatives from Europe, including, in 1879, rabbinical student Isaac Shwayder, husband of Ratchofsky's niece Rachel Lea Kobey of Manchester, England. Rachel joined Isaac at his residence in Black Hawk, Colorado, in 1881; Jesse was born on March 26, 1882. The family eventually totaled twelve children.

Rachel disliked the wild mining environment and in 1888 the family moved to Denver. Isaac bought a small grocery at Eleventh and Market. Young Jesse was musi-cally inclined: he played the violin and his soprano voice earned him a paying spot in 1891 in Wilberforce Whiteman's choir at St. John's Cathedral.

Five years after the Panic of 1893, Isaac was out of the food business and into used furniture. While attending West High School, Jesse worked as a salesman at the shop at Eighteenth and Larimer, quickly becoming top biller.

Jesse found his calling in 1903 when employee Gershen Simon was on the verge of being fired. Simon convinced Isaac to keep him on, just to build trunks to sell with the furniture. Jesse saw how quickly the trunks sold. At age twenty-one, Jesse opened his own retail luggage outlet at Fifteenth and Curtis on an initial in-vestment of $153.

The store was such a success that Jesse soon opened two others, hiring his father and brother Mark to run

The Shwayder brothers bag another successful advertisement.
From left: *Mark, Maurice, Ben, Jesse, and Sol.*

them. Noting that the largest American luggage pro-
ducer, Seward Trunk Company, had no representative
Out West, Jesse convinced the firm that pioneers
needed baggage, too. Within three years the three
Shwayders were accounting for $100,000 in annual Se-
ward orders. In 1907, Seward hired Jesse as New York
sales manager at the incredible salary of $4,000 a year.

Nellie Weitz, Jesse's girl for six years, married him
just before the move Back East. They stayed a year
before returning, with Jesse muttering that he'd rather
"make a dollar in Denver than three dollars in New
York." The big city had offered an incredible education,
however.

On March 10, 1910, Shwayder Trunk Manufacturing
Company opened at 1050 South Santa Fe Drive. Jesse

was a twenty-eight-year-old father now; his first daugh-
ter Ruth had been born in 1908 in New York. His first
son, King David, was born on August 21, 1910, as dad
buckled down for a $2,000 first-year loss.

By 1917, the company was worth $35,000 and growing
fast enough to need a new plant in the Zang Building at
Sixteenth and Platte. Jesse had built a better mousetrap,
a $4.98 suitcase that he'd named "Samson." His broth-
ers had objected to the price because most cases re-
tailed for less than $3.00 in those days, but sales proved
Jesse correct.

To convince the May Company to stock Samson bags,
Shwayder arranged for a window display of one of his
cases supporting a thousand pounds of sacked flour.
Then, he gave twenty-five employees the afternoon off

to go downtown and gawk. That crowd drew an even larger one, and Jesse had the scene photographed for his direct-mail campaign. Soon after, Jesse posed his father, himself, and three brothers on a plank balanced on a Samson bag. After Isaac died in 1916, the scene was reshot with all five brothers on the suitcase.

In 1923, the company moved to 1050 South Broadway, and in 1926, the Shwayder brothers—Jesse, Sol, Maurice, Mark, and Ben—recorded their first million-dollar-sales year. Railroad rates doubled the next year, so Shwayder opened a Detroit plant to serve the eastern U.S. market.

The stock market collapse in 1929 eventually affected luggage sales, but not the Shwayder empire. Maurice purchased a couple of carloads of card-table frames from a plant in Idaho in 1931 (people were playing a lot of cards during the Great Depression), and the company began featuring tabletops made from suitcase fiberboard. The next year, they sold $100,000 worth of tables, and by 1938 tables were outpacing bag production.

In 1941, Samsonite Streamlite luggage appeared. The plant soon was converted for war use as Jesse extended his "do unto others" philosophy to the Germans and Japanese, making bombs, hand grenades, and the strongest footlockers on the planet. The postwar years saw a vastly increased variety of products on the international market. The company's fiftieth anniversary was celebrated in 1960 with a folksy biography of Shwayder by Walter B. and Walter S. Lovelace. The business was doing $50 million in annual sales.

Shwayder relished the role of benevolent boss. Employees and friends received marbles engraved with the golden rule. Charities benefited from his generosity. He even became a radical campaigner against smoking, putting out his last cigar at age seventy, saying that they were "no good." (He banned smoking in his plant in 1965 but rescinded the order because of union pressure.)

Jesse celebrated his eighty-eighth birthday in 1970 by cutting the ribbon on the $18.5 million Samsonite Park complex in the Montbello area of Denver. Four months later, he died unexpectedly at his home on West Jewell. A real-life Horatio Alger, Jesse Shwayder's success was in the bag.

CARRY NATION

Had her campaigns against the bottle been merely lofty rhetoric, chances are her reputation would never have reached such heights. But there was something about this relentless crusader, dressed like a prairie black widow, that shot fear through the hearts of frontier bartenders. Carry Nation, you see, liked to get a little physical.

Carry Amelia Moore was born on her parents' farm in Garrard County, Kentucky, on November 25, 1846, into an environment of uncertainty. Her family moved many times during her formative years as her father attempted to second-guess and outrun the Civil War. Mother Mary was a woman of grand delusions, the most common being a royal identity crisis in which she thought she was Queen Victoria.

During a move to Missouri in 1856, Carry fell seriously ill and remained bedridden for most of a year. Her agony was compounded by the slaves who cared for her, who told her she was being punished by "an angry God." As a last resort for her recovery, her father took her to a revival, where she was "cured" and baptized in a stream. From then on, Carry was on the Lord's side.

The family moved to Texas, then back to Missouri. At seventeen, Carry had grown into a tall, striking woman, a book lover, and Sunday-school teacher. The war ended and the family was once again uprooted, returning to the site of their original Missouri plantation, which by then had become a ruin. Carry became interested in a boarder in the Moore home, a former Union captain who was in the medical profession. Marriage plans soon were announced, despite her father's protests concerning Gloyd's "problem." Dr. Gloyd, it seemed, was an absolute sot.

On their wedding day, November 21, 1867, Gloyd arrived late—and stewed. Things didn't get better. Carry would sit home worrying until Charles would stagger in reeking of gin, renounce the bottle, and pass out. Soon after the birth of their first baby, Charlien, in September 1868, Carry announced that she was packing up and going home. "If you leave me, I'll be a dead man inside of six months," whimpered Gloyd. Carry left, and six months later Gloyd died of alcoholism.

Carry was then the sole provider for her infant daughter and her mother-in-law. In 1877, at age thirty, she married a dreamer and part-time preacher named David Nation, hoping that he would improve her financial situ-

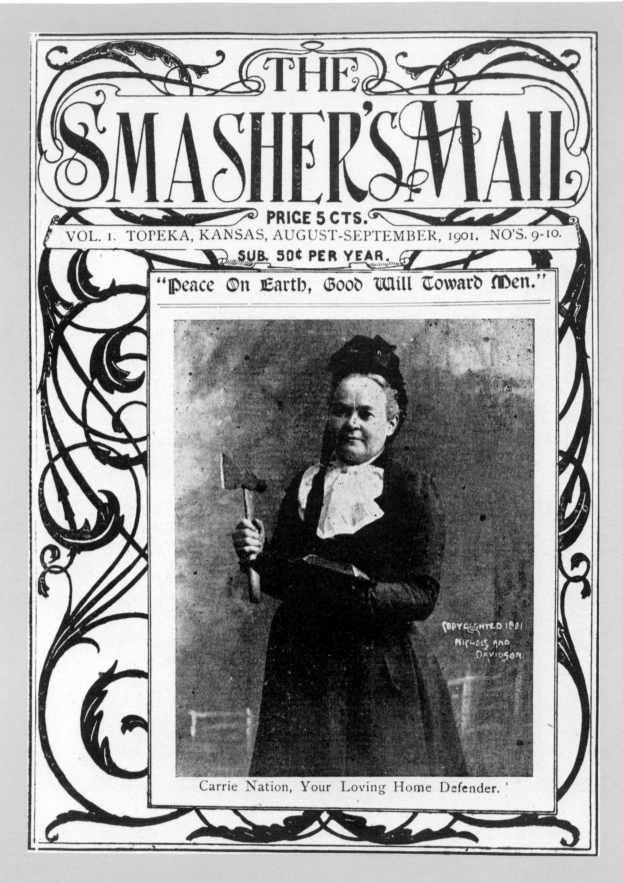

THE SMASHER'S MAIL

PRICE 5 CTS.

VOL. 1. TOPEKA, KANSAS, AUGUST-SEPTEMBER, 1901. NO'S. 9-10.

SUB. 50¢ PER YEAR.

"Peace On Earth, Good Will Toward Men."

COPYRIGHTED 1901
NICHOLS AND
DAVIDSON

Carrie Nation, Your Loving Home Defender.

Carry's temperance magazine misspelled her name, but the message was clear.

ation. A farming venture in Texas went sour, as did his attempt at practicing law. In nearby Columbia, Texas, Carry took a hotel job. Working from dawn to midnight, she wondered how different her life would have been if her first love had never come under the spell of liquor. Over a steamy ironing board in the dead of night, Carry saw the demon, the maker of widows and orphans, the undoer of this world, for what he was.

After a move to Medicine Lodge, Kansas, where David began preaching full time, her discontent peaked. Forty-six-year-old Carry thought her husband's sermons were too weak. She began to edit them, attacking illicit sex, tobacco, and, of course, booze. Her reputation grew. She was out every night, lecturing strolling young couples on the evils of sex.

Seven years later, filled with a vision after fasting for three days during a session with her Bible, Carry Nation realized her calling. She closed her first bar simply by praying at its door and threatening to do so twice a day until the owner left. On February 16, 1900, Carry and two supporters barged into a drugstore, found a barrel of expensive brandy, and rolled the "broth of hell" out into the street. A blacksmith provided a mallet, with which Carry splintered the keg.

Her next target was a bar in Kiowa, Kansas, which she demolished with rocks, or, as she called them, "smashers." At 180 pounds and nearly six foot, Carry was a prohibitionist hurricane; her symbol was a hatchet.

Her first arrest came in Wichita, after she destroyed a $1,500 mirror and a nude portrait of Cleopatra in a barroom. There were other arrests, as well as a few threats, bruises, broken bones, and forced departures from bars. The publicity from all this only added to her popularity. On a visit to Des Moines, Iowa, she was greeted by five thousand well-wishers, and bars closed until her departure.

By the time she reached Denver in 1906, however, many were disenchanted with her noisy piety as well as her violent tactics. She could still attract attention, but more and more she was a curiosity. On the morning after her arrival, *The Denver Post* vividly recounted Carry's tour of the red-light district on Market Street and the seven thousand spectators it drew: "The arc lights sputtered and threw a ghastly light over the mob, making it look like Walpurgis night, with the ordinarily sane men and women turned into insane fiends."

She continued to lecture across the nation and in Great Britain, but despite the fire she had saved for her later years, her rough schedule had exhausted her physical resources. On June 2, 1911, at age sixty-four, Carry Nation died of natural causes.

SILVER DOLLAR TABOR

Her name wasn't quite put together when the second and final daughter of silver millionaire H. A. W. Tabor and his famous wife, Baby Doe, was born on December 17, 1889, in their mansion at 1260 Sherman in Denver, but there's small wonder—the full name was Rose Mary Echo Silver Dollar Tabor. "Silver Dollar" came later from politician and orator William Jennings Bryan, who said "her voice has the ring of a silver dollar." The other names were picked by her parents, owners of Leadville's Matchless Mine, at the time a scant four years from financial ruin.

Baby Echo's first years were a lavish fairy tale, from diamond diaper pins to a hundred peacocks on the lawn. Tabor's personal worth was estimated as high as $100 million dollars in 1893. But their new baby's silver spoon was about to be ripped away, and her story is perhaps the most bizarre in Colorado's favorite family tragedy.

In 1893, Congress repealed the Sherman Silver Act, which had authorized the purchase of silver bullion and its coinage into dollars. The price of silver crashed, and during the ensuing four-year depression the Tabor fortune slipped away. Tabor died in 1899, after a brief stint as Denver's postmaster.

Baby Doe moved daughters Silver, age nine, and Elizabeth Bonduel Lilly, age thirteen, back to Leadville to honor Haw's final request to "hang on to the Matchless." Lilly hated the mining life, eventually departing to live with relatives and marrying a successful Wisconsin businessman. Silver stayed, becoming a source first of great pride, then of confusion and heartache for her mother.

By the summer of 1908, she was a long-stemmed beauty, with flowing auburn hair, deep brown eyes, and a curvaceous figure. One day that summer she caught a glimpse of President Theodore Roosevelt, who was vis-

A formal baby portrait, in the lap of luxury before the fall.

Silver's next attempt at literary fame was in Chicago. In an interview with a Chicago Press Club member she announced her arrival, describing herself as a smug, flip heiress "longing for the mining camps." Holed up in a tenderloin flat, she produced a plodding romantic novel, *Star of Blood.* Meanwhile, Baby Doe, still hanging on to the Matchless, lived in hope that Silver would restore the family's pride. Paying to have the hopeless volume published seemed a logical way to hasten the return of good times.

The book sold only as a curiosity. It was followed by a series of failed attempts at stardom that included work with a Colorado Springs film company, a touring musical show, and her own Denver weekly tabloid. After these failures, she announced that she was ready for a Chicago convent. Baby Doe was ecstatic, unable to see that her fragile daughter, "the leaf in the storm," was sliding fast.

The fantasies needed more and more help. The convent was only a story; Silver's existence depended on opium, cocaine, and alcohol. She ran with failed Bohemians and shimmied for Chicago gangsters, performing a serpentine dance with a scarf around her waist as sole attire. Her cast of leading men constantly shifted, along with her aliases and addresses.

On September 18, 1925, she was found nude in a run-down flat at 3802 Ellis Avenue, writhing on the floor, her back a mass of blisters after an accident with a pan of boiling water. A needle and morphine were strewn on her table. With her final breath, the thirty-five-year-old fallen princess asked for a jigger of whiskey. The official cause of her death was listed as "shock."

A few nights later at the Denver Public Library, a lonely figure in motoring cap and heavy boots, fingering a simple cross where once had hung diamonds, sat reading the torrid newspaper headlines about her girl. Lilly's quote ("I never approved of her. She looked at life so differently. I can see no reason now why she should be more to me than just a dead woman down in Chicago.") was there, along with the sordid descriptions of the scene. For the rest of her life, until she was found frozen to death at the Matchless in 1935, Baby Doe insisted that Silver was in a convent.

Silver Dollar Tabor, the West's ultimate poor little rich girl, had foreshadowed her own demise in the character of Artie Dallas, her heroine in *Star of Blood:* "No friends visit her lowly grave, but perhaps occasionally a wild bird hovers over the lonely spot, chanting a carol whose plaintive notes ascend into the infinite realms above and invocate, 'Be merciful to her, for she knew not what she did.'" It had been a long fall.

iting Denver, and that night she penned a song destined, in her mind, for greatness: "Our President Roosevelt's Colorado Hunt." Baby Doe had the tune published with help from a Denver musician, but it went nowhere.

Whispers of an affair between Silver and a livery stable owner spread around town, and Baby Doe was shocked. On Easter weekend in 1910, Silver returned from a Sunday evening party at eight o'clock Monday morning, drunk. Affairs with a saloon keeper and a clerk followed.

Roosevelt visited Denver again in 1910, and Silver was photographed singing her tribute song to him. After the newspaper exposure, she thought, a literary career in Denver would follow. She spent the next six months writing for *The Denver Times,* covering society funerals and stretching her $12 weekly salary by dining with a different reporter every evening.

MOLLY BROWN

The unsinkable Molly presents a loving cup to Carpathia *Captain A. H. Rostron in New York on May 29, 1912.*

In the shadow of the pyramids, Margaret Tobin Brown listened as the fortune-teller drew a prediction in the sand. The soothsayer saw the portly matron in a disaster on a large body of water in which "she possessed even more courage than the men who would be in the same calamity." Maggie (she always wanted to be called "Molly" or "Peggy," but never was in her lifetime) Brown had little time to consider the prophecy. All too soon, she would earn a reputation for being unsinkable on the night the ocean liner *Titanic* did the unthinkable.

Margaret Tobin was born to ditchdigger John Tobin and his wife, Johanna, in Hannibal, Missouri, on July 18, 1867. Arriving with a brother in booming Leadville, Colorado, at age nineteen, she went to work stitching carpets for a dry-goods firm. Maggie married thirty-one-year-old mining superintendent James J. Brown on September 1, 1886. Children Lawrence and Catherine arrived by 1889.

In 1893, J. J.'s venture with the Ibex Mining Company resulted in a fabulous gold strike; the Browns were rich beyond their wildest dreams. They moved to Denver's exclusive Capitol Hill, buying a home at 1340 Pennsylvania. Maggie began a quest to wow Denver society, a fruitless endeavor that eventually unraveled her marriage. Denver lore is filled with her futile attempts: parties to which no one came, squabbles with gossip writer Polly Pry, snubs from the top families. In 1909, when J. J. tired of almost twenty years of social charades, the couple separated. Maggie Brown then spent her time either touring abroad or at a rented Newport, Rhode Island, cottage.

Her reasons for booking a $4,350 first-class passage on the maiden voyage of the *Titanic* were many. After hobnobbing in Egypt with the John Jacob Astors and finding out *they* were going, it seemed a logical move. Indeed, the first-class passengers had a combined net worth of $500 million and provided some of the most glamorous names of the day.

Maggie boarded at Cherbourg, France, on the evening of April 10, 1912. The pride of the White Star Line was nearly nine hundred feet long and weighed 46,328 tons, fully equipped with a gymnasium, a swimming pool, a Turkish bath, lounges, smoking rooms, saloons, a hospital, a darkroom, and enough lifeboats for 52 percent of the 2,207 people on board.

Just before midnight on April 14, Maggie had retired with a volume from the ship's library when a jarring scrape tossed her to the floor: "I looked out, and seeing nothing but a strange, dark object looming through the cold and blackness beyond, went back to my book." The object was a massive iceberg that had ripped a three-hundred-foot hole in the bottom of the *Titanic*.

Venturing onto the deck, Maggie noticed the crowd was slightly bewildered, but there was still no indication of the tragedy that would unfold. Maggie went back to her quarters for her jewels, and when she returned topside, pandemonium was well under way. She was outfitted in a black velvet two-piece suit complete with sable stole and life jacket.

Observing what she called "a scene of tragic beauty," she helped women and children into the lifeboats. She witnessed the Astors parting as the band played ragtime. While helping load the sixth lifeboat, she heard, "You are going too," and was dropped four feet into the boat, which in turn was lowered seventy feet to the frigid Atlantic. It was 12:55 A.M.

Only twenty-eight people were aboard, though the lifeboat had the capacity for sixty-five. Maggie began to have problems with Quartermaster Robert Hitchens, one of two men on board, who refused to row. She and the other women managed to row out a distance from the *Titanic* as its stern hoisted three hundred feet in the air, throwing some five hundred people into the ocean. At 2:20 A.M. the ship stood vertical. The lights on board blinked off, then on again, then off for good as the steamer slid beneath the black waters.

The arguments between Hitchens and Maggie turned ugly. Over a thousand people were splashing about where the ship had gone down, and Maggie wanted to go back. Hitchens refused. After an hour, the pitiful wails ceased.

Soon Maggie would have enough of the quartermaster as his fearful speculations on the lack of food and water sent a wave of panic through the lifeboat. She insisted the crew keep rowing, for warmth if nothing else. When Hitchens tried to prevent her from helping a soaked seaman aboard, she told him to back off or she would throw him in the ocean. She virtually took charge of the boat, told her stories of the West to keep everyone's spirits up, and occasionally broke into songs that echoed across the chilly waves.

The *Carpathia* picked up the first lifeboats at 4:00 A.M. After an enforced rest, Brown nursed the survivors. By the time the ship docked in New York on April 19, she had initiated a fund for steerage-passenger relief and raised nearly $10,000. "Tell my Denver friends I'm safe," she said to reporters. When one asked how she'd managed to survive, she quipped, "Typical Brown luck. I'm unsinkable."

Two weeks later, she was in Denver, holding court from a Brown Palace Hotel suite. When asked about J. Bruce Ismay (the president of the White Star Line who had saved himself), she said she had told him that if he were a resident of Leadville, he would be strung up from the nearest pine tree. Her heroics even managed to win her a luncheon invitation from Mrs. Crawford Hill, leader of the Sacred 36, the cream of Denver's society.

Of the 706 survivors, her story became the most famous, embellished the year after her death in 1932 in Gene Fowler's *Timberline*. In the account that set the standard for the legend, she commandeered the lifeboat in a corset, brandishing a Colt .45 and bellowing: "You can't wear the *Social Register* for water wings, can you? Keep rowing, you sons of bitches, or I'll toss you all overboard!"

Colorado's most buoyant personality would have loved her unsinkable immortality.

CHARLES RUSSELL

Russell's Loops and Swift Horses Are Surer than Lead, *1916. Amon Carter Museum, Fort Worth, Texas.*

His first real job, after a feeble attempt at getting an education and a half-hearted try at herding sheep, came at the age of eighteen in the tough world that was Montana in 1882. He was a night wrangler, overseeing a couple of hundred horses and whatever else happened to be on the hoof. He spent his working hours under a million stars that shone over a very wild country. When relief came at dawn, Charley Russell would sleep a few hours, then spend the rest of the daylight drawing and painting.

Born into a family of brick manufacturers in Oak Hill, Missouri, on March 19, 1864, Charles Marion Russell received a proper education before entering the brick business. But early stirrings made it quite evident to Mary Elizabeth and Charles Silas Russell that young Charles might be a little different.

Around age four, the child was lost for a brief time.

The frantic family found him following a man with a trained bear. That night, the boy scraped the mud from his shoes and molded a small object that looked uncannily like his furry friend.

At sixteen, he announced boldly that he would have no more of schooling; he would head Out West and become a cowboy. His parents authorized a trip to the badlands of Montana so he might get it out of his system, but he never came home.

Russell's night wrangling would last eleven years. During that time he saw the great era of the West was disappearing, and he recorded every detail in his memory, if not on paper. He experienced firsthand the twilight of the age, as the last roundup drew closer and closer.

At the same time, another way of life was rapidly ending, and Russell experienced that, too. Unlike many

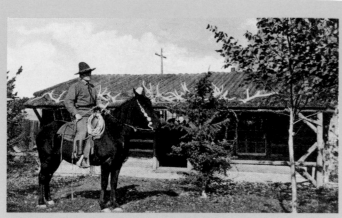

Charles Russell outside his studio in Great Falls, Montana.

of his cohorts, who hated and feared the American Indian, Russell had a deep interest in their history and traditions. After spending the summer of 1888 drifting in southern Canada, he and a partner stopped off at the Blood Indian Reservation in northern Montana to visit an old friend, Chief Black Eagle. The other man eventually went home; Russell accepted an invitation to stay for the winter. When he rode away in the spring, his interest had changed into a profound appreciation of the Indian.

By 1895, Charley, who had usually given his work to admirers, figured out that he might be able to earn a living from it. Saloon owners and others had commissioned work from him, and he'd gotten as high as $50 for a painting. Folks enjoyed what he had to say with a brush. He seemed to have a knack for capturing on his canvas a moment of supreme action or a night of bitter weather out in the open.

Having made the decision to turn professional, he visited an old friend, Ben Roberts, in Cascade, Montana. Staying with the family was a lovely young girl named Nancy Cooper. Russell was smitten; a year later, they were married. She was eighteen, he was thirty-two. Nancy saw him as he would be, the Rembrandt of the American West, and took over his business dealings.

She began demanding higher prices for her husband's work, which was now in several media: oil, watercolor, pen and ink, and bronze. At the same time, his talent as an artist had grown enormously. Early crude works gave way to finely detailed masterpieces, each expressing the heart and soul of his beloved landscape. Under her regimen, Charley would rise before dawn, make breakfast, then head out to his studio on the grounds of their Great Falls, Montana, home.

Many of his images portrayed the conflict of the West. Man fought against man and animal in a score of gritty panoramas. Buffalo hunts, bitter war, bronco taming, whatever the subject, Russell was absolutely familiar with it, and his gifts did not go unnoticed.

His first New York showing, in 1911, solidified his reputation and made the cowboy artist the toast of Broadway. Russell never put up a false front: in Gotham or in London, he'd wear his Stetson and boots. At parties, his stories were the ones asked for. Even the young Will Rogers listened and admired like everyone else.

In his later years, his palette grew more colorful and his production remained steady. His signature with the buffalo skull attached was now quite well known, and when Russell died of a heart attack shortly before midnight on October 24, 1926, he was greatly mourned. The West in all its glory would never be captured by such a capable interpreter again.

SAMUEL CODY

He never seemed to mind being the West's "other Cody," and in his flamboyant life he managed to link the Old West with the air age.

Samuel Franklin Cody, Jr., was born in Birdville, Texas, near Fort Worth, on March 6, 1861, the son of a rancher. Joining his first cattle drive at age twelve, he quickly mastered the rope, the bullwhip, the rifle, and the horse. He hit the trail for good after his parents' ranch was burned down by Indians, and from Texas to the Dakotas he held occupations ranging from buffalo hunter to trail boss to wild-horse tamer.

During one lazy afternoon on a cattle drive, a Chinese cook fashioned a kite and sailed it high above the dogies. Cody became fascinated with the ancient Oriental art of kite flying, and he fancied making kites large enough to carry men above the clouds.

Around 1883, Cody set off on a different kind of drive. Enlisted by horse trader John Blackburn Davis, Samuel

The West's "other Cody" in a magnificent flying machine.

set sail with a large group of horses being shipped from Galveston, Texas, to London, England. The seasickness was terrible, but he fell in love with London and with Davis's daughter, Lela, whom he married. They settled in England.

Several years later, with their second child on the way, Cody took off for the Yukon in search of gold. Lela wasn't thrilled with the wild plan; she waited in England with her children for news of a big Klondike strike. It never came.

After two years in the frozen northland, Cody returned to Texas, broke and nearly out of dreams. He supported himself with cowboy work and in 1888 joined *Adam Forepaugh's Wild West* show, amazing crowds Back East with his roping and shooting. After he got a

letter from Lela describing Buffalo Bill's European reception, Cody decided his future was across the ocean. He booked his passage and never walked on American soil again.

Lela barely recognized her husband with his shoulder-length locks (insisted upon by Forepaugh), but their two sons enjoyed this new figure around the house. Cody taught his family to shoot, and The Great Codys soon were touring Great Britain with the wildest of Western shows.

By 1893, Cody was billed as "The King of the Cowboys," and his group toured Europe and North Africa. In France, walking champ Galleaux challenged Cody and his horse, Bergamo, to a fifty-hour race. Similar challenges came from bicycling enthusiasts. In nearly every

instance, Cody proved that six legs were better than two.

Cody's inventive side soon emerged. In addition to his show duties, Cody authored melodramas such as *Klondyke Nugget* and developed a machine gun weighing just under five pounds that could fire 160 rounds a minute. The British government was interested in the weapon but not in Cody's price tag, so it remained his secret. He used it in his show, but no specimens exist today.

In 1903, Cody entered a new race, about which he wrote, "I hope at no very distant date to play an important part in the complete conquest of the air." Before the year was out, Cody had crossed the English Channel in a kite-powered canoe.

The Wright brothers made their historic flights the same year, but Cody proceeded with his inventions. His man-lifting kite, with which he had soared over two hundred times, was bought by the British navy in 1904. With the income, Cody was able to cease his show business activities and devote his full time to flying.

On October 7, 1907, Cody astounded Britain when he and an associate flew the engine-operated dirigible *Nulli Secundus* ("Second to None") from Farnborough to London, circling Buckingham Palace and St. Paul's Cathedral and covering over forty miles in the air.

On October 5, 1908, Cody coaxed his *Army Aeroplane Number One* on a flight of seventy-eight yards, ten feet off the ground. On October 16, after several adjustments, Cody flew a quarter of a mile before crashing into an embankment. The two experiments were the first manned flights on British soil.

The rest of his life was spent improving aircraft and entering flying contests. In a 1909 race, he introduced his famous *Flying Cathedral,* a huge, multiwinged airplane. On July 21, 1911, Cody entered a race that covered over one thousand miles. He had only two superstitions: never to fly on Friday the thirteenth and never to carry passengers wearing green.

Sadly, Cody failed to check the color of the socks of passenger W. H. B. Evans on August 7, 1913. During a series of test flights over Aldershot, England, Cody's plane was caught in a freak gust of wind. The craft nosed up, throwing the two men out. In his white aviator's coat, Cody was unmistakable against the bright blue sky as he plummeted silently to his death. Sons Leon and Frank witnessed the tragedy.

Samuel Franklin Cody's ultimate dream was to impress the folks back home in Texas by flying one of his contraptions across the Atlantic, according to John Williams of the Fort Worth Museum of Science and History. It was perhaps the only fantasy he ever had that didn't materialize. Fifty thousand mourners turned out in England for the funeral of this misplaced Westerner, a cowboy Icarus who hit the heights a long way from home.

BILL PICKETT

One of the brightest stars in American rodeo history was described by his biographer as a tenacious "black Hercules." Flamboyant Bill Pickett, lover of red shirts, cigars, whiskey, and fine horses, rode taller in the saddle than most Westerners. Thanks to painstaking research from biographers, especially Bailey C. Hanes, his story has not been forgotten.

Willie M. Pickett was born on December 5, 1871, thirty miles northwest of Austin, Texas, to former slave Thomas Jefferson Pickett and Mary Virginia Elizabeth Gilbert. His blood was a mixture of Negro, Mexican, Cherokee, and Caucasian. Details of his early life are scant: young Bill attended school through the fifth grade, but his advanced education came from various odd jobs on local ranches.

Cosmic inspiration struck in 1881 when ten-year-old Bill saw a bulldog holding a cow by biting its upper lip. A few days later, he chomped on a calf's mouth and brought it down with a flip of his body. It was a trick he could sink his teeth into, and it eventually made him famous.

By age sixteen, Pickett was credited with inventing another way of stopping steers. When they ran wild through the mesquite they were impossible to rope, so the inventive teenager decided to ride alongside the huge animals, jump on their backs, grab the horns, and somersault across, pulling his prey to the ground. Though most rodeo events come from a variety of sources impossible to attribute to a single cowboy, this one has been traced directly to Bill Pickett, who became the world's first professional bulldogger.

Bill's family relocated to Taylor, Texas, in the late

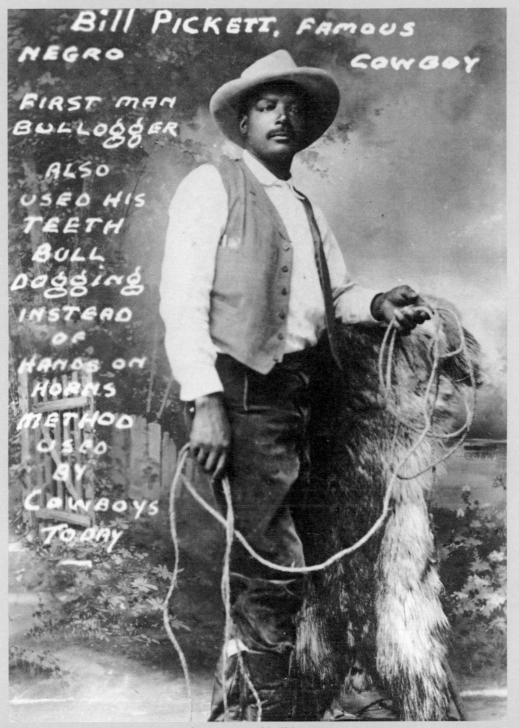

The inventor of bulldogging.

1880s, where he fell in love with Maggie Turner, the daughter of a white plantation owner and a black slave. They were wed on December 2, 1890, and although they had nine children, their two sons died in infancy.

Bill's first taste of show business came when he and his brother began the Pickett Brothers Bronco Busters and Rough Riders, touring fairs and rodeos in the 1890s.

At the Arkansas Valley Fair in Rocky Ford, Colorado, in September 1900, Bill provided the state with its first public bulldogging. Pickett nailed a huge steer "bite 'em style" and flopped it into the Colorado dirt.

Bill went solo around 1903 under the auspices of manager Dave McClure and became billed nationally as "the Dusky Demon." A throng of twenty thousand fans

witnessed his biting technique during Cheyenne Frontier Days in 1904. Said *Harper's Weekly:* "So great was the applause that the darkey again attacked the steer, which had staggered to its feet, and again threw it after a desperate struggle."

After a performance at the Fort Worth *Fat Stock Show,* Pickett signed with the famed *101 Ranch Real Wild West* show run by Zack Miller, who, along with brothers Joe and George, was quickly turning the Oklahoma ranch into an international institution. One of Bill's early performing cohorts on the ranch was future matinee idol Tom Mix.

The show was a large one: over ninety cowboys and cowgirls, almost as many Indians, three hundred head of cattle and horses, and several buffalo, all toured the country in railroad cars. Pickett loved the show, worked the ranch in the off-season, and stayed with the Millers the rest of his life.

His greatest feat came on a Mexican tour. Brother Joe had the bright idea that Bill could do with a fighting bull what he did with Texas steers. The bet, which insulted every matador south of the border, had it that Pickett could stay in the ring fifteen minutes with the meanest bull. He'd try to bulldog, but if he couldn't, he'd at least survive.

On December 23, 1908, Bill rode into the Mexico City ring on his prized horse, Spradley. After several miscues, Pickett jumped between the horns of an enraged bull named Frijoli Chiquita and held on for dear life. Tossed and battered for seven and a half minutes, Pickett's total time in the ring with the bull was an incredible thirty-eight minutes. In the end, Frijoli wasn't bull-dogged and Pickett wasn't killed, which caused a near riot among the twenty-five thousand spectators. Miller collected his five thousand pesos and the gate receipts, Pickett received his usual salary of eight dollars a week, some deep cuts, and several broken ribs. (Bill did inform the Millers that they could do the toro-dogging from then on.)

After a long recuperation, Bill rejoined the show. By then his family lived on the 101 Ranch. In 1913, the group toured South America, and the next year they played the British Isles. In England, Pickett dined with the Earl of Lonsdale and his family in their castle, a far cry from Bliss, Oklahoma, where white friend Arthur Rynearson had to buy meals for Bill at the town's cafe and bring them to Bill in the back of a drugstore.

Bill Pickett was a rodeo competitor until he was well into his fifties. Despite a color line that prevented him from competing in several contests, he flourished in the most racist of times. Sad days came in 1929, when, after a brief illness, Maggie died. At age sixty, Bill was kicked in the head while trying to break a young chestnut gelding at the 101 Ranch. He lingered in a coma for two weeks, then died on April 2, 1932. He was mourned publicly by friend Will Rogers in a nationwide broadcast.

According to his estimates, Bill dogged over five thousand steers during his exciting life. In 1971, he became the first black inducted into the National Rodeo Cowboy Hall of Fame. The legacy of Bill Pickett is a tough one, recalled each time a cowboy takes a steer by the horns.

LON CHANEY

Alonzo Chaney was born near Pikes Peak, Colorado, on April 1, 1883, the second of four children of deaf-mute parents. Papa Chaney was a popular Colorado Springs barber because, according to a later interview with Lon, people could talk to him all day and he never seemed bored.

Lon left school in the fourth grade to help at home with his younger brother and sister and his mother, who had inflammatory rheumatism. At a tender age, he had become a master of mime, communicating with his parents by physical animation. By the age of twelve, he was working for older brother John at a Colorado Springs theater as prop boy for twenty-five cents a night.

Sent to Denver a few years later to learn a trade, Lon quickly became an expert paperhanger and carpet-layer. His talent for mime, along with an appreciation for fine craftsmanship, helped him greatly when he eventually took to the stage.

As a young stagehand, he had studied the makeup techniques of the vaudevillians as they made their cross-country tours. John formed his own company in 1901, and eighteen-year-old Lon was only too eager to join him.

His theatrical apprenticeship lasted a dozen years, in houses of all sizes and degrees of quality throughout the Midwest and South. Times were hard, and Chaney often

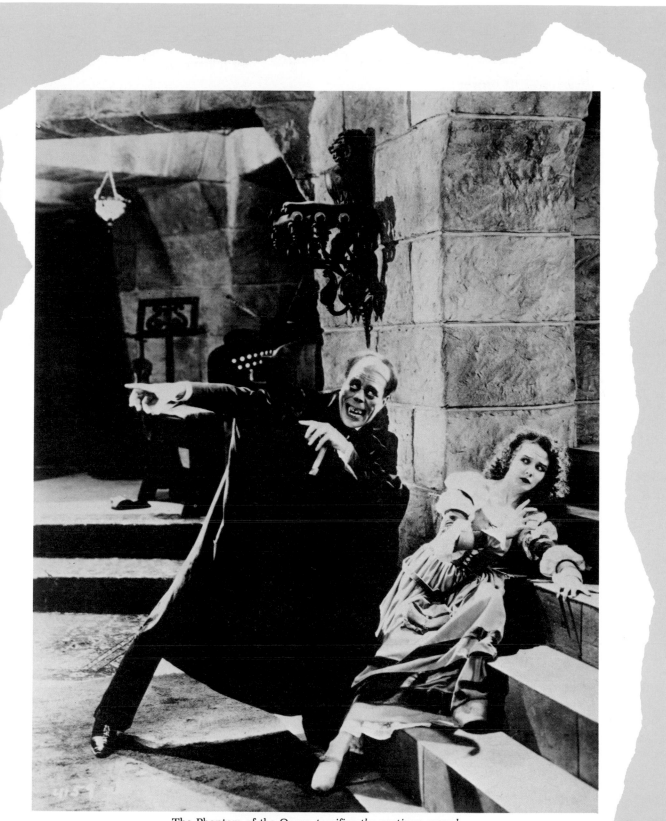

The Phantom of the Opera *terrifies the matinee crowd.*

was the man of a thousand jobs: comedian, villain, hero, janitor. Love struck in Oklahoma City; Chaney married Cleva Creighton just before her sixteenth birthday and a year later rejoiced in the birth of his son.

The euphoria didn't last. In Los Angeles, Cleva attempted a dramatic suicide backstage while Lon was performing. She survived, but Lon left her and began looking for a new way to support himself and his young son. He'd heard this new-fangled flicker business would pay people five dollars a day to ride a horse: no traveling, no starving, just horse riding. One of the great careers in cinema was born.

Chaney used his fertile imagination in countless bit parts, always adding a hint of something Hollywood wasn't accustomed to then: realism. He remarried and, when Universal City Studio expanded in 1915, the opportunity was there for bigger and better parts.

His big break came in *The Miracle Man* (1919) in which he played a horribly twisted cripple who was cured and walked away healed. Stardom was just around the corner for this man who could contort his body into unbelievable positions of agony, yet who maintained an astonishing humanity. He was a natural to play Quasimodo in the big-budget classic *The Hunchback of Notre Dame.*

Chaney devoured Victor Hugo's novel, and his portrayal of the hunchback was incredible. In the blistering Los Angeles summer of 1923, he applied pounds of makeup, a huge rubber hump, and a latex skintight suit to bring his character to life. The public was stunned when the movie premiered in September, and Universal Pictures rejoiced, even though Lon had cost them $2,500 a week.

The great movies followed: *London After Midnight, The Unholy Three, He Who Gets Slapped.* Chaney was hardly recognizable in his roles, prompting a great joke of the 1920s: "Don't step on that spider, it might be Lon Chaney!"

In the latter part of 1924, he began work as the crazed Erik in *The Phantom of the Opera.* His makeup boggled the mind: a headpiece created the high forehead, a piece of fish skin tilted the nose, while wire inserts flared his nostrils. He built up his cheeks with putty and molded his teeth from gutta-percha. He looked as if he'd been dead a hundred years.

While filming *Thunder* (1929), he developed pneumonia and underwent a throat operation to correct a problem that had been aggravated by swallowing a piece of fake snow. He completed his first talkie, a remake of *The Unholy Three,* then retired to the seclusion of his cabin in the Sierras. It wasn't known publicly, but Lon was suffering from throat cancer. A hemorrhage sent him to St. Vincent's Hospital in Los Angeles, where he died on August 26, 1930.

Chaney missed the chances he had been offered to play the leads in *Dracula* and *Frankenstein.* But his son Creighton, later called Lon Jr., starred in *The Wolf Man,* the last of the gruesome triad, in 1941.

WILL ROGERS

Fifty years after his death, it is difficult to grasp Will Rogers's enormous popularity. A man of unlimited genius and wit, his greatest rope trick was keeping his simple image intact while tackling the complexities of the world. He was America's greatest humorist. His newspaper column was a must for millions, as were his radio programs and the films that made him a Hollywood star. His secret was that he managed to remain himself, a basic down-home cowboy philosopher.

William Penn Adair Rogers was the last of eight children born to Clem and Mary America Rogers on November 3, 1879, in Indian Territory, near what became Oologah, Oklahoma. Though both his parents had considerable strains of Cherokee blood, Will was a far cry from the "poor Injun boy" he claimed to be in later life. On the contrary, Clem was one of the territory's more influential men, whose cattle and farming enterprises had made him wealthy. Willie was a terrible student, easily bored in the six different schools he attended. It seems the only lessons he took seriously were from black cowboy Uncle Dan Walker, who taught him how to throw a rope.

Following a stint at a Missouri military school ("I spent two years at Kemper—one in the guardhouse and one in the fourth grade"), Will left for Texas to become a cowboy. He returned home soon after to help around the ranch and met his future bride, Betty Blake. Rogers then followed what would become a lifelong urge to

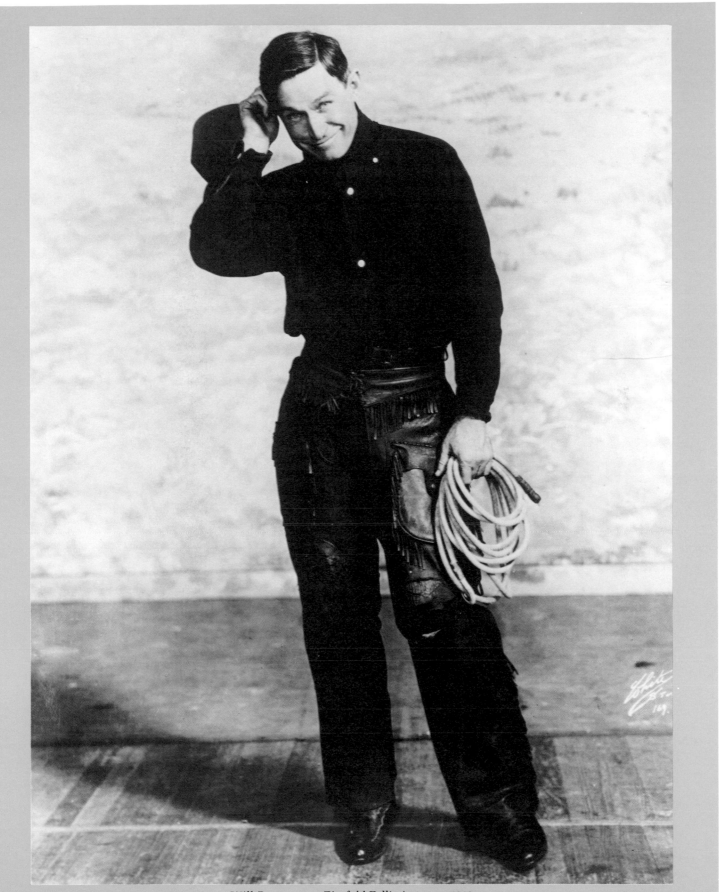

Will Rogers as a Ziegfeld Follies' *star, c. 1919.*

travel. In late 1901, he was a gaucho in Argentina. A few months later in South Africa, his roping earned him a spot in the touring *Texas Jack's Wild West* show, where he was billed as the "Cherokee Kid."

The next year Will played Australia and New Zealand with the Wirth Brothers Circus. He returned to Clem's ranch in 1904, announced his plans to stay in show business to his disgruntled father, then joined the *Mulhall Wild West Show* as a rider, roper, and general crowd pleaser. On April 27, 1905, he made his debut in Madison Square Garden, where he received rave reviews for roping a steer that had bolted into the stands.

After a decade of love letters, he convinced Betty to marry him on November 25, 1908. By now he had graduated from circus performer to vaudevillian and had found that he was able to get laughs by talking between lasso stunts. "Out West, where I come from, they won't let me play with this rope," he grinned. "They think I might hurt myself."

His big break came in 1913 when Florenz Ziegfeld put him in the nightly *Midnight Frolic*. Repeat customers laughed at the same jokes only once, so Will began walking on stage with a newspaper to comment on the day's happenings. By 1916, he was the unlikely star of Ziegfeld's larger show, the *Follies*, beginning his routine with "Well, all I know is what I read in the papers."

His "fresh-laid jokes" were a sensation. Rogers became nervous the night President Woodrow Wilson attended the show but managed to keep the chief executive and the audience in stitches with his drawling, laid-back approach to global problems. By the end of 1919, he had published two slender volumes of comments from his stage act.

The same year, Will went bicoastal, adding silent films to his resume. After working for Samuel Goldwyn, he began producing his own pictures, including *The Ropin' Fool* in which he performed fifty-three lariat tricks. For the first time, he lost money at an endeavor, but he quickly recovered his investment with a series of $1,000-a-pop after-dinner speeches. On December 24, 1922, his first weekly column appeared in *The New York Times*. It soon evolved into a daily column and received wide syndication.

A typical line from the outspoken Will Rogers: "Every time Congress makes a joke, it's a law, and every time they make a law, it's a joke." One reviewer commented, after a European tour produced a book entitled *Letters of a Self-Made Diplomat to his President,* "There has rarely been an American humorist whose words produced less empty laughter or more sober thought." By the end of the decade, "the honorary mayor of Beverly Hills" had a radio broadcast every Sunday evening.

Even with his international celebrity status, Will Rogers never overlooked the problems of downtrodden people. He cut short a lecture tour to do benefits for Mississippi Valley flood victims. Whatever the cause—drought, hurricanes, earthquakes—Rogers was able to raise millions in relief funds. He also aided victims of the Great Depression and provided one of that era's most famous quotes: "We are the first nation in the history of the world to go to the poorhouse in an automobile."

The movies had learned to talk, which only helped Rogers's screen persona. He ranked No. 1 at the box office in 1934, and No. 2 in 1935 behind Shirley Temple. The Rogers family lived on a spacious ranch in Santa Monica, California, but more often than not Will was speeding across the country by airplane, speaking everywhere from the White House to a small black congregation in Fort Worth, Texas. In the summer of 1935, while completing *Steamboat 'Round the Bend,* he quipped, "We are living in great times. A fellow can't afford to die now with all this excitement going."

At fifty-five, Will Rogers was at the peak of his popularity when tragedy struck. On August 15, 1935, while on a sightseeing trip to Alaska with aviator Wiley Post, the two were killed when their plane crashed near Point Barrow. Rogers's smashed typewriter was pulled from the wreckage; the last word typed in a story he had been writing was "death."

Fifty thousand mourners turned out for the Los Angeles services. In 1944, his remains were moved to a memorial in Claremore, Oklahoma. Time has only enhanced his spirit, leaving him, in death, exactly what he was in life: beloved.

JACK DEMPSEY

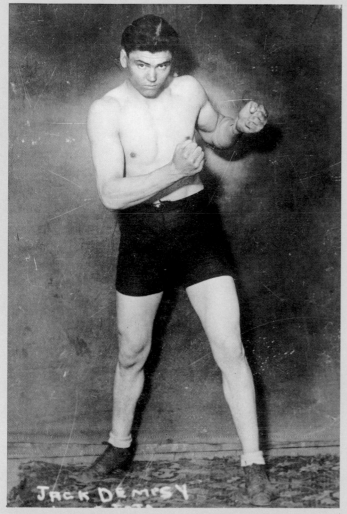

The Manassa Mauler looking tough in a photo studio in Victor, Colorado.

children, perhaps deep inside she could feel the embryonic hooks and jabs of a future champion.

William Harrison Dempsey was born on June 24, 1895, and grew up with only three toys: a wooden top and two fists. His father, Hyrum, was a good-natured dreamer who ran out of money in Manassa while moving his family from West Virginia to the West. Tales of opportunity eventually caused them to move from Manassa to Creede, to Antonito, and then to Alamosa. In Leadville, Hyrum earned four dollars a day working in the mines. When the job soured, they moved on to Montrose, where Celia opened a restaurant.

Eleven-year-old William, between washing dishes and shining shoes, began to fight with the town's toughs. His older brother Bernie taught him to bathe his face in beef brine to toughen it and to chew pine resin to strengthen his jaw.

In 1911, at the age of sixteen, young Dempsey left the family's new home in Utah to become a champion. The green pugilist would enter the toughest bars in the roughest mining camps and announce, "I can lick any man in the place." His high, squeaky voice and 130-pound frame drew some laughs, some takers, and some surprises. Dempsey felled many a sturdy miner.

The Denver Post sportswriter Otto Floto had arranged a series of bouts one evening for "Kid Blackie," as Dempsey billed himself, and he won them all. But afterwards, on the road to Grand Junction for a well-deserved steak dinner, they were stopped by masked gunmen who took the few hundred dollars Dempsey had made that evening. Dejected and hungry, they proceeded to the Grand Junction Hotel and ordered lavishly, with no idea how they would pay. Suddenly, Dempsey stared in disbelief at a group of men celebrating grandly at the next table. These were the very men who had robbed them. Dempsey leaped through the air and beat up the robbers.

In Cripple Creek, his brother Bernie was set to fight George Copelin, an ore shoveler and a good fighter. Losing his courage, Bernie called William to substitute for him and let him adopt his ring name, Jack Dempsey, which he'd borrowed from the great middleweight of the nineteenth century, Jack Dempsey the Nonpareil. The new Jack Dempsey won the fight handily and set his sights on bigger worlds.

But the next few years were hungry ones. Dempsey fought constantly for purses from $2 to $40. A trip to

The old peddler awoke from his deep slumber next to the potbellied stove, embarrassed and surprised. He apologized profusely to the woman who'd fed him and given him a warm blanket.

The peddler insisted Celia Dempsey of Manassa, Colorado, take whatever she wanted from his sack. Her charity in that bitter winter of 1894–95 deserved some reward, even if it was only secondhand wares.

Celia found nothing she could use among the combs and tin cups, but the tattered copy of *Life of a Nineteenth-Century Gladiator,* by the renowned bareknuckle fighter John L. Sullivan, caught her eye. Pregnant with the ninth of what would be her thirteen

New York in 1916 ended disastrously. He survived on the lunch he could get free by buying a nickel beer. His twenty-six knockouts meant nothing in New York.

Another New York newcomer, Damon Runyon, got him some fights, but Jack ended up with a heartless manager who threw him to the wolves in a Harlem mismatch. Jack returned to Utah, his ribs broken and his confidence shattered.

He found comfort in the arms of a dance hall prostitute sixteen years his senior. Her healing charms did the trick, and Jack married her. His family was shocked, but Celia did her best to educate Maxine to the joys of homemaking. The life was too slow for Jack's new wife;

the marriage withered, but Jack kept fighting.

His big break came in Toledo. Champion Jess Willard had barely lifted a glove since defeating Jack Johnson in a 1915 Havana bout. On July 4, 1919, the six-foot-six, 250-pound Willard decided to stage a patriotic show and whip this upstart from Out West.

Dempsey, at six feet one and 187 pounds, sporting oddly shaved sideburns and a deep tan, dropped Willard seven times in the first round with a viciousness boxing circles hadn't seen for some time. The battered, helpless Willard refused to leave his corner for the fourth round. Jack Dempsey, the Manassa Mauler, had finally arrived.

DAMON RUNYON

Long before television microwaved the news into a brown-and-serve package, Americans relied on hard-boiled newspaper reporters to be their eyes and ears. In the heyday of newspaper journalism, Damon Runyon stood—or slouched—with the best of them. His career sandwiched a slice of life Out West between two Manhattans, spanning forty years and seventy million words. Damon Runyon took the news out of the parlors and government offices and put it back on the street where it belonged.

William Renoyan and his family left Pennsylvania in 1852, bound for California. They got as far as Kansas, where they helped found the town of Manhattan. There, son Alfred Lee was born. Around that time the family's French name was Americanized to Runyan.

Alfred Lee's first and only son, Alfred Damon, came along on October 3, 1880. The boy's mother, Elizabeth Damon Runyan, suffered from tuberculosis. The family relocated to Pueblo, Colorado, in an attempt to improve her health, but she died before her son was eight. His two sisters returned to Kansas to be raised by Elizabeth's family, while father and son stayed to make their way in the frontier town.

The two shared a bed in a boarding house. The boy slept in it at night while his dad helped print *The Pueblo Chieftain;* the father slept in it during the day while his son terrorized the city. By age nine, the young tough had carved his initials in the steeple of the adobe St. Peter's Church at Seventh and Main and had smoked a cigarette downtown in broad daylight. He'd also told a few tall tales, earning the distinguished sobriquet the "boy storyteller of Pueblo."

Young Alfred started putting his words on paper around age thirteen. His first published work appeared in *The Pueblo Advertiser* while his father was working there as temporary editor. At the tender age of fifteen he was working for Colonel W. B. McKinney at *The Evening Post,* covering stabbings, lynchings, and other sordid events. Because of a newspaper typo, his first byline read "Runyon," but it looked good to the lad so he adopted it on the spot.

At age seventeen, Runyon lied about his age and saw two years of action in the Philippines against Spain. After the war, he worked for a time writing sports for *The Denver Post,* then did a stint with *The San Francisco Post,* where he witnessed the great earthquake of 1906, before returning to Colorado with the *Rocky Mountain News.*

By age thirty, Runyon was ready for the bright lights of Broadway. But he had been smitten by a society doll working at the *News* named Ellen Egan and he wanted to get married before he left. Runyon showed up at the Denver Press Club to ask steward Jimmy Wong for a loan. Wong agreed to lend him $250, but only if Al promised to abandon the demon rum. The reporter agreed, married Ellen, repaid Jimmy, and never took another drink. Folks say that might be why he had a daily intake of three packs of cigarettes and up to sixty cups of coffee.

His first Big Apple gig was as a sportswriter for Hearst's *American.* Editor Harry Cashman dropped "Alfred" from his byline, saying three names were too many. Runyon was assigned the best news and sports stories in the most exotic locations. He covered the

Damon Runyon with steward Jimmy Wong
at the Denver Press Club, 1910.

heavyweight bout between Jack Johnson and Jess Willard in Havana in 1915 as well as the exploits of General John J. "Blackjack" Pershing against Pancho Villa in Mexico.

But his real love was the pulse of the city. In the Roaring Twenties he was keeping Ellen in expensive clothes in a fine apartment with their two boys. He was never home, however, preferring to soak up the nightlife and its seedy characters who would later work their way into his short stories. Ellen divorced him in 1928.

His was a natural enough progression into fiction, and even during the Great Depression Runyon's gangster tales appeared in national magazines, including *Collier's, Cosmopolitan,* and *The Saturday Evening Post.* A 1931 collection of his writings, *Guys and Dolls,* sold over a million copies.

His outlaw fiction was an unexpected hit. No one could turn a phrase like Damon Runyon. For example, here is how he set up his short story "Dark Dolores":

Waldo Winchester, the newspaper scribe, is saying to me the other night up in the Hot Box that it is a very great shame there are no dolls around such as in the old days to make good stories for the newspapers by knocking off guys right and left, because it seems that newspaper scribes consider a doll knocking off a guy very fine news indeed, especially if the doll or the guy belongs to the best people.

Then Hollywood wanted him. Sixteen of his stories were sold to the movies. Runyon was at his zenith, ricocheting between coasts, pounding out a syndicated column, and having a ball. His investments included hunting hounds and fast horses. He owned some championship boxers, a string of Manhattan bachelor pads, and a $75,000 Miami Bay villa next door to his gangster buddy Al Capone. In 1932, he strolled down the aisle again, this time with beautiful Spanish dancer Patrice Amati.

With the coming of the 1940s, Runyon was as hot a ticket as he'd ever been. But he developed throat cancer. Narrow pipes replaced his larynx and trachea, and all his communicating was done by typewriter or pencil. Patrice left him for a younger man. He spent his days and nights with Walter Winchell and other friends, carousing at the Stork Club. On December 10, 1946, "a large and distinguished looking figure, in beautifully tailored, soft white flannels," the vision of death he had seen during his throat surgery, visited Alfred Damon Runyon in Manhattan's Memorial Hospital. This time the two left together.

As specified in his will, the ashes of Damon Runyon were flown high over New York City in a plane piloted by World War I ace Eddie Rickenbacker and scattered over the Broadway he loved.

GENE FOWLER

For Gene Fowler, the world had no constraints. In a time before there was such a term as "color commentator," Fowler pounded out the color for story after story on his typewriter. His legend grew in the most fertile soils: booming Denver, New York of the Roaring Twenties, and the golden age of Hollywood. Where rumpled, gin-soaked reporters breathed hard-boiled prose, Fowler was the king. But while many alcohol-sodden newsmen sank into obscurity, Fowler became a celebrated screenwriter and author—and, not incidentally, a raconteur and adventurer whose own exploits beat anything he wrote about.

His father, Charles Devlin, left home just before Gene was born in Denver on March 8, 1890. Gene didn't see him again until he finally came down out of the hills thirty years later. His mother, Elizabeth Wheeler, remarried when Gene was four. Young Gene liked Frank Fowler's name but didn't like him, so, the story goes, he kicked him in the head and went to live with his grandmother. What followed was an unruly youth— from tagging after Buffalo Bill in the streets at age six to delivering a valentine to a prostitute at thirteen.

The wildness continued through high school and into his career in journalism. Fowler yearned to be a sportswriter, but he could never convince an editor that that was where his talent lay. His news apprenticeship came during Denver's heyday, and he recorded events of the day with his original, down-to-earth eccentricity. Fowler started at the *Denver Republican* in October 1912. After that paper's demise a year later, he drank himself into a stupor at the Press Club, only to awaken two days later sitting at a typewriter at the *Rocky Mountain News*. He served as city editor for a time, keeping a pistol on his desk to awaken hungover reporters who dared to fall asleep on the job. More than once the bustling clatter of the city room was interrupted by the sound of a blank cartridge going off near a hapless cub reporter's ear.

Fowler soon moved to *The Denver Post*, where he joined Harry Tammen and Frederick Bonfils, whose story he would tell so masterfully in *Timber Line*. Says H. Allen Smith in his biography *The Life and Legend of Gene Fowler*, "They were flat-out pirates, and Fowler was an accredited member of the pirate crew." Reasons for his switch to the *Post* were many, the most reliable being that he was hopelessly lusting after a new staff cartoonist at the *Post*. Women figured heavily throughout Gene's life, whether he was joining the Salvation Army in an attempt to bed the band director's daughter or (according to writer Westbrook Pegler) keeping Queen Marie of Rumania horizontally occupied during her long American tour.

At age twenty-six, Fowler married Agnes Hubbard, a city hall worker whose first contact with the brash young writer was a mad chase through her place of business with her pursuer yelling, "Whether you like it or not, you will be the mother of my children!" They were married at Denver's Red Rocks; he wore a coat borrowed from Jack Dempsey and they were chauffeured back to town in a racing car by a renowned gambler named Cincinnati.

Hired away by William Randolph Hearst's *New York American* in 1918, Fowler walked in his first day on the job and demanded the outrageous salary of $100 a week. Hearst liked him, so he got it. Six years later he was managing editor. Fowler captured the Manhattan of the 1920s, a time that he referred to as "a carnival spin of mass make-believe—the world's last brief holiday from fear." His books were selling well then, and his legend was far out of proportion by the time the lure of Hollywood moved him across the continent.

Time was spent in three basic areas: writing books,

Fowler scans the horizon for literary inspiration in this 1933 gag shot.

including his novel *Salute to Yesterday* and his excellent biographies, writing forgettable movies for incredible profit, and cavorting with his cronies in the Bundy Drive group. Their exploits are some of Hollywood's zaniest. Once, shortly after Pearl Harbor, John and Lionel Barrymore, W.C. Fields, and Fowler showed up at a Los Angeles recruiting office filled with liquid courage, demanding high-risk overseas assignments.

Fowler died in 1960 at the age of seventy, while working on *Skyline*, a companion to *Timber Line* about his New York days. Agnes was with him, and his three children—Will, Jane, and Gene Jr.—were close by. During his life, he'd made over a million dollars and given

a good portion of it away to friends and friends of friends. His spirit was about as free as spirits get, but there was never an unkind word about Gene Fowler. His nuttiness was met with love, something he never could quite figure out. Ring Lardner called him "the last of the bison"; to Ben Hecht he was the "gilded pauper"; Lucius Beebe's tag was "last of the troubadours."

Full of honesty and spunk, Fowler once said, "I now know that a man who dares laugh or pursues his own simplicities is bound to be kicked to death. This does not deter me." He was a man of his time, and when they both passed, we all were the losers.

The official Lowell Thomas photograph from NBC, 1938.

Since ancient times, travelers have been the prime source of information on distant lands and faraway cultures. But until the twentieth century, the world had never seen a traveler like Lowell Thomas.

The son of teachers Harry and Harriet Thomas was born on April 6, 1892, in Woodington, Ohio. Harry soon earned a medical degree and set up practice Out West near the Cripple Creek gold diggings in Victor, Colorado. When he wasn't mending mining injuries and the like, Harry was building his own three-thousand-

volume library, which he encouraged his son to use.

Young Lowell sold newspapers in the rough saloons and had a boyhood crush on his Sunday-school teacher and future speakeasy queen, Texas Guinan. His father insisted that he learn the art of elocution, reasoning that a man who could speak clearly would always have a place in the world.

The boom days ended and Lowell's family moved back to Ohio in 1907. After attending Northern Indiana University, he returned to Cripple Creek to report for and then edit a local newspaper. At age nineteen, he moved to Denver where he did some free-lance writing and earned more degrees from the University of Denver. Chicago was his next move, and there he entered law school and wrote for the Chicago *Journal*.

After uncovering a blackmail scheme against the city's top meatpackers, Thomas was off on an all-expenses-paid railroad trip to the San Francisco World's Fair. (The railroad furnished the passage in return for glowing reports.) He stopped in Denver long enough to have a marriage proposal turned down by a friend from college, Fran Ryan.

In San Francisco, he bought a movie camera to take on a trip into the Yukon where he filmed his first travel-ogue. He showed it to social groups in Princeton where he went to study constitutional law. President Woodrow Wilson named him to head a "See America First" campaign, but World War I intervened. Thomas got around to marrying Ryan, and they honeymooned in war-ravaged Europe.

In Venice, Thomas met General Sir Edmund Allenby and arranged to follow him to the Near East as a journalist. While haggling over the price of dates in Jerusalem, Thomas stumbled upon the biggest story of his life. Standing among a group of sheiks was a dashing blond, blue-eyed Englishman in robes of the desert. Thomas joined Colonel T. E. Lawrence's famous campaign against the Turks and told the world of its latest hero in his best-selling *With Lawrence in Arabia*.

Back home, his lectures with movies were in great demand. Thomas soon tired of touring and bought an estate in Pawling, New York, where he could write. Before settling down, he traveled in Afghanistan, Malaya, and Burma, collecting a wealth of exotic material to draw from. His second book, *Beyond Khyber Pass*, cemented his position as the country's favorite travel author. A millionaire at thirty-five, he would write over fifty books packed with adventure and intrigue.

Thomas had seen his first crystal radio set in 1923, the year son Lowell Jr. was born. Seven years later, Thomas entered broadcasting history. Someone had suggested to CBS head William S. Paley that Thomas might succeed newsman Floyd Gibbons. The show's sponsor liked Thomas but wanted to hear him in action.

On September 29, 1930, the assembled crew—writers, technicians, and other experts—went about the confusing business of putting the initial show together. Frustrated by delays and getting nervous, Thomas walked out at 4 P.M., bought a newspaper, returned at 6 P.M., strolled up to the microphone and said, "Good evening, everybody." When he had finished "telling" the news, he signed off with "So long until tomorrow," establishing a forty-five-year pattern.

Thomas modestly credited much of his popularity to his time slot before "Amos and Andy." As a newscaster, "I had the whole world to myself," he once mused. "Cronkite was nine, Brinkley was five, and Harry Reasoner was a two year old. The rest of them weren't even born." In 1935, he became the voice of *Movietone News* newsreels, and in 1940 he delivered the first televised newscast for NBC.

War reporting was his work in the early 1940s; during the final thrust in the Pacific, Thomas was heard from underground catacombs on the Philippine island of Luzon. Toward the end of the war, audiences heard their objective announcer nearly come apart while describing Nazi death camps.

In 1949, Thomas and his son traveled to Lhasa, the capital of Tibet, obtaining the first pictures and interviews with the teenage Dalai Lama. Returning home, a horse threw him on a mountain pass, shattering his leg and hip in eight places. Carried on a platform over two hundred miles of impossible road at fourteen thousand feet, Lowell recorded sixteen daily newscasts, sending the tapes ahead by runner.

His first television series, "High Adventure," began in the 1950s. On one show he met with a group of New Guinea cannibals just after they'd had a rival tribe for dinner.

Fran died in 1975 after a fifty-eight-year marriage, and CBS took Thomas off the air on May 14, 1976. A thirty-nine-week PBS series, "Lowell Thomas Remembers," came next. In 1977, he published the first of his two-volume memoirs and married Marianna Munn in Hawaii. In 1980, he delivered the seconding speech for Ronald Reagan at the Republican National Convention. On August 29, 1981, he died in his sleep at his Pawling home of a heart attack at age eighty-nine.

Lowell Thomas crammed centuries of living into one lifetime. He knew the world firsthand yet retained his down-home attitude, becoming the most famous globe-trotter since Marco Polo.

ANTOINETTE PERRY

Tony, c. 1908, in a Denver production.

How many people know that the illustrious Antoinette Perry was born in Denver? Encouraged by her wealthy family to follow her heart, she headed for the footlights Back East and one of the most distinguished careers in the American theater. Her professional debut came in Chicago in 1905 a few days before her seventeenth birthday. She appeared as Dorothy in *Mrs. Temple's Telegram.* Later in 1905, she made her New York bow in the same play at Madison Square Garden.

A major star at eighteen, she was the ingenue opposite David Warfield in *The Music Master.* The following year, she received rave reviews in David Belasco's *A Grand Army Man.* Then, at an age when most actresses are awaiting their first break, Antoinette Perry retired. The occasion was her marriage to Denver businessman Frank Wheatcroft Freauff in November 1909. At age twenty-one, Antoinette filed away her scrapbooks of playbills and photographs and resigned herself to a life of wedded bliss.

As the years rolled by, she watched as her husband attained a distinguished position in Denver's fledgling utilities business. President of Denver Gas and Electric Company, F. W. also was directly involved with the management of more than one hundred other power companies across the U.S. He had more credits after his name in the *New York Directory of Directors* than any other man. Then, on July 31, 1922, at the height of his success, he dropped dead after an attack of indigestion. *The Denver Post* called him the "Napoleon of Light" and referred to his wife simply as "his wife" in the page-one obituary.

There were several directions available to the thirty-four-year-old widow. An inheritance of well over a million dollars meant she could opt for a life of leisure or maybe take deluxe tours to exotic places. Instead, she decided to follow her heart back to the Great White Way.

On January 22, 1924, she made a triumphant return to the New York stage as Rachel Arrowsmith in *Mr. Pitt* at the Thirty-ninth Street Theater. Other roles, including 154 performances in the George S. Kaufman and Edna Ferber comedy *Minick,* came her way until 1928, when she began to direct plays instead.

Nineteen twenty-eight also marked the beginning of her association with producer Brock Pemberton, and the two could be seen lunching regularly at Sardi's. Hits like *Goin' Home* and *Hotbed* were modest, but the pair's

success was assured in 1929 when they unfolded the raucous comedy *Strictly Dishonorable* at the Avon.

The team of Pemberton and Perry was the toast of Manhattan. *Dishonorable* played 563 shows and was followed in succession by *Personal Appearance* and *Ceiling Zero*. In 1937, they presented a limited run of *Now You've Done It* by Denver playwright Mary Chase.

With the outbreak of World War II, Perry was named chairman of the board of the American Theater Wing, the theatrical war-service organization. Aside from her Broadway duties, she oversaw 1,500 auditorium programs, 350 legitimate plays, and 6,700 hospital-ward entertainment units that were comprised of over 40,000 volunteers. At its peak, the wing was sending out 1,200 entertainers a month to lighten the spirits of war-torn, weary GIs.

Still, these efforts weren't enough for Antoinette Perry. She felt that during the dark days of war America needed a good comedy, something uplifting, and maybe just a bit silly. Pemberton and Perry knew they had found the right vehicle when they read Mary Chase's whimsical play about a giant, invisible rabbit and his jovial bar buddy, Elwood P. Dowd. *Harvey* opened November 1, 1944, to a thunderous New York ovation. *Harvey* went on to have the fourth-longest run in Broadway history at the time, and won Chase a Pulitzer Prize.

Harvey was still running when Antoinette Perry, a Christian Scientist who refused all medical attention, died in her Park Avenue apartment on June 28, 1946, of a heart attack.

Broadway mourned, and friends were determined that this great woman of the theater not be forgotten. Producer Jacob Wilk had the idea for an Antoinette Perry award, and Brock Pemberton, always the showman, suggested that a series of annual awards be given in her name for excellence in the theater. The first Tony Awards were presented on Easter Sunday, 1947, in the Grand Ballroom of the Waldorf Astoria, and have been ever since—a fitting tribute to Denver's grand lady of the stage.

FLORENCE SABIN

Florence Sabin learned a lesson at age four that she called her introduction to public health. While enrolling her sister in a Denver grade school, her mother was shocked to see the children all drinking from the same dipper. To make matters worse, the teacher displayed a cavalier attitude—that was the way it had always been done. When Sabin returned to Denver over sixty years later to retire, she saw that same thinking was still in force. That would change soon enough as the doctor took her last health crusade Out West.

Florence Rena Sabin was born in Central City, Colorado, on November 9, 1871, the second daughter of miner George Sabin and his wife, Serena. Her mother died on Florence's seventh birthday from complications of childbirth. She and sister Mary lived briefly with a Chicago uncle, then with their grandparents while they attended Vermont Academy.

Florence graduated Phi Beta Kappa from Smith College in Massachusetts in 1893. By then, she had made up her mind to pursue a medical career, but lacked the necessary funds. Three years of teaching at Denver's Wolfe Hall followed, and then she entered Johns Hopkins University in Baltimore.

Sabin relished the tough curriculum. During a two-month obstetrics course, she was required to deliver nine babies. Also, there were professors who took pride in discouraging female students. Still, Florence came through with flying colors and even found enough spare time to develop a healthy interest in baseball.

Following her graduation in 1900, she spent a year as an intern, studying the anatomy of the lymphatic channels. Her findings were published in a respected medical journal, and she received a $1,000 prize for "the best scientific thesis written by a woman embodying new observations and new conclusions based on independent laboratory research."

Her distinguished career at Johns Hopkins continued for twenty-three years. In 1905, she became an associate professor of anatomy. In 1917, she became the first woman on the faculty as professor of histology. She authored the outstanding textbook *Atlas of the Medulla and Mid-Brain* and made a model of an infant's brainstem that was used as a popular educational tool. Besides her teaching responsibilities, she focused on the study of the origins and growth of blood cells. Her tuberculosis research provided radical new ways of thinking about the killer disease.

When the head of the department of anatomy died in 1917, Sabin was overlooked in favor of a male, though she was next in line. She was puzzled by this decision

Sabin in her Rockefeller Institute laboratory, c. 1928.

but refused to brood. In 1923, she became the first woman elected to the National Academy of Sciences. The next year she became the first woman president of the American Association of Anatomists. In 1925, she shocked Johns Hopkins when she resigned to take up a post as the first woman on the staff at New York's Rockefeller Institute of Medical Research.

Fifteen colleges eventually awarded her honorary degrees. *Pictorial Review* awarded her $5,000 in 1929 for "the most distinctive contribution made by an American woman to American life" in her field. In 1931, *Good Housekeeping* named her one of America's twelve greatest women (out of 2,786 nominations), along with Jane Addams and Helen Keller. Still, she was basically

unknown in Colorado. The Rockefeller Institute enforced its retirement policy in 1938, and Sabin returned to Denver to live quietly with her sister, now retired from the Denver school system.

In December 1944, *The Denver Post* reporter Frances Wayne was interviewing Governor John Vivian about the state's postwar plans. Wayne was incensed that not one of the committees had a woman on it. Sensing some unfavorable press, the governor asked Wayne for her suggestion. She told him that one of the greatest women in the world was living in Denver.

Vivian checked with his cronies, who told him Florence Sabin was a seventy-three-year-old spinster who had made a name for herself Back East. She was a sweet

old lady who would never think of rocking the political boat. Sabin was summoned from her Cheesman Park apartment, received the appointment to head the state's health program, then proceeded to turn the state upside down.

Sabin was disgusted by the results of a study conducted by the American Public Health Association. Most health laws had been passed in 1876 and left on the shelf to collect dust. Only five states had a worse diphtheria record than Colorado, only two had a higher death rate from scarlet fever. There was no uniform pasteurization for Colorado's milk and there were no regulations. Only 16 percent of the state's communities had modern sewage systems. From 1940 to 1945 there had been 8,245 preventable deaths from disease, over three times the number of Coloradoans killed in World War II.

Sabin's campaign was remarkable. Over a four-year period, she drove to every one of the state's counties at her own expense, speaking to civic groups. Her speech would always begin, "We think of our state as a health resort, yet we're dying faster than people in most states." When the 1946 elections rolled around, those in support of Sabin's healthy overhaul were the ones elected. In 1947, she stood proudly by as Governor Lee Knous signed her health bill into law.

On October 3, 1953, the pioneer lifesaver died of a heart attack while watching the World Series on television. Called "the most eminent of women scientists," her life had been one of total dedication. In 1958, Colorado placed a statue of Florence Rena Sabin in its niche in Washington's National Statuary Hall, a space that had been vacant for nearly a century. It was a fitting tribute to the state's woman of the century.

CLYDE TOMBAUGH

The 1925 Burdett (Kansas) High School yearbook made an astounding prediction. The prophecy for graduating senior Clyde Tombaugh, nicknamed "Comet Clyde" because of his preoccupation with the cosmos, is simple and direct: "He will discover a new world." A mere five years after this lighthearted forecast, the ex-farmboy would do just that, rocking the world with news of a mysterious distant cousin found twinkling in the skies.

Clyde William Tombaugh was the sixth child of farmers Muron and Adella Tombaugh in Streator, Illinois, born on February 4, 1906. His interest in the heavens started early with a telescope borrowed from his uncle, Lee Tombaugh. At twelve, he ordered a 2½-inch, 45-power achromatic lens from Sears.

In 1922, he moved with the family to a wheat farm in Burdett, northeast of Dodge City. By day he worked with a pitchfork, but by night he was lost in the stars.

Tombaugh subscribed to astronomy magazines and devoured every library book on the subject. The year after his graduation, he constructed a high-powered telescope, grinding his own lenses, and even excavating his own underground laboratory to test his creations. He sold his first telescope to Uncle Lee; with the money he constructed a 9-inch telescope strictly for the purpose of sightseeing on Mars.

The Tombaughs had no money for college, but a practical education opportunity arose after the self-taught astronomer sent some drawings of Mars and Jupiter to the Lowell Observatory in Flagstaff, Arizona. Strapped for funds, the observatory was in need of a gifted amateur to conduct experiments. The hours would be long, the pay low, but it would be great hands-on experience, they promised. Tombaugh was delighted. Equipped with sandwiches from Adella's kitchen and the advice of his father ("Make yourself useful and beware of easy women"), the twenty-two-year-old climbed aboard the train on January 14, 1929.

The astronomer Percival Lowell had founded his observatory in the 1890s. He was criticized by the scientific community because of two radical beliefs. One held that the "canals" of Mars were built by intelligent beings; the other maintained that there had to be a ninth planet in the solar system, "Planet X" Lowell called it, because something was causing a gravitational pull on both Uranus and Neptune. He searched for Planet X for thirteen years, never found it, and died a disappointed man in 1916. His wife contested his will, which put the observatory's planet search on hold for another thirteen years.

In February 1929, a 13-inch objective lens arrived in Flagstaff. It was a vital tool in the search for the missing planet. Tombaugh's job was to expose what the telescope saw on photographic plates, then compare the

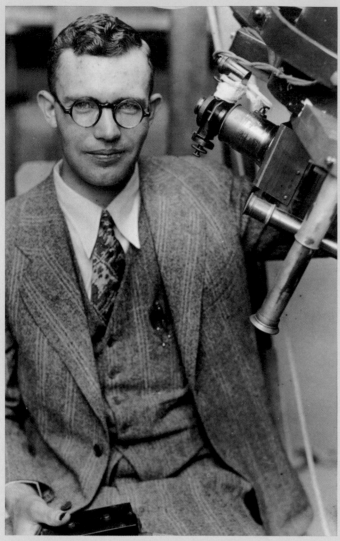

Clyde Tombaugh, two years after discovering the planet Pluto.

on January 21, 23, and 29 when he saw *it*. Dangling in the firmament, over 3.5 billion miles from the sun, was a tiny planet. Referring to other exposures, he tracked its movement which was too slow for a common asteroid. Strolling into the office of the man who had hired him, Tombaugh said, "Dr. Slipher, I have found your Planet X."

Slipher advised young Tombaugh to keep the discovery a secret until more evidence could be gathered. That night was too cloudy for observation, so Tombaugh went to see Gary Cooper in *The Virginian*. The next evening was clear, and photos showed the planet, on course, having shifted slightly to the west. A month of checking followed, all of which confirmed the twenty-four-year-old's amazing discovery.

On March 13, 1930, the 149th anniversary of the discovery of Uranus and the 75th birthday of Percival Lowell, the announcement of the trans-Neptunian planet was made public. Clyde Tombaugh became the only living person to have discovered a planet. The news caused an incredible sensation.

Name suggestions poured in. Mrs. Lowell desired the planet to be called "Zeus," then "Lowell," and finally "Constance" (her name). The scientific community recommended "Minerva" and "Cronus." "Pluto" was first suggested by eleven-year-old Venetia Burney of Oxford, England, in honor of mythology's god of the lower world. It seemed a perfect name for the most remote planet.

Internationally recognized, Tombaugh was rewarded by the Lowell staff with an assignment to duplicate the impossible and find another planet. He never did, but in the process of searching he discovered a globular star cluster, a cloud of galaxies, five open galactic star clusters, one comet, and 775 asteroids. On his photographic plates he marked 3,969 asteroid images, 1,807 variable stars, and 29,548 galaxies. His discoveries earned him a scholarship to the University of Kansas, where he picked up a master's degree in astronomy and a bride, Patricia Ilene Edson.

Tombaugh's exciting life, recounted in his *Out of the Darkness*, included several research projects that helped in man's ventures into space. He started the astronomy department at the University of New Mexico in 1961, retired as a full professor in 1973, and today is professor emeritus at age eighty.

Pluto continues its lonely orbit, which takes 248 years to complete, a frigid (minus 373 degrees) twilight world that is nearing its perihelion—the point at which it passes closest to the sun—in 1989.

plates in search of planetary movement among the tiny specs of stars. (Sometimes there were as many as half a million.) Using a Blink-Comparator, he literally blinked images back and forth, scanning across millions of distant suns.

The discouraging search continued into summer, helped none by visiting astronomers who scoffed at the project. Said one, "Young man, I am afraid you are wasting your time. If there were any more planets to be found, they would have been found long before this." Perhaps he had a point. Sir William Herschel had discovered Uranus from England in 1781; Johann Galle had found Neptune from Berlin in 1846. Perhaps there were only eight planets. Tombaugh took a break in July, went home to Kansas, then returned to his Arizona haystack to search for the needle.

On February 18, 1930, he was blinking plates exposed

WOODY GUTHRIE

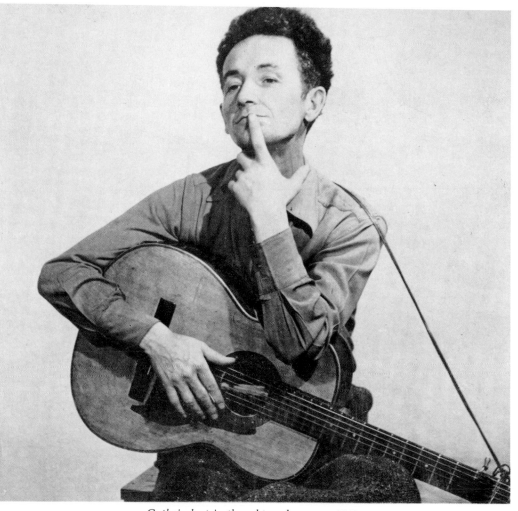

Guthrie lost in thought and song, c. 1940.

America's greatest troubadour, Woody Guthrie, defies simple description. In the guise of a hobo Okie, he wrote more than a thousand songs during his life as he ricocheted between triumph and tragedy.

Woodrow Wilson Guthrie was born in Okemah, Oklahoma, on July 14, 1912. His father, Charley, tried a variety of careers to support his wife, Nora Belle, and their five children, dabbling in real estate and home-town politics and even writing an antisocialist column for the local newspaper.

Woody's childhood was one disaster after another. Before he was twelve, he saw three homes destroyed,

two by fire and another by a tornado. His mother suffered from a rare, undetected nervous disorder, Huntington's chorea, and was perceived as a madwoman. When Woody's sister, Clara, was burned to death in an accident at age fourteen, his mother was blamed. Eight years later, another fire nearly killed Charley while he slept. Nora Belle was taken to the state hospital in Norman, where she eventually died.

In the summer of 1927, Woody was on his own. Independence agreed with the boy: with a harmonica given to him by a black shoeshiner and all the clothing he could fit into a knapsack, he became a teenage, freight-hopping hobo.

Two years later, he reunited with his father in Pampa, Texas. An uncle taught him to play a beat-up guitar, and Woody collected spare change serenading in pool halls and barbershops. He also started making long trips to the local library, soaking up knowledge like a great sponge. Outside, clouds of dirt were forming what would come to be known as the Dust Bowl; inside, its most famous figure completed his education.

On October 28, 1933, he married Mary Jennings, a Roman Catholic, to the dismay of both families. Professionally, Woody had graduated to honky-tonks and barn dances, supplementing his income as a sign painter.

In the summer of 1936, sick of the dust and Pampa, the singer left home, commemorating the break with a ballad, "So Long, It's Been Good to Know You." Riding in boxcars and thumbing were his forms of transportation as he joined the Great Depression migration, traveling up to Ohio, then back to Denver's skid row, where he played for quarters in Larimer Street dives. Eventually, he made it to the Okies' promised land, Los Angeles.

An audition with cousin Jack Guthrie led to a daily radio show over station KFVD. Jack didn't stay long and was replaced by Maxine Crissman, better known by his professional name, Lefty Lou. The show was a folksy smash, with fan letters pouring in at the rate of a thousand a month.

The plight of the people developed into a major theme for Guthrie as he became more and more political. For the *People's World* he wrote a regular column, a light mixture of common sense and communism. He and actor Will Geer became regular performers at crowded labor camps and smoky union halls. ("Oh you can't scare me," he sang, "I'm sticking to the union.")

Soon, Guthrie was headed for New York City, where he lived for a time with the Geers, then with Huddie "Leadbelly" Ledbetter. It was 1940 and Irving Berlin's popular "God Bless America" irked him a great deal, the way it suggested that Providence would take care of mankind's problems. In a flophouse near Times Square, Guthrie penned his stirring answer, an ode to the American spirit called "This Land Is Your Land."

Sponsored by folk-music archivist Alan Lomax, Woody was put to work recording his songs for the Library of Congress and posterity. RCA released his *Dust Bowl Ballads,* bringing him national attention and $300. He began writing for the *Daily Worker* and became the star of CBS radio's "Back Where I Come From," and other shows.

The remainder of his performing days he spent touring solo, as well as with Pete Seeger and with the Almanac Singers, wherever he felt oppression needed to be fought. Mary tired of his vagabond spirit, and his marriage dissolved in 1941. He began a new romance in 1943 with Marjorie Greenblatt, a Martha Graham dancer. The same year, his autobiography, *Bound for Glory,* was published to wide acclaim.

World War II gave him new enemies to sing about. After service with the merchant marine, he was drafted into the army on V-E Day, May 8, 1945. He married Marjorie as soon as he was discharged but was struck by another tragedy in 1947 when their daughter Cathy Ann was killed in an apartment fire on her fourth birthday.

Woody extended his career into the 1950s, but the hard luck was far from over. In 1955, he was stricken with the same affliction that killed his mother and was in and out of hospitals for the rest of his life. The folk resurgence in the 1960s brought him the recognition he never got during his heyday.

According to his son Arlo, quoted in Joe Klein's definitive 1980 biography:

When he can't write or talk or do anything at all anymore, he hits it big. Kids are singing "This Land Is Your Land" in school and people are talking about making it the national anthem. Bob Dylan and all the others are copying him. And he can't react to it. . . . He's sitting there in a mental hospital, and he knows what's going on, and he can't say anything or tell anyone how he feels. It's Shakespearean.

Woody Guthrie's misery ended on October 3, 1967, at Creedmoor State Hospital in Queens, New York. His legacy was his music—greats such as "Roll On, Columbia," "Oklahoma Hills," and "Pastures of Plenty." He had despised poverty and had championed the wronged. A complex genius of the road, Woody Guthrie had reflected America in his songs, with pain and with honesty.

BOB WILLS

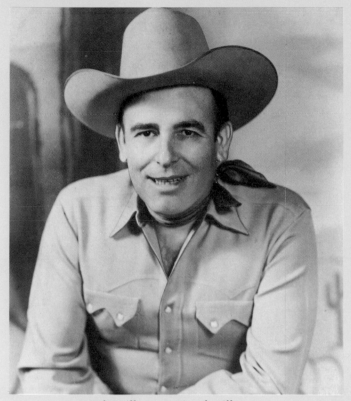

A Bob Wills promotional still, c. 1951.

Bob Wills was an American original. A cigar-chomping, foot-stomping fiddler from deep in the heart of Texas, he did things with Western music that simply had not been done before. In the process, he developed Western swing, a lively hybrid of musical influences that had the effect of setting feet in motion.

James Robert Wills was born on March 6, 1905, near Kosse in Limestone County, Texas. The first of ten children, Jim Rob learned to play the fiddle from his father, John, who had learned the tricky instrument from his father many years earlier. Fiddles (called "the devil's instruments" because they made folks want to shake a leg) were frowned upon in the Bible Belt, so when a living could not be made through music, Papa John supplemented the family income as an itinerant cotton picker. Living in the dusty migrant camps scattered across Texas, young Wills absorbed a wealth of ethnic musical culture—from Mexican fiesta tunes to the blues of the black man.

Wills started playing the mandolin because his father needed a backup. Jim Rob was forced to change instruments, however, at a barn dance in Turkey, Texas, in

1915. His father lost track of the time during a prolonged visit to the corn-liquor wagon, while his ten-year-old son waited nervously inside the hall. The natives were growing increasingly restless. Finally, Jim Rob picked up his father's fiddle and "preached his first sermon." When John finally made it inside, he was astounded and proud.

Through his teens, Wills played with the family and other bands at dances and on local radio stations. He changed his name to Bob while fiddling blackfaced with a traveling medicine show that simply had too many Jims. During the summer of 1929, he and guitarist Herman Arnspiger formed the Wills Fiddle Band in Fort Worth. A year later they were joined by a singing cigar salesman, Milton Brown. The trio began playing over Fort Worth's KFJZ radio station as the Aladdin Laddies on a program sponsored by Aladdin Lamps. Next, the Laddies were heard statewide over the Texas Quality Network originating from WBAP in Fort Worth. The Burris Mill and Elevator Company, makers of Light Crust Flour, picked up the sponsorship, and on January 1, 1931, the Light Crust Doughboys made their debut. Country music historians point to that date as the birthday of Western swing.

The Doughboys cut their first records for the Victor label the following year, but all was not well within the group. W. Lee O'Daniel of the Burris Company did not condone Wills's drinking and carousing, and the furious fiddler was given the cowboy boot in August 1933. Wills took the group's latest vocalist, Tommy Duncan, and banjo-playing Johnnie Lee Wills and formed Bob Wills and the Texas Playboys.

A brief gig on Oklahoma City's WKY radio station was cut short when a vindictive O'Daniel bought the air time, forcing the Playboys out. The group next journeyed to Tulsa, where they began a twenty-four-year relationship with station KVOO. The band quickly became the most popular music makers in the Southwest.

Swing, the kind of music popularized by Glenn Miller and Benny Goodman, was the big-band rage of the day. In order to make Western music jump, Wills did the unheard of: he added drums and a brass section. Combined with traditional instruments including piano and steel guitar, the new sound took Western music from its home on the range and put it in the dance hall.

The group had reached its zenith by 1940, when Wills released a vocal version of "San Antonio Rose," a song

he had written as an instrumental piece in 1938. "Rose" sold a million copies, then was recorded by Bing Crosby, who sold another million. Wills switched recording labels to Columbia, and the group appeared in ten Hollywood films.

World War II would have the same effect on Western swing that it did on the big bands. One by one, the Playboys went off to war. Wills enlisted at age thirty-eight in 1942, but was released the following July. Various versions of the Playboys played through the 1940s and into the 1950s, but the prewar magic was never recaptured. By the late 1950s, music lovers were combing their hair like Elvis, and Western swing sounded to them like a relic from a bygone era.

In 1968, Wills was inducted into the Country Music Hall of Fame. Texas honored him with a special day on May 30, 1969; the very next day he was paralyzed by a severe stroke and confined to a wheelchair.

It was not quite the end of the trail, though. By the early 1970s, groups such as Asleep at the Wheel were rediscovering Western swing as well as its forgotten patriarch. In 1973, Wills picked a roster of Playboy all-stars, and with superstar Merle Haggard, mapped out plans for a multidisc package called *For the First Time.* On the first day of the session, Wills had another stroke and never regained consciousness. The album was recorded as scheduled and sold well. Seventeen months later, on May 13, 1975, Wills died in a Fort Worth rest home. The Playboys re-formed under the direction of Leon McAuliffe and Leon Rausch and in 1977 were named the Country Music Association's Instrumental Group of the Year.

Today, Bob Wills is revered in country-music circles. Cool before country was cool, Wills brought a new sophistication to what had been referred to as "hillbilly" music and in the process became the genre's first swinger.

MARY COYLE CHASE

Toward the end of World War II, folks were in dire need of a good laugh. Not a naughty snicker or a spiteful joke, just a joyful bit of silliness to counteract the grim times. Denver playwright Mary Coyle Chase anticipated that need, and when her creation, an overgrown invisible bunny, took to the Broadway stage, she was nearly trampled by the success.

Denverites Frank and Mary Coyle celebrated the birth of their daughter on February 25, 1906, and raised her on love and Irish folktales. At age eleven, Mary attended a production of *Macbeth* at the old Denham Theater and was absorbed by the words it took to make a great play. She was graduated from West High School at sixteen and went on to attend the University of Colorado and the University of Denver.

Employed by the *Rocky Mountain News* in 1924, the young female reporter quickly earned a reputation for outrageousness as well as for her writing skills. Once, she debunked the superstition that disaster would befall if a woman entered a mine or excavation site: disguised as a man, she ventured into the incomplete Moffat Tunnel and emerged unscathed. For one feature, she took truth serum and managed to lie. When no photo could be found for a sensational divorce story, Coyle boldly swiped a tennis-team picture that included the desired subject from the wall of the Denver Country Club. Once outside, she commandeered a passing coal truck for a speedy trip to the newsroom.

Three years after her 1928 marriage to reporter Robert Chase, she was unceremoniously fired for a practical joke. The *News* had distributed some charity baskets for Christmas. Mary phoned the city editor, and in her best Irish brogue, complained mercilessly about "wormy apples." She was reinstated, but soon left, by choice, to freelance and raise three sons, Michael, Colin, and Jerry.

By 1934, she was writing plays. Her first, *Now You've Done It,* flopped on Broadway in 1937. A second was never produced; and her third, *Sorority House,* culled from her Boulder days, was sold to Hollywood for $2,500.

Her typewriter continued to produce flops until inspiration struck one chilly morning in 1942 when she saw a woman walking to a bus stop. Chase was not acquainted with the woman, but she knew her story. "She was a widow who had worked for years to send her only son through college," Chase recalled later. "The day I looked at her, her boy had been dead about two

months, killed in action in the Pacific. I asked myself a question: could I ever possibly write anything that might make that woman laugh again?"

The question haunted Chase for three months, until one morning she awoke from a strange dream. In her sleep, she had seen a psychiatrist pursued by a great white rabbit. She remembered her mother's story of the *pooka*, a large fairy who took the form of an animal and was visible only to the person who believed in it. Fueled by cigarettes and coffee, Mary Chase dropped into a writer's trance that lasted nearly two years. In the summer of 1944, *The White Rabbit* was complete.

She mailed the manuscript to the producer Brock Pemberton, in New York, who had overseen her work seven years previously. A few nights later, while Mary was reading a bedtime story to her sons, Pemberton called with praise and promised a production to be directed by Antoinette Perry, formerly of Denver.

The photo that ran in the press when Mary Coyle Chase won the 1945 Pulitzer Prize.

Comedian Frank Fay, rebounding from a bout with the bottle and a disastrous marriage to Barbara Stanwyck, was cast in the role of Elwood P. Dowd, a likable alkie who meets a 6-foot-1½-inch rabbit underneath a streetlight on Fairfax (which might have been Colfax). For the Boston opening of the renamed *Harvey*, Chase wore a borrowed dress and clutched a note from her husband: "Don't be unhappy if the play does not succeed. You still have your husband and your three boys, and they all love you." She was well prepared for failure, but success was another matter.

Fay jokingly chastised the author as she fretted, calling her a "dumb Denver housewife." Said Leo Gaffney in the *Boston Record*, "This is a play with a spiritual message in farce terms." With that, the big white rabbit was ready for the Great White Way.

Opening at the Forty-eighth Street Theater on November 1, 1944, *Harvey* was a sensation. The critics raved, complaining only of aching ribs from too much laughter. During the four-and-a-half-year run of 1,789 performances *Harvey* became one of the most popular comedies of all time. Joe E. Brown starred in a British version. Numerous studios bid for the screen rights, won by Universal with the first million-dollar bid in history. On May 7, 1945, Mary Chase became the first Coloradoan to win a Pulitzer Prize.

Back in Denver, the sudden fame put Chase in a bittersweet fishbowl. Once she awoke from a nap to find three strangers who had wandered in to meet her. In recalling these turbulent days for *McCall's* in 1952, she wrote: "Most people believe . . . that in this world there is a magic room, papered with money, lit with fame, resounding with the sweetest music of all, piped from heaven like Muzak; that in this room is the life glorious and no pain. They wonder how you got in there while they're kept out. Most people believe this as a fact and yet call a six-foot white rabbit pure fantasy."

Though her life was never the same, Chase did manage to keep her sanity. She saw her masterpiece become a successful motion picture with James Stewart and made certain it was never turned into a musical or television sitcom. She wrote the mildly successful *Mrs. McThing*, starring Helen Hayes, and explored the world of teenage boys in *Bernadine*, which also found its way to Hollywood.

"The greatest unacclaimed wit in America," as Dorothy Parker had called her, died of a heart attack at her Denver home on October 20, 1981.

Mary Chase had made a sad world laugh. Though *Harvey* was imaginary, his effect on Mary Chase and the rest of us was very real.

FRED HARMAN

Harman at work in his Pagosa Springs studio.

The Sunday funnies were a safer place to ride thanks to the efforts of Red Ryder and Little Beaver. Red was a square-jawed, flame-haired good guy who never swore or smoked. His cohort, a prairie-wise Navajo boy, spoke pidgin English while bamboozling the meanest villains this side of Dick Tracy's enemies. This memorable duo claimed to be from Rimrock, Colorado, but they were really a product of the fantastic imagination of Fred Harman.

Fred Harman, Sr., was a Missouri farmboy-turned-lawyer-turned-rancher who found his way to Colorado and a cavalry post called Fort Lewis (in modern-day Pagosa Springs). On a trip back to Missouri in 1900, he met Birdie Olive Walker of Ohio and married her soon after. Fred Jr. was born in St. Joseph, Missouri, on Febru-

ary 9, 1902. At age two months, his family moved Out West.

The newest Harman learned ranch life at an early age. Brothers Hugh and Walker came along, and the three often spent long winter hours drawing at the kitchen table. A relative sent one of Fred's sketches to the St. Joseph *News Press,* and at age six, he was a published artist.

The Harmans moved to Kansas City in 1916. Quitting school to fight the Kaiser, Fred ended up "guarding pipes and reservoirs to save Kansas City's precious water" in the Missouri Home Guard.

The following years saw Harman bouncing between cowboying in Colorado and working as a pressman's helper for a Kansas City newspaper. A visit to the

paper's art department convinced Fred that there was some "easy money" to be made.

After another summer in the Rockies, Fred was back working as an artist for the Kansas City Filmad Company, drawing silent movie slides for thirty dollars a week. After a year he and another staff artist, Walt Disney, quit Filmad, rented a studio, a movie camera, and a Model T and went into business. Times were tough, and the company folded. Walt headed for Los Angeles to start another Mickey Mouse operation, and Fred was back in the saddle again.

Things began looking up in 1924 when mail call brought a job offer from the Artcrafts Engraving Company of St. Joseph, which produced catalogs of Western gear. Fred spent long hours drawing every conceivable type of accessory, from boots to bridles. On June 5, 1926, he married Lola Andrews; Fred III was born in May 1927, on the day Lindbergh landed in Paris.

Fred's brothers had joined his ex-business partner as Hollywood animators. Disney invited Fred for a tour of his studio in the early 1930s, but Fred chose not to follow the trail of the movie cartoonist. After the reunion, however, wheels were whirring in Fred's head. If Walt could do all this with a mouse, what couldn't Fred do with his experience?

While he worked in the art department of Buckbee-Mears in St. Paul, Minnesota, in 1934, Fred developed a newspaper strip called "Bronc Peeler and Little Beaver," but it never really clicked.

It was not the end for Fred Harman, however. While in New York City in September 1938, he showed some ideas to the Scripps-Howard newspaper syndicate. Little Beaver was still there, but Bronc had a new name: Red Ryder.

On November 6, 1938, the first Sunday strip appeared across the country. In it, Red adopted ten-year-old Little Beaver after an accident had killed father Chief Beaver, then broke up a stagecoach holdup. Western funnies

fans were ecstatic. In March 1939 the daily strip was launched when Red found this note: "Got a heap of trubble down Crater Creek. Hoap you help, Zeke." The "happy-go-lucky, straight-shooting, two-fisted wanderer of the West" was off and running.

Fred's characters appeared in 750 newspapers. He bought a ranch near Pagosa Springs, Colorado, and began dreaming up one predicament after another for his heroes. Red and L. B. lived on a ranch with Red's aunt, the Duchess, and dealt with the worst: murderer Acc Hanlon, sexy train robber Donna Ringo, and the terrible twins Oliver and Bolivar. The adventures offered scenic authenticity, set in a time somewhere after the last Indian uprising and before the Tin Lizzy.

The spinoffs made Fred a wealthy man. The radio version gunned down the competing Lone Ranger series in the ratings. Over forty films were made, the most popular Red was actor Wild Bill Elliott and the best Little Beaver was Robert Blake. Perhaps Harman's most lucrative bit of wrangling came when Red Ryder teamed up with Daisy to endorse air rifles and BB guns. All were happy over the merger except America's sparrows.

Fred kept the strip going until 1964, when he decided "the trail was getting shorter" and he wanted to capture the West on canvas. Artist Bob McLeod tried to keep Red riding his trusty Thunder, but it didn't work; Red and Little Beaver retired unceremoniously in the late 1960s. Fred used his later years to produce over four hundred oils, which alone would have guaranteed his reputation as one of the West's foremost artists. A victim of emphysema, he relocated to Phoenix in the late 1970s and died there on January 2, 1982.

Today, Fred III runs the Fred Harman Art Museum at his father's Pagosa Springs studios, where the public can see the famous works. Every Fourth of July the city gears up for the Red Ryder Roundup. For Fred Harman, it was a wonderful ride. You betchum, Red Ryder!

JACKSON POLLOCK

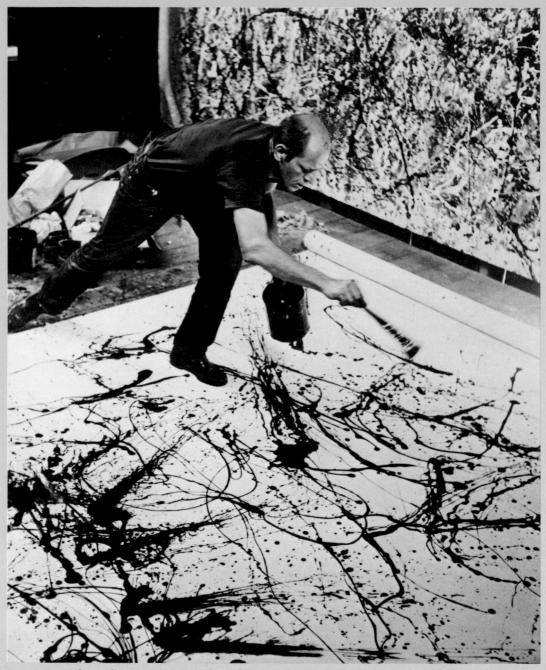

From the wide-open spaces to the wild inner spaces. Pollock at work. © Hans Namuth.

Jackson Pollock's link with the West was brief but important. The fifth son of LeRoy and Stella May Pollock was born in Cody on January 28, 1912, in the dead of a bitter Wyoming winter. His parents were of Scottish and Irish extraction. Paul Jackson Pollock was ten months old when his family made a Thanksgiving Day move to San Diego, California.

His childhood was divided between California and

Arizona. In 1913, the family again moved, this time to Phoenix, where LeRoy purchased a thirty-acre truck farm. In 1917, they were back on the West Coast where Jackson started grade school in Chico, California.

Young Jackson's early interest in art came from his oldest brother, Charles, who composed layouts for the *Los Angeles Times.* The boy's art classes began at age ten at the Otis Art Institute and lasted nearly two years. By 1929, Jackson was already showing signs of rebellion. He was booted out of Manual Arts High School in Los Angeles for helping publish and distribute a leaflet criticizing his school's emphasis on sport. Later that year, he wrote brother Charles, who was in New York studying with Thomas Hart Benton: "As to what I would like to be. It is difficult to say. An artist. . . . People have always frightened and bored me."

Pollock was reinstated briefly at Manual, but in September 1930, he joined brothers Charles and Frank in the Big Apple and began taking $12-a-month art classes from Benton. The artist saw promise in his brooding young disciple, but whether he noted that Jackson possessed the spirit that would eventually set the art world on its ear is difficult to say. In 1935, Benton wrote: "You've the stuff old kid—all you have to do is keep it up." Pollock's paintings of this period, however, were hardly more than imitations of Benton's landscapes.

In 1934, Jackson began work in New York with the Federal Art Project of the Works Progress Administration (WPA). His salary wasn't much ($7,800 over eight years) but it provided the freedom to paint constantly. He was a very troubled young man, reaching for the whiskey bottle as often as the easel. Alcoholism was a problem he'd suffer from all his life.

In 1940, during an exhibition at the McMillan Gallery in New York, Jackson met his future bride, artist Lee Krasner. Influences on his art came from every direction at this point. For example, he observed poster painters work on banners at Communist party headquarters; while others watched the slogans appear, Pollock stared at the patterns the drips made on the floor.

Two years later, Pollock was introduced by Krasner to artist Hans Hofmann. A celebrated exchange occurred when Hofmann noted that the thirty-year-old painter "worked from the heart," but that he should enroll in Hofmann's classes to learn to work from nature. Said a smoldering, stubble-faced Pollock: "I am nature."

While working as a janitor after his WPA termination, Pollock made the most important contact of his life, Peggy Guggenheim. She guaranteed wages; Jackson guaranteed art. He proceeded to exhibit at her Art of This Century gallery.

Pollock's unorthodox techniques received as much notice as the whirling, splattered masterpieces he produced. Tacking unstretched canvas on the floor, he would drip and sling his color in a maelstrom of controlled violence. "This way I can walk around it," he would say, "work from the four sides and literally be *in* the painting. This is akin to the method of the Indian sand painters of the West."

In 1945, Pollock and Krasner set up studios and home at The Springs, a farm in Long Island's East Hampton. They were married October 25 at Norman Vincent Peale's Marble Collegiate Church on Fifth Avenue.

Criticism of Pollock would fall into two major categories: praise and damnation. Said Eleanor Jewett, writing for the *Chicago Daily Tribune* in 1945, "His chief trouble seems to be that his trumpet has gone wild and he is sounding in all directions at once." Alfred Frankenstein wrote five months later in the *San Francisco Chronicle,* "He is one of the most vibrant and exciting, nervous, flaming, and brilliant painters now at work in this country."

Names for paintings were passé by the late 1940s, when he completed works such as *Number 1, 1948.* When a woman asked him, "Mr. Pollock, how do you know when you've finished a picture?" he replied: "Madam, how do you know when you've finished making love?"

The 1940s and 1950s were his beat glory years, when he became the most talked-about artist in the world. His canvases reached huge proportions, some as large as twenty-by-nine feet. "It seems to me that the modern painter cannot express this age, the airplane, the atom bomb, the radio, in the old forms of the Renaissance or of any other past culture," he said with the conviction of a soul afire.

Depression and the bottle were still enemies to be contended with. In 1955, he confided that he hadn't touched a brush in over a year because, according to biographer Francis V. O'Connor, "he wondered whether he was saying anything." Shortly after 10 P.M. on August 11, 1956, his convertible overturned near his home, killing him instantly.

Jackson Pollock was not your regular Westerner. Still, his spirit was as untamed as the Wyoming landscape. *Newsweek* said he "prowled over his flat canvas with his stick and paint can like a hungry hawk scouting his terrain in soars and swoops." As enigmatic as a starry night, the fruits of his turbulent voyage remain for all to see: visions of chaos frozen perfectly in time.

PASSING

THROUGH

MARK TWAIN

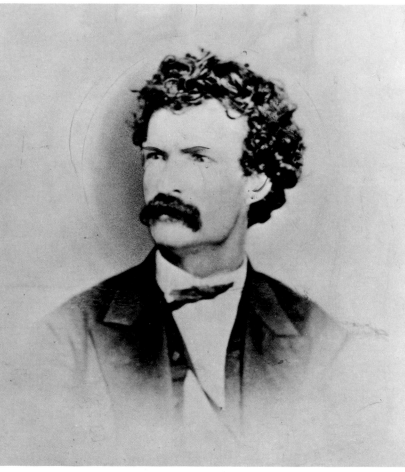

Twain during his San Francisco newspaper days, taken between 1864 and 1866.

Long before he was recognized as America's favorite author, Samuel Langhorne Clemens served a wild literary apprenticeship Out West. He came in search of gold or silver, anything that might make him rich overnight. Instead, although he would have preferred wealth, he discovered himself.

At age twenty-seven, Clemens's career as a steam-boat pilot on the Mississippi River was cut short by the Civil War. After a month in the service of the Confederacy, he resigned for a chance to travel with his brother Orion, who had been appointed secretary to the governor of Nevada Territory. "I envied him the long, strange journey he was going to make," he said later. "He would see buffaloes and Indians and deserts and have all

kinds of adventure, and maybe get hanged or scalped and write home and tell us all about it."

In the summer of 1861, the brothers left St. Joseph, Missouri, on an Overland Mail stagecoach. With a fifty-pound baggage limit, they opted to take a large dictionary and plenty of tobacco, shipping their dandier duds back home. ("It was a sad parting, for now we had no swallow-tail coats and white kid gloves to wear at Pawnee receptions in the Rocky Mountains.")

Upon arriving in Carson City, Nevada, twenty bumpy days later, Samuel's instant-employment scheme fizzled. There was no budget for a "secretary's secretary." Six months of uneventful prospecting followed, after which he sold two humorous articles to the Virginia City *Territorial Enterprise.* (He had published previously in his hometown, Hannibal, Missouri, but had only toyed with the idea of a writing career.) Furthermore, the paper's editor, Joseph Goodman, offered him a $25-a-week job, which Clemens happily accepted in July 1862.

Frontier journalists strove to enrage as well as to inform, and many wisely chose pen names. It was at the *Enterprise* that Clemens first signed his work "Mark Twain," a river phrase used to indicate two fathoms under the keel, the shallowest depth allowable for a steamboat to sail in. A deceased New Orleans writer first used the tag, but the more popular Twain reasoned, "As he could no longer need that signature, I laid violent hands upon it without asking permission of the proprietor's remains."

For nearly two years Mark Twain poured out the outrageous copy the miners craved. After a waggish attack on the fine ladies of Carson City and their fund-raising efforts, he found himself being challenged to a duel by the owner of a rival newspaper. Just before the match, a sharpshooting friend of Twain's picked a sparrow out of the sky, a feat the two claimed had been accomplished by Twain. The challenger was now too afraid to follow through. Twain didn't laugh long—an edict from the governor demanded mandatory jail for duelists. The Comstock Lode country's favorite columnist was on a stagecoach bound for San Francisco the next morning.

Twain burst upon the Barbary Coast literary scene with a job he hated at the *Morning Call.* Serving as the entire reportorial staff, he combed the city for news by day, attended portions of plays at night, then compiled his stories. All his outlandishness was edited out. The bright spot of the job was a regular check and the chance meeting with author Bret Harte, who served as a U.S. Mint secretary in the same building. Though Twain would later say he was "incapable of emotion,"

Harte managed to have quite an impact on the Missourian's literary outlook.

After four months Twain was fired. "For two months," reported the unemployed humorist, "my sole occupation was avoiding acquaintances." He played long hours of penny-ante poker in a Montgomery Block Turkish bath, where he met a gentleman named Tom Sawyer. Years later, after Tom Sawyer became a household name, the real one opened a tavern by the bay with the sign, "Ale and Spirits! The Original Tom Sawyer: Prop."

Twain now free-lanced for the *Golden Era,* Harte's *Californian,* the *Dramatic Chronicle,* and the *Enterprise.* After helping a friend who jumped bail following a barroom brawl (the same one who had influenced the duel), Twain chose to leave town for a spell. He would go gold-digging in the Mother Lode country. On December 4, 1865, he left for Jackass Hill in Calaveras County.

One afternoon, tired of the strenuous labor, Twain missed striking gold by just one pan. The author refused to wash out the last scoop, which other miners found later filled with gold nuggets. Instead, all Twain got from Angel's Camp was a tall tale he'd heard about a rigged jumping-frog contest.

Returning to San Francisco as broke as ever the following February, he found a letter from humorist Artemus Ward requesting a story for an upcoming book. Twain dashed off what would become known as "The Celebrated Jumping Frog of Calaveras County." It was too late for the book, but Ward's publisher gave the hilarious tale to the *Saturday Press,* and Twain was a sensation. He had been discovered Back East, and things would never be the same.

In March 1866, he sailed to the Sandwich Islands (today's Hawaii) for four months of travel writing. "When I got back to San Francisco," he would later write, "I found myself out of a job, so I hired a hall and gave a lecture. I've never had to do a day's work since." True, his Victorian stand-up routine was a hit. He even gave it in Virginia City, the scene of his first literary triumphs. Finally, on December 15, 1866, he sailed out of San Francisco Bay en route to New York and his future.

In 1872, his Western recollections were released in *Roughing It.* The moral of the tale in which Samuel Clemens became Mark Twain was simple:

If you are of any account, stay at home and make your way by faithful diligence; but if you are "no account," go away from home, and then you will have to work, whether you want to or not.

HORACE GREELEY

"GO WEST, YOUNG MAN ; GO WEST !"

Greeley gives his Westerly advice again in this fanciful illustration.

The May 10, 1859, edition of the *New York Tribune* announced the long-awaited trip with classic under-statement: "Mr. Greeley left this city by the Erie Rail-road last evening, on his way to the Pacific States. We shall probably receive from Kansas the first letters of the series he proposes to write during his journey."

For at least ten years, Horace Greeley, the country's most influential newspaperman, founder and editor of the *Tribune,* had been aching to take his own advice. Although the phrase, "Go West, young man, go West," had originally been uttered by John Babson Lane Soule, editor of the *Terre Haute Express,* in 1851, Greeley had adopted it as his motto. It was the creed of the west-ward expansion, six simple words that summed up the hope and romance of America.

Now, after Greeley had been delayed by commit-

ments for years—cofounding the Republican party, serving a brief stint in Congress, and surviving the untimely deaths of five of his seven children—he was ready to see the frontier for himself.

The rail trip from New York to Missouri took a week. In St. Joseph, he boarded a steamer that took him to Atchison, Kansas, then transferred to a wagon and then a stagecoach that eventually took him to Manhattan, Kansas. He marveled at the vast buffalo herds, praised the agricultural possibilities, but found many residents "idle and shiftless. To see a man squatted on a quarter-section," reported Greeley, "waiting for someone to come along and buy out his 'claim' . . . this is enough to give a cheerful man the horrors."

Trudging on, Greeley recorded a day-by-day account of his gradual departure from civilization: "23rd–Leavenworth: room bells and baths make their final appearance; 24th–Topeka: beef steak and washbowls last visible. Barber ditto; 26th–Manhattan: potatoes and eggs last recognized . . . chairs ditto; 27th–Junction City: beds bid us goodbye."

On June 1, the mules pulling Greeley's Leavenworth and Pikes Peak Express stagecoach were frightened by friendly Indians, causing the vehicle to overturn. The forty-eight-year-old editor made light of the incident, but a year later he would still be limping.

Trail-weary and hurting, Greeley arrived in the less-than-a-year-old city of Denver on June 6. He checked into the dirt-floored Denver House, where a guest was allowed "as good a bed as his blankets will make." The all-night gambling afforded little sleep, prompting Greeley to say that Denverites were "prone to deep drinking, soured in temper, always armed, bristling at a word, ready with the rifle, revolver, or bowie knife." His social review also noted that he had seen "more brawls, more fights, more pistol shots with criminal intent in this log city of 150 dwellings not three-fourths completed nor two-thirds inhabited, nor one-third fit to be, than any community of equal numbers on earth."

Nevertheless, Greeley's visit probably saved the infant city. Rumors that the gold strikes were all a hoax had cut down on travelers, and Denver was on the verge of extinction. Greeley promised his readers the truth: "I shall state nothing at second-hand where I may know if I will. I have come here to lay my hand on the naked, indisputable facts, and I mean to do it."

His report from the mountain diggings was glowing: "We . . . have seen the gold plainly visible in the riffles of every sluice, and in nearly every pan of the rotten quartz washed in our presence." *Rocky Mountain News* editor William Byers was so thrilled with the report that

when his evening's edition ran out of newsprint, he printed an extra edition on brown wrapping paper. The scribe warned that "next to outright gambling, the hardest way to obtain gold is to mine for it. . . . A good farmer or mechanic will usually make money faster . . . by sticking to his own business than by deserting it for gold-digging." Weeks later, over thirty thousand hopefuls had arrived anyway.

More history would be made after Greeley crossed the desert in Utah ("If Uncle Sam should ever sell that tract for one cent per acre, he will swindle the purchaser outrageously"). Mormon leader Brigham Young was a source of confusion and controversy to Easterners. A two-hour interview was published in the *Tribune* on July 13, 1859, a journalistic coup that managed to show Greeley at his best and reveal the religious leader as a man of conviction.

The most humorous leg of the journey came when Greeley boarded a stagecoach in Carson City, Nevada, bound for Placerville, California. The unfortunate passenger knew nothing of driver Hank Monk who, according to one account, once "drank so much that he gave whiskey to his horses and watered himself, thus becoming sober enough to handle his drunken team."

Greeley became impatient as the coach lumbered up a long grade, informing the driver that he "was not going to a funeral." At the summit, Monk lit a stogie, cracked his whip, and Greeley got the ride of his life. Greeley bounced "like a corn in a popper" as the coach took the mountain curves on two wheels. The innkeeper in Placerville noted, "The canvas roof of the coach was ripped in half a dozen places; Mr. Greeley's hat was all bashed in; the team was foamin' at the mouth." (Twelve years later, when Greeley was running for president, Monk wrote the candidate asking for a job upon his election. Greeley replied: "I would rather see you ten thousand fathoms in hell than give you a crust of bread.")

Greeley faced one last indignity that forced him to return by sea rather than land: a plague of boils. The next year, he published *An Overland Journey,* which he ended with a passionate plea for a transcontinental railroad. Within ten years, that dream was a reality.

Horace Greeley's press junket Out West still ranks as one of the most important chapters in the settling of the continent. The famed editor lost his presidential bid in 1872 in a landslide defeat to Ulysses S. Grant and died three weeks after the election from utter exhaustion. Westerners held a special place for their most vocal promoter and his dogged determination to see things for himself.

NED BUNTLINE

Buntline, William F. Cody, and Texas Jack prepare for their 1872 Chicago debut.

Ned Buntline was the pen name for one of the nineteenth century's most active knaves. Known for his reams of pulp fiction, he was a devoted lover of ladies, liquor, and money. In his tireless search for ideas, he even stumbled across the old West's greatest hero and in so doing gave the world Buffalo Bill.

Edward Zane Carroll Judson was born on March 20, 1823, in Stamford, New York, though falsifications make the date impossible to verify. His father, Levi, began a family tradition of terrible writing with self-published patriotic ramblings. At age ten, young Ed ran away to sea for nine years, providing himself with enough expe-

rience for a lifetime of writing nautical romances, as well as a pseudonym.

A "buntline" is a rope at the bottom of a square sail. He originally adopted the name to conceal his identity from a captain who came off unfavorably in Ned's first published tale, *The Captain's Pig,* in 1842. Upon learning his captain had offered a reward for the author's identity, Judson promptly resigned his commission.

In Pittsburgh, he published two issues of a tattle sheet entitled *Ned Buntline's Magazine* before folding it and heading for Cincinnati. There he started the *Western Literary Journal* to publish his own drivel and to criticize European writers. In 1844, he moved the publication to Nashville, Tennessee, and began a popular feature printing the names and scams of gamblers working the region.

Involved in a love affair with a married woman, Buntline unceremoniously widowed his lover after the cuckolded husband came looking for him with a pistol. Trying to escape a lynch mob, Buntline tumbled out of a high window, giving himself a limp for life. He did receive a necktie party, but friends managed to cut him down in time. Buntline had published his last effort in Nashville.

In Philadelphia he originated another scandal sheet called *Ned Buntline's Own.* Soon Ned was providing adventure stories for the top publications of the day. For twenty years, despite a year in prison for inciting an anti-British riot in New York City that claimed thirty-four lives, Buntline cranked them out.

The formula seemed simple enough: "I never lay out plots in advance," he claimed, "how can I know what my people may take it into their heads to do? When I hit a good [title] I consider the story about half finished." By the summer of 1869, Ned Buntline was the highest paid writer in the country at $20,000 a year, banking more than Twain, Melville, or Whitman.

It was in that hot summer that he journeyed Out West in search of a new protagonist, specifically Major Frank North, the hero of a recent Indian battle. Arriving by Union Pacific in North Platte, Nebraska, Ned found that the elusive North had a healthy mistrust for writers, commenting that "real men" didn't brag about their exploits.

North pointed to a young man sleeping off a serious hangover in the barracks yard. "If you want a man to fill that bill, he's over there under a wagon," grinned the major. Buntline squatted to behold the twenty-three-year-old William Franklin Cody, his mustache and beard infested with flies. A star was born.

The young scout and the old hack became fast friends, spending ten days drinking and swapping stories. Following Ned's departure, Cody next heard from him when he saw a story in Street & Smith's *New York Weekly* entitled "Buffalo Bill: The King of the Border Men. The Wildest and Truest Story I Ever Wrote." It was pure hogwash, and Cody was thrilled.

Two years later, Cody visited his friend in New York City. After attending Buntline's play (which proper publications referred to as the adventures of "Bison William"), he realized that his future lay in show business.

Chicago was chosen for the theatrical debut of Buffalo Bill. Buntline leased a theater managed by Jim Nixon, promising that Cody was on the way from the West with twenty Indians. Cody arrived with only "Texas Jack" Omohundro, a fellow ex-scout. It was five days before showtime, December 12, 1872, and the house was sold out. With Nixon already bouncing off the walls, Buntline admitted that they had no script.

The trio checked into a hotel and began to drink. In four hours, Buntline had completed a script entitled *The Scouts of the Plains.* Leaving Cody and Omohundro behind to learn lines with bellboys to copy scripts, Ned set off for skid row in search of "Indians."

Opening night ranked as one of the great theatrical disasters of all time. Buntline, as scout Cale Durg, spent the entire show feeding lines to his stage-frightened co-stars. Following a long temperance speech in the second act, Durg was killed by "savages." From the wings he watched his death avenged many times over. At the final curtain, he grimaced that Bill and Jack had failed to deliver one line as written. The public couldn't have cared less; they loved it.

The troupe moved on to St. Louis, then to New York. Cody gave Buntline the boot from the show, replacing him with another "real" character, Wild Bill Hickok. (Hickok didn't last long. When he quit, he left a message for Cody with the stage manager: "Tell that long-haired son of a bitch I have no more use for him and his damn show business!")

Buntline's fame and scandalous persona remained with him the rest of his days. Called the "dime millionaire" by many, he was married at least eight times (twice simultaneously) and was once reported to be keeping six mistresses. His pace slowed in older age, after he developed a heart ailment. However, he looked back fondly on the time he was able to write 610 pages in sixty-two hours. After a long illness, the fastest pen in the West died on July 16, 1886. A direct forerunner of today's best-selling authors, he lived life to its fullest and painted it in exciting shades of purple.

ISABELLA BIRD

Bird and Birdie in an 1873 engraving.

Many chroniclers came West in the late nineteenth century strictly to sensationalize, adding to the region's riproaring reputation. Such was not the case with Isabella Bird Bishop, the era's most unlikely travel critic.

A plumpish Victorian spinster, she began her globe-trotting for reasons of health. When her letters to her sister in Edinburgh, Scotland, eventually saw publication, they gave her readers a rare glimpse of the world beyond the British Empire.

Life began at forty for this sturdy adventuress. On her first sojourn she panned Australia ("a prosaic, hideous country"). Next, she sailed to the Sandwich Islands (today's Hawaii) and came away renewed and ready for her badlands hiatus in Colorado.

The goals for her 1873 expedition were mixed. She wished to see the fabled Estes Park region, report on Rocky Mountain flora and fauna, and find out if the local people were as wild as reports would have her believe.

From Cheyenne, Wyoming ("a God-forsaken place"), she took a train to the Greeley Temperance Colony, arriving on September 10. She approved of the city's booze ban, but found her first taste of Colorado cuisine seriously lacking, commenting that her dinner's chief features were "greasiness and black flies." A buggy took her to Fort Collins the following morning, while she

listened politely as her drivers discussed the hottest topics of the day, politics and "Injun trouble."

Pronouncing Fort Collins "altogether revolting," she enlisted another wagon to carry her closer to Estes. Nine hours and forty-five miles later, her driver was hopelessly lost, but he managed to find a wilderness family who agreed to lodge Isabella in their cabin. Bird conducted knitting classes but found the family boring. After much conversation, she persuaded them to lead her into Estes Park for a "frolic."

The head of the family, Mr. Chalmers, proved to be as bad a guide as he had been a host. He lost his way, forgot to tie the horses, and had to rely on Isabella's basic navigational skills to get them back to their cabin.

Following a brief stay with a more agreeable family, Bird arrived in Longmont and enlisted two young men to guide her to her destination. She was not to be disappointed. "Never, nowhere, have I seen anything to equal the view into Estes Park," she wrote. Amidst the mountain glory, she met Welshman Griffith Evans and a rustic, one-eyed trapper, "Rocky Mountain Jim" Nugent. Evans provided her with accommodations at his family cabin. Her adventure was on an upswing when a problem for which she was unprepared presented itself.

Over starlit campfires and during the ascent of Longs Peak, Rocky Mountain Jim bared his soul, pouring out his heart to Isabella, weeping over his misspent bachelorhood. Clearly, this mountain hunk with "sixteen golden curls," had fallen for the British damsel. For much of the duration of her Colorado stay he tried to win her. The lady was flattered by his emotion but refused to give her heart to a man with blood on his hands and whiskey on his breath.

As for Longs Peak, she fell in love with it:

The grey of the Plains changed to purple. The sky was all one rose-red flush, on which vermilion cloud-streaks rested; the ghastly peaks gleamed like rubies, the earth and heavens were new created.

On a borrowed horse named Birdie, she then took a long, circular excursion as far south as Colorado Springs, over to the Continental Divide, then north again to her base at Estes Park.

Her first glimpse of Denver, "the great braggart city," came during a sandstorm in which she coined an expression that would be repeated often. The storm, she

said, "covered the city, blotting it out with a dense brown cloud." The city itself appeared to be a town of men. She saw five women on the streets the entire day. Her conclusion? "I should hate even to spend a week there."

In Colorado Springs ("a queer embryo-looking place"), she paid a social call to the editor of the literary journal *Out West* and sold him her story on the ascent of Longs Peak. Bird and Birdie next rode into the Garden of the Gods ("in which, were I a divinity, I certainly would not choose to dwell").

The cheap price of life in the mining camps, with the random shootings and lynchings, made her comment, "Things up there are just in that initial state which desperadoes love." She continued, "The almighty dollar is the true divinity, and its worship is universal."

Rejoining her friends at Estes Park, she cooked a Thanksgiving dinner during a snowstorm. Nugent gave the romance one last shot, sulking miserably when Isa-

bella rebuked his advance. In early December she bade farewell to Birdie, who had carried her over seven hundred miles of rough terrain. Nugent escorted her to the Greeley stagecoach, and her excursion was over. (A year later she received a sad postscript: Evans had shot and killed Nugent during an argument.)

The exciting life of Isabella Bird, however, had just begun. Her first book, on Hawaii, received wide acclaim, as did her second, *A Lady's Life in the Rocky Mountains,* published in 1879. She traveled to the Far East, established five hospitals in India, Korea, and China, and wrote at least one book for each adventure. She was the first woman ever elected a Fellow of the Royal Geographical Society. She died aged seventy-three in 1904 in Edinburgh.

Her reviews of the West are a priceless reminder of the real past, a witty and honest account of a newly civilized beginning in a dangerous paradise.

OSCAR WILDE

Long before he became Britain's wittiest playwright, Oscar Wilde traveled Out West. At age twenty-eight, he toured America lecturing on the Aesthetic Movement, the popular Victorian philosophy of "art for art's sake." His literary career was yet to blossom fully; his fame at this point rested on a few poems, a single play, some high-handed art criticism, and an operetta called *Patience* by Gilbert and Sullivan that satirized Wilde's aestheticism.

Oscar Fingal O'Flahertie Wills Wilde, born October 16, 1854, in Dublin, Ireland, arrived in New York City in early January 1882, pronouncing that he found the Atlantic Ocean "disappointing." At customs, Wilde modestly stated: "I have nothing to declare. Except my genius."

He lectured in New York and other Eastern cities before his tour moved west by train, across Nebraska and on to California. On his way Back East, Wilde appeared in Salt Lake City, then up in Cheyenne, and then back down in Denver.

The Aesthetic Movement had swept the mile-high boomtown. Tickets to Wilde's April 12, 1882, Tabor Grand Opera House appearance were snatched up quickly, even though the price had been boosted from

$1.00 to $1.50. Prostitutes on Holladay Street appeared in public adorned with sunflowers and lilies, the unofficial Wilde emblems. Daniel and Fisher's department store proclaimed that Wilde would do an in-store promotion for their $15 suits.

Wilde's train arrived late, detained by a spring snowstorm. Wilde proceeded to the Tabor in a glassed-in, horse-drawn carriage. Onlookers pressed their noses against the window and Wilde remarked to a reporter from one of the nineteen metropolitan newspapers that covered his arrival: "This is a simple curiosity. . . . It is evidence of an unfinished civilization."

Just after nine, Oscar made his entrance to the parlor set at center stage. *The Denver Times* said he entered in "a languid, dreamy sort of walk such as one would think a lovesick girl would have in wandering through a moonlit garden." His six-foot-plus frame was dressed in his own fashion, which included, beneath his shoulder-length hair, a black velvet suit with knee pants, Beau Brummel purple-lined coat, and white lace shirt.

Following the lecture, Wilde's voice could be heard booming down the hallway from his Windsor Hotel quarters: "Take away this tea and bring me a bottle of wine!" While dining on fish, potatoes, an omelet,

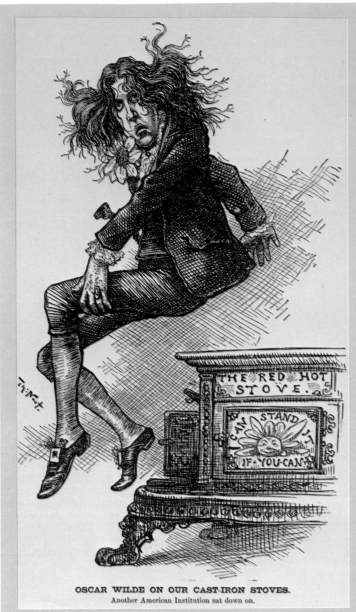

OSCAR WILDE ON OUR CAST-IRON STOVES.
Another American Institution sat down on.

*Noted cartoonist Thomas Nast's caricature of Wilde,
at the time of his American tour.*

miners very charming and not at all rough," said Wilde.

Indeed, he would wax poetic about mining garb, calling the workers the only "well-dressed men" in the entire country:

Their wide-brimmed hats which shaded their faces from the sun and protected them from the rain, and the cloak, which is by far the most beautiful piece of drapery ever invented, may well be dwelt on with admiration. . . . They only wore what was comfortable, and therefore beautiful.

Following the lecture, Wilde was shown to Pap Wyman's saloon, where he discovered "the only rational method of art criticism I have ever come across." Above the bar's sole entertainer was the legend: "Please do not shoot the pianist. He is doing his best." Quipped the visitor, "The mortality among pianists in that place is marvelous."

Before leaving Leadville, Oscar had to see the Matchless Mine, the source of Tabor's riches. Lowered into its depths in a rickety bucket, the poet surprised the miners with his capacity for booze. "Having got into the heart of the mountain," said Wilde, "I had supper, the first course being whiskey, the second whiskey, and the third whiskey. . . . When I lit a long cigar, they cheered till the silver fell in dust from the roof on our plates."

The tour also included Colorado Springs and Pueblo before heading Back East. Crossing Kansas, Wilde received a telegram from the city of Griggsville, begging him to address the town on aesthetics. Wilde wired in return: "Begin by changing the name of your town."

In his lectures in England on wild America, Oscar confided his two favorite things about the United States were Walt Whitman and the Rocky Mountains. He married soon after returning and would father two children while his career skyrocketed as a result of his novels and plays, including *The Picture of Dorian Gray* and *The Importance of Being Earnest.*

In 1895, a series of accusations by boxing's famed Marquis of Queensberry concerning an illicit relationship supposedly between Wilde and Queensberry's son brought the popular author persecution—and imprisonment. His private sexual choices turned British society upside down.

The cultural world mourned Oscar Wilde in 1900 when he died of cerebral meningitis; others condemned his indiscretions. Out West, they remembered fondly their aesthete and his rave review of the region. They knew the importance of having been with Oscar.

relishes, and mutton chops, he received Opera House owner H.A.W. Tabor. The silver millionaire wished to make sure that a stop at his Matchless Mine in Leadville was on the visiting celebrity's itinerary. Writing about the visit, Oscar reminisced: "I was told that if I went there [Leadville] they would be sure to shoot me or my travelling manager. I wrote and told them that nothing that they could do to my travelling manager would intimidate me."

Arriving at Leadville's Tabor Opera House, the Irishman was informed of the entertainment that had preceded him. Two murderers had been tried, found guilty, and executed, right on stage. "But I found these

Mr and Mrs Rudyard Kipling

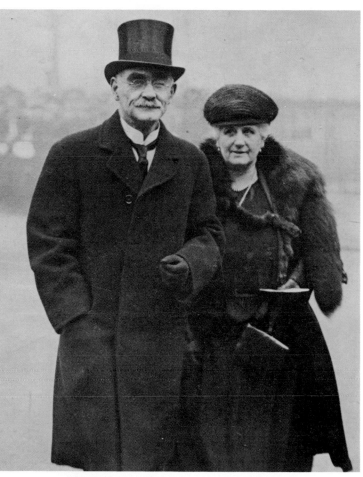

The Kiplings, who did not meet Out West.

When the world's most famous living writer died on January 21, 1936, the outpouring of sentiment was extraordinary. A column on the front page of *The News Chronicle* of London was devoted to Rudyard Kipling's death, although most of the space was allotted to King George V, who was very ill. American newspapers also mourned the loss of the great master of fiction and letters. In Salida, Colorado, the local paper reminisced about how Kipling fell in love with his future bride in their town and wrote a novel during his stay. It was a great story, but there was a slight problem: it was one of the more interesting things that never happened Out West.

Oh, yes, Kipling was once in Salida, as was his future bride, Caroline Starr Balestier. And they later married in London, on January 18, 1892. But as far as a Rocky Mountain rendezvous is concerned, the twain never met there. Kipling did meet Mark Twain while in the West, but not Caroline.

She arrived in Salida first, with her brother, Wolcott, a writer and literary staff member of the *New York Tribune,* to visit a friend, socialite Amy Graves, just in time to ring in 1885. In April, Wolcott returned to New York to become editor of *Tidbits,* a popular journal. Caroline followed in July, after helping launch the first Episcopal Sunday school in riproaring little Salida.

Meanwhile, her future husband had celebrated his nineteenth birthday on the day Caroline and her brother

hit Salida—December 30, 1884—thousands of miles away in his native India. At the time, he was editor of the *Civil and Military Gazette,* the newspaper with the largest circulation in the Punjab. When he wasn't meeting deadlines, he was soaking up the Eastern atmosphere that would bring him fame.

Kipling's excursion in America began when his ship docked in San Francisco in 1889. His trip was documented in letters and later a book called *From Sea to Sea.* In both he played the *enfant terrible,* aiming his rapierlike British wit at the crude frontier. Embarking on a very gentlemanly, leisurely tour of the West, he logged a journal full of barbs aimed at Portland, Salt Lake City, Denver, Chicago, and other ports of call.

Kipling managed to harbor a few respectful thoughts about the wild country, however. Besides Twain, Bret Harte captivated him, as did American women ("They are clever; they can talk; they are superbly independent"). As for the country itself, he came away with somber impressions. After "impressing the natives" in Gunnison, Colorado, by catching a three-pound trout on "tiny English hooks," he took a ride to Denver on the narrow-guage railroad over Marshall Pass:

So we went up and up and up till the thin air grew thinner and the chunk-chunk-chunk of the labouring locomotive was answered by the oppressed beating of the exhausted heart. . . . One monster of forty mineral cars slid past, scarce held by four locomotives, their brakes screaming and chortling in chorus; and in the end, after a glimpse at half America spread mapwise leagues below us, we halted at the head of the longest snow tunnel of all, on the crest of the divide, between ten and eleven thousand feet above the level of the sea . . . a wind as keen as a knife-edge rioted down the grimy tunnel.

There was drama, new experience—but no Caroline.

Most Kipling biographers report him striking up a friendship in London, after the American tour, with one Wolcott Balestier around the end of 1889. About a year later, Kipling met Caroline and they collaborated on a novel—*The Naulahka*—with Wolcott. Upon his departure for the Orient, any kind of romance seemed cool at best, although there were vague references to an "understanding."

Wolcott died of typhoid in December 1891 in Dresden, Germany. Kipling received word in India, sailed for England, and arrived on January 10, 1892. He married Caroline eight days later and remained with her the rest of his life. He had his American girl, though there was never any tryst above the timberline.

Lowell E. Mooney, writing for *Denver Westerners Roundup* in 1970, came up with some excellent ideas on how the Kipling tale got started. It seems that Kipling was in Salida for about twenty minutes once to change coaches, hardly enough time to kindle a nineteenth-century affair. The mistake seems to have been an honest one: folks remembered Caroline being there with a writer—her brother—and the man she later married happened to be a writer who once had been in Salida, and, well . . .

There is some evidence that he might have stayed in Salida a little longer, but it doesn't hold up well. Sure enough, Kipling registered at the Jackson Hotel in Poncha Springs, five miles west of Salida, but, as Mooney points out, so did "William Shakespeare," "Grover Cleveland," "William McKinley," and "Jimmy Whistle-britches."

Rudyard Kipling came away from the Rockies with a bagful of stories but no wife. The story of his courtship among the columbines is, like the best Kipling, purely fiction.

LEW WALLACE

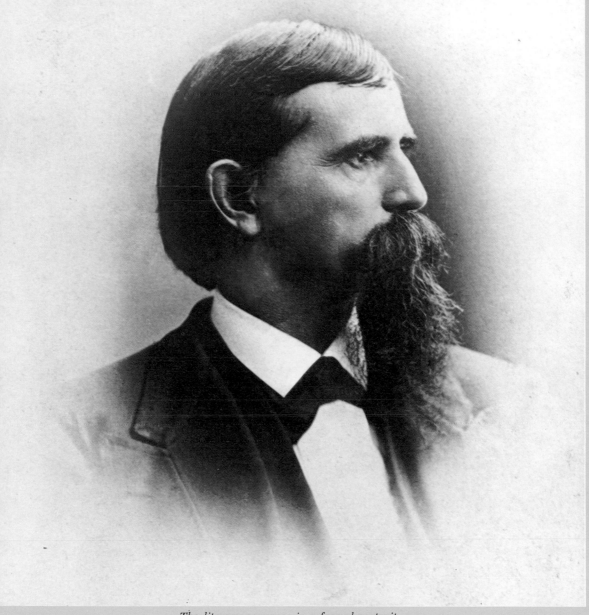

The literary governor in a formal portrait.

The brief time Lew Wallace spent in the West was filled with intellectual juggling. Besides being territorial governor of turbulent New Mexico, he found time to complete what would become the most popular novel of his day. Dealing with a cast of characters, both real and fictitious, that ranged from Billy the Kid to Ben-Hur, Wallace's hefty mental feats made him the region's most compelling moonlighter.

Lewis Wallace was born on April 10, 1827, in Brook-ville, Indiana. Ten years later, his father was elected Indiana's governor. Young Wallace fell in love with the state library and decided that he would someday like to pen historical romances.

A star-studded military career began in 1846 when nineteen-year-old Lew fought in the Mexican War. He marched home, married, passed the bar, and became a state senator in the following decade. In the Civil War, Wallace advanced up the ranks quickly, and was a

major general at the Battle of Shiloh in April 1862. After service on the military court that tried the Lincoln assassination conspirators, he returned to his Hoosier law practice. In 1873, he wrote his first novel, *The Fair God,* a romance set during the conquest of Mexico.

For his stumping in the Rutherford B. Hayes campaign of 1876, Wallace was rewarded with the $2,600-a-year governorship of New Mexico. After a long journey by train and buckboard, Lew Wallace arrived in Santa Fe on the night of September 30, 1878. He had himself sworn in immediately, then sent a handwritten note to the new ex-governor, Samuel Axtell, informing him he was fired.

The fifty-one-year-old chief executive's next order of business was to deal with the Lincoln County War. In addressing the situation, a bloody conflict between cattle barons John Chisum and Lawrence Murphy, Wallace quipped, "If peace and quiet are not restored in Lincoln County in the next sixty days, I will feel ashamed of myself." A threat of immediate martial law quieted the guns briefly, as did a blanket amnesty policy for all parties involved.

Now, Lew Wallace could get down to his other business. Inside the two-hundred-fifty-year-old adobe El Palacio del Gobernador, he would complete the massive novel he had begun in 1873. The sprawling, two-hundred-thousand-word epic which Wallace called *Judah: A Tale of the Christ,* began with the idea of having a Jewish hero and a Roman villain. Scribbling by candlelight in purple ink, Wallace worked his holy horse opera, with its thundering chariot race between Ben-Hur and Messala, toward its involved conclusion.

Billy the Kid could not have cared less. The nineteen-year-old William H. Bonney had used the cattle war to pursue his favorite pastime, murder. With Billy's testimony, however, Wallace could obtain an important conviction against the Murphys. The Kid queried the governor and Wallace responded. A clandestine meeting was set for March 17, 1879, at the home of John Wilson.

The Kid knocked promptly at 9:00 A.M., then stepped in. Relaxing with a Winchester in his right hand, a six-shooter in his left, the desperado listened to Wallace's plan. After a mock arrest, the Kid would testify. Then, said the governor, "I will let you go scot-free with a pardon in your pocket." (In the end, the Kid went through with the arrest but escaped from prison before he could testify, leaving Wallace no other recourse but to restore the price on his head.)

In the next year, the literary governor would deal with supposed death threats from the Kid—"I mean to ride into the plaza at Santa Fe, hitch my horse in front of the palace, and put a bullet through Lew Wallace"—as well as the raiding escapades of the seventy-year-old Apache Chief Victorio. As if this were not enough, he also had to reunite Ben-Hur with his mother and sister in the leper colony and recount the Crucifixion.

In March 1880, Wallace took a leave of absence to tote the weighty finished manuscript to his publisher in New York. Joseph Henry Harper thought it an impressive work. His only wish was that the title be changed to *Ben-Hur* because Judah sounded like Judas. Wallace agreed and departed with a book contract. Back home, Victorio had been driven into Mexico, where he eventually would be shot by soldiers.

Ben-Hur hit the bookstores November 12, 1880, at $1.50 a copy. Critics were less than enthusiastic. Wrote one, "I protest, as a friend of Christ, that He had been crucified enough already, without having a territorial governor after Him." In the first seven months, *Ben-Hur* sold fewer than three thousand copies, earning Wallace some $300. This supposed failure, along with the endless troubles in New Mexico, caused a depressed Wallace to resign his office on June 4, 1881. Billy the Kid never got to shoot the governor; the Kid himself was dispensed with at age twenty-one by Sheriff Pat Garrett the next month.

President James Garfield had stayed up all night reading *Ben-Hur.* He wanted the ex-governor to write more books, and to that end made him ambassador to the Ottoman Empire in July 1881, a tamer locale for a sensitive author. During his tenure in Turkey, Wallace would become the most famous writer in the world.

To Wallace's surprise, *Ben-Hur* was a best-seller three years after its release. In 1886 it was selling forty-five hundred copies a month. By 1890 it had passed the half-million mark and was compared with *Uncle Tom's Cabin* as an all-American favorite. The theatrical version bowed on Broadway on November 29, 1899, and played continuously around the country for the next twenty years, to be withdrawn only when the silent-screen version was ready to roll.

Wallace maintained his interest in Western politics after his leap to fame and fortune. Just before his death (of stomach cancer) on February 15, 1905, he publicly criticized a bill calling for Arizona and New Mexico to be admitted as one state. Although Wallace wrote other books, none was a Western, and none was as successful as the biblical bonanza realized during his darkest hours Out West.

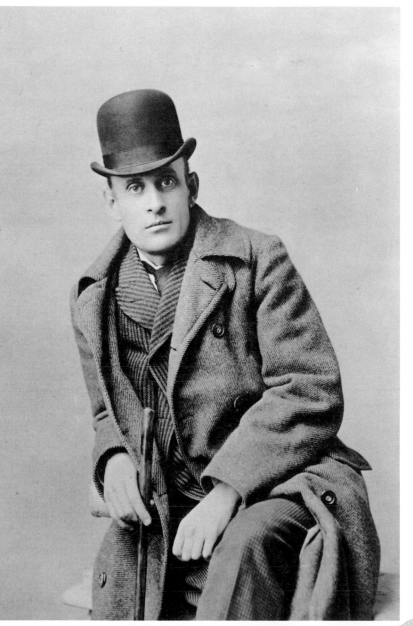

The children's poet laureate in 1894.

Before becoming internationally prominent as the "children's laureate," Eugene Field spent two wild years Out West. The future author of childhood classics managed to bring a sense of scatterbrained, good-natured fun to a region ripe for wit. Denverites were hardly surprised when their most eccentric journalist left town to take the world—especially its children—by storm.

A St. Louis native from New England stock, Field was born on September 2 or 3, 1850 (historians disagree). His father, Roswell, was a well-known lawyer, a defender of Dred Scott in the fugitive slave's initial trial. At age six, following the death of his mother, Frances, Eugene was sent to school in Massachusetts. Higher education was acquired at Williams College in Massachusetts, Knox College in Illinois, and the University of Missouri.

At nineteen, Eugene inherited $8,000 from his father's estate and promptly blew the entire wad on a six-month European holiday. When he returned in 1873, he married Julia Sutherland Comstock. The same year he began a large family and a prolific literary career.

His newspaper writings were seen first in the *St. Louis Journal,* followed by three other Missouri newspapers over the next eight years. In 1881, Eugene Field made two monumental decisions: to move to Denver and to become famous.

Field's column, "Odds and Ends," filled with satire, humor, and tongue twisters, knew no boundaries in the untamed boomtown. He was an instant celebrity, and his two-year stint as editor of *The Denver Tribune* was a public delight. Material from this column became the basis for his first book, *The Tribune Primer,* published in 1882.

As famous as his columns and satires was his penchant for practical jokes. Perhaps his best came when he masqueraded as the touring Oscar Wilde the day before Wilde's arrival in Denver. Field toured the city as the costumed aesthete, even dropping by *The Tribune* to grant an interview. He also reveled in writing filthy poetry and enjoyed appearing in drag for shock value. Frightening children in theater audiences with hideous facial contortions was another Fieldian favorite.

Field wrote with microscopic penmanship on a lap desk, his feet perched high on his standard desk. The major portion of his Denver stay was spent at 315 West Colfax Avenue, where he lived an intrinsically happy family life. He encouraged his offspring to enjoy childhood with total abandon.

The Denver days ended in 1883 when, at age thirty-three, he was hired away by *The Chicago Morning News* for $50 a week. The first installment of "Sharps and Flats," his Windy City column of cultural satire, appeared on August 16, 1883, and soon became his greatest forum.

Field's reputation went national in April 1888 with the publication in *America* magazine of the poem that would make him truly renowned. Overnight, his fame changed to that of a gentle chronicler of pastoral childhood. "Little Boy Blue," a poem with adult appeal, would be his ticket to the stars. It begins with the famous lines: "The little toy dog is covered with dust, But sturdy and staunch he stands." He completed the piece in under two hours.

In March the following year, his column launched an incredible journey as "Wynken, Blynken, and Nod one night Sailed off in a wooden shoe." A public starved for sentiment and nostalgia eagerly awaited his collections, namely, *A Little Book of Western Verse, With Trumpet and Drum,* and *Lullaby-land.*

Other favorites included a cuddly confrontation between a Gingham Dog and a Calico Cat in "The Duel" and 1894's seasonal smash "Jest 'Fore Christmas" ("Father calls me William, sister calls me Will, Mother calls me Willie, but the fellers call me Bill").

A victim of dyspepsia, Field shocked the world when, at age forty-five, he went to bed and died. A grief-stricken public eagerly awaited his last written words. They would not be disappointed: "Lie thou there, my pen; for a dream—a pleasant dream—calleth me away. I shall see those distant hills again, and the homestead under the elms; the old associations and the old influences shall be round about me, and a child shall lead me and we shall go together through green pastures and by still waters. And, O my pen, it will be springtime again!"

The rage for Field grew and continued to be strong for three decades following his untimely death. Monuments, usually paid for by contributions from children, sprang up at Washington Park in Denver and in every other town where he had hung his derby. Only the years eroded his popularity, as the childhood he eulogized slipped further and further into the past.

WILLIAM HENRY JACKSON

Jackson would go to great heights for the perfect shot.

Photography was rapidly becoming more sophisticated in the late nineteenth century when William Henry Jackson took his camera Out West on a monumental quest: to make a visual record of the young country's wide-open spaces.

Jackson was born on April 4, 1843, in Keeseville, New York, the first child of George Hallock Jackson and Harriet Maria Allen. His father dabbled in the new science of daguerreotypes, so camera parts were among Willie's first toys. "I got the feel of a camera almost before I could walk," he recalled later.

At fifteen, Jackson became an apprentice photographer for C. C. Schoonmaker in Troy, New York. He learned the art of retouching, exorcising moles and wrinkles from parlor portraits. After moving to a studio in Vermont, he joined the Second Vermont Brigade in 1862, but luckily for posterity, he didn't have to give his life to preserve the Union. At the Battle of Gettysburg, he was assigned to guard baggage trains.

In 1866, he traveled with two comrades to the Nebraska Territory, then became a bullwhacker in Montana. He next joined a Mormon wagon train to Utah and eventually migrated to Los Angeles. Returning to Omaha the following summer, he laid the groundwork for the Jackson Brothers Studio which he established with brothers Ed and Fred in 1868.

Jackson married Mollie Greer on May 10, 1869. Adventure still beckoned; he was hardly satisfied capturing prairie weddings and ice-cream socials. His ticket out came in 1870, when Dr. F. V. Hayden, head of the U.S. Geological Survey, stopped in Omaha to see if Jackson would join his survey team.

From Cheyenne, the group followed the Oregon Trail. Jackson had assembled three hundred pounds of equipment to be carried by mule—a variety of cameras, fragile glass plates, a portable darkroom lined with orange calico, and all the appropriate chemicals. When he was without fresh water for processing he melted snow.

The Jackson artistry in photographs of scenery and people in the wilderness was astounding. His landscapes were magnificently beautiful panoramas, clear to the finest detail. Sympathetic to Indian causes, he photographed native Americans at home, recording them in their final glory.

The following year, 1871, Jackson exposed the wonders of Yellowstone on glass for the first time. Old Faithful had erupted regularly for centuries before the arrival of the man with three eyes, but photographs brought the punctual geyser national attention. On the strength of these images, Congress unanimously established Yellowstone as the country's first national park less than a year after Jackson had developed his plates in the 160-degree water of its natural hot springs.

A grieving Jackson prepared for another expedition in 1872; Mollie had died in childbirth earlier in the year. Most of his work that season centered on the Grand

Jackson's Grand Canyon of the Yellowstone.

Teton range. His crew had heard of the legendary "snowy cross," a natural formation somewhere in Colorado. If the phenomenon really existed, it had never been photographed.

In August 1873, Jackson found the cross south of present-day Vail. Unhappy at the time ("an evil mule named Gimlet slipped his pack and broke many of my exposed plates"), the discovery of the century's equivalent of the Holy Grail made up for his loss. Ascending a fourteen-thousand-foot adjacent peak for a perfect view, Jackson and company waited out a cold, wet, hungry night for a dawn shot. He was not disappointed.

The breathtaking views of the Mount of the Holy Cross made Jackson famous. Even the poet Longfellow wrote in awe of the magnificent discovery. On October 8, 1873, Jackson married Emilie Painter, then prepared for another camera outing.

Congressional appropriations for the 1874 trips were late in coming but they gave him enough time to photograph Indians at Los Pinos in southern Colorado. The most stunning portrait was of Chief Ouray, taken six months after the Ute chief had told Alfred Packer's party that they didn't have nearly enough food for a winter expedition. Jackson then journeyed to the Mesa Verde reservation, where he made the first photographs of the sites of prehistoric cliff dwellers.

More expeditions followed, but in 1879 Congress stopping funding the photographic unit. Jackson went into business in Denver, setting up a studio at 413 Larimer. A portion of his income came from a new development in the world of communications, the "picture post card." He continued to photograph wild Colorado, but with the settling of the frontier a need for new horizons developed. Worldwide excursions followed, one of which took him to Siberia in the late 1890s.

Relocating his business to Detroit in 1898, Jackson spent his final half-century photographing and painting. One of the most honored men of his time, he published his autobiography, *Time Exposure,* in 1940 at the age of ninety-seven. He died aged ninety-nine in New York City from injuries suffered in a fall at his home.

William Henry Jackson's photographic legacy numbers at least 800,000 exposures. Nearly all of his subjects have been changed by time; even the peak of the Mount of the Holy Cross is different today, damaged in a 1951 rockslide. Each exposure was a painstaking experiment, conceived under the most difficult circumstances with bulky, complicated equipment. Jackson's was the first and most honest view of the West, and it serves today as an invaluable link to a time that passed in the wink of a shutter.

THOMAS MORAN

There are no indications that artist Thomas Moran was seeking an upheaval in his creative life when he joined the first major expedition to Yellowstone in 1871. His reasons for going were basic: as the first trained artist to view the area, he would have an instant market for his pictures and the opportunity to garner future commissions. The perilous wonders that lay ahead would exceed the artist's wildest dreams, and he would soon get more than he bargained for Out West.

Moran was born into an artistic family in Bolton, Lancashire, England, in 1837. His father, Thomas Sr., a weaver by trade, moved his family to America in 1844, settling first in Baltimore, then in Philadelphia. Following grammar school, young Tom was apprenticed to the engraving firm of Scattergood and Telfer.

Marine artist James Hamilton introduced the teenager to watercolors. Thomas sold his first works to bookstores in return for art books. After two years learning to engrave, he and his brother Edward established a small studio. Moran spent long hours sketching the Pennsylvania countryside. In 1861, the brothers went to England to study art under J. M. W. Turner.

Upon his return in 1862, Thomas married a Scottish expatriate and etcher, Mary Nimmo. In 1866, the couple began a two-year tour of Europe studying the old masters. Back in the states, Moran continued to teach painting, to illustrate books and magazines, and to exhibit whenever possible.

In 1870, with a wife and three children to support, the thirty-three-year-old artist was in need of a breakthrough in his career. Moran was assigned by *Scribner's* magazine to illustrate an article by Montanan Nathaniel Langford, a member of the Washburn expedition, on the wonders of the fabled Yellowstone country. Moran's illustrations were based on rough sketches provided by a soldier and a civilian in the party. He did his best, but curiosity left him awake nights, wondering what this fairyland really looked like.

When he learned that Dr. F. V. Hayden would be taking his geological survey team into the area during the summer of 1871, he asked to go along, stating that he would pay his own way. Hayden had already acquired photographer William Henry Jackson for the excursion, but he accepted Moran's request, reasoning that a colorist would be able to provide something his photographer could not. Moran borrowed $500 from Jay Cooke of the Northern Pacific Railroad in return for a dozen future watercolors and arranged with *Scribner's* for a healthy advance.

The railroad dropped Moran at Green River, Wyoming, where he made his first on-the-spot Western sketch. A stagecoach bounced him to Virginia City, Montana, where he joined the survey team. According to Jackson, the artist appeared "frail, almost cadaverous, and seemed incapable of surviving the rigors of camp life and camp food." Jackson conceded that he "made a picturesque appearance when mounted. The jaunty tilt of his sombrero, long yellowish beard, and portfolio under his arm marked him as the artistic type, with something of local color imparted by a rifle hung from the saddle horn." After Moran's first day on horseback, he found a pillow could be placed rather artistically between himself and his McClellan saddle.

On July 19, 1871, the party reached the first Yellowstone wonder, Devil's Slide on Cinnabar Mountain. The next day they were the first white men to view the awesome Mammoth Hot Springs. Moran was not afforded long hours at each site, just enough time for some quick sketches and color notations. Recognizing the value of Jackson's exposures to his own future work, Moran helped the photographer with his bulky equipment.

When he wasn't painting the wilderness, Moran was fishing it.

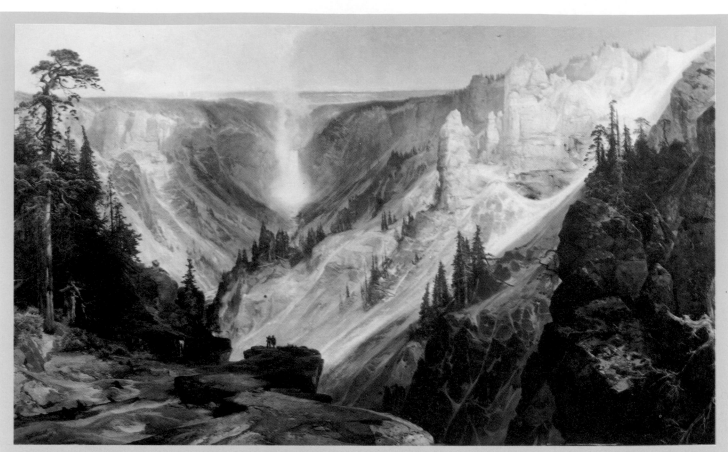

Moran's Grand Canyon of the Yellowstone, *1872.*
National Museum of American Art, Smithsonian Institution.
Lent by the U.S. Department of the Interior, National Park Service.

On July 25, he sketched the 156-foot Tower Falls. At the Grand Canyon of the Yellowstone, Moran felt totally inadequate, commenting that the colors were "beyond the reach of human art." The churning waters of Cascade Creek bounding from the rocks inaugurated "a mass of foam and spray, through which all the colors of the solar spectrum are reproduced." From there, he went on to witness the eruption of Old Faithful.

In early August, Moran returned Back East with a book of sketches and a mind swirling with the vibrant colors he'd seen. During the winter, he poured out his visions. A series of Moran's chromolithographs were paired with Jackson's photographs and submitted to Congress, playing a large part in the decision to make Yellowstone the first national park on March 1, 1872. The government purchased several large oils, including the seven-by-twelve-foot *Grand Canyon of the Yellowstone* for $10,000.

In 1872, Moran toured the Yosemite region with his wife, who found the rough terrain quite uncomfortable. In 1873, he accompanied Major John Wesley Powell on the Colorado River expedition through Utah and Arizona. The next year, he was in Colorado to sketch the phenomenon of the Mount of the Holy Cross. Idaho and Nevada were toured in 1879. He reunited with Jackson and weathered a prodigious thunderstorm at Devil's Tower, Wyoming.

In 1892, the now internationally acclaimed painter made a sentimental journey back to Yellowstone, where he found a hotel erected at Mammoth Hot Springs. It was here, perhaps, that the artist realized the importance of capturing with his paintbrush the wild country before civilization reached it.

Moran retired to Santa Barbara, California, in 1916. He died there in 1926 at age eighty-nine. The man who signed his works with the initials "T. Y. M." for his nickname, T. "Yellowstone" Moran, had found his soul in the vanishing Western wilderness.

His detractors were quick to note that he was not a true son of the West. Indeed, he was a Yankee who arrived on the frontier just before the last roundup. Yet, his brain filled with images and his saddlebag with paintbrushes, Frederic Remington dedicated himself to keeping the memory of the West alive for generations.

Frederic Sackrider Remington was born in Canton, in upstate New York, on October 4, 1861, to Pierre Remington and Clara Sackrider Remington. Pierre was a journalist who started the *St. Lawrence Plaindealer* as a platform to voice his Republican views. A Civil War hero, his main activities after the conflict centered on writing, harness racing, and the organization of the Canton Fire Department, for which his young son served as mascot. Frederic grew up with horses, studying and memorizing their every move and posture.

He entered the Highland Military Academy in Massachusetts at age fifteen, gaining popularity with the other cadets for his portraits. His father wanted his son to pursue a journalism career, but Frederic was born to draw. In 1878, the boy enrolled in the first classes offered by the School of Fine Arts at Yale. His first published drawing was made that year, a sketch of a battered football player in *The Yale Courant*. (Remington himself, at 180 pounds, played on the Yale line.)

He dropped out of college in February 1880, following the untimely death of his father. Frederic went to work as a clerk in the New York governor's office in Albany, but fellow employees noted that he let his work pile up, choosing to sketch his days away instead. In the summer of 1881, at nineteen, he vacationed in the West.

Camping out under the stars in Montana, Remington was overwhelmed by the changes that were taking place around him. "I knew the wild riders and the vacant land were about to vanish forever," he would write, "and the more I considered the subject, the bigger the Forever loomed. Without knowing exactly how to do it, I began to try to record some facts around me, and the more I looked the more the panorama unfolded."

The young man returned to his daily Albany routine, but visions of the cowboy refused to leave him. On his twenty-first birthday he departed for the wild country again, this time to ranch in Kansas. With his small inheritance, he lived on the land, roping and branding by day and painting by night. He began submitting his work Back East and on February 26, 1882, his first published illustration, *Cowboys of Arizona*, appeared in

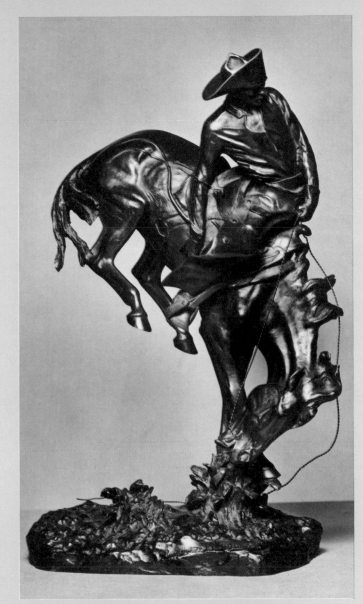

Remington's The Outlaw, *1906.*
Amon Carter Museum, Fort Worth, Texas.

Harper's Weekly. Though it was retouched by a professional, Remington was delighted with his success.

More sales followed, and the artist returned to Canton in 1884 to marry Eva Caten, whom he nicknamed "Missie." Eva's father had been refusing the suitor his blessing since 1879, but he had come to have a new belief in the young man's future. After two years in Kansas City, the couple set up housekeeping in Brooklyn, New York, and Remington enrolled at The Art Students League to refine his painting technique.

Remington at work in the field, c. 1905.

Frequent trips Out West became a Remington trademark. He even joined the search for Geronimo in the parched Apache badlands. Back in New York, he sold his entire portfolio to Yale friend Poultney Bigelow, editor of *Outing* magazine, who commented, "Here was the real thing, the unspoiled native genius dealing with Mexican ponies, cowboys, cactus, lariats, and sombreros . . . these were the men of the real rodeo."

By 1889, Frederic Remington was one of the best-known illustrators in the country. He had begun to publish his writings as well. He tried to bridge the gap between illustration and art with works such as *A Dash for Timber.* (His man and horse in action wasn't an editorializing statement, but instead a frozen moment of absolute, pure Western drama.)

In 1889, Remington traveled with the Mexican army, portraying on canvas scenes of their skirmishes with Indians. The trip also introduced bright, bold colors—the colors of the Mexican terrain—into his palette. The next year he toured the Little Bighorn, but just missed the massacre at Wounded Knee. Remington readily admitted he never understood the native American, but managed to capture some of his wild essence in epic works such as *An Indian Trapper.*

In 1895, Remington discovered a new medium. Encouraged by famous sculptors of the day, he tried his hand at clay. In August of that year, his first bronze cast,

The Bronco Buster, was finished. His well-known bronze *Coming Through the Rye,* portraying four cowboys on horseback shooting off their guns, was completed in 1902.

Remington's work made him an international celebrity. When Theodore Roosevelt published his Western memoirs, it was Remington he wanted for his illustrator. When it came time to re-release Longfellow's *Song of Hiawatha* and Parkman's *The Oregon Trail,* Remington was chosen as illustrator.

Influenced by Impressionism, the cowboy painter began to experiment with light in mysterious and beautiful ways. He became fascinated with the night, creating striking paintings of moonshadows in the snow.

Just before Christmas Day, 1909, he suffered abdominal pains. The diagnosis of appendicitis came too late. After undergoing emergency surgery on his kitchen table in Ridgefield, Connecticut, he died on December 26, 1909. He was forty-eight.

In part because of his premature demise, and in part because of his subject matter of cowboys and Indians, Frederic Remington's reputation as a fine artist remains as controversial today as it was during his lifetime. A prolific genius, Remington left us a vision of the West that remains authentic and romantic. His timeless characters will ride the range forever.

GRAND DUKE ALEXIS

Grand Duke Alexis (seated) *in a Kansas studio,*
flanked by his trusty scout, George Armstrong Custer.

In 1871, the son of Czar Alexander II became the first Romanov to visit America. It was clear that he was here for more than a mere state visit. In his twenty-one imperial years, he had attended plenty of grand balls. He was ready for adventure.

At a White House dinner given by President Grant on November 23 of that year, Civil War hero General Phil Sheridan assured Grand Duke Alexis that there was a wealth of excitement beyond the Mississippi. It was a wild land of staunch pioneers, untamed Indians, and

buffalo. If the royal visitor wished, he could have the War Department's Western Division for protection. The matter was settled. The Russian entourage was about to make a slight detour Out West early in the next year.

During the following weeks, the grand duke made his Eastern stops while Sheridan frantically did his advance work for the Western visit. The royal hunt's grand marshal would be the brash General George Armstrong Custer, the thirty-two-year-old Indian fighter four years away from his last stand. Their guide would be none other than William F. Cody, twenty-five, already known as Buffalo Bill.

Sheridan required Cody to "put on a show" for the imperial rifleman. To Sheridan, that meant corralling some friendly Indians to add to the pageantry. Cody found Sioux Chief Spotted Tail on the Frenchman River in southwest Nebraska, spent the night in his lodge, and, for a thousand pounds of tobacco, rustled some disgruntled braves (some say a hundred, others say a thousand) from their winter quarters. In the meantime, Colonel George Forsyth established Camp Alexis in southern Nebraska, on Red Willow Creek.

Alexis and his comrades left St. Louis by chartered train on January 11, 1872, and were met the following day in Omaha by Custer, resplendent in his buckskin. On the morning of January 13, the train chugged into North Platte and was welcomed by an enthusiastic throng, headed by Buffalo Bill.

After speeches and hoopla, the troops were off. According to Marshall Sprague in *A Gallery of Dudes,* the party "included a whole pack of Department of the Platte generals, two companies of infantry in wagons, two of cavalry, the Second Cavalry's regimental band, outriders, night herders, couriers, cooks, trailing groups of Indians and sutlers, and three wagons of champagne and royal spirits."

Sunday, January 14, Grand Duke Alexis turned twenty-two. After a spirited breakfast, Custer's scouts reported a buffalo herd near Medicine Creek. Custer finished applying his warpaint, then led the charge. (*Frank Leslie's Illustrated Newspaper* described his face as "illustrated with setting suns, anatomical dogs, and primitive canoes.")

As the party approached the unsuspecting buffalo, Cody signaled to let his guest have the first kill. Grand Duke Alexis rode out on Cody's horse, Buckskin Joe, got within twenty feet of the targets, and fired six wild shots from his engraved Smith and Wesson pistol. The shaggy beasts looked up and began to mosey away. Cody handed the grand duke his famed "Lucretia" .50-caliber rifle, the same one he had used to wipe out 4,280 buffalo in an eighteen-month period. This time, Alexis fired from a distance of ten feet, and the first animal crumpled.

"Very soon the corks began to fly from the champagne bottles," recounted Cody. Indeed, the Russians started quite a little party on the prairie. Alexis severed the buffalo's tail and waved it proudly. Lunch was served. Spotted Tail offered Alexis his pipe, but the young duke told the chief he preferred cigarettes. Early in the afternoon, Alexis—quite by accident—downed a buffalo cow with a pistol, and again the bottles appeared. "I was in hopes that he would kill five or six more before we reached camp," remarked Cody, "especially if a basket of champagne was to be opened every time he dropped one."

The second day saw a total of fifty-six buffalo bagged and a harried Alexis sent up a telegraph pole by a wounded beast. On the way back to North Platte, Sheridan suggested that Cody drive Alexis in an open carriage, saying, "Shake 'em up a little, Bill, and give us some old-time stage driving." Cody exaggerated that he covered "six bumpy miles in three minutes." Alexis commented, "I would not have missed that ride for a large sum of money, but, rather than repeat it, I would return to Russia by way of Alaska and swim the Bering Strait."

Alexis presented Cody with a fur coat and cuff links when the two parted company in North Platte. From there, the royal train proceeded to Denver, where they were honored with a ball at the American House. A fiddler told Custer that there was good hunting to the southeast, near Kit Carson, Colorado, and another trek exhausted the supply of caviar and sparkling wine. Custer accompanied Alexis through Kansas, back to St. Louis, then to Florida, where Alexis boarded the *Svetlana,* making sure his many hundreds of pounds of iced buffalo meat were packed on board.

The czar was not thrilled with the Americanization of Alexis, especially after the duke married a commoner upon his return. The marriage was annulled, and Alexis spent the rest of his life with mistresses. He later headed the Russian navy, resigning after the Japanese destroyed the fleet in 1905. He died in 1908. Perhaps the best times he had were in the glory days of the Old West, when he rode the range with Buffalo Bill.

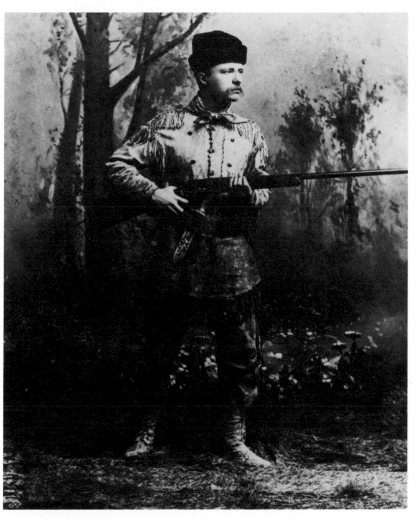

*Loaded for hunting bear, complete with alligator boots,
silver belt buckle, bowie knife, and scabbard by Tiffany.*

Young Theodore Roosevelt couldn't put enough miles between himself and the misery he'd left in his native New York City. At three in the morning on February 14, 1884, his mother had died of typhoid. Then, at two that afternoon, his twenty-two-year-old wife had succumbed to complications from childbirth. "When my heart's dearest died," he later wrote, "the light went from my life forever."

Following that summer's Republican National Convention in Chicago, the twenty-five-year-old future president placed his infant daughter in the care of an aunt, hopped aboard a westbound train, and headed for

a "vigorous open-air existence." He saw the wide-open spaces of the Dakota Badlands as just the remedy for his ravaged emotions.

Roosevelt had visited the territory the previous autumn and he had been captivated by the rugged country. The men of the range were hard pressed to remember a more determined cowboy, though with his high-pitched voice and pince-nez he seemed an unlikely rancher. The Yankee in buckskin would be given no special favors, however. It was his land to conquer on his own.

Establishing a ranch, which he called Elkhorn, on the

banks of the Little Missouri, Roosevelt hired Bill Sewall and his nephew, Will Dow, to manage it. That left Roosevelt time to explore, hunt, and write. His experiences would lead to an acclaimed trilogy, with the first volume, *Hunting Trips of the Ranchman*, published in 1885.

At first, he amused his hard-core ranch hands, then won their respect. Once, when some cattle broke loose, the men cracked up at his order to "Hasten forward quickly there!" One of his companions later recalled, "He was not a purty rider, but a hell of a good rider." Another time, Teddy dismissed a cowboy on the spot for branding a stray. "A man who will steal *for* me will steal *from* me," he blurted, "you're fired!"

Teddy best loved the hunt. During one two-month excursion into the woods, he killed scores of duck, grouse, sage hens, doves, prairie chickens, and rabbits, not to mention a goodly number of elk, deer, and bear. Later as president, he started a national craze by refusing to shoot a baby bear, giving one toy manufacturer the idea for the "teddy bear." Such consideration was not in evidence on these early trips, when he once boasted of shooting a cub "clean through from end to end."

The true adventure was hunting the grizzly, which, Roosevelt was convinced, "would make short work of any tiger." On an expedition in the Big Horns in Wyoming, he wrote to his sister:

Cocking my rifle and stepping quickly forward, I found myself face to face with the great bear, who was less than twenty-five feet off. . . . Doubtless my face was pretty white, but the blue barrel was as steady as a rock. . . . As I pulled the trigger I jumped aside out of the smoke, to be ready if he charged; but it was needless, for the great brute was struggling in the death agony.

Perhaps Roosevelt's favorite adventure Out West was a manhunt. In the spring of 1886, three men made the mistake of stealing a boat from Roosevelt's ranch and taking off down the Little Missouri. With Sewall and Dow, Roosevelt built a makeshift boat and headed in hot pursuit through the ice jams. They caught the men by surprise, and not a shot was fired. But getting them back to justice presented a problem.

Roosevelt's companions took the boats back while Roosevelt hired a wagon and driver to transport his thieves. There was no room on the wagon for Roosevelt, so he walked behind, his gun cocked, reading *Anna Karenina*. He walked forty-five miles in two days before finding a jail. When asked why he hadn't shot the thieves and saved himself a lot of trouble, he replied that the thought had never occurred to him.

Though he made frequent trips Back East, Roosevelt spent the better part of two years on the frontier before leaving for good just before the dreadful winter of 1886. His future was to be full of adventures too: he remarried, became assistant secretary of the navy, led his Rough Riders up San Juan Heights in Cuba during the "splendid little war" with Spain in 1898, was elected governor of New York that same year, and became vice-president under William McKinley, receiving the nomination at the Republican National Convention of 1900. The following year, an assassin's bullet put him in the White House. Said Republican National Chairman Mark Hanna: "Now look! That damned cowboy is president of the United States!"

During his nearly eight years as chief executive, Roosevelt went Out West on numerous occasions for hunting and socializing. Stories of his daring were often outlandish: one claimed that he once insisted on being dangled by his ankles over a cliff so he could shoot a mountain lion between the eyes. President Roosevelt brushed off this report as a "bully lot of rot."

During his terms in office he increased the area of the national forests by 148 million acres, established five national parks, sixteen national monuments, four national game refuges, and fifty-one national bird sanctuaries. Historians have concluded that the first naturalist president's love of "the strenuous life" may have been his greatest contribution to the country.

KATHARINE LEE BATES

Bates, about two years after her trip to Pikes Peak inspired one of America's greatest anthems.

Katharine Lee Bates, American educator and poet, had a secret ambition. She once confided to a friend that she hoped to "write a great poem, a poem that people will read long after I am dead, a poem that will always be remembered." Her name has been forgotten over the years but not her masterpiece, one of America's best-loved songs, which she conceived on the summit of Pikes Peak.

Katharine Bates was born into the family of a Congregational minister, William Bates, on August 12, 1859, in Falmouth, Massachusetts. Her father died a month after she was born. At age twelve, she moved with her family to Grantville.

In 1876, Katharine entered Wellesley College in Wellesley, Massachusetts, and began working on her English degree. Poetry was already a passion; she received her first national recognition with a poem called

"Sleep," published during her sophomore year in William Dean Howells's *Atlantic Monthly*.

She graduated at age twenty-one and began her forty-five-year teaching career. Her first assignment was at a high school in Natick, Massachusetts, followed by a brief stint at Dana Hall, a private school for girls. She then was hired as an English instructor at Wellesley, eventually headed the department, and remained there until she retired.

Though the plump, proper teacher enjoyed the security of her position, she loved the adventure of travel. Her children's story called "The Rose and the Thorn" won her a $700 prize, which she spent on a cultural tour of Europe. She studied at Oxford during the 1892–93 school year. Upon returning home, she and other American educators (including writer Hamlin Garland and Woodrow Wilson) were selected to teach at a summer session of Colorado College in Colorado Springs. At age thirty-four, Katharine bade a fond farewell to her elderly mother, whom she supported financially, her collie Hamlet, and her parrot Polonius, and headed Out West.

En route she stopped for a day at Chicago's famed World's Columbian Exposition and was overwhelmed by her country's ingenuity and resources. Already, the wheels were turning in her poet's brain.

At Colorado College, teachers met after classes to discuss the ways of the world and the meaning of life. During one session, as described by historian Ernest Emurian, Katharine compared America to the world's great societies of the past. "Unless we are willing to crown our greatness with goodness, and our bounty with brotherhood," warned a stern Kate, "our beloved America may go the same way."

At the conclusion of the summer term, Katharine joined a group for a mountain excursion, the most famous trip up Pikes Peak since Zebulon Pike's journey in 1806. On July 22, 1893, Katharine bustled into the back of a creaky covered wagon with a sign on its frame inscribed "Pikes Peak or Bust" and began the ascent.

At the summit of the 14,110-foot mountain, some of the tourists got out to throw snowballs; others did well to catch their breath. Katharine stepped down, walked away from the group, and beheld the majestic panorama of America the Beautiful.

Her soul tingled from the lofty view: the cloudless sky,

the endless prairies framed by silent mountains. Years later, when asked about the moment, she would recall, "Then and there, as I was looking out over the sea-like expanse of fertile country spreading away so far under those ample skies, the opening lines of the hymn floated into my mind."

The moment was hardly longer than that. The scheduled half-hour visit was cut short when two members of the group became violently ill from the altitude. After "one ecstatic gaze" she was back in the wagon, heading down the mountain, her mind ignited by patriotism.

Before leaving Colorado Springs, Katharine recorded four very important lines in her notebook:

O beautiful for spacious skies,
For amber waves of grain,
For purple mountain majesties
Above the fruited plain!

Back at Wellesley, Katharine resumed her duties, pausing at times to work on her poem. In 1895, she sent the finished product to a publication called *The Congregationalist*. It was published on the Fourth of July, and by the fifth Katharine was famous.

Fan mail arrived daily. One man asked for ten copies of the poem for his grandchildren. More than a hundred composers wrote, asking permission to put their music to her words. She politely sang each song as it came in but for years found none that suited her.

The piece of music Bates finally chose, "Materna" (Latin for "motherly"), had been composed by New Jersey music dealer Samuel Augustus Ward in 1882 for a composition called "O Mother Dear, Jerusalem." Some sources credit the ultimate match as being the handiwork of Dr. William Penn Brooks, president of Massachusetts Agricultural College, in 1912. Regardless, the music and words seemed made for each other, and "America the Beautiful" became perhaps the country's favorite song in World War I.

In 1928, Miss Bates, then retired, attended the National Education Association meeting in Minneapolis, where she heard her song sung by a chorus of girls from twenty nations. She died the next year on March 29 at age seventy. After an active campaign by supporters of both songs, her's was edged out as the national anthem in 1931 by "The Star-Spangled Banner."

Her biographer, Dorothy Burgess, analyzing the popularity of "America the Beautiful," said of the song and her fellow citizens: "It rejoices in the gifts of their great country, it honors their dead, it pays homage to their past, it utters their aspirations and it lifts their prayers. It is truly an American anthem." Katharine Lee Bates achieved her secret ambition. Her words ring out from sea to shining sea.

MOTHER CABRINI

A congregation of doves swirled about her father's small hut on the morning she was born, July 15, 1850, in Sant'Angelo Lodigiano, Italy. From her first moments, they knew that Francesca Maria Cabrini, whose confirmation name would be Xaviera, was special. Still, it is doubtful the townspeople imagined that this frail little girl would become a strong-willed figure Out West, as well as the first American saint.

In her childhood, she nearly drowned after losing her balance near a spring. They found her on dry land, with no memory of how she had survived. In another incident, a locked church door threatened to cancel services, but a touch by Francesca freed the latch, and the door swung open.

Her future seemed preordained. At eighteen, she joined a local religious order, the Sisters of the Sacred Heart. Her organizational talents shone in 1888, when she set up a school in Rome under the auspices of Pope Leo XIII. The following year, at his request, she sailed for a new land reputed to be filled with sin and corruption. Landing in New York City in March, she worked tirelessly in the Little Italy section, forming an orphanage and later a hospital.

From New York, she journeyed to Nicaragua and then to Grenada, where her order was eventually expelled due to an uncertain political climate. From there her mission led her to the sin-ridden town of New Orleans, then to South America, then back to Rome.

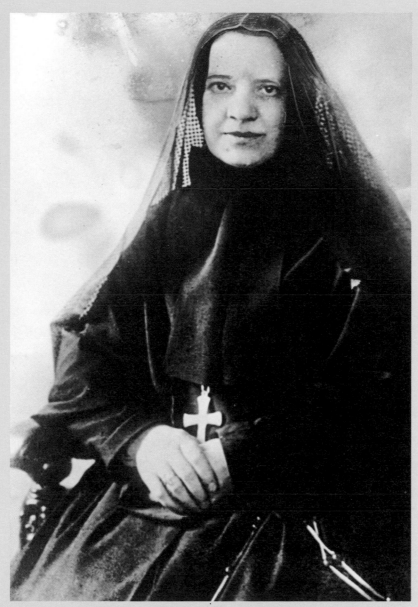

Mother Cabrini in 1905.

In July 1902, Mother Cabrini was invited by the Most Reverend Nicholas C. Matz, second bishop of Denver, to inaugurate a house for her community of nuns in the Mile High City. Upon her arrival, she rented a house at Thirty-fourth and Navajo and established quarters for nuns and orphaned Italians.

Gold miners deep inside the Rocky Mountains soon were astounded to find a host of nuns visiting their lightless diggings. Descending by cage hoists, Mother Cabrini brought to the miners her message of salvation: "My good brothers, we come down into the bowels of the earth to you in the name of your Creator, He who pines for your filial love."

Repeated trips to the American West followed. In 1904, when she was visiting Salt Lake City, a wild black stallion came stampeding down the streets toward her group of nuns. All scattered except Mother Cabrini, who stood her ground. When the horse reached her he stopped, bowed, and then proceeded on his rampage.

While she was sleeping on a train traveling across Texas after a visit to New Orleans, a highwayman fired a shotgun loaded with nails through the window of her sleeping car. The conductor halted the train and went back to check, fearing the worst. Mother Cabrini was covered with splintered glass but unhurt. A nail flying straight for her head had been diverted mysteriously down through her pillow and mattress at a ninety-degree angle.

Mother Cabrini became a naturalized American citizen in 1909. She returned to Denver in 1912 to scout out a summer property for her expanding orphanage. In real estate, she was a holy terror. *Time* magazine would later say, "She was as tough as she was canny."

In the foothills west of Denver, she stood on the highest point of a nine-hundred-acre tract and inhaled the mountain's majesty. "Here is the summer home for my little ones," she whispered. With that, she selected some white rocks and fashioned a heart on the ground to signify the Sacred Heart of Jesus.

One hot afternoon she and the sisters were gathering stones for a three-story, fourteen-room home when they became thirsty. They had been told the land had no water when Mother Cabrini signed the papers, but she seemed not to care about such trivialities. Now it was hot, and they were thirsty. There was no water? "Nonsense, lift that rock," said Mother Cabrini. They did, and water flowed from a mountain spring.

When she died on December 22, 1917, in the Columbus Hospital she had founded in Chicago, her legacy lived on. Over the years she had ventured across the ocean to the New World sixty-seven times and had founded sixty-seven different facilities: orphanages, convents, hospitals, and more, all in God's name.

The move to canonize Mother Cabrini began soon after a miraculous incident occurred in her Columbus Hospital in Manhattan in 1921. An infant named Peter Smith had been horribly scarred and blinded when a nurse had washed his eyes with a solution of 50 percent silver nitrate instead of the usual 1 percent. All night the nuns prayed. The next morning his eyes were clear, but he had contracted a severe case of pneumonia. Another night of prayer followed. He was well the next morning.

In 1938, Mother Cabrini was beatified by Pope Pius XI. On July 7, 1946, in canonization ceremonies at St. Peter's in Rome, she became the first American saint. At the same time, Peter Smith, then a young man and a candidate for the priesthood, was meditating in the Catskills.

On July 11, 1954, on the property near Denver that she had chosen for her summer orphanage, the Mother Cabrini Shrine was dedicated, a twenty-two-foot-high statue of Christ reaching out to the mountains. It is the West's monument to this humble nun whose goodness and creativity were inexhaustible.

ZANE GREY

Zane Grey did not invent the American West. Indeed, the glory days were over by the time he ventured Out West in search of something to write about. Still, enough romance lingered in the air to seize the imagination of this brooding dentist, giving him a literary lasso with which to rope the best-seller charts and become the patriarch of Western fiction.

Pearl Zane Gray (he would eventually change the spelling to "Grey" and drop the first name completely after a fan letter began, "Dear Miss Grey") was born January 31, 1875, in Zanesville, Ohio (the town founded by his maternal grandparents). His mother, Alice Josephine Zane, was an avid storyteller, but Grey's stern and humorless father, Dr. Lewis Gray, had no time for such nonsense. The sour preacher-turned-dentist deprived the world of the first Zane Grey story when he torched his fourteen-year-old son's first manuscript, "Jim of the Cave," and whipped the boy with a carpet strip for writing it.

To help scrub these foolish literary aspirations away, Doc Gray put his son to work in his office, where the boy assisted by pulling teeth with his powerful hands. Those hands were good for more than boosting bicuspids—Pearl turned into a mean baseball pitcher and earned a scholarship to the University of Pennsylvania, thanks to his blinding fastball. Upon graduation in 1896, he settled in New York City, where he set up a small dental practice.

Dr. Pearl Zane Gray found the profession of his father a total bore. Business was so bad, he closed shop in the summer to supplement his income playing semiprofessional baseball. In the winter, the time between appointments was spent reading adventure stories. In 1900, he met seventeen-year-old Lina Roth, a lover of literature who hoped someday to marry a writer. Zane put down the drill and picked up the quill.

An avid angler, Dr. Gray's initial goal was to become a fishing writer. His first published work came out in 1902 when he sold "A Day on the Delaware" to *Recreation* for $10. Next, he began a historical novel based on the exploits of an ancestor. *Betty Zane* was completed in the spring of 1903 and met with unanimous rejection.

Zane Grey, c. 1928. He plotted his novels while his corks bobbed in the water.

The book did impress Zane Grey's most important editor, Lina, who had acquired the nickname "Dolly." With $200 from her inheritance, she paid to publish it. A second manuscript, *The Spirit of the Border,* was accepted by a small publishing house, which gave Grey enough encouragement to leave dentistry, marry Dolly, and move to Lackawaxen, Pennsylvania, to write full time.

By 1907, Zane Grey was thirty-five. His future looked bleak. Dolly's savings were dwindling. After attending a lecture by Arizona cattleman Buffalo Jones, Grey decided a trip to the Grand Canyon might have some influence on his work. On March 27, 1907, Zane Grey arrived Out West.

His soul was stirred by the wild terrain and the pioneers who occupied the vast frontier. Western subjects in literature at this time consisted of hokey dime-novels and Owen Wister's classic *The Virginian.* Writing in longhand while seated in a Morris chair, Zane Grey sought to bring the West to life.

His first Western, *The Last of the Plainsmen,* was snubbed by Harper and Brothers and its editor Ripley Hitchcock, who said, "I do not see anything in this to convince me you can write either narrative or fiction." Grey was dashed, but unready to throw in the saddle blanket. Next came *The Heritage of the Desert.* Hitchcock was forced to eat his words: Harper published the novel and sold thirty-one thousand copies on its first printing.

In 1912, his third Western began, "A sharp clip-clop of iron-shod hoofs deadened and died away, and clouds of yellow dust drifted from under the cottonwoods out over the sage." Zane Grey had started what would come to be regarded as the best Western novel of all time, *Riders of the Purple Sage.*

Income for this lean, mean writing machine increased dramatically. In 1909, the year son Romer was born, Grey had brought in $423. With *Desert Gold* in 1913 he reached the $100,000 mark. In 1917, *Wildfire* was the No. 3 best-selling book. In 1918, *The U.P. Trail* was No. 1. In 1920, the same year F. Scott Fitzgerald's *This Side of Paradise* sold 35,000 copies, Zane Grey's *The Man of the Forest* sold 714,500 copies.

Despite his success, the author suffered from fits of depression, helped none by critics who considered his work cowboy corn. He was able to soothe his wounds with a twenty-five-room Spanish mansion in Altadena, California, as well as a fishing yacht worth half a million dollars. (He was a champion fisherman, holding as many as ten world records at one time.)

His literary output was incredible—Grey was capable of turning out one hundred thousand longhand words per month. That meant two, and sometimes three, best-sellers in a year's time. After a stroke in 1937 left him paralyzed, he rehabilitated himself and was fishing in Australia a year later. In 1939, following the publication of *Western Union,* he suffered a heart attack on October 21 that proved fatal.

At age sixty-five, Zane Grey had left a legacy of sixty-six novels; twenty-six would be published posthumously. Over 130 motion pictures were made from his books, and he is believed to have earned $37 million in his lifetime. Total book sales by the one-hundredth anniversary of his birth in 1975 tallied over 50 million.

With a cast of characters led by heroes, villains, and horses, Zane Grey became the most successful author in the country. An incurable romantic with no literary training, he discovered a gold mine in the West and, in the process, defined a genre.

JOE HILL

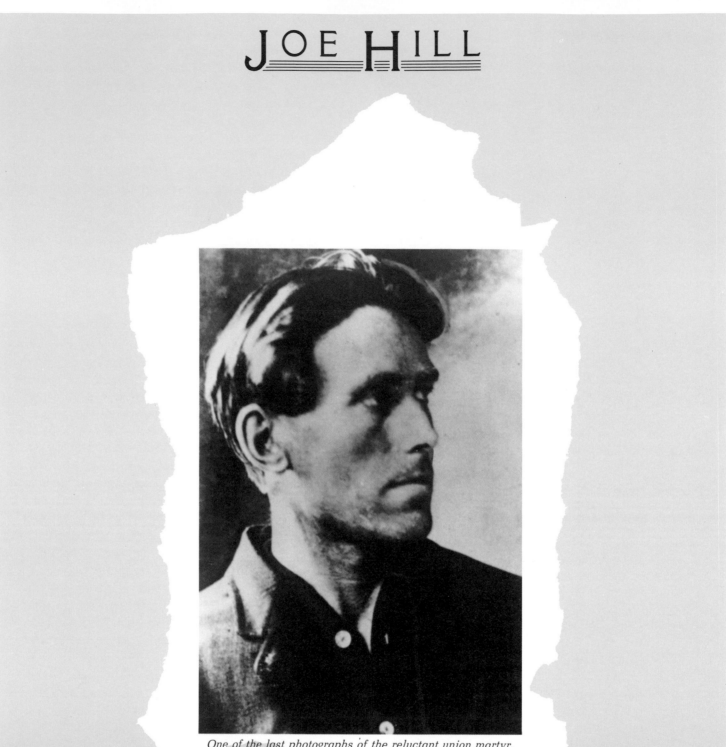

One of the last photographs of the reluctant union martyr.

For most of his life, Joe Hill was an unknown labor organizer and songwriter, praising the workers of the world with his clever rhymes. His route to legendary status was a confusing one that began obscurely in his native Sweden and ended in a hail of bullets and headlines Out West.

Joel Emmanuel Hägglund was born to parents Olof and Margareta on October 7, 1879, in Gavle, Sweden. Conductor Olof was killed in a railroad accident when Joel was eight, leaving the youngster to help support the family of nine children. Eventually, he found work at sea and following his mother's death in 1902, he emi-

grated to the United States.

After a year in New York City, Häglund left for Chicago, where he was fired from a machine shop after attempting to organize the workers. To escape being blacklisted over the incident, he changed his name to Joseph Hillstrom and became known to associates as Joe Hill. By 1910, he had joined the Industrial Workers of the World, the radical "One Big Union" known as the Wobblies, whose manifesto defiantly declared, "It is the historic mission of the working class to do away with capitalism."

Hill's main contributions were his songs, rousing anthems such as "Casey Jones—The Union Scab," that he composed to bolster the spirits of thirty-five thousand striking shopmen on the Illinois Central Railroad. His greatest hit, "The Preacher and the Slave," gave the American lexicon a new phrase: "You'll get pie in the sky when you die."

En route from Los Angeles to Chicago in 1913, Hill stopped in Salt Lake City to work as a miner. Fired from his job after an illness kept him out for two weeks, he moved in with friends, the Eselius brothers, in nearby Murray. On the evening of January 10, 1914, Joe Hill and acquaintance Otto Applequist left for an undisclosed destination.

Just before 10:00 P.M., Salt Lake City merchant John Morrison and sons Arling and Merlin were closing their family-owned grocery. Morrison, an ex-policeman, lived in fear of retaliation for law-enforcement services he performed in the line of duty. Already, he'd survived two attempts on his life since leaving the police force.

Suddenly, two masked gunmen stormed into the store. One yelled, "We have got you now," and opened fire. When the smoke cleared, Morrison and Arling lay dead. Before calling the police, Merlin noticed his father's pistol on the floor next to his brother, but it was impossible to tell whether Arling had fired the weapon.

Joe Hill arrived at the home of Dr. Frank M. McHugh just after 11:30 that night. "Doctor, I've been shot," he said. "I got into a stew with a friend of mine who thought I had insulted his wife." The bullet had passed through his body, grazing his left lung. McHugh dressed the wound and sent Hill back to the Eselius home. Three days later he told authorities about his mysterious patient.

The police arrested Hill on January 13, shattering his right hand with a bullet when he tried to reach for a handkerchief. Applequist was never seen or heard from again, and Hill was charged with murder. All revenge motives in the killings were suddenly forgotten, as were four suspects who were released after Hill's apprehension.

At his trial, Hill steadfastly refused to reveal how he had been wounded. On the third day he publicly fired his pair of lawyers, complaining, "I have three prosecuting attorneys here, and I intend to get rid of two of them." Other defenders were appointed, but nothing seemed to go right for the penniless Wobbly. According to author Gibbs M. Smith, whose *Joe Hill* is the most detailed account of the case, "Hill seems to have believed that he would be dealt with justly, regardless of what he did as a defendant."

Joe Hill was found guilty and sentenced to death on July 18, 1914. When asked to choose how he wished to exit this world, he replied: "I'll take shooting. I'm used to that. I have been shot a few times in the past, and I guess I can stand it again."

Now the furor erupted. I.W.W. officers took the conviction personally and did everything possible to arouse public sympathy for "Worker Hill." As the appeals and stays of execution were exhausted, pleas for clemency arrived from such notables as Helen Keller and President Woodrow Wilson. Swedish Foreign Minister W. A. F. Ekengren tried up until the eleventh hour to prevent the execution.

On the night before his death, Joe Hill wrote his own epitaph when he wired I.W.W. founder Bill Haywood: "Don't waste any time mourning—organize!"

At 5:00 A.M. on November 19, 1915, the prisoner awoke, ripped his blankets to shreds with a broken broom handle, and tied his cell door shut with the pieces. He barricaded himself behind his mattress when the guards came. After being subdued, he said, "Well, I'm through, but you can't blame a man for fighting for his life."

Joe Hill was led into the courtyard and seated on a wooden chair, a paper target pinned over his heart. From a blacksmith shop, twenty feet away, five rifles pointed through holes punched in a canvas drape. A deputy shouted "Ready, aim..." and Hill himself yelled, "Fire—go on and fire." Three of the four live bullets found their target. At 8:16 A.M. Joe Hill, a reluctant martyr, was pronounced dead.

HOUDINI

The soft amber footlights of Denver's Orpheum Theater glowed, reflected in the mystified eyes of Chief of Police Glenn Duffield. Onstage, the world-famous master magician Harry Houdini was completing an evening of ragtime-era bafflement.

Water splashed onto the wooden stage as the star of the show was lowered headfirst, shackled and hung by his feet, into a huge tank of water. It was Houdini's show-stopping finale. And, just like local patrons in other large cities, the Denverites were certain he had drowned until he bounded out from behind the stage curtain, soaked, but full of spirit.

Duffield worked his way through the mesmerized crowd to the backstage area, only to find Houdini besieged by autograph hounds. At the first opportunity, he introduced himself and asked Houdini his secret. The magician politely declined to divulge it. Duffield then surmised, aloud, that Houdini must use "safe" locks. The onlookers' jaws dropped as their bold chief predicted disparagingly that Houdini would be reduced to a bound-and-gagged clown if only Denver's finest could fasten the bonds.

That was too much for old Harry, who had built a reputation on duping the men in blue the world over.

The gauntlet had been thrown, the challenge made. Houdini couldn't decline. He would be handcuffed and his ankles would be bound. Then he would be fitted into a straitjacket, hoisted by his feet, and left to dangle upside down from the roof of the old, four-story *Denver Post* building at Fifteenth and Champa streets. There, thought Duffield, the fakery would be exposed for all to see.

By noon on Thursday, December 30, 1915, more than seven thousand people had gathered in front of *The Post*. Houdini arrived at 12:25 P.M. and met two detectives, Wash Rinker and Herbert Cole, on the small platform that had been erected for the occasion. After his

hands were cuffed, Houdini seemed to fret over the straitjacket, the strongest type available from the Colorado Asylum for the Insane. He asked the two detectives to let him down in fifteen minutes if he had not freed himself. "I'll know by then," he said, somberly.

When the jacket was cinched as tight as the detectives could pull it, a huge crane's line was lowered from the top of the building, Houdini's ankles were attached to its hook end, and he was jerked rudely into the white winter sky. The crowd waited patiently, watching as the forty-one-year-old Houdini hung silently, more than thirty feet above the cold pavement.

Nothing was happening. Duffield smiled, nodded, and winked knowingly at his assistants. Had the man who had wriggled free of his chains in the East River finally met his match? Was this to be Houdini's last public challenge?

Of course not. Suddenly, he began to gyrate wildly, thrashing, twisting, and jackknifing his supple body into unbelievable contortions. An instant passed and Houdini's triumphant laugh echoed off the building walls up and down Fifteenth Street. He rolled the straitjacket off his body, let it flutter briefly in the wind, and then dropped it into the crowd. Thunderous cheers erupted as Houdini was lowered to the platform. It had taken two and a half minutes to serve a figurative dish of crow to Chief Duffield. Detective Rinker was stupefied. "I've strapped up a hundred insane patients and never one of 'em got away," he mumbled in embarrassment. "But you see," smiled Houdini, "I'm not insane."

Houdini died on Halloween night, 1926, of appendicitis. His fascination with the occult prompted him to predict that he would contact the living if at all possible. But more than fifty years of Halloween seances by his devotees have turned up no messages—just magical memories of the ultimate escape artist.

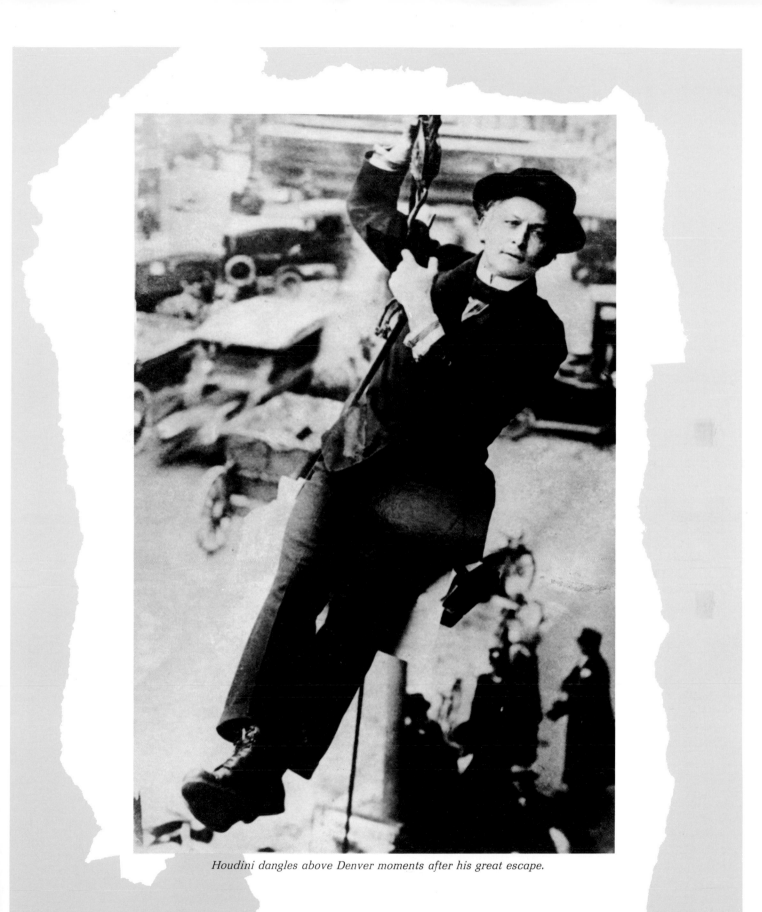

Houdini dangles above Denver moments after his great escape.

FATHER FLANAGAN

Father Flanagan rehearses with the Boys Town choir in 1947.

A favorite Hollywood plot of the 1930s dealt with the kind Irish priest who found the toughest kids on the planet and, through love and goodness, put them on their way to being model citizens. Out West, this sentimental scenario happened in real life, thanks to the tireless efforts of Father Flanagan and the young men of Boys Town.

The fragile Edward Joseph Flanagan was born on his father's farm near Roscommon, Ireland, on July 13, 1886.

When only a few weeks old, he suffered a near-fatal convulsion, an ominous preview of the health problems he would encounter throughout his life. At age six, he astounded parents John and Nora with his rescue of a lamb from a brier patch. The boy worked patiently and methodically with the thorns until the animal was finally freed, virtually unscathed.

The aspiration to become a priest came early for Eddie. A Father Featherstone made the prediction after

mass one morning, and Nora, mother of twelve children, was very proud. Older brother Pat was already studying for the cloth. Bright and helpful Edward would be a natural. The road to priesthood would be a long one, though, with many a winding turn.

At fourteen, Eddie enrolled at Summerhill College, a strict facility in the coastal town of Sligo. After completing the curriculum, he followed brother Pat, who by that time was a priest in Omaha, Nebraska, to America. In 1906, he graduated from Maryland's Mount St. Mary's College, then entered St. Joseph's Seminary in Dunwoodie, New York, where he managed to supplement book learning with frequent visits to hospitalized Irish immigrants. A severe bout of pneumonia, however, forced the postponement of his graduation to the clergy.

On doctor's orders, Edward visited his brother in Omaha in 1907. There he discussed his future with Bishop Scannell, who in turn arranged for the twenty-one-year-old Flanagan to study at the Gregorian University in Rome.

More health problems followed, due to an unusually cruel Italian winter. Heartbroken, Flanagan returned to Omaha in 1908. He took a bookkeeping job at the Cudahy Meat Company. He regained his strength and received a liberal education in financial matters, knowledge that would come in handy in later years. Finally, in 1912, after three years of study at the Jesuit University in Innsbruck, Austria, he was ordained. Returning to Nebraska, his first assignment was as an assistant pastor in O'Neill.

Six months later, he was filling the same position at St. Patrick's Church in Omaha when he began a new project. A severe drought had increased unemployment, and Father Flanagan worried about the men sleeping on the Omaha sidewalks. Through a real-estate agent he found the owner of the dilapidated Burlington Hotel, on the corner of Eleventh and Mason.

Rent was arranged at a few dollars a month. Next, Flanagan hustled for everything he would need: food, building materials, blankets, beds. He recruited the homeless to fix up the hotel. Inside the decaying Burlington, the sounds of hammers and saws could be heard far into the night. Soon, the Workingmen's Hotel was a reality, a skid-row oasis in a desert of hard times.

As the hotel's business increased, Father Flanagan studied his "guests" intently. Some were just down on their luck, while others were hardened misfits who would never reverse their downward mobility. All seemed to share one characteristic, a dismal childhood from an assortment of broken homes. Whatever the reason—alcoholic fathers, neglectful mothers, general abuse—a main ingredient called love had been lacking in their backgrounds.

One night, while Flanagan was completing some paper work in the hotel lobby, a nine-year-old waif stepped inside. His father was long gone, his mother had just died, and the mean streets were his home. Flanagan took the boy in, and eventually placed him in a foster home. From that time on, Flanagan would channel his strengths to the needs of youth.

Just before Christmas in 1917, Father Flanagan rented a large house on the outskirts of Omaha for $90 a month. His first occupants, five "criminals," aged ten and under, had been rescued from sentences to reform school when the priest persuaded the judge to release them to his care. A week later, fifteen more street urchins had found their way to the house. Two nuns, along with Flanagan's mother and sister who had come from Ireland, helped with their care.

"It seems that every time I turn around," Flanagan noted, "there is another poor boy arriving from juvenile court." By Christmas Eve, nearly every race and creed was represented and the needy children just kept coming. Soon, the home relocated to a larger house and then to a forty-acre site outside town. Flanagan's friend Henry Monsky raised more than $200,000 for dorms, classrooms, a baseball field, and a chapel. About this time, the group received an unexpected motto.

A destitute woman had brought her small son to Flanagan. When she left, Flanagan found that the boy was unable to walk. A handicapped boy was something unprecedented for Boys Town, simply because of the extra care required. An older boy named Joe happened by the office and hoisted the younger one on his shoulders. "Is he too heavy?" asked Father Flanagan. Joe grinned, "He ain't heavy, Father. He's m'brother."

By 1936, the newly incorporated city of Boys Town was home to several hundred boys. In addition to a boy mayor and a boy chief of police, residents ran the theater, gymnasium, barber shop, bakery, laundry, and power plant. They were discovered by Hollywood in 1938, and Spencer Tracy won the Academy Award for Best Actor for his portrayal of Father Flanagan in *Boys Town*. (He later presented the award to the real Father Flanagan.) The good Father used his new celebrity status to benefit his favorite village.

On May 15, 1948, while touring Berlin orphan facilities at the request of Uncle Sam, Father Edward Flanagan died of a heart attack. Boys Town mourned one of the world's most famous clergymen as headlines repeated his simple creed, "There is no such thing as a bad boy."

QUEEN MARIE OF RUMANIA

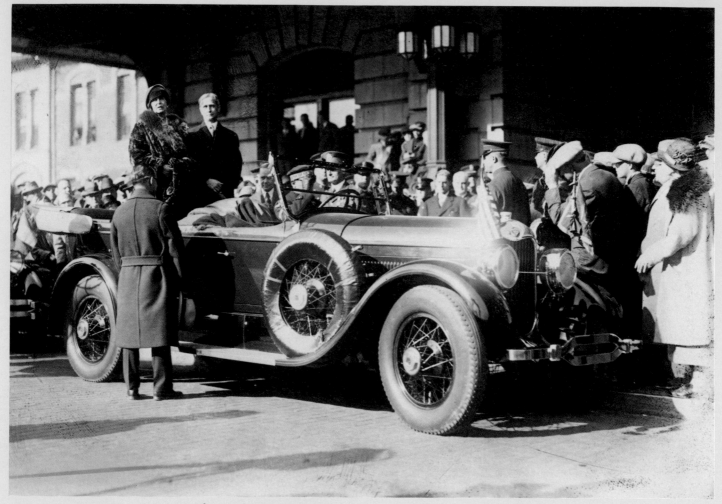

The royal visitor from Rumania was a mile-high crowd pleaser.

When the people of Rumania wondered why the Sam Hill their Queen Marie was going to America in 1926, she said the idea had come to her in a dream. An invitation from wealthy American businessman Sam Hill to dedicate his unfinished library in Maryhill, Washington, clinched it. She knew that Americans already loved her and thought a grand tour, including a swing Out West, could aid her country's post-World War I finances—as well as her own.

Marie was born in England in 1875, the daughter of the Duke of Edinburgh and Grand Duchess Marie, daughter of Russia's Czar Alexander II. She could have become the Queen of England, but she turned down a proposal from Prince George. Instead she married Prince Ferdinand of Rumania, and they ascended to the throne in 1914.

She brought to America two of her six children, a desire for dollars, and a questionable reputation. Marie was a writer and wanted to peddle her impressions of America. She was quoted as saying, "Now let's talk business. I am a professional writer, am I not? What will you pay?" She then granted "exclusivity" to two rival syndicates.

Marie had another passion besides writing—men. Ferdinand was a sickly type, and scandal within the castle walls was as commonplace as tourists looking for Count Dracula. Her Majesty, of course, couldn't have cared less. She arrived in October 1926 in New York City wrapped up in the riproaring spirit of the Roaring Twenties. After receiving the key to the city from dashing Mayor James J. "Jimmy" Walker, Marie rode with him in an open car, remaining composed when a con-

struction worker shouted to Walker, asking His Honor if he'd managed to bed Her Highness.

She locked up some advertising endorsements ("Queen Marie says: 'It's better to reach for a Lucky, than a sweet'") and was ready to tour. The Baltimore and Ohio Railroad provided ten luxury cars for her entourage of eighty, which included Prince Nicholas and Princess Ileana, aides, her dear friend dancer Loie Fuller, several European dignitaries, railroad officials, members of the press, and Creki, the royal spaniel.

Among the reporters was a young journalist who had recently left Denver for a job with William Randolph Hearst in New York. At age thirty-six, Gene Fowler had a devilish charm that, according to several sources, literally swept the fifty-one-year-old monarch off her feet. Marie missed several of her back-platform appearances on the train to Washington. Embarrassed members of her party noted that there was no sign of either the queen or Gene.

Those episodes weren't reported at the time, but the public delighted in misadventures that were. "Bunny" Ayres, a young Ford employee in charge of motor transportation, was booted off the tour for a while when he hustled Princess Ileana to a college football game without permission. Loie Fuller also was dismissed after several run-ins with railroad officials. The question of the princess's paternity came up when the Queen of Yugoslavia, daughter of Queen Marie, who wasn't on the trip, was quoted in American newspapers saying, "Why does Mother promenade that Mlle. Shtirbey over the world?" Rumania's "Black Prince" Shtirbey had been a pal of Marie's for years.

Following the dedication, the caravan stopped in Wyoming to pick up America's first woman governor, Nellie Tayloe Ross, then moved south for a November 10, 1926,

date in Denver. Queen Marie greeted the Queen City that morning at Union Station. Then her party motored to City Auditorium, where she was met by another crowd fourteen-thousand strong. From the auditorium, it was off to Lookout Mountain for a pastoral luncheon in the Charles Boettcher mansion.

Writer Thomas Hornsby Ferril, who was at the luncheon, recalled that the Secret Service mistook Prince Nicholas for a waiter and made him wait with the hired hands until the meal was served. At another point, Creki raised his leg on the Boettchers' Steinway grand piano. After lunch, Marie headed for an hour-long advertising stint at the Denver Dry Goods Company, where she endorsed Hoover Suction Sweepers.

That afternoon, Marie met with Denver schoolchildren in City Park, where she commented that "Denver has the finest police department in the world. I have never seen policemen so courteous, so neat, so efficient, and so good-looking." At a gala at the Brown Palace Hotel that night, the flapper monarch announced a plan to write a book of fairy stories for American children and named State Senator Henry Toll as her American literary agent, having known him only for fifteen minutes.

An off-the-cuff idea to name a Colorado mountain peak after her never jelled, and soon it was back to Bucharest. Queen Marie died in 1936. As for her favorite reporter, H. Allen Smith writes in his *The Life and Legend of Gene Fowler* that when asked about the queen, Fowler "smiled that satisfied smile, lifting his eyebrows. Fowler was not a Barrymore, but he could convey meaning without speech." Author Ben Hecht wrote that Queen Marie had to "return Fowlerless and heartbroken to the throne."

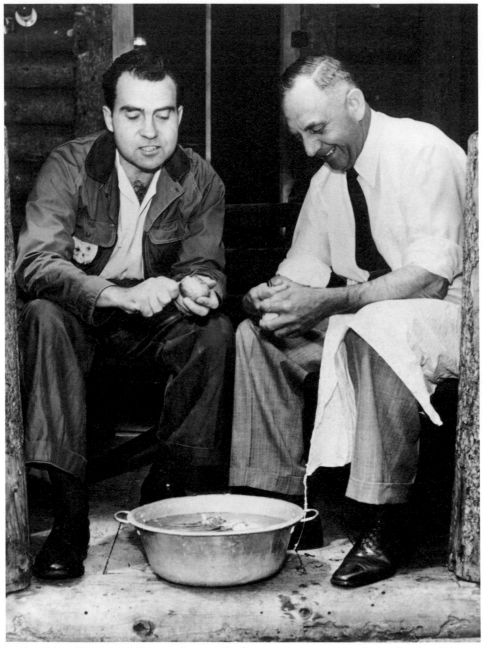

Candidate Nixon and Kansas Senator Carlson conduct a top-level meeting Out West.

By the time young Richard Nixon's plane touched down at Denver's Stapleton International Airport on July 27, 1952, he was already a man of many accomplishments. He'd managed to parlay his World War II poker-playing skills into quite a successful political career. He'd been elected to the Eightieth Congress at age thirty-three, after labeling his opponent, incumbent Jerry Voorhis, a blatant communist. That campaign had been so successful that he repeated the tactics in 1950, calling California Senator Helen Gahagan Douglas the "Pink Lady" and winning by 700,000 votes.

As a senator, he'd sent Alger Hiss to prison, establishing himself as the country's top red baiter. America was in love with this thirty-nine-year-old Cold War hero. Two weeks before landing in Colorado, he'd been nominated for vice-president of the United States at the Chicago Republican National Convention. At the top of the ticket was the most popular man in America, Dwight David Eisenhower, who just happened to be Out West fishing at the time of Nixon's visit.

Nixon, his wife Pat, and his daughters, Patricia, age six, and Julie, age four, waved heartily to the crowds at Stapleton. Mrs. Nixon was still a little flabbergasted by the recent events, telling reporters: "Two years ago when we finished up our campaign for senate, I thought, 'Good, no more of this for at least six years now.' Then Dick got into this."

Leaving the wife and kids in Denver, Nixon hopped into a car and drove seventy-two miles west to Fraser, then two miles west of there to the Byers Peak Ranch, owned by Ike's buddy, Askel Nielsen. He arrived in a business suit but quickly borrowed some khakis and a sport shirt.

Eisenhower had been vacationing since the end of the convention, keeping in touch with his national campaign headquarters at Denver's Brown Palace Hotel and monitoring events at the Democratic National Convention. Adlai Stevenson, the governor of Illinois, had received his party's presidential nod the day before; this seemed the perfect time for a strategy session in the mountains.

Nixon greeted the standard-bearer who flashed that winning Eisenhower smile and congratulated him again on his Chicago nomination. "It's a victory for the party and, more important, for the country, not just for me, my boy," quipped Ike. The reporters loved it. Then, Ike thrust a fishing pole in Nixon's hand and motioned toward the St. Louis Creek. It was time to fish for some of that famous Rocky Mountain trout.

Nixon's smile wavered a bit. Though a pro at baiting communists, the candidate had not had much experience with fish. Eisenhower scoffed and led him toward the sparkling summer waters.

Handed a trout by a photographer, Nixon seemed puzzled. "What is this?" he asked.

Ike, undaunted, began a diligent lesson in casting. Nixon tried, but to no avail. "You're throwing it back too far," mumbled Eisenhower, "here, let me show you."

Nixon stepped back, and the general who had commanded the Normandy invasion on D day took a relaxed stance, brought the pole gracefully back, then whipped the fly into his running mate's neck. Nixon smiled for reporters again as an embarrassed Ike removed the hook and assured his companion that it was only a scratch. Nixon was told to keep practicing.

The fishing lesson had been a flop, but Ike was still game. Nixon and ten others were getting hungry, and Ike had promised to cook. Those in attendance included Senator Carlson of Kansas, Senator Seaton of Nebraska, Representative Hillings of California, and several advisers. Eisenhower had promised roast beef, mashed potatoes, squash, and cole slaw.

The future president would need some assistance in the kitchen, but after Nixon's performance at the creek, Ike was probably a little leery of exactly which chore to assign him.

Nixon returned a half hour later, sans trout. Waiting for him on the porch was a gunny sack of spuds and a pail of water. Senator Carlson (at right in the photo) was there to help, and the two sat down to collaborate on their top-level assignment.

Back in the kitchen, fussing over the cole slaw, Ike smiled to himself. He'd found himself a running mate with a peel.

JACK KEROUAC

It was the little midget newspaper-selling woman with the short legs, on the corner of Curtis and 15th. I walked around the sad honky-tonks of Curtis Street; young kids in jeans and red shirts; peanut shells, movie marquees, shooting parlors. Beyond the glittering street was darkness, and beyond the darkness the West.
—Jack Kerouac, *On the Road*

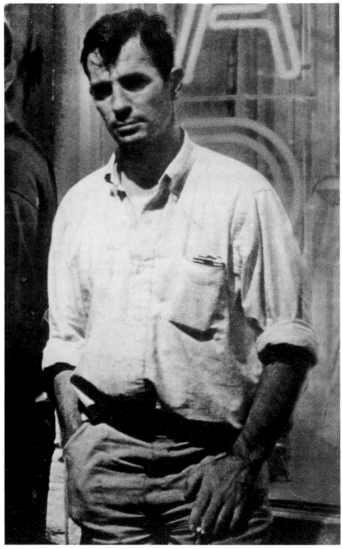

Kerouac in New York City, 1958. "Always headed for Denver."

Before Jack Kerouac, visiting writers had always portrayed Denver in travel-brochure terms, hailing the clean air and beautiful scenery. The most famous chronicler of the postwar, prehippie "beat generation" also found a lot to love about the Mile High City, but for different reasons. Kerouac saw Denver as the ultimate destination for his desolation angels, a gem of urban reality complete with raucous night life.

"Jack Kerouac is accused of writing about people going nowhere," moaned one early critic, "but they were always going to Denver, and that is a definite destination indeed." Kerouac first saw Denver in the summer of his twenty-sixth year, and that brief, hot period of romantic frivolity stayed with him forever.

"He let me off on Larimer Street," says Sal Paradise, Kerouac's character in *On the Road*. "I stumbled along with the most wicked grin of joy in the world, among the old bums and beat cowboys of Larimer Street." It was July 1947, and Kerouac had bused and thumbed his way Out West to see poolhall prodigy Neal Cassady, a friend whom he would make famous as Dean Moriarty in *On the Road*.

Cassady was raised on Denver's mean streets and had grown up tough, wise, and crazy. His passion was stealing cars, taking them on joy rides, and abandoning them in the mountains. By his own estimate, he stole five hundred autos from 1940 to 1944 and was apprehended by the police only three times.

When Kerouac appeared on the scene, Neal was living in a six-dollar-a-week basement room and balancing a complicated relationship with his wife Luanne, University of Denver coed Carolyn Robinson, and a young unknown poet from Columbia University, Allen Ginsberg. Kerouac would view his friend's confusing scene as a comedy in *On the Road*, though his publishers insisted he not use real names.

Other local figures with parts in the book would be brother and sister Robert and Beverly Burford who appear as Ray and Babe Rawlins ("a tennis-playing, surf-riding doll of the West"), and Edward White, whom Kerouac had met when White was at Columbia studying architecture. White inadvertently set American literature on its ear when he suggested that Kerouac "sketch" his scenes and characters as a street artist would. That tip gave the author his voice: exuberant, unbridled speed raps racing in all directions at once.

Jack Kerouac's first novel, *The Town and the City*, was published to mixed reviews in 1950. He moved on to a new novel and was still struggling with his visions of Denver and the rest of the country when he purchased several sixteen-foot rolls of Japanese drawing paper to feed into his typewriter. Three weeks and rivers of coffee later, his beat odyssey was complete, though it would be six long years before a publisher took a chance with *On the Road*.

When the book became the smash of 1957, Kerouac nearly drowned in a flood of publicity, confused that he was being called "ahead of his time" for a novel he'd written so long ago. Denverites, in turn, were treated to a frank appraisal of their postwar past.

Kerouac's view was both compelling and original:

At lilac evening I walked with every muscle aching among the lights of 27th and Welton in the Denver colored section, wishing I were a Negro, feeling that the best the white world had offered was not enough ecstasy for me, not enough life, joy, kicks, darkness, music, not enough night. . . . I wished I were a Denver Mexican . . . anything but what I was so drearily, a "white man" disillusioned. . . . It was the Denver night; all I did was die.

The West would figure in other Kerouac works as well. In his biography of Cassady, *Visions of Cody*, in which Neal is called Cody Pomeray, more gritty light is thrown on Denver:

The appearance of Cody Pomeray on the poolroom scene in Denver at a very early age was the lonely appearance of a boy on a stage which had been trampled smooth in a number of crowded decades, Curtis Street and also downtown; a scene that had been graced by the presence of champions, the Pensacola Kid, Willie Hoppe, Bat Masterson repassing through town when he was a referee, Babe Ruth bending to a side-pocket shot on an October night in 1927, Old Bull Balloon who always tore greens and paid up, great newspapermen traveling from New York to San Francisco, even Jelly Roll Morton was known to have played pool in the Denver parlors for a living; and Theodore Dreiser for all we know upending an elbow in the cigar smoke, but whether it was restaurateur kings in private billiard rooms of clubs or roustabouts with brown arms just in from the fall Dakota harvest shooting rotation for a nickel in Little Pete's, it was in any case the great serious American poolhall night.

Kerouac journeyed to Denver many times before his death from advanced alcoholism in 1969. He once brought his mother along with the hopes of relocating permanently here, but it never happened. Jack Kerouac's relationship with Denver remained platonic and idealistic, a beat love story between a lost dreamer and his city in the clouds.

CHRISTO

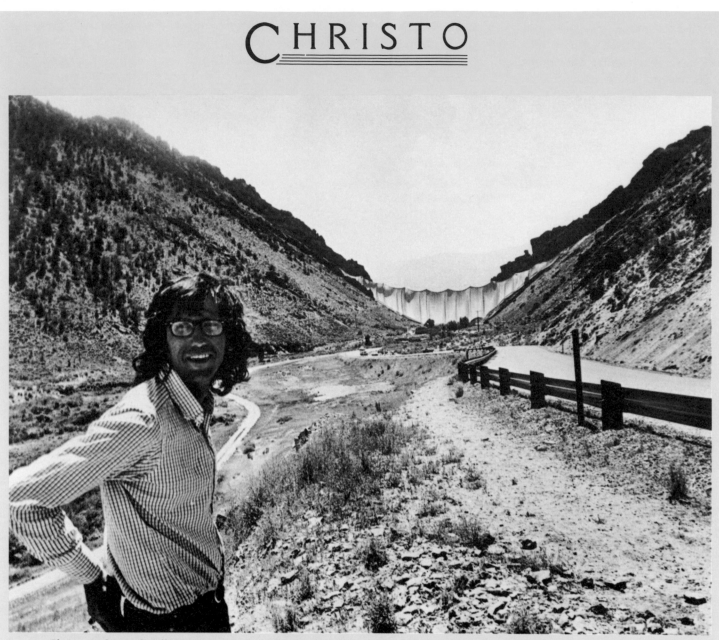

Christo in front of Valley Curtain, *Rifle, Colorado, 1970–72. Project director: Jan van der Marck. © 1972 by Christo.*

At first, Colorado Governor John Love thought the letter was a joke. Jan van der Marck, a former Chicago museum director, was outlining an outlandish project to be undertaken by the Bulgarian-born artist Christo, right in Love's backyard. Christo had chosen the two mountainsides at Rifle Gap seven miles north of Rifle, Colorado, for his next work of abstract art. He wanted to hang a big, orange curtain from the top of the mountains down to the valley floor.

Love was less than impressed and said so in a February 1971 press conference: "I think it has some potential effects on safety and the environment and the ecology, perhaps." Another problem he cited concerned Colorado Highway 325, which lay directly in the path of the proposed curtain. This was no problem for Christo's people. They'd already provided for a large hole, one hundred feet wide by twenty feet high, to be cut in the fabric to permit uninterrupted traffic flow.

For years, art critics had tried to explain the avant-garde works of thirty-five-year-old Christo Javacheff, saying that "by draping or wrapping common objects, they take on new identities and pure art forms." In 1962, he'd filled the rue Visconti in Paris with a wall of colored oil drums two stories high. In Minneapolis in 1966, he'd erected a four-story "Air Package," filled it with balloons, and had the whole works hoisted in the air by

helicopter. He'd wrapped Chicago's Museum of Contemporary Art in a dark brown tarp in 1969, the same year he covered one million square feet of coastal rocks near Sydney, Australia, with polypropylene. Now, he was ready to gift wrap the Rocky Mountains.

Editorialists and letter writers had a field day in the pages of *The Denver Post*. "Amid nature's beauty, who needs this?" read an editorial. In answer to Governor Love's ecological concerns, one letter writer asked: "What about strip mining, shale exploitation, wildlife decimation, the Winter Olympics, and the pollution problem in Denver? Perhaps Christo would be willing to consider the wrapping of Governor Love in a Colorado flag for his next project."

Christo chose to ignore the controversy and deal with the problems at hand. The curtain had cost $60,000, and the budget for hanging it was nearing the half-million dollar mark. Funding had been privately raised, mostly through the sale of Christo's drawings, collages, scale models, and "Packages" to museums, collectors, and dealers.

The bare logistics were enough to give an interior decorator nightmares. The curtain itself would weigh six tons and span 250,000 square feet. Manufactured by a company in Mississippi, it would be made of the same materials used for erosion-control purposes. Steel support cables had been manufactured by U.S. Steel.

The summer stretched on, with eighteen workmen putting in ten-hour days and six-day weeks. Near the end of August, one Rifleite moaned that the curtain was too late for the tourist season. The installation of cables, sturdy enough to support a twelve-ton curtain rod as well as the colossal drapery, was the major hang-up.

On October 1, with winter already in the air, the curtain was finally ready, or so it seemed. On October 9, the hoisting began. A mechanism malfunctioned, leaving a portion of the curtain to flap and rip in the wind. Christo halted the proceedings, closed camp, and announced that he would try again the next year.

Detractors begged the Colorado Division of Highways to revoke Christo's permit, but to no avail. The spring thaw found Christo and Jeanne-Claude, his wife and number-one assistant, back at Rifle. The budget had now jumped to $700,000.

An unfurling date of August 9 was set but postponed due to a snag on the guide ropes of the giant tarpaulin cocoon that was used to lift the curtain into place. The next morning, a windless Colorado beauty, all was ready. Christo gave the signal at 10:30, and the tarp unrolled halfway. A brave workman cleared the snag, and at long last, the curtain was hung.

Spectators marveled. Its measurements were magnificent: 1,250 feet across by 200 feet high. "It's beautiful," whispered the artist's twelve-year-old son, Cyril. He was right. Billowing in the midst of a country so majestic, yet so wild and craggy, stood this perfectly clean, perfectly manufactured, orange nylon curtain. It was mind-boggling.

But the effect would be brief. Twenty-eight hours after the grand unveiling, a freak forty-mile-an-hour wind sailed through the gap, shredding Christo's dream in a matter of minutes. As the long orange strands whipped above his head like lost kites, the artist smiled. "The project was over for me at 11:00 A.M. on Thursday," he said. "I promised I would get it up there, but I didn't promise how long it would stay."

After the ten-day winds had subsided, workers collected the fabric and dismantled the cables amid the undamaged environment. Pieces of the curtain would be included in a limited edition art book on this fantastic happening.

Christo would go on to other projects, including a great "running fence" in California and wrapped walkways in Kansas City, Missouri, leaving Westerners holding him in much more respect than they had when he arrived. Out West, people have a special place for those who succeed against all odds, regardless of how wacky their ideas may seem.

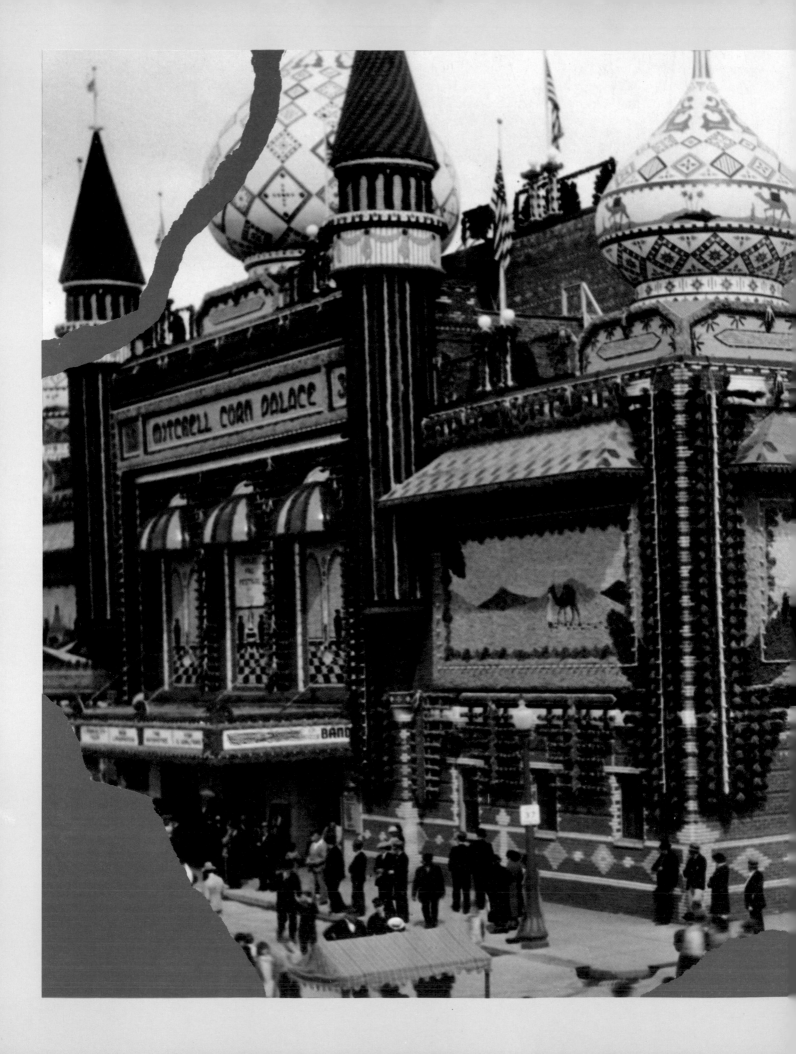

LANDMARKS

DEVILS TOWER

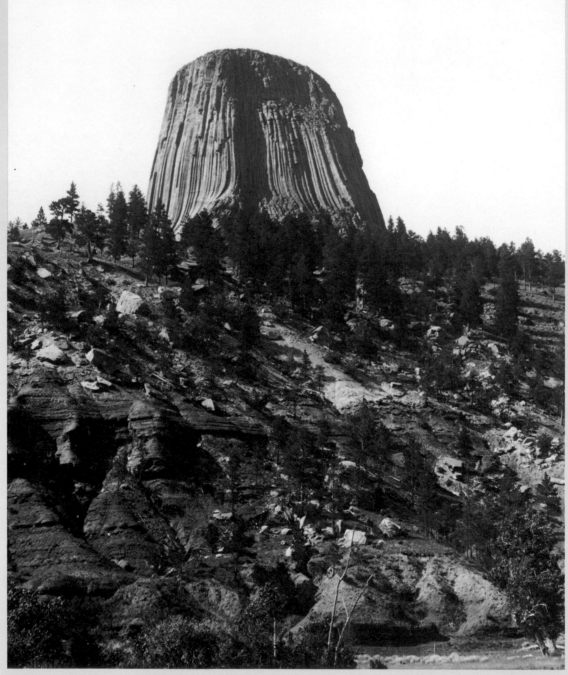

Mateo Teepee, Wyoming's mysterious natural formation.

Devils Tower, the gigantic petrified stump gracing Wyoming's northern plains, has been a dreamer's haven for years. Formed twenty thousand years ago during the Black Hills uplift, it is a geological curiosity. The flat-topped hill measures 1,700 feet in diameter at its base, 275 feet at the top, and is 1,250 feet high. The deep, vertical grooves down its sides are its most unusual characteristic.

Indian tribes called it Mateo Teepee, meaning "Bear Lodge." Their legends about it vary only slightly.

Sioux lore says three maidens gathering wildflowers were ambushed by huge bears and scrambled to the top of a rock to escape. Each time the bears leaped for them, the Great Spirit raised the rock. The bears' giant claws ripped into the stone as they slid down the face of the growing mass. Eventually, the attackers all died from falling off the mound, which had become a small mountain.

The Kiowas say seven sisters sought refuge on the rock, that the hill rose into the sky, and the sisters became stars, later called the Pleiades. The Cheyennes say it was brothers, not sisters, and one of the boys possessed such an incredible singing voice it made the earth move. In all the stories, the frustrated bears slid harmlessly away, leaving telltale grooves in the tower's sides.

It is said the great Sitting Bull made his prophecies here, seeing visions of the end of the white man and the return of the buffalo. Breathing the future, he could foresee the Little Bighorn victory and eventual glory returning to his troubled people.

By 1875, some Indians were calling the formation "the bad god's tower," which Colonel Richard Dodge, on duty with a U.S. Geological Survey party, adapted to Devils Tower.

Nearly a hundred years later, another dreamer made a pilgrimage to Wyoming. The Indians would have been proud, for he was capable of weaving equally fantastic stories.

Steven Spielberg, at twenty-eight, had just directed a phenomenally successful film called *Jaws;* now he had license to make any type of movie he chose. With *Close Encounters of the Third Kind* he would present an everyman who becomes entangled with an advanced life form from outer space. The results would be spectacular, sobering, amusing, and lovable. Aliens had visited the earth in the cinema for many years, but never this way.

For this alien encounter he would return to Mateo Teepee, the tower of legend that changes hues with the time of day, glowing at dawn, sunset, and in moonlight. Spielberg would call on the bright stars of Wyoming as the backdrop for his majestic meeting of man and spaceman. Later, he recalled, "I felt the sky was as important to the suspense and mystery of *Close Encounters* as the water was to *Jaws.*"

Because of the filming's tight secrecy, we don't know if the prairie-dog town at the base of Devils Tower witnessed the mother ship's landing or if that was done in a California studio. We *do* know the film ends in a celestial light show, with hundreds of pre-E.T.'s scampering about, extending long, pink fingers to a baffled human congregation. Richard Dreyfuss boards the spacecraft before it floats away, and Devils Tower slips back into the Western darkness.

A happy Spielberg said, "I haven't made *It's a Wonderful Life* yet. I will some day."

Another dreamer had had a close encounter with Devils Tower.

RED ROCKS

In the primeval West, when the ages slowly passed from Paleozoic to Mesozoic, amphibious dinosaurs swam around and through great underwater rock formations. Aeons later, when the ocean had subsided, land beasts such as the gigantic vegetarian brontosaurus picnicked on hundreds of pounds of leaves a day. They had to be careful, though. Nature's prehistoric upheavals had left one particular area acoustically perfect; the most delicate munching could be heard in all directions, attracting other thirty-ton monsters to what had been a private feast.

Two hundred fifty million years later, in May 1911, world-famous opera star Mary Garden stood in this same formation. By her side was editor and industrialist John Brisben Walker, current owner of the tract now known as Red Rocks. Full of mountain glory, the diva delivered an angelic "Ave Maria," claiming afterward that her voice had never sounded better, not in the world's finest opera houses.

The rocks formed by that prehistoric sea cradled the tones, whirled them up the slopes and out across the mountains. Never once did they echo; they only became

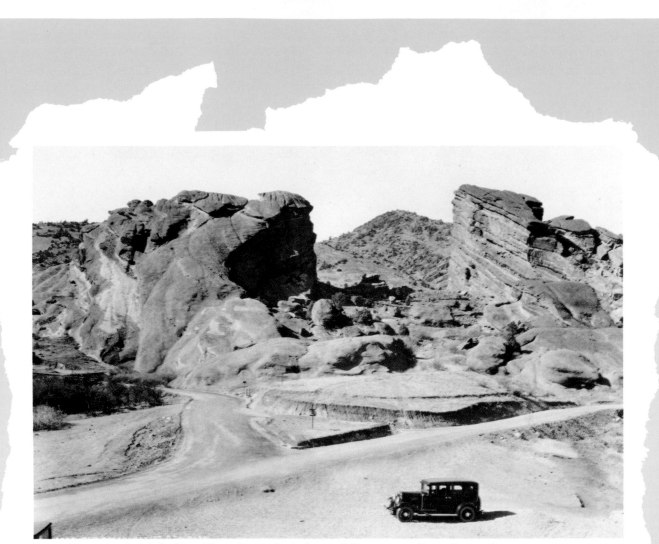

A fashionable sedan waits in front of the acoustically perfect rocks.

louder as they proceeded up and out the long inclined area, a distance of two hundred feet.

In the 1920s, after Walker had spent considerable time and money convincing the city of Denver to buy the park from him for $54,133, more dreams were hatched. Mayor Benjamin Stapleton got a lot of credit for the legislation and the official support, while the manager of improvements and parks, George E. Cranmer, pulled out all stops to construct his dream. Cranmer, a wealthy music lover, had toured the ancient theaters of Greece, dreaming among the ruins of Epidaurus of his own Red Rocks back home in Colorado.

The Great Depression and the federal programs spawned by the New Deal actually helped keep down the costs of building the theater. Construction of dressing rooms, stage, and seats for ten thousand spectators began in September 1936, with the Civilian Conservation Corps working on the theater and the Works Progress Administration handling the parking facilities and connecting roads.

Construction went smoothly, sometimes to the tune of a cappella grand opera. Cranmer brought in a steady stream of singers and acoustics experts to test and retest. Years after the opening, he even brought in the son

of Richard Wagner, Wolfgang, to offer sound advice. Sometimes he would drop a pin on the stage, just to see if it could be heard in the back row. It always could.

With war clouds on the horizon, Red Rocks had its formal opening June 15, 1941, with Metropolitan Opera soprano Helen Jepson providing a gracious initiation. About seven thousand fans showed up for the prestigious event and were mesmerized by a performance that included a hundred-piece orchestra and a hundred-voice chorus. When war broke out in December of that year, Cranmer's acoustically perfect theater was silent for the duration of the hostilities.

In August 1946, the Buffalo Bill Centenary program was held at Red Rocks, putting the theater back in business. Concerts by the Denver Symphony became common. On Saturday nights, the public was invited to free square dances. The first Easter sunrise service was celebrated the next year.

By 1962, some citizens had become worried about the musical styles being presented at Red Rocks, including the "radical" sounds of groups like the Kingston Trio and Peter, Paul, and Mary. A Ray Charles concert that summer brought stern editorials, calling members of the crowd "ruffians." While some were upset, others were delighted. The times they were a-changing.

In 1964, the Beatles charged the outrageous sum of six dollars a ticket. Parents who had sat quietly amidst symphonic lullabies watched helplessly as their young screamed bloody murder and rocked the Rocks.

This new type of music would become more common among the ghosts of the dinosaurs, thanks to a rock-and-roll P.T. Barnum by the name of Barry Fey. Fey's Summer of Stars mushroomed into a major business, with top acts the world over showcasing their talents under the Colorado skies. Red Rocks was *the* place to play. The biggest names gave their best shows in this incredible natural amphitheater. Whether it was the Grateful Dead playing three consecutive sold-out evenings or Bruce Springsteen throwing roses in the rain, the crimson enclosure finally lived up to its press.

On summer days, the rocks sit there as they have for so many millennia, baking in the sun. By night, they continue to enhance music in a fashion just short of unnatural. From the brontosaurus to the B-52s, Red Rocks has heard it all.

TOMBSTONE ARIZONA

History is filled with cities that personify an era. The Old West had quite a few such places, but none as outrageous as Tombstone, Arizona. A desert boomtown, it attracted a wild combination of humanity and was notorious for being a place where you could live like a king or die with your boots on.

On April Fools' Day, 1877, twenty-nine-year-old prospector Ed Schieffelin arrived at Fort Huachuca in the San Pedro Valley and announced his intention to hunt for silver in Apache country. The soldiers scoffed at the notion, saying that all Schieffelin would find would be his tombstone. He spent the summer dodging Indians and seeking ore. By October, his clothes were in tatters and he was down to his last nickel. It was the perfect time to discover a vein of pure silver, seven inches wide by fifty feet long.

Schieffelin's "lucky cuss" was his first strike, producing some gold and $15,000-a-ton silver. Partnering with his brother Al and assayer Dick Gird, he founded the Tombstone Mining District. Other miners had similar luck and in turn attracted those who preyed on the *nouveau riche,* especially gamblers and prostitutes. Saloons, such as the Oriental and the Crystal Palace, emerged and operated twenty-four hours a day. By 1881, the population of seven thousand was served by 110 licensed liquor establishments.

Though sin was big business in Tombstone, traces of clean living existed. Churches and schools were supported by a heavy gambling tax. Culture was to be had at Schieffelin Hall, erected by Al to attract touring companies and other legitimate theatrical endeavors. It even outlasted the boom, staying open until 1917 when Shakespeare's *As You Like It* played.

Newspapers started up nearly as fast as new silver mines. The most famous was born when editor John P. Clum decided "every Tombstone needed an *Epitaph,*"

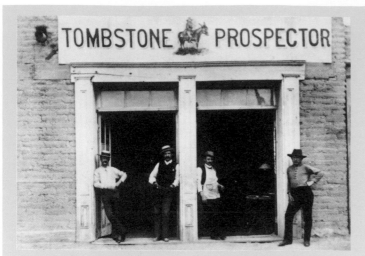
Outside the Tombstone Prospector, *started in 1887.*

and went to press with the first issue of his tumbleweed tabloid on May 1, 1880. In his initial editorial, future Mayor Clum declaimed, "Tombstone is a city set upon a hill, promising to vie with ancient Rome, in a fame different in character but no less important."

And, what news there was to cover! Tombstone's celebrity roster read like an Out West's "who's who." The more obscure names, Buckskin Frank Leslie, Curly Bill Brocius, and Johnny-Behind-the-Deuce, were dwarfed by the sagebrush superstars who found their places in the sun on the streets of Tombstone.

Texan Johnny Ringo once killed a drunk for speaking disrespectfully to a lady. After going on a ten-day drinking binge himself, Ringo rode out of town only to be mysteriously murdered, his body found days later. Both Luke Short and Bat Masterson came to gamble after stints in Dodge City, but even they were overshadowed by the brothers Earp and their friend Doc Holliday.

Wyatt Berry Stapp Earp and his brothers Jim, Morgan, Virgil, and Warren came seeking their fortunes in the politically lucrative field of keeping the peace. Their early attempts were frustrated. According to author Odie B. Faulk in his *Tombstone: Myth and Reality,* "If it were not for their wives making money sewing they might have been forced to go to work." Wyatt could often be seen outside the Earp household at First and Fremont streets raising hell because his shirts were not properly starched.

Virgil was appointed city marshal at one point, but failed in two attempts to be elected. Wyatt became a deputy for Pima County, but when the new Cochise County was formed, he was overlooked in favor of rival John Behan. Wyatt was dashed but maintained a high profile gambling and providing security at the Oriental.

A series of events culminated in the celebrated Gunfight at the O.K. Corral, a thirty-second shootout that saw the Earps and Holliday blow three hapless cowboys to kingdom come. The incident produced a chain reaction of violence; Virgil was crippled by an unknown attacker and Morgan was murdered while trying to make a shot at Bob Hatch's Billiard Hall.

These and other shenanigans caused President Chester A. Arthur to issue a proclamation on May 3, 1882, threatening to impose martial law if the town did not clean up its act. The trend toward law and order was slow but zealous. A robbery in neighboring Bisbee by a gang of amateurs resulted in the deaths of four Christmas shoppers in what became known as the Bisbee Massacre. A posse was formed, the bandits were apprehended and hanged in Tombstone in March 1884. The final nail in the outlaw coffin came with the election of tough Texas John Slaughter as sheriff of Cochise in 1886.

For many, a tour of Tombstone ended in Boothill Cemetery. Joining the least satisfied customers of the O.K. Corral, Billy Clanton and Frank and Tom McLaury, were a host of Western also-rans who found their tombstones early. Some of the epitaphs were straight. Others, like the one for a deceased Wells Fargo agent read, "Here lies Lester Moore, Four slugs from a .44. No Les, no more."

In 1881, an enterprising company spent $558,000 erecting a twenty-eight-mile pipeline to bring water from the Huachuca Mountains. Soon after, the Sulphuret Mine struck water, as did a number of others. Eventually, pumps were taking 7 million gallons of water out of the mines on a daily basis. This, along with a couple of disastrous fires and a drop in the price of silver, put an end to the boom. In Tombstone's brief heyday, from 1878 to 1886, some $80 million worth of silver had been brought out of the ground.

Postboom notoriety came when writer Stuart Lake created the legend of Wyatt Earp, and Walter N. Burns wrote *Tombstone: An Iliad of the Southwest.* A new kind of drifter appeared in town, and locals had the foresight to realize that there was gold in them thar tourists. An annual "Helldorado" celebration was inaugurated in 1929. Movies, and later television, only helped add to the community coffers.

Restoration became an ongoing project. By 1976, churches outnumbered bars five to two and Tombstone had elected Marge Colvin as its first woman mayor. Tombstone takes pride in the fact that its famous slogan, "The Town Too Tough To Die," has never become its epitaph.

THE NAVARRE

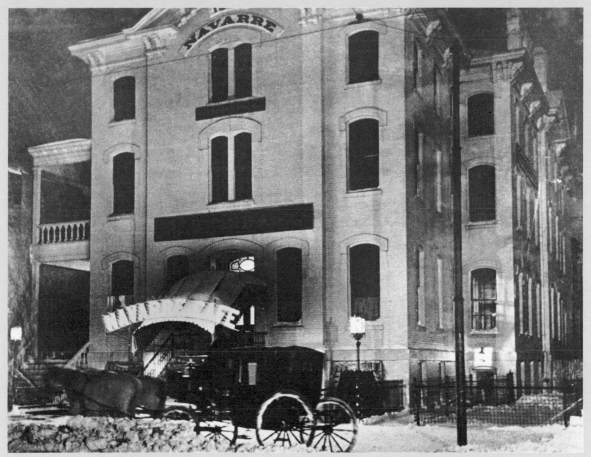

*A hot time on a cold night, the Navarre in 1902. The secret tracks
to the gambling casino ran under the street where the coach is parked.*

In its time, which began nearly 104 years ago, Denver's Navarre, a solemn Victorian building at 1727 Tremont, has been a microcosm of Denver's various social activities: a boarding school for girls, hotel, gambling house, restaurant, brothel, jazz showcase, and home of political fund-raising events. Everyone from the rapscallion to the devout has found a home there.

In 1879, Professor Joseph Brinker and his wife, Elizabeth, left Kentucky, intent on seeking a dry climate for his health and bringing a bit of education Out West. In Denver, on what then was Clancey Street, Brinker had a four-story house and dormitory constructed. In 1880, the Brinker Collegiate Institute opened its doors to young ladies who desired to learn "customary Christian virtues."

Despite the dry climate, Joseph died nine years later. Elizabeth sold the property soon after to C. W. Hun-

sicher and Robert Stockton, who opened the Hotel Richelieu in 1890. Its fine interior decorations included heavy red velvet draperies, which gave the place a classy atmosphere and kept the roulette wheel hidden from public view.

Yes, Hunsicher and Stockton loved to gamble. But luck deserted them the night they got into a friendly game with Ed Chase and Vaso Chucovich, when the stakes happened to be the Hotel Richelieu. Chase and Chucovich renamed the hotel the Navarre, after Henry of Navarre, the lusty sixteenth-century French king. The Navarre was now a full-fledged casino with a twist: the schoolgirls' dormitory rooms upstairs housed hookers, including the notorious Mary Paxton and Belle Malone.

Just across Clancey, which had recently been renamed Tremont Place, a fancy new hotel was being built in a former cow pasture. History clouds the details

of how the deal was swung, but when the Brown Palace Hotel opened its doors in August 1892, it was linked to the Navarre by an underground rail system, the existence of which has long been denied by Brown officials. Prominent guests could venture out for a night of gambling and whoring, return to their hotel rooms, and never be seen coming or going.

In 1904, Mayor Robert W. Speer told Chase and Chucovich that they could stay in business, but the gambling and prostitution had to go. Both men were admirers of Speer (Chucovich's estate provided for a $100,000 monument to the man) and agreed to turn the Navarre into a fine restaurant, but old-timers insist that the top floors continued their special brand of commerce into the late 1920s.

Chucovich bought out his partner in 1914 and continued the tradition of fine dining; the place soon became a headquarters for politicos. When Chucovich died in 1933, his will stipulated that funds from the Navarre's sale were to benefit his native town of Risan, Yugoslavia.

Trustees ran the Navarre until New Year's Day, 1946, when Johnny Ott started his restaurant there, quickly making it Denver's finest postwar spot. Ott held the reins until the mid-1960s, even though a Texas millionaire, M. B. Rudman, had purchased the premises at a

public auction in 1952 for $175,000 after eating a particularly fine Colorado steak there.

The next owner was Denver tobacco and candy wholesaler James Dikeou, who purchased the building in 1963. Dikeou's private club closed a year later. On June 2, 1967, clarinetist Peanuts Hucko reopened the club, serving up great food and hot jazz until 1974, when it was boarded up.

Everyone thought the Navarre was deserted until 1977, when eighty-five-year-old Dikeou was found beaten to death in an apartment there. In 1979, Clancey Street Development bought the Navarre from Dikeou's estate and announced a $1.5 million renovation program, which never got off the ground. Another group bought the building in 1980, but their scheme to turn it into an office building didn't work out, either. On July 15, 1983, the Navarre was sold again, this time to businessman and art patron William Foxley, who has since used the building to house his extensive art collection as the Museum of Western Art.

While other Denver palaces have vanished, never to be reflected on the mirrored glass skyscrapers downtown, the Navarre has stood its ground. Its mystery is only enhanced by its longevity, as well as its delightfully shady past.

THE TABOR GRAND

"Mr. Hopkin, who is that fellow?"

The renowned artist Robert Hopkin turned to silver king Horace Austin Warner "Haw" Tabor, who stood indignantly in the theater foyer, glaring at the mural in progress. "Why, Mr. Tabor, that's William Shakespeare."

"What's he ever done for Denver?" spat Tabor. "Take him out and put my picture in its place."

Hopkin smiled to himself, remembering the size of his commission, and obediently began applying turpentine to his incomplete portrait of the bard. It was the summer of 1881, and around him construction of one of the world's greatest theaters, the Tabor Grand Opera House at Sixteenth and Curtis in Denver, was in full swing.

The opera house was the pinnacle of Tabor's rags-to-riches-to-rags story. An impoverished Vermont stonecutter, Tabor had caught gold fever in 1859 and headed Out West to seek a cure. Finding no gold, he started his own store at Oro, near Leadville, and became postmaster, then mayor. His wife, Augusta, complained constantly about his grubstaking, or financing prospectors in return for a cut of their take. One day, two of these wide-eyed dreamers pulled a chunk of silver out of the Little Pittsburgh Mine and along with Tabor set up a $20 million corporation in one year, 1878.

Tabor's luck seemed boundless. The purchase of the Matchless Mine for $100,000 soon returned profits of $80,000 a month. Haw Tabor became drunk with wealth and power, divorced Augusta, married the legendary

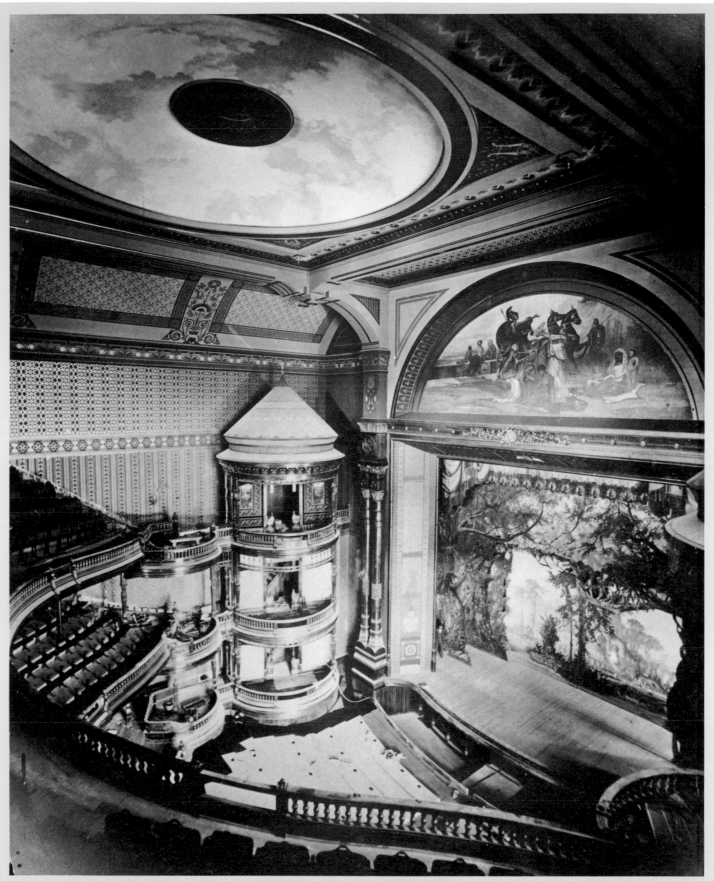

The interior of the Tabor Grand, c. 1890.

Baby Doe, and became Colorado's lieutenant governor. Seeking another monument to his greatness in addition to his Leadville hotel, theater, and bank and his Tabor Block—Sixteenth and Larimer in Denver—Tabor decided to erect a theater to rival the elegant opera houses of Europe.

A global search for the proper materials was launched. From Brussels came carpet for the stairways to the balconies; brocades and tapestries came from France; carved cherry balustrades were imported from Japan; mahogany was shipped from Honduras.

Sixteen months and $750,000 later, the Tabor Grand was ready for its christening. Although the opera house took up only a portion of the building, which also housed 172 rooms for stores and offices, it was 75 feet wide and 150 feet long and extended the full height of the five-story building. On opening night, September 5, 1881, Tabor sat in Box A behind a two-foot-square block of solid silver six inches thick, with his name emblazoned on it in gold relief letters.

It rained cats and dogs that night. Fifteen hundred Denverites sloshed in their finery through the mud to their expensive seats (top price: two dollars). When Hopkin's massive drop curtain was lowered, the crowd saw Roman ruins, complete with broken pillars, and lions cavorting in the rubble. At the bottom of the panorama was a verse from Charles Kingsley: "So fleet the works of men, back to the earth again; ancient and holy things fade like a dream."

The opening night players of honor, the Emma Abbott Grand English Opera Company, contributed another bad omen. Miss Abbott initiated the theater with the scene from *Lucia di Lammermoor* in which Lucia, having lost everything in life, loses her mind. Then the theater was formally dedicated, with Tabor receiving praise and a gold watch fob from an enchanted city. The lights dimmed again, and the troupe performed the opera *Maritana*.

Despite the ominous portents, Tabor's fattest years followed. The greatest performers in the world stopped off to play in this frontier curiosity: Sarah Bernhardt, Lillian Russell, Madame Modjeska, Lily Langtry, and Edwin Booth. But Haw Tabor wouldn't be upstaged. Once, during a performance of *Otello* by Tommaso Salvini, the star sent word to Box A to keep the noise down or he'd stop the show. Replied Tabor: "Tell that wop that I am worth $10 million and that he'll ring the curtain down when I say so."

When the government went off the double currency standard in favor of gold in 1893, Tabor was wiped out; he returned to the Matchless and hard labor. Later, influential friends made him Denver's postmaster. In 1898, his dream opera house was mortgaged for $500,000. One dark November night, before it passed permanently into the hands of receivers, Tabor sat in his box in the lifeless theater, sobbing. Four months later, he was dead.

Vaudeville found a home at the Tabor during the next two decades. In 1922, it was gutted and transformed into a movie palace. Although the new owners renamed it the Colorado Theater, they couldn't escape the Tabor curse. Their venture failed, one partner committed suicide and the other ended up an invalid. Harry Huffman then stepped in and restored the old Tabor name.

Newspaper editorials as early as the 1940s demanded that this creaking wonder be demolished. Said one writer: "The time of victory ought to be the time for getting rid of a lot of obsolescent structures that have been cluttering up the town." In 1956, the Tabor again made headlines, being converted to "Todd-A-O" for a showing of *Oklahoma*. This resurrection lasted three months; then the doors were shut for good.

In 1964, an aging vaudevillian took the stage, his straw hat and cane in hand, and danced a timid two-step. Photographs were taken, then the area was cleared so the wrecking balls could take over. Soon, the last monument to the silver king was a memory.

THE CORN PALACE

In early 1892, two Mitchell, South Dakota, businessmen considered the future of their twelve-year-old city. Real-estate developer Louis E. Beckwith and jeweler L. O. Gale realized that a community of three thousand could generate only so much business. If Mitchell had an attraction—some reason for outsiders to visit—the economy would be stimulated. They decided to build the Corn Palace.

Sioux City, Iowa, had built a corn castle that had flopped miserably and eventually been destroyed. Still, Beckwith and Gale believed that theirs could work. The designer of the Sioux City Palace, a Colonel Rohe, was

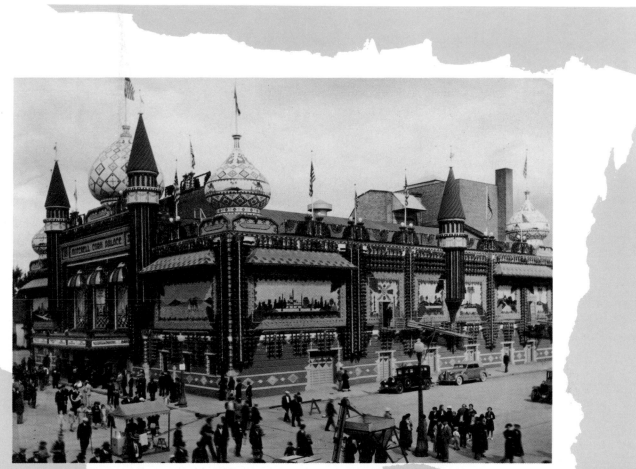

The Corn Palace in the 1930s.

retained to construct a similar sanctuary behind Beckwith's house. Contracts were made with local farmers for a rainbow of yellow, red, purple, white, and calico corncobs.

Slowly, the wooden structure, measuring one hundred by sixty-six feet, began to take shape on the corner of Fourth and Main. A festival would be planned around the grand opening, a glorious tribute to King Harvest called the Corn Belt Exposition. As the ears arrived, they were sawed in half (lengthwise), then nailed to the walls.

In September 1892, the Phinney (Iowa) State Band kicked off the ceremonies honoring the world's only corn palace. Crowds were treated to a masterpiece of amazing maize. The palace itself consisted of many swirling geometric patterns, all decorated in corn and native grasses. The top of the fodder fortress was graced with elegantly patterned turrets, each flying a forty-four-star American flag.

The Exposition was such a hit that a forty-two-by-one-thousand-foot addition to the Corn Palace was built in 1893. After that year's model, drought and de-

pression caught up with the Gay Nineties, and the Corn Palace was shucked for the rest of the century. Famous orator William Jennings Bryan spoke at a 1900 attempt to rekindle interest in the palace, but in 1901 it was again closed.

In 1902 things would change. The citizens of Mitchell were in control of the Corn Palace, an opportunity they would not fritter away. High visibility just might make Mitchell the new state capital. Incorporation papers were filed, Rohe again was hired to complete a husky task, and local women redecorated the massive interior of the renovated palace with South Dakota farm produce. The town did not win the designation of capital, but they did devise an unforgettable festival.

In 1904, John Philip Sousa and his band were the hottest musical act in the country. The Corn Palace planners wanted them and even agreed to the $7,000 salary Sousa demanded as the price for having to travel to such wild country. When the train chugged into Mitchell, Sousa looked out the window, saw the unpaved and the unshaved, and refused to get out. Finally, when two local bankers brought the entire performance fee in

cash, the band leader's attitude showed a remarkable change, and he wowed the populace with three rousing shows daily.

The Corn Palace was rebuilt the following year at Fifth and Main. Decorations changed with the times, geometric designs giving way to landscapes and portraits. For a 1911 Egyptian theme, charioteers and ancient gods stalked around the building. In 1916, the Corn Palace went to World War I, featuring kernel colonels standing guard against a backdrop of amber waves of grain.

Plans for a third Corn Palace were drawn up as the 1920s arrived. The construction was not completed in time for the opening, so the festival was held in a tent, with a circus theme. Scenes of disarmament graced the 1921 Corn Palace at its new home at Sixth and Main.

In 1929, in preparation for Mitchell's fiftieth anniversary, 7,230 bundles of grain and two tons of corn were anchored to the harvest house. By World War II, the grain was replaced by painted murals of war scenes.

In 1948, noted Indian artist Oscar Howe took over the annual job of designing the palace, adding a three-dimensional perspective to exciting scenes. He departed in 1971, after creating many memorable panels depicting the life and times Out West. Also in 1948, North Dakota's Lawrence Welk played the Corn Palace for the first time. He became the palace's favorite entertainer over the years with a total of five engagements.

The Corn Palace almost popped out of existence on June 20, 1979, when an arsonist set fire to it. Water and smoke caused the most damage, especially to the basketball court where Mitchell High and Dakota Wesleyan University play their home games. All was rebuilt, the thirty-five-hundred-seat auditorium was repaired, and by August 8 it was ready to reopen with a recreation theme.

The Corn Palace welcomed 1985 visitors with a tribute to native Americans, depicted with 200,000 half ears of corn pneumatically stapled to walls. The ultimate goal of Beckwith and Gale has been achieved. This Taj Mahal of vegetation annually attracts a half million curiosity seekers and economy stimulators proving that with perseverance and dedication no task is too corny.

THE ICE PALACE

Hard times in the Gay Nineties had the officials of Leadville, Colorado, more than a little concerned. Silver, which had been their bread and butter since the boom, had dropped after the Panic of 1893 from over a dollar an ounce to just over sixty cents. For the city to survive, something stronger and more permanent than silver would have to become the core of its economy. In a moment of enthusiasm and giddiness, they chose ice.

In the summer of 1895, the first meetings were held to organize their Crystal Carnival for the coming winter, which would feature every cold-weather sport imaginable. Real-estate agent E. W. Senior advised that folks wouldn't travel all the way to Leadville just to toboggan. No sir, they would need an attraction. He proposed an ice palace, like the ones he'd heard about in Canada and Moscow.

The matter was settled. An ice palace it would be, the biggest one ever, something to dazzle the imagination and give the drooping economy a boost. By September, however, Senior was having a hard time raising the necessary funds. He'd come up with $4,000, but he estimated that he'd need at least $6,000 more before the first blocks of ice could be stacked up. Some say Leadville had grown wary of Senior, a teetotaler, and were heeding the warning, "Never trust a man who doesn't drink."

In a meeting on October 25, it was decided that the successful manager of the productive Lilian, Benton, Agwalt, and Antioch Mining Companies, a mustachioed go-getter named Tinsley S. Wood, should spearhead the project. Wood agreed, but he said that if the castle was to turn from water into solid reality, he would need to see $20,000 up front. James J. Brown, husband of the Unsinkable Molly, plopped down a $500 bill, and the snowball was rolling.

On November 25, 1895, a cold cornerstone was laid. Eighteen teams of horses began hauling ice from the lakes around Leadville to the five-acre site on Capitol Hill, between Seventh and Eighth streets. Stonecutters chopped the ice into five-by-two-foot blocks, which then were fitted over a wood frame and mortared with water. Eventually, ice had to be quarried out of Palmer Lake, sent by train to Leadville, then molded by Canadian woodchoppers, who worked faster than stonecutters.

A total of five thousand tons of ice was used for the finished product. In December, a chinook wind threat-

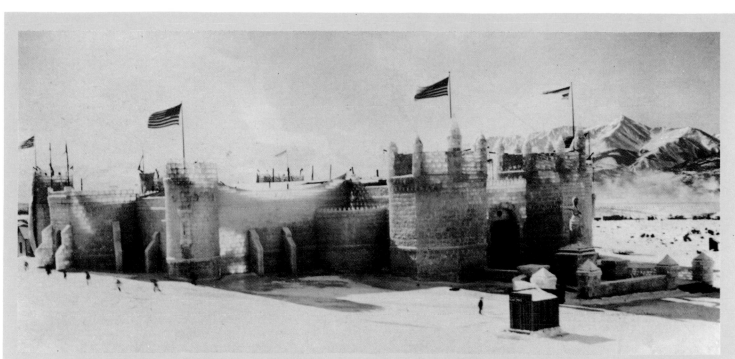

A cold, windy day at the Ice Palace. Note the statue of Lady Leadville in the front courtyard.
The ice skaters at the left provide an idea of the structure's size.

ened the massive structure with temperatures reaching 65 degrees, but muslin, purchased with $5,000 from Wood's already depleted funds, was draped over it to block the heat wave. At night, water was poured over the walls, giving them a mother-of-pearl reflection under the cold winter moon.

On January 1, 1896, twenty-five hundred people turned out in 8-below-zero weather to behold the magic of their Norman-style ice castle. They were not disappointed. It was gigantic: 450 feet long by 350 feet wide, with two corner towers soaring 90 feet into the air. A medieval fortress in the snow, Leadville's Ice Palace was all they'd said it would be, and more.

A statue of Lady Leadville, all of ice, standing nineteen feet high on a twelve-foot pedestal, pointed to the mines with one hand and carried in the other a chilly scroll that read "$207,000,000." That was the value of the minerals that had been taken out of the ground during the glory days.

Inside the ice house were three main rooms, two ballrooms (one that served as a restaurant), and a fifteen-thousand-square-foot skating rink. Ice statues representing prospectors and rich men lined the walls, while frozen inside the walls were Colorado mementos, including beef, newspapers, and six bottles of Coors beer. (Coors also sent a case of beer, which was stolen and later recovered with only six empty bottles. Ironically, fearing that freezing would mar the sparkling contents of the display, Coors officials had bottled the case

with salt water.)

With Jack St. Clair's Fort Dodge Cowboy Band providing the music, the frozen gala made for a hot time in the old town that night. Backers predicted the castle would last until July—it would have to, to make any sort of profit.

By February, however, the novelty had worn thin. Excursions from Denver consisted of people bringing sack lunches, touring the location for fifty cents, then going home on the evening train. Ticket sales sagged. On March 1, more bad news arrived in the form of sunshine, causing Lady Leadville to perspire nearly as much as the members of the Crystal Carnival Association.

Old-timers couldn't remember a warmer, earlier spring; with each passing day, the turrets and towers slowly flattened themselves. Wood wanted to blow the thing to smithereens rather than let it turn to slush, but he was overruled. After one last ball in the hall of the Frost King, the palace was closed for good on March 28, 1896.

Original estimates predicted a five-dollar return on the ice-cube castle for every dollar invested. A final tally, after the lavish festivities and expenditures, came up with a new equation of ten additional dollars spent for every dollar originally invested. Tinsley and company had taken a cold bath, but they had no regrets. They'd frozen a memory Out West, a frigid fairy castle that disappeared like a winter's dream.

WINCHESTER MYSTERY HOUSE

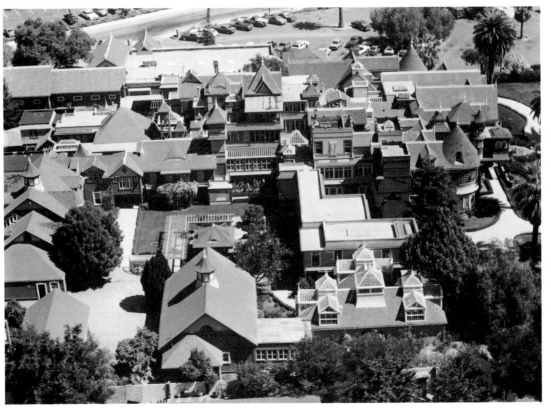

An aerial view of the haunted house that Sarah built.

The haunting of Sarah Winchester began shortly after the death of her husband, the heir to the famous rifle fortune. A Boston medium told her that her inheritance was blood money. The spirits of all who had died looking into the wrong end of a Winchester were out to get her. Salvation could only come from a great house, a never-ending sanctum of constant construction to appease the dearly departed. With that in mind, Sarah

Winchester began building a house Out West, where there would be space enough for her needs.

Sarah Pardee had married William Wirt Winchester, the son of Oliver Winchester, patent-holder of the "rifle that won the West," in 1862. Their one child, Anne, died in infancy in 1866. When William succumbed to tuberculosis in 1881, he left his forty-two-year-old widow a fortune of $20 million, plus 48.8 percent of Winchester Repeating Arms Company stock, giving her an income of $1,000 a day (tax-free until 1913).

Following the spiritualist's advice, Sarah sold her New Haven, Connecticut, home and journeyed Out West, until the spirits showed her the way to San Jose, California, where she purchased an eight-room farmhouse being built by a local doctor. Next, she hired a staff of twenty-two carpenters to work around the clock. Eighteen gardeners were assigned to cultivate more than a hundred imported plants and shrubs and to conceal the construction with a six-foot cypress hedge around the six-acre grounds. Well-paid domestics catered to her every whim, and she had plenty of whims.

What developed was a twisting, turning maze of bizarre architecture designed completely by Sarah and her gun-shy ghosts. Stairways led to ceilings. Doors opened onto walls. A $1,500 Tiffany window was installed in the interior where no sun could ever illuminate it. Skylights emerged from the floors. One hallway was two feet wide, while a door was four feet ten inches in height, just right for the petite Sarah. A storage cabinet opened to a half-inch deep space. One stairway had seven turns and forty-four two-inch steps, for a total rise of only nine feet.

The number "13" abounded. Many rooms had thirteen wall panels with thirteen windows. Windows featured thirteen panes. Chandeliers had thirteen lights. There were thirteen bathrooms, thirteen glass cupolas in the greenhouse, and thirteen California fan palms lining the front driveway.

Sarah's days were filled with activity. She would rise late in one of the mansion's forty bedrooms (she slept in a different one every night to fool her spooks). Quickly, she made the rounds with foreman John Hansen and dispensed the day's building schedule. Only her Chinese butler was allowed to see her face; she wore a veil in front of everyone else. (When two workers accidentally saw her face one day, they were dismissed with a year's wages.)

She might travel to town in the afternoon to select more materials, though she remained in her carriage while clerks brought their goods out to the curb for inspection. Back home she dined on a $30,000 gold service, with a table set for herself and twelve invisible guests.

At midnight the bells tolled, and Sarah would don a gown etched with occult designs to prepare for her nightly seance with a wild ghost chase. After skipping through her Victorian labyrinth, she would disappear into a room via a secret panel. Then she would open a window onto a flight of steps and follow another maze until she came to the Blue Room with its thirteen coat hooks. For the next two hours she would play the organ and communicate with her deceased designers, inventing the next odd construction. At 2:00 A.M. the bells sounded again, and Sarah would pick a bedroom.

Neighborhood children were allowed to play on the beautiful grounds and in the front parlor, but all others were denied access. President Theodore Roosevelt dropped by in 1903 but left in a huff when the servants told him to use the back door.

The construction continued, twenty-four hours a day, seven days a week, for thirty-eight years. The mansion rose seven stories, but the top three were lost in the San Francisco earthquake of 1906. (Sarah was trapped in her bedroom during the quake and then took up residence on a houseboat for two years, with a messenger delivering her daily blueprints.) Later, the haunted castle was built out instead of up. One hundred sixty rooms held ten thousand windows, two thousand doors (including cabinets), forty-seven fireplaces, six kitchens, and only two mirrors. (Ghosts do not like mirrors.)

The hammers stopped on the night of September 5, 1922, when Sarah Winchester, aged eighty-three, died peacefully in her sleep. The house was left unfinished. She had spent over $40 million, leaving just $4 million of her original inheritance. Her remaining assets went to a niece and to a tuberculosis foundation she had begun in her husband's name. Furnishings and ornaments were removed for auction. It took six weeks to empty the monstrosity.

The home was purchased by locals the following year and opened to the public for the first time. On Friday, May 13, 1974, the Winchester Mystery House was designated a California historical landmark. A massive restoration project required thirteen thousand gallons of paint. Today, it is one of the main tourist attractions in the Santa Clara Valley.

Seances in the house have turned up different spiritual tidbits: the sounds of a baby crying, organ music, eerie lights, and footsteps. These occurrences would not have surprised the enigmatic Sarah Winchester, whose sole legacy is this overgrown, grotesque beauty haunted by sorrow and fear.

MOUNT RUSHMORE

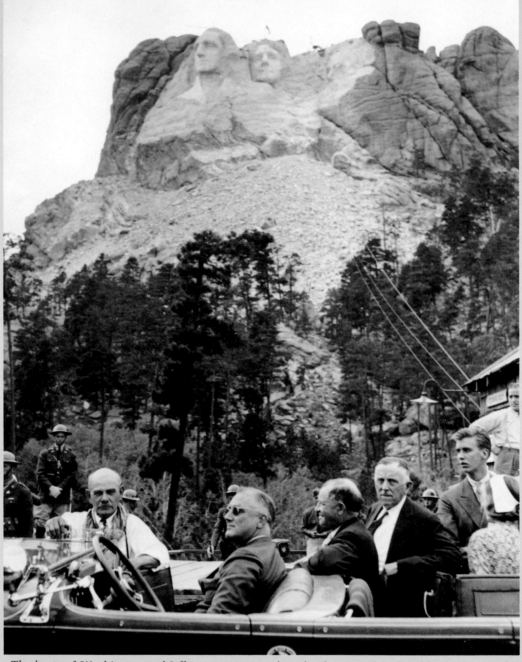

The busts of Washington and Jefferson were complete the day President Franklin D. Roosevelt arrived, August 30, 1936. The face of Lincoln was not quite finished.

On the balmy afternoon of October 1, 1925, Gutzon Borglum stood atop a granite slab six thousand feet above sea level in the heart of South Dakota's Black Hills, steadying an American flag. An eccentric, a patriot, and a sculptor, he looked out over the land of the free and began his quest to carve the faces of four American presidents onto Mount Rushmore.

Born to Danish immigrant parents in Bear Lake, Idaho, on March 25, 1867, John Gutzon de la Mothe Borglum was to become a curiosity in his field. As an art

student in Paris, he was a friend of Rodin. His own subjects, however, were drawn from the American West. His medium progressed from paint to clay to mountains.

When Rushmore was suggested as a site for his art, Borglum already was involved in a controversy over a monument to the Confederacy for the state of Georgia. Fired for running over budget after completing a huge bust of Robert E. Lee and a portion of a bust of Andrew Jackson on Stone Mountain, Borglum destroyed his designs for the project and had his head of Jackson pushed off the mountain.

South Dakota would be a different story. The idea of a monument came in 1923 from the director of the state's historical society, Duane Robinson, who had visions of giant Buffalo Bills and other figures from Out West. But it was Gutzon Borglum who chose Mount Rushmore—named for a New York attorney who first examined the titles to the land in 1885 — on which to carve his masterpiece.

His favorite Americans would be the subjects. In his interpretation of history, the outstanding presidents were George Washington, the founder; Thomas Jefferson, the expander; Abraham Lincoln, the preserver; Theodore Roosevelt, the carrier of the nation's ideals into this century.

For nearly two years after the dedication in 1925, Borglum and state officials searched for funding, collecting dimes from South Dakota schoolchildren and other private contributions. More than once, when an exhausted bank account halted work, Uncle Sam came through. Total cost was $989,992.32, of which $836,000 came from federal coffers.

National attention again focused on Rushmore with its second dedication on August 10, 1927, by President Calvin Coolidge. The president would later have a falling out with the sculptor. Borglum wanted a five-hundred-word history of the United States to carve on the side of Rushmore; Coolidge agreed to write it but was so outraged by Borglum's editorial blue pencil that the idea was dropped.

Finally, after months of showmanship, Borglum was ready to begin on the bust of Washington. Critics scoffed at what they called his "jumboism," predicting failure and embarrassment. But high atop Rushmore, the lonely George Washington carver was far away from his detractors.

Washington's head would be sixty feet long, his nose alone larger than the head of the Sphinx. Borglum maintained that the faces "had always been there" and he was simply removing the tons of mountain—at first using dynamite—to reveal his presidents.

The work continued on and off over the next three years, until Washington was unveiled on the Fourth of July in 1930. The country was in the depths of the Great Depression, and dollars again were scarce. His workers kept on, however, toiling on booms and ladders for between sixty cents and a dollar an hour. Thomas Jefferson's bust was now in progress; he would be shown at age thirty-three, the year he wrote the Declaration of Independence.

On August 30, 1936, President Franklin D. Roosevelt arrived in the Black Hills to dedicate the second head. Lincoln's likeness was now in the blocking-in stages. Borglum would make Lincoln's eyes lifelike by leaving twenty-two-inch shafts of granite in them to reflect light. Honest Abe was dedicated formally on September 17, 1937, during the state's Golden Jubilee.

The final figure, Theodore Roosevelt, would rest between Jefferson and Lincoln. With pneumatic drills and more dynamite, the image of Teddy soon began to take shape, and he was dedicated July 2, 1939.

Though some fine-tuning remained, the project was essentially finished. Over 400,000 tons of granite had been removed in the effort. The controversial Borglum had etched his big dream on the scale of men 465 feet tall. Some say the long toil at that altitude weakened him. Gutzon Borglum died of a heart attack in Chicago in October 1941, and the finishing touches were added by his son, Lincoln, who had aided his father from the beginning. The lack of funding coupled with harsh weather had stretched the completion time from the projected five years to more than fourteen.

Over the years, cracks have developed in the great heads, and annual maintenance is required. Workers suspend themselves over the stone faces and apply a mix of white lead, linseed oil, and granite dust (devised by Borglum in anticipation of the problem) to the trouble spots.

Mount Rushmore National Memorial could outlast mankind, eroding only fractionally every hundred thousand years. Borglum's presidents are as much a monument to the individual spirit as they are to the men and ideals they represent. Sculpted in granite during this country's most economically unstable years, they are timeless, staring steadily into eternity.

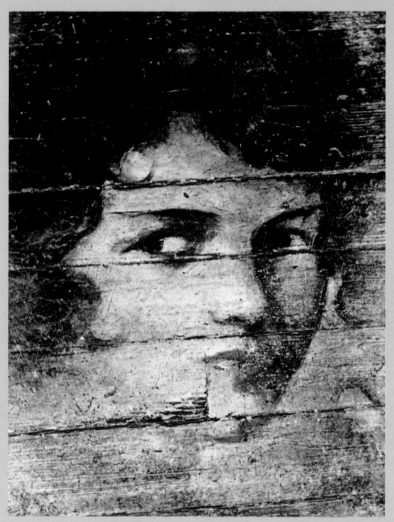

*Madeline of the Floor. For nearly forty years,
her true identity remained a secret.*

Silently she stares from the Teller House floor, a stoic princess with a varnished smile. Central City's famed "Face on the Barroom Floor" is a major Colorado attraction. She is not the Madeline in H. Antoine D'Arcy's poem, "The Face upon the Floor," though the two are often mistaken; nor is she a relic from the silver-boom days or a commissioned portrait of Baby Doe Tabor. This lady has a story all her own that combines art, anger, spite, mystery, and, yes, love.

The man behind the face, Herndon Davis, whom journalist Ernie Pyle called the "painter laureate" of the West, was born on October 27, 1901, in Wynnewood, Oklahoma, when it was still Indian territory. Thought to be a third cousin of Confederate President Jefferson Davis, Herndon was a lifelong rebel. His introduction to art came at age fourteen, when he was an apprentice to

a Kansas City sign painter. His first real job was as a commercial artist for Chicago's Armour and Company painting billboards. Following a year of formal art training in Missouri, Davis enlisted to fight in World War I. Uncle Sam recognized his talent, issued him a pen instead of a rifle, and parked him at the War College in Washington, D.C., to work on military maps.

After his discharge, he spent a year at Yale, followed by tough times in the job market. A second army hitch found Davis inking for the Army Publicity Bureau. After a third tour of duty, he was hired by the *Washington Post* and moonlighted for the *New York Herald Tribune.* In 1929, he married Jamaican Edna Juanita Cotter, a dark-eyed beauty with classic features.

With the arrival of the Great Depression, Davis moved to Colorado and began an illustrious career with *The Denver Post* and the *Rocky Mountain News.* For the Denver Press Club he painted a life-size mural of the combined city rooms. His painting for public consumption was stirring and forthright—dramatic patriotic portraits and imaginative historical pieces including a map of Alfred Packer's trail.

Privately, he possessed a wild and warped sense of humor. He painted the portrait of Keg Buffet owner A. B. Wade on a wooden bar stool at the proprietor's request, for instance, because he wanted "everyone to sit on his face." Herndon Davis loved a good joke as well as a good drink, two factors that would contribute greatly to the birth of Madeline.

> 'Twas a balmy summer evening, and
> a goodly crowd was there,
> Which well-nigh filled Joe's barroom
> on the corner of the square.
> And as songs and witty stories came
> through the open door,
> A vagabond crept slowly in and posed
> upon the floor.

In the summer of 1936, thirty-four-year-old Davis was commissioned to do a series of paintings for the Central City Opera Association and the Teller House. While in the Teller one Sunday afternoon, he got embroiled in a boisterous argument with Opera Festival founder Ann Evans, granddaughter of Colorado's second territorial governor, John Evans. Miss Evans had her own opinions on the authenticity of Western art, views that greatly agitated Davis. Their shouting match got out of hand, and Evans stormed out, leaving the artist to ponder his fate.

"You're going to get fired," goaded sixteen-year-old busboy Joe Libby. "You know that? Why don't you give them something to remember you by? Paint a picture on the floor."

The plot was set in motion. After sending Libby for a brick to sand the floor's surface, Davis assembled the tools he'd need for his midnight portrait: his oils and brushes, a case of Coca-Cola, and a fifth of Puerto Rico's finest gold rum.

> Say, boys, if you give me just another
> whiskey, I'll be glad,
> And I'll draw here a picture of the face
> that drove me mad.
> Give me that piece of chalk with
> which you mark the baseball score:
> You shall see the lovely Madeline
> upon the bar-room floor.

After the Teller House bar closed, Davis and Libby crept downstairs, supplies in hand. By candlelight, Davis scrubbed, poured himself a drink, and got to work. After many sips and giggles, the portrait was complete. It was 3:30 A.M.

History does not record Evans's reaction to the elegant graffito, just the fact that Davis "left Denver soon after."

In 1946, he returned to find his portrait famous, but as an "unknown" work from the Gay Nineties. Infuriated, he drove to Central City and autographed his masterpiece. (The signature was turpentined into oblivion by Teller management as soon as he left.)

Davis managed to keep the identity of his model secret until his death on November 7, 1962. He died while working on a massive historical mural for the Smithsonian Institution. The truth had been told to two friends, Denver lawyer and historian Fred Mazzula and Dr. Nolie Mumey, who promised not to reveal it as long as Davis lived.

Edna Juanita Davis held both booze and bars in great disdain and was "sore as a boil" at her husband for confiding in his cronies that she indeed was the mysterious Madeline. To her last day on October 31, 1975, at age eighty-five, Nita denied that she was the drinking world's favorite *Mona Lisa,* the face on the barroom floor.

Inspired by a busboy, anger, and a poem, Herndon Davis had paid homage to the woman he loved on an otherwise forgettable piece of floor. The portrait is viewed by thousands every year, and it remains the West's most beautiful practical joke.

LONDON BRIDGE

The bridge that retired to Arizona.

For nearly two thousand years, in one architectural form or another, it was a London mainstay. Besides providing a route across the fabled river Thames (its only bridge until 1749), London Bridge also served as the subject of one of the world's best-known children's songs. In 1968, however, the old bridge traded fog for sand dunes and retired to Arizona.

It should be noted that the bridge standing proudly today over an arm of man-made Lake Havasu, Arizona, was not the first structure to be called London Bridge. The Romans set up a temporary pontoon bridge at the Thames site in A.D. 43. Records next mention a span

there in 984, which was the site where a witch was drowned. A stone bridge was begun in 1176, finished in 1209, and lasted more than six hundred years.

Arizona's London Bridge, certainly the most famous version, was designed and built by John Rennie in 1824. Constructed of granite in five arches, it was 928 feet long and 49 feet wide.

Thousands of commuters—the famous, the infamous, and the unknown—used London Bridge on a daily basis. The characters of Charles Dickens often crossed it, as did other fictional favorites. But in 1962 a shocking discovery was made. London Bridge really was falling

down, sinking slowly into the Thames under the great weight of twentieth-century traffic.

To junk the bridge would have been a historical tragedy. Still, safety could not be ignored as the mud rose a little higher each day. The government decided to put the bridge on the market, hoping that someone might find a use for it.

Enter Robert McCulloch of the McCulloch Corporation, famous for outboard motors and chainsaws. He'd begun planning his desert spa in the early 1960s on seventeen thousand acres in Mohave County, Arizona, after visiting the area looking for a testing site for his products. Starting with a mobile home unit for his workers, Lake Havasu City expanded like a blooming desert flower. McCulloch dreamed of a tourist attraction to go along with it.

In April 1968, newspapers were filled with speculation that old London Bridge was about to fall into American hands. A spokesman for the McCulloch Corporation dropped several hints but also managed to say, "If we don't win the bid, we'll just all have breakfast." The next day, however, the news was out. Read one London headline: "London Bridge Sold to Apaches!"

McCulloch's winning bid was $2,460,000. He arrived at the figure by doubling the bridge's value as scrap granite and adding $60,000 because he would be sixty when the bridge was dedicated.

The next problem was determining how in the world he could move 130,000 tons of granite blocks and reassemble them into anything resembling London Bridge. A code was devised as the bridge was dismantled. Each piece was tagged with four numbers: one indicated the span, another the row of stones, and the next two the position in that row. The pieces then were shipped ten thousand miles to Long Beach, California, and trucked across the desert.

On September 23, 1968, Sir Gilbert Inglefield, Lord Mayor of London, laid the cornerstone for Arizona's London Bridge, baptizing it with water brought from the Thames, while Lake Havasu schoolchildren merrily sang, "London Bridge is going up, going up, going up."

The project took three and a half years, with English engineer Robert Beresford supervising the reconstruction. The total tab for the bridge, including dismantling, transportation, and reassembly, came to around $7 million. So that it would not be a dry-land phenomenon, a mile-long canal was scooped out between the lower Colorado River and Lake Havasu, creating a two-square-mile island to be occupied by hotels, restaurants, and similar structures.

On October 10, 1971, London's new lord mayor, Sir Peter Studd, perspired under his heavy official robes in the ninety-degree Arizona heat. "There's not a Londoner who isn't delighted to have the bridge in its new home," he said as five skywriting planes soared overhead, welcoming the thousands who had come to see the dedication of London Bridge. Three thousand white pigeons were released as twelve skydivers slowly descended over the desert. Cowboys, Indians, and Boy Scouts participated in a gala parade depicting bridge history. Historical lapses of taste, such as the times criminals' heads were displayed over the bridge, were omitted from their story.

McCulloch got his wish; London Bridge is now Arizona's second greatest tourist attraction, following the Grand Canyon. Lake Havasu City boasts 709 businesses, two hospitals, schools, and radio and television stations. There's also a golf course and forty-five miles of shoreline for boating.

And, of course, there's London Bridge.

What did London do without its most famous bridge? The same thing citizens had done since the Romans: they rebuilt. Present guidebooks of London footnote that the most famous London Bridge is now an American tourist attraction, Out West.

HEADLINES
AND
EPITAPHS

THE BUFFALO

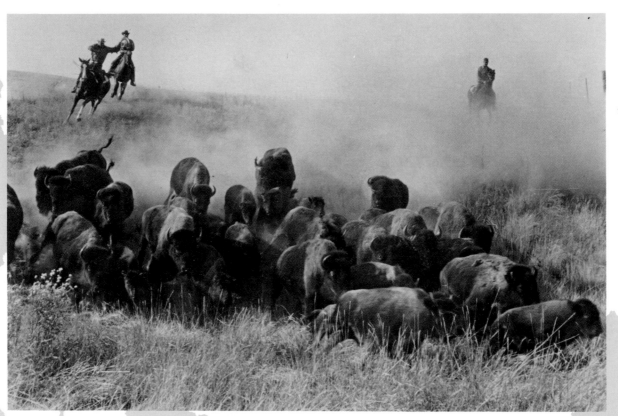

The animals that barely survived the winning of the West.

Times were never easy for the North American bison. Life was a series of hardships, from having to learn to walk within hours after birth to keeping up with the great herds as they moved along their nomadic trails. Danger came in the form of prairie fires that led to suicidal stampedes and hard winters that buried the delicious grasses under mounds of heavy snow. But it was man, specifically the white man, who brought the species to the verge of extinction, providing the West with one of its sorriest chapters.

Shaggy ancestors of the bison, commonly and incorrectly referred to as the American buffalo, first came to

this continent over 200,000 years ago on the land bridge that geologists believe connected today's Siberia and Alaska. Their descendants, the *Bison occidentalis,* thrived in the New World, covering the continent with great hoofprints. As late as 1769, Daniel Boone hunted bison on the western slopes of the Appalachian Mountains, though population expansion already was pushing the great beasts Out West. They numbered at one time some 70 million.

Early explorers, passing groups of buffalo that extended for thirty miles, were baffled by the great herds. Lewis and Clark recorded sighting a herd of twenty thousand on their way back from the Pacific Northwest in 1806. By 1850, after gun-slinging hunters had begun to make an impact, the bison population hovered around 50 million.

Plains Indians hunted bison for over ten thousand years. The bearded beasts figured in all facets of Indian life, from religion (they believed bison had come from great subterranean caverns) to everyday existence. Besides providing meat, the bison bones were used for making weapons and tools; hides for blankets, robes, boats, ropes, and shelter; sinews for bowstrings; and grease for fuel. The skull was a source of "great medicine" for medicine men.

Paintings show Indians in the great hunt, poised with spears and arrows or galloping on horseback alongside the woolly monsters. Though some bison met their end this way, many others died in a more expedient fashion. Hunting parties were known to frighten herds over steep cliffs; those two-thousand-pound animals not killed by the fall were finished off by waiting braves. Cruel as it seems, the strategem generally was used only in November or December as a means of quickly laying in large stores of food for the winter.

The true danger to the species came from the great white butchers. As Sioux Chief Red Cloud once observed, "Where the Indian killed one buffalo, the hide and tongue hunters killed fifty."

Buffalo robes had been a major factor in the fur trade since the white man first laid eyes on the mentally and physically slow animals. In 1840, 15,000 robes were shipped from present-day Colorado to St. Louis. Ten years later, that number topped 100,000.

Killing bison was big business to men such as William F. Cody, who was hired in 1867 by the Kansas Pacific Railroad to provide meat for the men working on the railroad. He earned the nickname "Buffalo Bill" working with a Springfield rifle he called "Lucretia Borgia," with which he killed 4,280 bison in eighteen months.

Dudes on vacations Out West escaped the city humdrum with gallant railroad excursions during which they shot bison for sport from the car windows. The carcasses were left for the wolves or to rot in the sun.

In 1870, European tanneries discovered that bison hides could be turned into fine leather. No longer did hunters have to confine their work from November to March, when the fur was thickest. Now, slaughter could be a lucrative year-round activity. What Sitting Bull called a "death wind" blew across the Plains.

By 1872, over two thousand buffalo hunters resided in Kansas alone. Sickening, drunken events were common. In one example, Thomas Nixon of Dodge City, looking to set a record, alternated between two Sharps rifles and wiped out 120 bison in forty minutes. Many other bison were killed in "still hunts," in which the hunter set up a great distance away and picked off animals one by one without stampeding the herd. Sixty could drop before the rest of the herd noticed.

Money was not the only root of the evil done the bison. Some whites saw the destruction of the species as an indirect way to eradicate Indians, by eliminating an element vital to their survival.

By 1874, the kills had dropped dramatically in the southern Plains as the bison moved up North. The peak year was 1882, when 200,000 hides were shipped from the northern Plains. The number decreased to 40,000 the next year and 300 the next. The animals continued to disappear until 1895, when naturalist Ernest Thompson Seton announced that there were only 800 bison left on the face of the earth.

National and state preservation legislation had a miraculous effect, as did individuals such as Texas rancher Charles Goodnight, who literally took the bison in. In 1913, when the buffalo nickel was minted, the animals numbered just over 3,000. Today, we have over ten times that many.

The annihilation of the American buffalo was halted when the species was on the brink of oblivion. His fate still rests in our hands, but now he runs on protected lands, unaware of his ancestral tragedy.

THE DISCOVERY OF YELLOWSTONE

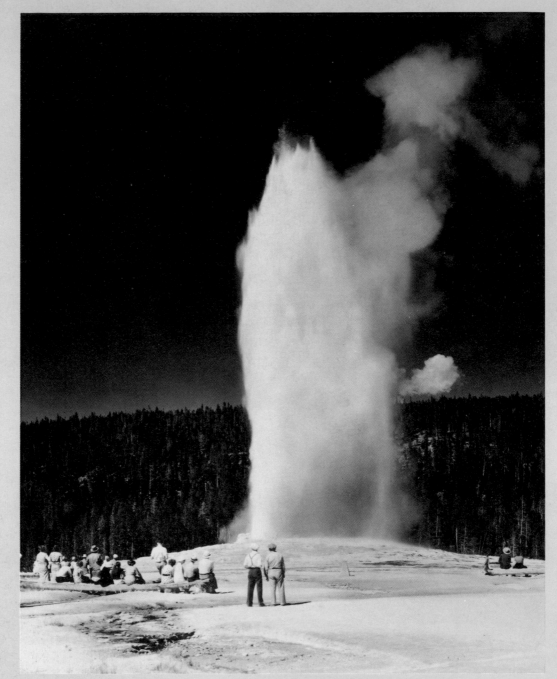

Old Faithful became a favorite tourist attraction in the twentieth century.

In the fall of 1810, frontier explorer John Colter arrived in St. Louis, Missouri, full of stories about a phenomenal natural wonderland Out West. Having left the Lewis and Clark party in 1806 for a longer look at the region, Colter journeyed to the south, eventually becoming the first white man to behold awesome Yellowstone. The tales of "Colter's hell" and stories from trappers such as Jim Bridger fueled the American imagination, causing others to seek and confirm the glory in the wilderness.

Perhaps the biggest mystery of Yellowstone was that it remained a secret for so long. Native Americans tended to shy away from the land of geysers and hot springs, regarding the belching terrain as a playground for evil spirits. The Blackfeet Indians kept its existence to themselves, believing the haunted waters would possibly make the white man stronger. The only true Indian residents of the area were the Tukarikas, or Sheepeaters, a much maligned branch of the Shoshone tribe.

Though white men trickled in after Colter, Yellowstone remained veiled for another sixty years. An unknown trapper carved the initials "J.O.R." on a tree in 1819. The *Philadelphia Gazette* published a "letter from the West" in 1827, setting in print for the first time an eyewitness account of the world's newest wonder. Bridger arrived around 1830 with two hundred other trappers, but his story of catching a fish in deep, cold water then cooking it by pulling the line through a boiling upper flow, caused several to doubt his tale.

The first official government expedition arrived in 1859, when Captain W. F. Raynolds of the Corps of Topographical Engineers was sent to explore the region around the Yellowstone River. Raynolds stayed north of the spectacular sights, however, and other expeditions were postponed by the Civil War.

Three Montanans—David Folsom, C. W. Cook, and William Peterson—set out on September 6, 1869, to dispel the rumors about this weird land once and for all. In their six-week tour, they saw Yellowstone Lake, Fountain Geyser, and some of the ten thousand thermal features. But, according to early historian Hiram Chittenden, they were "unwilling to risk their reputations" by recounting what they'd seen.

Montana Surveyor-General Henry D. Washburn finally stopped the rumor mill with his 1870 tour. After stumbling through heavy timber on the morning of September 18, the party of nine came to a clearing of clouds and steam. They stared in awe at one spectacular geyser that erupted with great force and regularity. Washburn named the scalding tower "Old Faithful." Said Chittenden of the reliable spout: "She bowed out the era of tradition and fable, and ushered the civilized world into the untrodden empire of the Fire King."

The discovery was big news; previous knowledge of geysers had been limited to Iceland and New Zealand. Uncle Sam showed renewed interest and in 1871 ordered the U.S. Geological Survey under Dr. F. V. Hayden to document the findings. That team's photographer, William Henry Jackson, eagerly packed his equipment in anticipation of being the first to capture Yellowstone's sights.

Hayden also showed a keen interest; he had been the staff geologist on the unsuccessful Raynolds expedition, which failed to see where "hell bubbled up." With a budget of $40,000 from Congress and a team of thirty-four, the journey began in June 1871.

After joining forces with a team of military engineers, the group arrived at the Yellowstone Basin in late July. Jackson painstakingly photographed the Grand Canyon of the Yellowstone, along with the Upper and Lower Falls. From there, the group went to the Boiling Mud Springs at Crater Hills, then on to the geysers for Old Faithful's film debut. (Actually, Jackson made his exposures on glass plates, developing them in the boiling springs.)

The thirty-eight-day tour yielded photographs, Hayden's five-hundred-page report, and important sketches from artist Thomas Moran. Establishing the area as a national park became Hayden's pet project. A handsomely bound prospectus complete with visuals was presented to each member of Congress, and the efforts began to preserve Yellowstone as a public park.

Those who would have opened the area for agricultural development were voted down in the Senate and in the House, where the final tally was 115–65 with 60 abstaining. President Ulysses S. Grant signed the bill into law on March 1, 1872, and the country had its first national park "for the benefit and enjoyment of the people."

The area that became Yellowstone National Park, land that had been shunned by the Indians, fortunately had also eluded the white man in his westward expansion and quest for gold. Less than two years after its official "discovery," it was made the first protected area in the country, by a government that up to then had not seemed overly concerned with environmental issues. The mystery of man's ways had joined forces with a timeless, natural wonder, and the uncharacteristic harmony and forethought saved Yellowstone for generations to come.

COMANCHE

The most famous horse in America stands with Captain Henry Knowlan (background)
and keeper Gustav Korn, about ten years after the Battle of the Little Bighorn.

In less than an hour, it was over. A cocksure thirty-six-year-old General George Armstrong Custer had made a series of miscalculations on June 25, 1876, dividing his forces and grossly underestimating the strength of the enemy. In the ensuing massacre, which pitted him and 225 of his men against ten times that many Indians, his entire command was wiped out.

The braves led away the army horses that were unhurt; the wounded ones were destroyed. All except one. As the cleanup went on around him, the great horse Comanche drank slowly from the waters of the Little Bighorn. He was wounded in seven places, but the Indi-

ans would not go near him. Two days later, he was found by troops sent to find Custer. The mystery of the most famous horse of the nineteenth century had begun.

Custer's last stand initiated a burst of patriotism and newsprint; the lack of army survivors gave romanticists a field day. Facts were scattered to the winds.

For instance, it was suggested that Comanche was Custer's own mount and that he'd been given his name when the army captured him during an Indian battle in Texas. Not so. He was purchased by an army quartermaster from a civilian horse trader in St. Louis on April 3, 1868. He was shipped to Fort Leavenworth, Kansas,

arriving on May 10 and receiving a "US" brand on his shoulder. About this time, First Lieutenant Tom Custer, brother of General George, left his Seventh Cavalry station at Ellis, Kansas, and returned with Comanche and forty-one other horses.

Captain Myles W. Keogh, an Irish soldier of fortune in the famous division, was in need of a second mount, and Comanche was a true cavalry horse: claybank in color, fifteen hands high, 925 pounds, six years old at the most. Keogh purchased the horse from the government for $90 to be a fighting horse.

In a skirmish with Comanches on September 13, 1868, the big claybank took an arrow in the right hind quarter, which was not discovered until back at camp. Keogh was astonished at his horse's stoical disregard for pain and named him after the brave Indian tribe.

Other adventures followed, including another skirmish with Comanche's namesakes in 1870 and an 1873 action in the South against the Ku Klux Klan. After healing from wounds received in the latter engagement, Comanche and his master were assigned to the Montana and Dakota territories to protect railroad surveyors from Indian raids.

They were with Custer when he heard there might be some Indians in southern Montana and headed for the Little Bighorn. About noon, the men found themselves surrounded. On one side stood Chief Gall and fifteen hundred Hunkpapa Sioux. Trying to reach high ground, the men were met at the top of a bluff by Chief Crazy Horse and another thousand braves, including many Cheyenne.

Keogh perished with the others. In an interview years later with one of Chief Gall's men, Little Soldier, a plausible reason surfaced as to why Comanche was spared.

Little Soldier had seen Keogh order his men to kill their horses and use the carcasses as barricades. The bond between Keogh and Comanche was too strong, however; Keogh knelt under his horse's front legs and fired his pistol from there. There he died, gripping the bridle. The Indians perceived this as a horse who was commanded by a spirit. Little Soldier admitted that "no Indian would take that horse when a dead man was holding the reins."

Found two days later, Comanche was cared for and shipped to Fort Abraham Lincoln in the Dakota Territory. He was never ridden again, only saddled for special occasions, and was given free run of the posts he called home. Paydays would find him sipping buckets of beer with the soldiers who cherished him.

Comanche was looked after for fourteen years by Gustav Korn, an army blacksmith. Korn was killed on December 29, 1890, at the Battle of Wounded Knee, and the old war horse became despondent. On November 6, 1891, he succumbed after an attack of colic.

Professor Lewis Dyche was engaged by the men of the Seventh Cavalry to perform a taxidermy job on their symbol, but when they were unable to come up with the $450 tab, Dyche took the body away. The stuffed horse was displayed at the 1893 Chicago World's Fair, then put on permanent display at the Dyche Museum of Natural History in Lawrence, Kansas. In 1950, he was given a glass case to protect him from the elements and the crowds who came to pull hairs from his tail and mane.

Today, Comanche resides on the sixth floor of that museum, surrounded by Indian artifacts, majestic and silent, as he was the time he stood surrounded by Sioux and Cheyenne warriors.

THE GOLDEN SPIKE

The race begun by President Lincoln's Pacific Railroad Act of July 1, 1862, was drawing quickly to a close. The mammoth effort to build a transcontinental railroad by 1876 was about to be completed an incredible seven years ahead of schedule. Two fiercely competitive rail companies were to put aside their differences to work together—separately. The wildly symbolic "wedding of the rails" was set for desolate Promontory Point, Utah, in May 1869. To solidify the vows, the railroads would drive a golden spike into the ground where their tracks met.

The Central Pacific Railroad built from the West, beginning in Sacramento, California, then winding up and over the Sierra Nevada mountains. Managed by President (and California Governor) Leland Stanford, Vice-President Collis Huntington, Treasurer Mark Hopkins, and Construction Supervisor Charles Crocker, the Central Pacific faced major natural obstacles.

Granite mountains sometimes slowed progress down to eight inches of track a day. The weather was treacherous at times, but a reliable work source was found in some ten thousand California Chinese, who proved

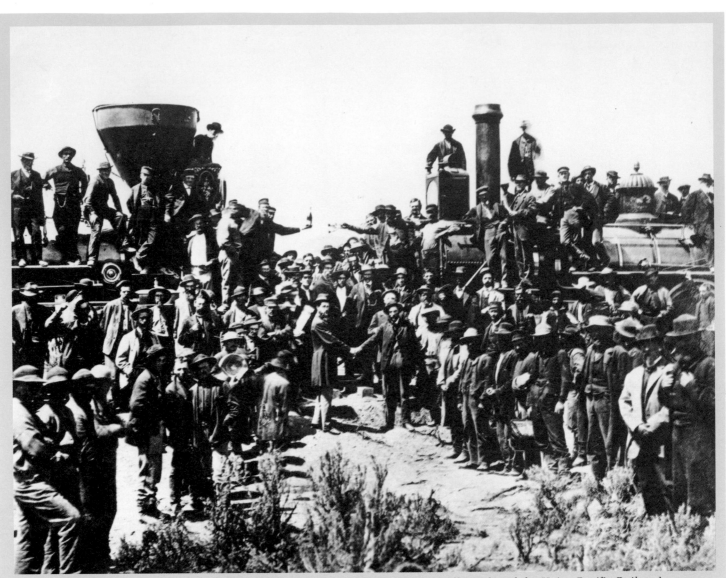

Central Pacific Railroad Chief Engineer S. S. Montague (left) and Grenville Dodge of the Union Pacific Railroad at the golden spike ceremony. Officials were not pleased by the display of spirits at such a reverent time.

to be strong and efficient under the most terrible conditions.

The Union Pacific began building westward from Omaha, Nebraska, on July 10, 1865. Under the supervision of General Grenville Dodge, the Union Pacific Railroad faced its share of problems. Supplies had to be brought by the Mississippi-Missouri river systems. And food was scarce until the young Buffalo Bill was hired to bring home the meat.

Then there was the Indian problem. Native Americans were, at first, curious about the huge Irish workforce, and routinely observed the backbreaking labor. When they decided that the Iron Horse would probably hasten their own demise, they fought back with a vengeance. Many workers were killed in countless Indian attacks, but still the tracks moved on.

As the railheads snaked closer together, the going got tougher. Two suspicious explosions blew a number of Orientals out of existence. The Chinese returned the gesture, taking out a few Irishmen, and an unspoken truce was set into force. They would mete out their aggression on the railroad.

If the Union Pacific cabled that they had completed six miles in a day, the Central Pacific replied that they had managed seven. At Granger, Utah, the Union pounded out seven and a half miles in one day in October 1868. Crocker boasted that the Central could do ten miles in one day. Union Vice-President Thomas Durant wired back: "Ten thousand dollars that you can't do it before witnesses."

Crocker gave the signal to start work at 7:00 A.M. on April 28, 1869, fourteen miles outside Promontory. A

crew of Chinese backed up the eight rail carriers. By nightfall, the eight men had each lifted 250,000 pounds of iron. A whopping 3,520 rails had been spiked to 25,800 ties for a grand total of ten miles and fifty-six feet. Besides losing the bet, Durant's troubles continued when he was held hostage in Piedmont, Wyoming, by angry workers demanding back pay. Only when the payroll arrived was his entourage allowed to proceed to Promontory for the ceremony.

The big event happened on May 10, 1869. Dignitaries from both lines arrived on schedule, but arguments soon broke out regarding protocol. Stanford brought a series of commemorative spikes, the granddaddy of which was cast from $20 gold pieces. On it were inscribed the words, "The Last Spike," the dates of the beginning and completion, and "May God continue the unity of our country as this railroad unites the two great oceans of the world." Dodge thought this measure to be overblown, and he complained that the last spike should be an iron one and he would drive it in.

Leland Stanford prevailed. He would drive the golden spike with a silver-headed hammer into a laurel tie inscribed in silver. A special telegraph table was set up adjacent to the gap, and wires were connected to the spike and hammer so the whole world would know once the blow was struck.

The last tie was laid between the Central's Jupiter locomotive and the Union's 119. A group of Chinese laborers hoisted the last rail. Suddenly, someone advised a photographer to "take a shot." The Chinese knew little English, but the sight of the black box pointing at them and the word "shot" made them toss the rail and duck for cover. After a loud argument, they put the rail in place.

At 12:40 P.M., after a prayer that most of the crowd of six hundred missed, the telegraph operator, W. N. Shilling, tapped, "We have got done praying. The spike is about to be presented." The spike was inserted in a drilled hole, and Governor Stanford stepped forward with a silver hammer. The band stopped, the crowd hushed, Stanford raised the hammer high above his head, and brought it down full force. *And he missed.*

The drunken men who had been working on the railroad the past few years guffawed loudly. Stanford looked flustered, then handed the hammer to Durant, who also missed. Shilling could wait no longer, and clicked out "It is done." After a few ceremonious taps by other dignitaries, the spike was finally driven in by Dodge.

Wild celebrations erupted nationally. One hundred guns were fired in a New York City salute. A seven-mile parade formed in Chicago. A magnetic ball on the Capitol dome in Washington fell, and in Philadelphia, the Liberty Bell rang.

The pandemonium around the official ceremony was joked about for years, but the reality of what happened ranks in importance somewhere between the signing of the Declaration of Independence and man's first stroll on the moon. In one precious moment an era ended and another one began, all with a missed stroke Out West.

HOP ALLEY

At night, they say, the lights of Hop Alley could hypnotize you with their red and yellow hues, translucent through the heavy clouds of punk and opium. Denver's Chinatown, an area bordered by Nineteenth, Twentieth, Blake, and Market streets, was a thriving Oriental community of the Old West. At its peak, it housed over two thousand immigrants, with a culture all its own.

Coolie track-laborers chose the area to establish places of business upon the completion of the Kansas Pacific Railroad in 1870. Laundries and restaurants abounded, along with mercantile establishments where you could buy everything from Chinese silk to litchi nuts. You could also find a few gambling halls, prostitutes, and opium dens.

Hop Alley's first mayor, Chin Lin Sou, had been a foreman in the Gilpin County gold mines. He brought his wife from China, telling reporters that "her countenance shone like the moon at midnight. Her lips were like lotus blossoms, and her fingertips were dripping with honey." In 1873, the Chinese "Year of the Rooster," they were blessed with the first Chinese baby to be born in Colorado, Lily Chin. When she became Lily Look on her wedding day in 1894, she wore a dress adorned with five-dollar-gold-piece buttons and a necklace of raw nuggets.

Colorful tales came from the mining-camp days. One concerned an honest laundry owner, Gee Chow, who was known to keep gold dust for various miners. One

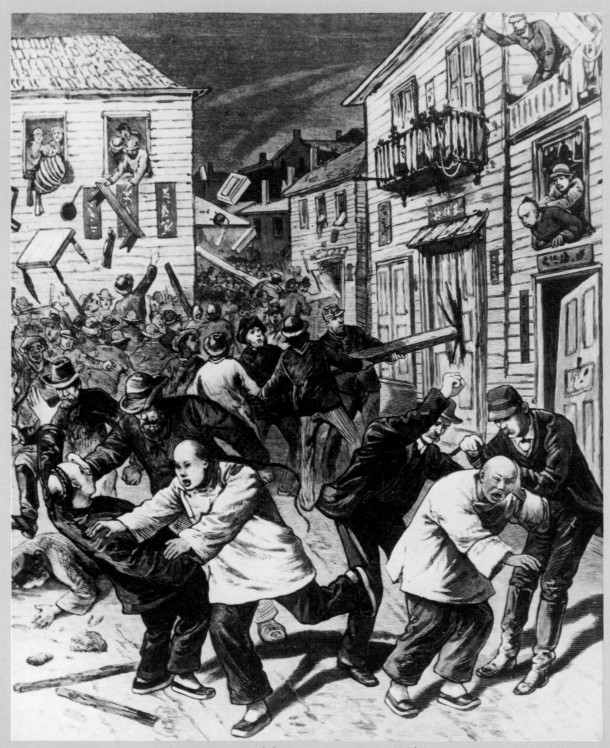

Artist's impression of the great riot in Denver's Chinatown.

group, working a placer claim in a nearby gulch, swore him to secrecy as they left bag after bag of sparkling dust with him. Gee asked to buy in but was turned down flat, so he enlisted the services of an American agent and bought the land outright for $60,000.

It wasn't long, however, before his Chinese workers reported that the gulch was as bare as a chopstick; he'd been hoodwinked by a "salted" claim. Gee kept silent and set his own scheme into action. A laborer arrived daily at his laundry with a poke of gold dust, then left with it hidden under his blouse. The salters decided the new claim owner had struck it rich, hired themselves an

agent, and bought the land back for $160,000. By the time they realized the land was as worthless as it had been when they left it, Gee Chow and his money were on a slow boat to China.

Most Denverites welcomed the Chinese community, but racism was often evident. The worst incident occurred in 1880, the "Year of the Dragon." A drunken cowboy whacked a Chinese resident over the head with a pool cue. Trying to defend his friend, another Chinese fired a shot. No one was hurt, but rumors spread like prairie wildfire: a Hop Alley denizen had killed a white man. Mobs gathered with torches and clubs, determined to oust the "heathen Chinee." Queues were clipped, and one elderly Oriental was lynched on Seventeenth Street.

A few tales of Caucasian valor emerged. Renowned desperado Jim Moon happened to be picking up his laundry at a friend's establishment when the riot reached the shop. Moon waved his six-shooters at the rioters and shouted that he would kill the first person who touched his favorite merchant. "If you kill Wong," he screamed, "who in the hell will do my laundry?" Wong, and fourteen others, were saved by the belligerent cowboy.

Incidents such as the riot, coupled with the country's policy of limiting Chinese immigration, caused a decrease in the population of Hop Alley and finally Chinatown disappeared. As late as 1909, however, the opium dens were still doing business, undisturbed by the police. Guided tours even stopped off in the drug-infested cubicles where, according to writer S. A. Meyer, anyone with sixty cents could partake of the "molasses-like stuff, the long inhalations, and the burst of smoke from the nostrils."

Oriental and Out West cultures never fully meshed. At the funeral of noted gambler Kong Ping, an American observer remarked about the custom of burying food—in this case a Peking duck—with the departed. "You must know," he said, "that the food returns to ashes as the body. Our friend cannot eat this food." A Chinese mourner replied, "Neither can the American smell the flowers which you send."

At the demise of Hop Alley, there were neither ducks nor flowers. Some residents stayed in Colorado; others moved on. After house razings took place in the 1940s, all that remains of Denver's fabled Chinatown are memories as fragile as rice paper.

BARBED WIRE

Consider the problem. The wide-open spaces were just that, thousands of miles of untamed grasslands, wild and fenceless. The buffalo herds and great cattle drives were restricted only by nature. The boundless freedom Out West was to be snagged, however, on a prickly thing known as barbed wire.

Galvanized wire was popular before barbed wire came along—over 350,000 miles of it were sold from 1850 to 1879—but if a cow wished to get through the strands of a fence, a little nuzzling was all that was necessary.

The public wanted cheaper, stronger fencing. Moaned one agriculture editor, "It takes $1.74 worth of fences to keep $1.65 worth of stock from eating up $2.45 worth of crops."

At an 1873 county fair, the future of fencing was about to get spurred in the right direction. On display in De Kalb, Illinois (which was considered a part of the West back then) was Henry Rose's patent No. 138763, artfully named "Wooden Strip with Metallic Points." Basically,

it was a slab of wood equipped with sharpened wire points designed to attach to a built fence. The most remarkable thing about Rose's forgettable invention was how it inspired three friends who attended the fair.

Farmer Joseph F. Glidden, lumberman Jacob Haish, and hardware-store owner Isaac Ellwood looked with interest at Rose's exhibition. Quietly, they hatched three separate ideas. Each went home to begin his clandestine tinkering. Glidden used wife Lucinda's coffee mill to twist wire into a two-prong point for fitting on a wire fence. Haish worked on what would come to be known as an S-barb. Ellwood couldn't quite perfect his fence, and after seeing Glidden's brainchild, the two became partners.

The results were the first legal entanglements over the sharp new product. Glidden's patent application for "The Winner" on October 27, 1873, was held up over a year by Haish's legal protests. In all, both received five patents and barely spoke to each other again. Glidden is considered the originator, although his neighbor had

a placard made for his house that read "Jacob Haish, Inventor of Barbed Wire."

As business was booming, sixty-year-old Glidden sold his interest to the Washburn and Moen Manufacturing Company of Massachusetts for $60,000 and royalties of 25 cents per hundred pounds made, and sat back to count his money. From production of nearly 3 million pounds in 1876, power equipment made possible the jump to 80.5 million pounds in 1880. Literally hundreds of wire companies sprang up, each with its own variations and twists, and the courts were jammed with lawsuits.

Stockmen at first weren't thrilled with the idea of their livestock being sliced to ribbons by the ugly little barbs. It took the showmanship of a true salesman, twenty-one-year-old John W. "Bet-a-Million" Gates, to do the convincing, and he did it deep in the heart of Texas.

Gates, an account executive for Washburn and Moen, was sitting in a San Antonio chili parlor observing the antics of a medicine showman when the idea hit him. After obtaining permission from city officials to set up a temporary corral downtown, the flamboyant young man invited cattlemen to bring their meanest Longhorns to the public display.

"This is the finest fence in the world!" bellowed Gates, dressed in his best dude duds. "It's light as air, stronger than whiskey, and cheaper than dirt!" After a

few feeble attempts at busting out, the steers were bored with the idea and remained contentedly contained. Probably the worst injury came to Gates, who no doubt suffered severe writer's cramp from filling out orders at eighteen cents per pound well past sundown.

Barbed wire spread across the prairie like wildfire. The famed XIT Ranch in Texas set up a fifteen-hundred-foot fence. Railroads became big customers, fencing off their right-of-way. Over seventeen hundred styles of wire were developed—some illegally, tagged "moonshine wire." "Riding the fences" became a new cowboy chore, and the "fence cutters" were the cause of many violent outbreaks and full-scale range wars.

Certain domestic problems arose from the fencing, as pointed out in *Harper's*: "It used generally to be expected that every gentleman had some more or less well-defined ideas on the subject of helping a lady over a fence.... Just how gracefully to thrust a young woman wearing a new summer gown with spinnaker sleeves through a five-wire barbed fence, each wire carrying sixty-five four-pointed barbs to the rod, has not yet been explained to the public."

Today, barbed wire still has its practical uses, but it's also an item for serious hobbyists. The American Barbed Wire Collectors Association was formed in 1966. Many books have been published on the subject, the most comprehensive being *The Wire That Fenced the West*, by Henry and Frances McCallum.

Fence cutters in Nebraska.

SOLID MULDOON

The Muldoon, complete with tail, rests between shows.

The news coming out of southern Colorado in September 1877 was calculated to set the scientific world on its ear. A petrified man had been found, a hulking giant who had been trying to sleep off eternity underneath a cedar tree. The local papers were calling it the "Solid Muldoon," after the hero of an Irish drinking song who was a solid man. Could this be the link between man and ape, so recently alluded to by Charles Darwin? Promoters hoped so, as they tried to pull off a scam that was almost rock-solid perfect.

The Neanderthal native had been unearthed southwest of Pueblo. Towering more than seven feet tall and weighing in at five hundred pounds, it was discovered by accident. William A. Conant was a retired singer from an Eastern entertainment establishment, working as a railroad agent in Colorado Springs. He had made news the previous spring by discovering a petrified turtle and a petrified fish in the area, but his most fabulous find came during a lunch break.

As Conant told the *Colorado Springs Gazette* on October 13, 1877:

I discovered the curious stones or toes protruding from the ground. Carefully removing the dirt from them, I soon discovered the shape of a human foot. Calling to my son to bring the shovel from the wagon, I proceeded to remove the soil until the limbs of a human being were exposed, and finally the full figure.

The old man had accidentally broken off Sir Solid's head while trying to pry it loose, but it was cemented back on before the public exhibition. The most remarkable aspect of the anatomy, besides its herculean proportions, was a small tail that protruded a few inches from the lower spine.

Colorado's most famous rock star was put on display in a local theater, where it drew a daily flow of curiosity seekers. The most famous person to view the body was showman Phineas Taylor Barnum, who was in the area to give a temperance lecture and visit his local ranch. Barnum was elated, saying, "We have found the missing link which Darwin claims connects mankind with the beast creation. It is certainly the petrified body of a man with a tail."

Barnum was so impressed with the find that he became partners with Conant in the upcoming road exhibition. As the touring titan wowed audiences in Denver, Cheyenne, and Omaha, suspicions arose. One of the first doubters was none other than Darwin himself, who had been sent a stereoscopic photograph of the stoned celebrity in hopes that he would endorse it. "It is impossible to form a judgment without seeing the specimen," wrote daughter Francis Darwin. "It seems to be a strong probability that the whole thing is an imposture."

A Pueblo newspaper editor visited the burial site and found no trace of an exhumation. "We were unable to discover that he had ever lived in the neighborhood," he reported. "In fact, the whole thing is too thin and smells of P. T. Barnum."

Following the tour, the Solid Muldoon had been parked in New York City where it lay for five weeks on exhibition. Some $20,000 had been realized when E. J. Cox, a small cog in the "Giant Company," as the promotion firm was called, blew the whistle. Cox, who was not getting what he believed to be his fair share, sang like a bird for a *New York Tribune* reporter. The hoax was exposed in February 1878.

The Muldoon had been the brainchild of George W. Hull, a bankrupt prankster who in 1869 had bestowed on the world the Cardiff Giant, a twenty-nine-hundred-pound gypsum humbug. Following Darwin's 1871 publication, *The Descent of Man,* Hull was convinced he could build a better mousetrap.

Capital was raised through a small tobacco store he opened in Elkland, Pennsylvania. Hull then leased a farm and set up a laboratory in an icehouse. For a while, his son-in-law served as a lower-body model, until the long hours of standing naked with his legs in plaster made him walk off the job. Hull then hired a New York sculptor and used his own torso for the upper-body molds.

After a disgusted cousin quit the tobacco shop, Hull brought in Cox to mind the store and invest in the dubious undertaking. According to Walter Wyant in *The Colorado Giant,* Cox was shown the secret doings. "Look at that tail," grinned Hull, "it is worth a million dollars!" He had even gone so far as to add to the giant's mold goose flesh and a skeleton of a few well-placed bones, should any experts wish to drill into the fossilized Frankenstein.

Hull was running short of funds, even though the Portland cement used to cast the creature had cost a mere $11.45. In March 1877, after making an initial contact with P. T. Barnum, Hull shipped the Muldoon to Connecticut for inspection. Barnum liked the idea and wired a former employee, none other than the erstwhile singer, Conant, to be his unofficial liaison in the "discovery." The year-old state of Colorado was deemed a perfect location for the prehistoric find because it offered an authentically dramatic sense of the wild. The giant was loaded into a crate, and all was ready for the trip by rail. Before its departure, Hull cast a concrete fish and turtle, just to spice up the diggings.

Local papers blasted the fraud as the participants sought their respective alibis. Conant continued his railroad work in Albuquerque, Hull left for parts unknown, and Barnum played down the incident. As for the Solid Muldoon, it, too, disappeared. Perhaps it is waiting to be discovered by some innocent future generation that will have no idea about the role it played Out West in the great missing-link stink.

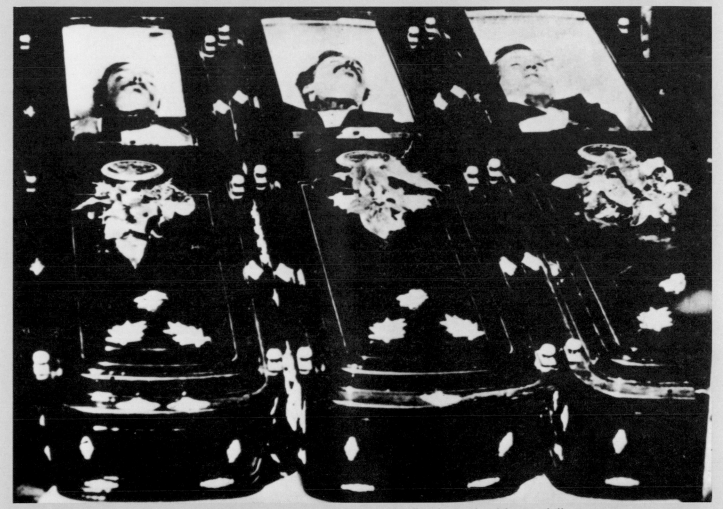

The aftermath: Frank and Tom McLaury and Billy Clanton head for Boothill.

"The men we killed there had to be killed," spat Wyatt Earp when asked about the fabled events of October 26, 1881. "They were bad." To Earp, the story was cut and dried. Historians, however, have had a more complex time with the Gunfight at the O.K. Corral.

Tombstone, Arizona, was a rough place to raise your kids. Mining had raised the population to twelve thousand; of that number, Earp later estimated, "about four hundred were cattle-thieves, stage robbers, murderers, and outlaws." This sagebrush Hades attracted a roster of Western personalities: Johnny Ringo, Bat Masterson, Luke Short, Doc Holliday, and the brothers Earp.

By the time he was thirty-three, Wyatt Berry Stapp Earp had a spotted past. He'd jumped bail after a horse-stealing incident in 1871, been caught banking fines he'd collected as a Wichita, Kansas, peace officer, and made little impression as Dodge City deputy marshal from 1876 to 1879.

Earp and brothers Virgil, James, and Morgan had migrated to Tombstone in 1879. With them rode the wildest dentist in the West, a consumptive young alcoholic named John "Doc" Holliday, and his common-law wife, reformed prostitute "Big Nose" Kate Elder.

Wyatt got his first job in Tombstone as a guard riding for Wells Fargo; he later became a deputy sheriff for the vast Pima County. When Cochise County was carved out of Pima, rival John Behan was chosen sheriff. Wyatt consoled himself with a job playing poker and keeping the peace in the Oriental Club. Virgil became assistant town marshal of Tombstone.

On the night of March 15, 1881, four masked men attempted to rob a stage leaving Tombstone; driver Bud Philpot was shot through the heart. Behan's posse, including the Earps, found a man tending the culprits' horses. He identified the bad guys as Bill Leonard, Jim Crane, and Harry Head but didn't mention the fourth man, who had pulled the trigger.

Witnesses had seen a frail rider leaving the scene, says James Horan in *The Authentic Wild West*. Word spread that the man was Doc Holliday (Later accounts even said Wyatt had planned the holdup.)

Wyatt offered a deal to Ike Clanton, a rustler and friend of Leonard, Crane, and Head. If Clanton would betray the trio so Earp could arrest or kill them, then Ike could have the reward and Wyatt could have the glory —and probably win the next election for sheriff. Clanton later testified that he turned the plan down.

In June, Virgil was named town marshal when the elected official mysteriously departed. More news followed: Leonard and Head were killed trying to rob a grocery in New Mexico. By summer's end, Crane had met a similar fate.

Then Kate Elder got drunk and put the finger on Holliday, according to historian Frank Waters. Doc was arrested, and Wyatt put up $5,000 in bail. The next day, after a confrontation, a remorseful Kate repudiated the charges and left town.

By October, the Earps and Holliday were still anxious to tie up loose ends. Clanton was known for having a Texas-sized mouth, and Wyatt was sure the story of his scheme was being spread. Just after midnight on October 25, Holliday challenged Ike to go for his gun, but Ike refused.

The next day, Ike was joined by his brother Billy and the McLaury brothers, Frank and Tom. They decided against a confrontation with Earp and went to the O.K. Corral to saddle up and leave town. Behan met them there and in trying to disarm them discovered that only Billy was armed. Coming down the street were four grim figures: Wyatt, Virgil, and Morgan Earp, and Doc Holliday.

Behan tried to disarm that group, too, but they brushed him aside. Some say Virgil commanded the Clanton men to "throw your hands up." Others say Wyatt spoke first: "You sons of bitches, you have been looking for a fight and now you can have it!"

The gunfire lasted thirty seconds. When the dust cleared, the McLaurys and Billy Clanton lay dead, Virgil and Morgan wounded. Ike escaped.

In the inquiry that followed, the Earps and Holliday were cleared of wrongdoing as deputized officers of the law. Doc left town soon after, eventually dying of tuberculosis in Glenwood Springs, Colorado.

Virgil Earp was crippled in an ambush and Morgan was assassinated while playing billiards. Wyatt was bent on revenge until the Klondike gold lured him out of the badlands. He settled in Los Angeles, wrote some farfetched memoirs, and authorized others to write biographies that lionized him.

Thanks to Hollywood, the battle has become folklore. In reality, it remains a suspicious incident that inadvertently immortalized the Earps and Holliday while increasing the Boothill Cemetery population by three.

THE OKLAHOMA LAND RUNS

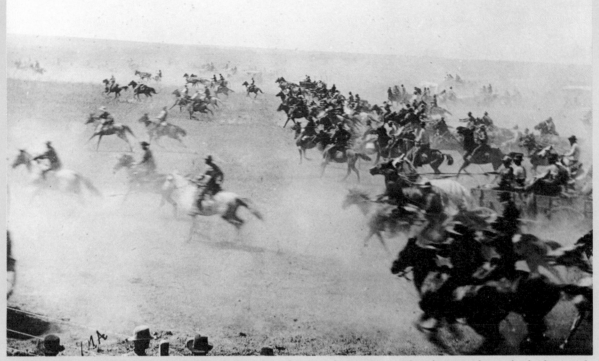

The Cherokee Outlet opens on the 100-degree day of September 16, 1893. The photographer, who had missed the run of 1889, built a special platform in order to capture this panorama.

The white man had forgotten that certain lands had been pledged to the Indians by President Andrew Jackson for "as long as the grass grows or the water runs." The lapse of memory was no surprise. The white man would have taken Oklahoma's plains by hook or by crook.

What was unique was the way the titles would be granted. For the time being, greed would give way to speed. In a sweeping gesture of sportsmanship, Uncle Sam decided the homesteaders could make a run for it.

The lands in question had been intended for the displaced Five Civilized Tribes from the East. Eventually, more than fifty tribes would be parked in the area. In 1866, Cherokee lawyer Colonel Elias C. Boudinot noted 2 million acres of "unassigned lands," land not ceded to the Indians, existed in the heart of their territory. The thirty-by-fifty-mile rectangle seemed a perfect place for pioneers to raise their children.

Many efforts were made by whites to squat on the prized earth, most notably by the opportunistic colonist David L. Payne, whose attempts to bring his boomers to settle the land were eventually thwarted. More effective were Washington lobbyists who, in early 1889, finally took measures to pay the Indians for their wide-open spaces, sometimes as much as $1.25 an acre.

Three weeks after taking office on March 3, 1889, President Benjamin Harrison issued a novel proclamation. As of noon on April 22, prospective land owners could enter the unassigned areas and claim up to 160 acres by driving a stake into the ground. Town sites and farmlands were sectioned off, and, in the frantic weeks before the formal opening, the outlying areas were filled with dream seekers.

It was an opportunity unparalleled in history. Where so much of the West's settlement had taken months and years, the occupation of this patch of Oklahoma would

be completed between noon and sundown. The hopes of at least fifty-thousand settlers hung in the balance. When a minister remarked to a cursing wagon driver, "My friend, don't you want to go to heaven?" the driver hollered back, "That's just where I'm headed, and, if I can cross the Cimarron, I'm bound to get thar!"

Of course, it was not Eden. Choice plots offered ample water to support the good life, but other parts of the West were more plentiful. And, despite the vast reaches of free country (the proposed $1.25 fee per acre to reimburse the government for its payments to the Indians was thrown out with the Free Homes Act of 1900), there was still not enough to go around. The odds of disappointment were far greater than the chances to join the landed gentry.

Still, people came from all directions, even from overseas. Three days before the opening, daring hopefuls were allowed through the surrounding lands to the edges of their brave new world. Various starting points formed around the perimeter. Traffic would be directed inward.

Families crowded on five-hundred-dollar race horses, purchased especially for the big event. Some rode bicycles; at least one man straddled an ox. Special trains would run through the territory, with participants dangling from the sides. When it was learned that a press train would enter first, several homesteaders switched to journalistic careers on the spot.

At noon on sunny April 22, bugles sounded and shots rang out down the line. The air filled with a tremendous whoop, the ground shook, and dust flew around the chaotic spectacle. "Harrison's hoss race" was on.

Spring grasses and wildflowers were trampled in a blur of calico and buckskin. Said the St. Louis Republic, "Shrill cries rose from the boomers, their whip lashes resounded, the horsemen among them shot forward impetuously, the teams tugged at the rattling harneses, and the whole motley crowd swept forward in gathering motion."

One of the first problems was the "sooners," who had decided that a game of such magnitude required equally large-scale cheating. Many had sneaked in to stake early claims, hence their name; their cases filled the law courts for years to come. On April 22, one old man was found in the area already working in a garden on his four-inch-high onions. When asked how it could have happened, the farmer praised the rich soil where he said he had planted just fifteen minutes ago.

By evening, the lots and town sites had filled. Tent cities of Oklahoma City, Guthrie, Kingfisher, Stillwater, El Reno, and Norman sported population counts reaching into the thousands. Outside the towns, homesteaders celebrated day one of a new beginning about which the *Chicago Tribune* said, "The land may be had for the asking and retained at the muzzle of a Winchester."

Over the next few years, more Indian lands were acquired at rock-bottom prices and opened via the land run. On September 22, 1891, the Iowa, Sac, Fox, Potawatomi, and Shawnee lands were up for grabs. Two 1892 runs took the Pawnee, Cheyenne, and Arapaho real estate. On September 16, 1893, in the largest run of all, more than a hundred thousand settlers gobbled up the fifty-eight-by-hundred-mile Cherokee Outlet. Following the smaller Kickapoo land run of 1895, a lottery system was devised for the remaining Indian acres.

The coming of the white man to the broken-promise land had been swift and final. In a frenzy of greed and progress, another aspect of the Old West was dispatched into inglorious history.

THE SAN FRANCISCO EARTHQUAKE

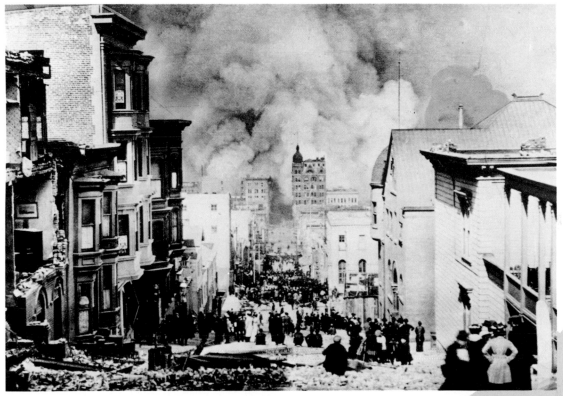

Crowds gape as fire creeps up Sacramento Street. Arnold Genthe's picture is one of the best news photos of all time.

San Francisco's greatest nightmare began at 5:13 A.M., Wednesday, April 18, 1906. It came without warning as most of the city slept through a pink dawn. Billions of tons of earth along the six-hundred-mile San Andreas fault shifted in a great grinding jolt, causing a tremor that was recorded as far away as Cape Town, South Africa.

Police Sergeant Jesse Cook and produce man Al Levy were talking at the corner of Washington and Davis streets. The horses sensed it first. From a point to the north, two hundred miles out at sea, the quake had raced in at a speed of seven thousand miles per hour, ripping through five-hundred-year-old redwood forests and small towns, then cut back to the ocean to reshape cliffs and draw a new coastline.

Cook felt a "deep and terrible rumble. I could see it actually coming up Washington Street. The whole street was undulating. It was as if the waves of the ocean were coming toward me, billowing as they came."

John Barrett, the *San Francisco Examiner*'s city editor, reported buildings "dancing" and said, "It was as though the earth was slipping quietly away from under our feet. There was a sickening sway, and we were all flat on our faces."

Across the city, from the elegant homes of Nob Hill to the flimsy shacks of Chinatown and the brothels of the Barbary Coast, buildings began to fall. Church bells in swaying steeples rang in unison. Many believed it was Judgment Day. "This is going to be a hell of a day," Barrett said to two reporters. "Let's start covering it."

In the first minute-long tremor, chimneys and towers crumbled, whole walls fell into streets and disintegrated. The massive City Hall, which had taken $7 million and twenty years to construct, fell in twenty seconds. The four-story Valencia Hotel toppled in an instant, killing all eighty guests.

After a ten-second lull, a second tremor lasted half a minute. The Brunswick, Denver, and Cosmopolitan hotels were reduced to rubble. People took to the streets in all stages of undress, trying to escape the tipsy buildings. Trolley tracks were lifted three feet into the air.

In his suite in the Palace Hotel, Enrico Caruso awoke. The great tenor had performed the night before in *Carmen*. Now he scrambled on the floor of his room, trying to save his jewelry and an autographed picture of President Theodore Roosevelt. When opera conductor Alfred Hertz came to check on him, Caruso said he feared his vocal chords had been damaged. Hertz urged him to throw open the windows and sing. To those fleeing below, it was Caruso's "bravest and best" performance.

Photographer Arnold Genthe had no time to mourn the loss of thousands of exposed plates that shattered in his studio. Throughout the next few days, he would traverse the holocaust with his equipment, recording the scenes of the great disaster for all time.

Actor John Barrymore had spent the evening entertaining another man's fiancée. At the first signs of trouble he dressed in black tie and went about the city trying to get a drink. Barrymore found a bottle of brandy, got drunk, then wrote a wildly fictitious account of the calamity that he sold to a New York magazine for $100.

Yet, there was little room for humor. As fires were starting, the city's brilliant fire chief, twenty-six-year veteran Dennis Sullivan, fell three stories out of his home above the fire station. He never regained consciousness and died the following Sunday. The 585-man fire department faced a myriad of blazes and no water supply—the city's water mains had been destroyed.

Block after block disappeared in uncontrollable flames. An Italian neighborhood near Telegraph Hill threw a thousand gallons of wine on the fires. While the Grand Opera House and The Emporium burned, a woman in the Hayes Valley area attempted to cook breakfast, unaware that her flue had been wrecked. This "ham-and-eggs" fire did the most damage of all, igniting the St. Nicholas Hotel, St. Ignatius Church, Mechanics Pavilion, and most of the records in City Hall.

While firemen vainly attempted to curtail the inferno with dynamite, usually starting more fires than they extinguished, another problem arose. Looters went about their sordid business. Mayor Eugene Schmitz ordered them to be shot on sight. Three soldiers came upon a man cutting off the fingers of a dead woman at Third and Market to get her rings and filled him with bullets. Meanwhile, at the U.S. Mint, thirty-four men were gunned down as they tried to get at the $39 million inside.

For four days the fires raged, threatening to engulf the city. Thousands made an exodus to the surrounding hills and neighboring cities. Ten thousand evacuated Chinatown before it was leveled. Writer Jack London noted, "Surrender was complete."

On Saturday night, the rains came. On Sunday, the catastrophe of earth, wind, and fire could be observed but hardly comprehended.

Fire had consumed three thousand acres or 520 city blocks, comprising 28,188 buildings. Included were thirty schools, eighty churches, and ten thousand gardens. A quarter of a million people were homeless. The death toll ranged between 450 and 700. The fire was half again the size of Chicago's 1871 cookout; it covered six times the area of London's 1666 blaze. Total loss estimates reached the $500 million mark. Many insurance companies went belly up, though others established credibility by paying off 70 percent of the total losses.

The rebuilding was a massive undertaking, but San Francisco was ready to show her progress to the world in 1915 when she hosted the Panama–Pacific International Exposition.

THE BUFFALO NICKEL

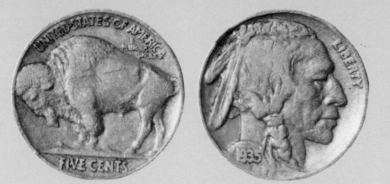

America's only coin where neither side won the toss.

When sculptor James Earle Fraser answered Uncle Sam's call for new coin designs in 1911, his proposal evidenced his love for the West. On September 19 he wrote, "The idea of the Indian and the buffalo on the same coin is, without doubt, purely American and seems to be singularly appropriate to have on one of our national coins." Thus began the story of the buffalo nickel.

Fraser was born in Winona, Minnesota, on November 4, 1876. The son of a railroad construction engineer, he saw a good deal of the West traveling in Dakota Territory with his father. An early interest in art, especially sculpture, had him carving by age eight, and before his twentieth birthday he'd completed a famous work: *The End of the Trail,* a dramatic image of a weary warrior slumped on his equally exhausted horse.

After the government indicated that Fraser's coin design would be considered, the sculptor worked throughout 1912 in his Greenwich Village, New York, studio. Preliminary approval came from Secretary of the Treasury Franklin MacVeagh on January 13, 1913, and official production began February 21.

The new coin was a beauty. On the back, the American bison was profiled in amazing detail, standing atop a mound that read "FIVE CENTS." The mound shape caused minting problems and was amended before year's end to a flat platform. The front featured a proud Indian chief with "LIBERTY" just above his forehead, an "F" for Fraser on his shoulder, and the date. But the era's most popular coin (after all, it could buy a beer, a cigar, or a trolley ride) was not without controversy.

For starters, the coin was thicker than its predecessor and didn't fit into bus and streetcar fare boxes. Coin machine manufacturers protested that they had been buffaloed, but they finally modified every nickel slot in the country to accommodate the chunky newcomer.

The model for the bison soon was identified as Black Diamond, the offspring of two of P.T. Barnum's donations to New York's Central Park Zoo, but the mystery of the Indian was not so rapidly solved.

The scam behind the old Indian-head penny was well known: the face wasn't that of an Indian at all, but the image of twelve-year-old Sarah Longacre, an engraver's daughter who posed in a war bonnet furnished by Indians touring the Philadelphia mint. But the man on Fraser's coin looked genuine, and the country wanted him credited.

Fraser was elusive, saying only that the bust represented all American Indians. This opened the door to several impostors who claimed they modeled the proud image.

The most boisterous claimant was Chief Two Guns White Calf, a Blackfeet who saw the nickel for the first time when he got one from a tourist in Glacier National Park. Newspapers quickly picked up on the story, and for twenty years Two Guns appeared in articles with titles like "You Carry His Portrait in Your Pocket—Perhaps!" Two Guns went to his grave believing he was the Indian on the nickel, but such was not the case.

Trying to quell the controversy, Fraser only stoked its flames when on June 10, 1931, he wrote to the Commissioner of Indian affairs: "I used three different heads. I remember two of the men, one was Iron Tail, the best Indian head I can remember; the other one was Two Moons, and the third I cannot recall."

Chief Iron Tail was a Sioux, born in the South Dakota region around 1850 and named for the way bison hoist their tails in the air during a chase. After warring with

the white man, he joined *Buffalo Bill's Wild West* show, touring Europe in 1889. Iron Tail also performed for similar shows with *Pawnee Bill and the 101 Ranch* show.

The Cheyenne Chief Two Moons's greatest accomplishment came one summer afternoon in 1876, when he participated in the defeat of Custer at the Little Bighorn. When the wars were over, Two Moons became a prominent Army scout and was received by President Woodrow Wilson in the White House.

The forgotten man in Fraser's explanation probably was Chief John Big Tree, a Seneca. Big Tree lived past the age of one hundred, into the late 1960s, and until his final day he claimed to be the Indian Fraser failed to credit. It's easy to see how Big Tree could have worked himself into Fraser's subconscious: as a young man he had been the model for *The End of the Trail*. (Big Tree's likeness also appeared as the Pontiac automobile's famous hood ornament.)

Some conciliatory reports credited Two Moons as the model for the forehead, Big Tree the nose and mouth, and Iron Tail the chin and throat.

The nickel itself had enough quirks to keep coin collectors happy for years. Because of the high shoulder relief, the dates were rubbed down and disappeared after brief circulation, increasing the value of those nickels that retained the year of issuance. Double mint marks appeared on some, but the best production goof occurred at the U.S. Mint in Denver in 1937 when a die problem produced a slew of nickels with three-legged bison.

By law, coin designs must remain in circulation for twenty-five years. When the buffalo nickel reached the quarter-century mark in 1938, it was retired in favor of Felix Schlag's Jefferson nickel. The jitney from Out West was left behind. When Fraser died in 1953, his most famous creation, like the images it commemorated, was a shelved piece of history.

THE TEAPOT DOME SCANDAL

Until Watergate, the nastiest political scandal in America's history centered around a lump of ground Out West. Fifty miles north of Casper, Wyoming, Teapot Dome (named for a rock formation) was an oil reserve set aside by Uncle Sam in 1915 to provide emergency fuel for the navy. This field, and the man who controlled it, would soon become synonymous with all that was wrong with the Harding presidency.

Warren Gamaliel Harding was not the best judge of character. Primarily a good old boy from Ohio, the twenty-ninth president had surrounded himself with a cast of questionable characters ranging from dignified statesmen to backroom con-artists. Included on this roster was the poker-playing buddy Harding had chosen to be his secretary of interior, Senator Albert Bacon Fall of New Mexico.

Fall was born on November 26, 1861, in Frankfort, Kentucky, and later moved Out West. Settling in Las Cruces, New Mexico Territory, he was admitted to the bar in 1889. Elected to the legislature in 1890, Democrat Fall tackled education problems and used his influence in the territory's move toward statehood.

In 1893, President Grover Cleveland appointed Fall judge of the Third Judicial District, a position he was forced to resign two years later amidst charges of impropriety. In 1896, he was elected territorial senator from Dona Ana County. He joined the militia at the outbreak of the Spanish-American War, but never saw battle. Switching to the Republican party in 1902, Fall eventually became one of his state's first U.S. senators when New Mexico was granted statehood in 1912.

Conservationists were stunned when Fall, a Westerner personified, complete with drooping mustache and wide-brimmed Stetson, became secretary of interior in March 1921. They needn't have worried. Although Fall made noises as if he wanted to chop down every tree in Alaska in the name of commerce, his real purpose in office centered around the greening of his own bank account.

On May 31, 1921, Fall persuaded the president to

Outside the courtroom, defense attorney Wilton J. Lambert, Albert Bacon Fall, Edward Doheny, and the chief defense attorney, Frank Hogan, meet the press following Doheny's 1926 acquittal.

make the incredible decision to transfer the nation's naval oil reserves from the Navy Department to the Interior Department. In addition to Reserve No. 3 at Teapot Dome, Fall assumed control of No. 1 at Elk Hills, California. His reasons were supposedly patriotic—to protect the reserves that were in danger of being tapped by bordering private interests.

In a secret meeting on July 12, 1921, without the benefit of competitive bidding, Fall leased Reserve No. 1 to a crony, Edward Doheny. In April 1922, Teapot Dome was turned over to Harry F. Sinclair and his Mammoth Oil Company. When news of the leasings leaked, Fall refused to comment in the name of national security. Shortly after, it was noticed that he was making lavish improvements at his Three Rivers ranch. The Teapot was about to boil over.

Now another Westerner moved onto the scene, Montana's Senator Thomas J. Walsh, a member of the Public Lands and Surveys Senate Committee. The investigation, at times tedious and confusing, would attempt to shed light on the questionable transactions. In January 1923, the White House announced that Fall, who had come into the cabinet at great personal and financial sacrifice, would be leaving in March.

With storm clouds gathering, President Harding opted to take his summer vacation. Rumors of widespread corruption and graft were now becoming headlines, and it has been suggested that the problems that lay ahead for Harding caused him suddenly to become ill. He died in San Francisco on August 2. A nation mourned its fallen leader, then got ready for the big fireworks in Washington.

Despite Fall's attempts to stonewall, the truth slowly revealed itself. On October 24, he lied under oath, saying that he had never received any compensation from Doheny or Sinclair. On January 24, 1924, Doheny admitted he had made a "loan" of $100,000 to Fall, delivered in a little black satchel. Archie Roosevelt, son of Theodore and former officer for one of Sinclair's companies, testified that his boss's secretary had told him of a pay-

ment of $68,000 to the manager of Three Rivers. (The secretary, G. D. Wahlberg, later insisted that Roosevelt heard wrong: what had been given was "six or seven cows," not "sixty-eight thou." The testimony provided the Walsh Committee with some much-needed comic relief.)

Doheny was eventually acquitted, but as the sordid mess dragged on, it was discovered that Fall had received nearly $400,000 in bribes: $260,000 in Liberty bonds from a dummy Sinclair company, and the Doheny dough. All contracts were voided in 1927, and on October 25, 1929, Fall was convicted of accepting the Doheny payoff. In July 1931, Fall began a one-year prison sentence, the first cabinet member ever to be jailed. Upon release, he was excused from his $100,000 fine because of destitution.

Fall lost Three Rivers to foreclosure in 1935 and spent the rest of his days in failing health, existing on his war-service pension. He died on November 30, 1944, in an El Paso hospital, a broken and embittered man, convinced that he would be vindicated by history.

Many would remember Fall by the president's comment, "If Albert Fall isn't an honest man, I'm not fit to be president of the United States."

THE PIONEER ZEPHYR

It wasn't particularly hot in Denver on the afternoon of May 25, 1934, but Ralph Budd, president of the Burlington Railroad, and E. G. Budd (no relation), president of Budd Manufacturing, were getting a little warm under their starched collars. You could see it in their reflections on the stainless-steel body of their baby.

For the previous year, the two men and workers from 107 companies had devoted considerable time and energy to an idea they hoped would set the transportation world on its ear: a stainless-steel train with a 660-horsepower diesel engine, capable of traveling over a hundred miles per hour. Named for the west wind, the Zephyr had been completed by Budd Manufacturing in Pennsylvania and shipped to Colorado for its inaugural run: a nonstop whiz from Denver to the Chicago World's Fair.

Nothing is ever easy, though. Twelve hours before the launch, inspectors discovered a broken armature bearing on the power car. After a frantic telephone search, a bearing was located in Omaha and put on a plane. At ten that evening Ralph Budd took to the airwaves, predicting a brilliant run the next day but failing to tell the public that at that moment the Zephyr was scattered about the Burlington workshop in bits and pieces.

The all-important bearing arrived just before one in the morning, scarcely three hours before the scheduled departure. Amidst the confusion in the dead of night, the train's mascot, a high-country burro named Zeph, arrived and promptly planted himself astride the rail that would carry the armature from the lathe.

Finally, with Zeph installed in a proper crate and seventy-two Chicago, Burlington, and Quincy Railroad officials and members of the press aboard, the shiny Zephyr rolled out onto Union Station's track number one. A signal from an Indianapolis Speedway flag, and the starting tape was broken at 5:04:40 A.M. The race against the sun was on.

At first, engineer John S. Ford held the speed under fifty to break in the new bearing. He began to open up, and the powerful train reached the top of a grade at eighty miles per hour. But some nameless villain accidentally slammed the door on a cable running from the power section, and the great engine shut down.

As the Budds drew closer to cardiac arrest, a frenzied search finally turned up a piece of usable cable. Luckily, the train then was on forty-two miles of downhill track, so the repair was made before the Zephyr came to a stop. From there, Ford let 'er rip.

At one hundred miles per hour, the Zephyr held a treacherous curve. Zeph became trainsick and his crate shattered, but he was quickly revived with some cereal prepared in the stainless-steel kitchen. While still in Colorado, the train reached its top speed of the trip, a blinding 112.5 miles per hour.

At every town and whistle-stop along the route, crowds gathered to glimpse the silver bullet blazing across the American heartland. "There it is, there it ain't," gasped one farmer. The 360 miles of Nebraska track were covered in a scant 281 minutes. In Iowa, 274 miles were chomped up in 212 minutes.

Two hundred miles outside Chicago, near the Mississippi River at Burlington, Iowa, the train was forced to slow because of a downgrade. Air pressure dropped, and the brakes locked. The nonstop feat was threatened

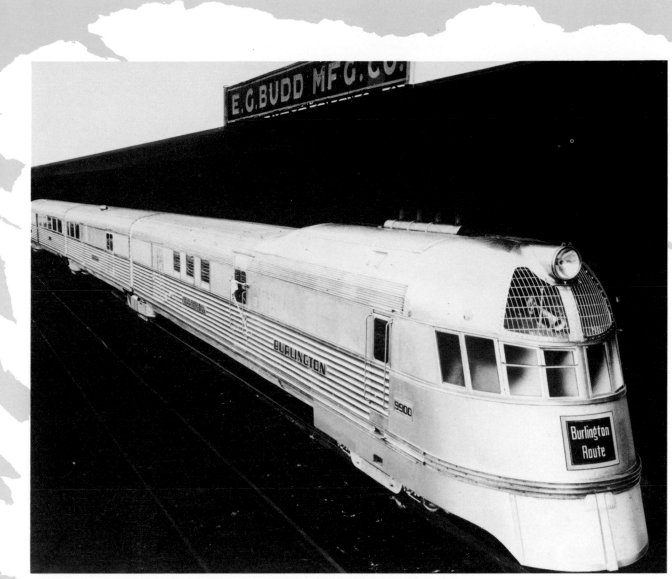

The train of stainless steel.

again as the Zephyr dropped to ten miles per hour. The brakes released at the last moment, and the great trek continued.

In Princeton, Illinois, the bullet passed a dubious moving landmark. The coal-burning Aristocrat had left Denver at 5 P.M., Friday; at 4:55 P.M., Saturday, its occupants gaped as the silver streak sped by the windows.

At 6:09 P.M. (Denver time), the Zephyr pulled into the Century of Progress Exposition to the cheers of fifty thousand onlookers. The 1,015 miles had been covered in 13 hours, 4 minutes, and 58 seconds at an average speed of 77.6 miles per hour. Fuel costs had been $14.64. Flowers clipped from Denver's City Park at three-thirty that morning were presented, still fresh, to the mayor of Chicago, and the Budds released well-deserved sighs of relief. The first movement of Burlington's symphony in stainless steel had reached a glorious conclusion.

Passenger service began in November of that year, after the Zephyr had starred in RKO's *Silver Streak.* Other Zephyrs soon followed, including one that would break the record in 1936 by going the opposite direction in just over twelve hours.

The original train, number 9900, was renamed Pioneer Zephyr, and it carried over a million people during its long career. Retirement ceremonies were held on February 20, 1960, after the Zephyr had logged over 3,200,000 speedy miles.

DUST BOWL

Every moving thing lifted the dust into the air: a walk-ing man lifted a thin layer as high as his waist, and a wagon lifted the dust as high as the fence tops, and an automobile boiled a cloud behind it. The dust was long in settling back again.

—John Steinbeck, *The Grapes of Wrath*

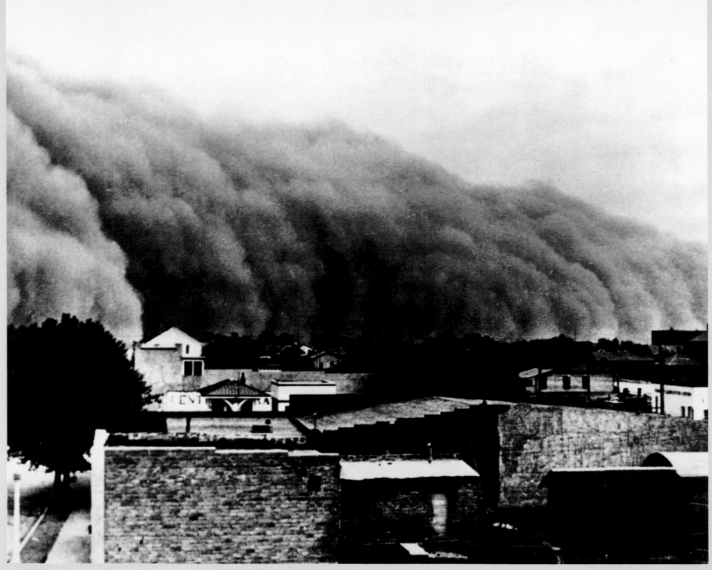

A storm rolls into Union County, New Mexico, May 31, 1937.

The origins of the Dust Bowl, a million-acre tract of devastated country comprised of portions of Montana, Wyoming, Colorado, New Mexico, Texas, Oklahoma, Kansas, Nebraska, South Dakota, and North Dakota, were many. Wheat prices soared at the outbreak of World War I, from 91 cents to $2.06 a bushel by 1917. Soil protecting grassland was reduced sharply as wheat crops expanded from just under 500,000 acres before the war to 1,188,934 acres. Conservationists' warnings went unheeded despite the area's dry climate.

A terrible drought, incessant wind, new technology that made rapid sodbusting possible, and soil already subject to erosion caused the greatest ecological disaster this country had ever seen; eventually 756 counties in nineteen states were affected.

In 1931, much of eastern Colorado received three inches less moisture than normal. By 1933, the annual rain deficit in Kansas was close to five inches. Goodwell, Oklahoma, registered nine inches below normal for 1932 and 1933 rainfall. Ground moisture sank to dangerous levels. Winter snows failed to protect the earth, alternately freezing and thawing. But it was the wind that would turn the plains into a desert nightmare.

On January 21, 1932, a duster with sixty-mile-per-hour winds lifted a mighty cloud of dirt ten thousand feet into the air above Amarillo, Texas. As the storm moved into Kansas and Oklahoma, crops were destroyed and travel was restricted.

In April 1933, weather bureaus around the region recorded 179 separate dust storms. On May 9, brown earth from Montana and Wyoming blew eastward toward the Dakotas, the winds eventually sucking up 350 million tons of dirt. Twelve million tons fell on Chicago, and by May 11 many residents of Boston and New York City smelled soil from Out West for the first time. The black cloud eventually reached five hundred miles out over the Atlantic.

Perhaps the worst storm of the era came on "Black Sunday," April 14, 1935. A truck driver spent five and a half hours driving the fifty miles between Springfield and Lamar, Colorado, in the unnatural darkness. The storm hit Garden City, Kansas, at two in the morning and denied daybreak for over forty-eight hours. When the dust finally settled, everything was covered in crimson silt, and the sun burned eerie shades of green through microscopic particles in the air. Geologists estimated 5 million tons of dust hung over Wichita, Kansas, 167 tons per square mile.

After this "black blizzard," Associated Press reporter Robert E. Geiger, filing from Guymon, Oklahoma, first used the term "dust bowl." It stuck. The people living this bleak and gritty existence, sometimes at temperatures of 108 degrees, at least had a name for it.

Some saw the Dust Bowl as a fulfillment of a biblical prediction from Deuteronomy: "The Lord shall make the rain of thy land powder and dust; from heaven it shall come down upon thee, until thou be destroyed." Others kept a sense of humor. Farmers claimed they had a new way of planting: throwing seed into the air as their fields blew past. A man reportedly fainted after being struck by a drop of rain and needed two buckets of sand tossed in his face to be revived.

Many, like the Okies in John Steinbeck's *The Grapes of Wrath*, left the desolation behind, packing their belongings atop automobiles and heading for the promised land of California. But most stayed, their lives hinging on the slogan "If it rains." Crops refused to grow in the baked earth, cattle vomited mud until they died. Women packed windows with oil cloth, then watched helplessly as the dark talcum filtered in anyway, rippling on the floor and outlining babies asleep in their cradles.

Health problems were rampant, as hospitals, their windows plastered shut, saw an influx of respiratory afflictions. Inhaled dust could cut into the lungs like ground glass. In March 1935, the Springfield, Colorado, morgue held six bodies, aged seventeen to seventy-five, all victims of "dust pneumonia," or silicosis.

Solutions began on farms like that of Andy James in Dalhart, Texas, whose field held fifty-seven dunes reaching thirty feet high. Charles Whitfield of the Soil Conservation Service sowed the sand with "sunlovers," drought-defying kafir and Sudan grass, black amber cane and broom maize. In three months, half the dunes had disappeared. Shelter-belts, trees planted in rows to cut the wind as the Russians had done in the Ukraine in 1880, were a solution for some. Rains returned in 1940, and the land began to come back.

Diversification was the key to the future. Droughts are a fact of life—history records some lasting up to two hundred years—and they have to be planned for. A hard lesson in ecological balance had been learned in the Dust Bowl, and Mother Nature would not be fooled again.

SMOKEY THE BEAR

ANOTHER **30 MILLION** ACRES
WILL BURN THIS YEAR —

unless you are careful!

FIRES!

Little Smokey and Ray Bell's daughter, Judy, prepare to say goodbye before the cub goes to Washington in June 1950.

High above the charred remains of a forest in New Mexico's Capitan Mountains, a frightened black bear cub clung for dear life to the top of a great matchstick that had once been a tree. He soon was rescued, and even before his burns healed he was on his way to becoming the world's most famous animal. Despite the terrifying episode, 1950 would be a very good year for Smokey the Bear.

Smokey the symbol had been born five years before, a brainchild of the Wartime Advertising Council (later

the Advertising Council) to replace World War II fire prevention slogans such as "Careless Matches Aid the Axis." Walt Disney had lent his character Bambi for the 1944 campaign, but a permanent symbol was needed.

The first description of the new standard-bearer came on August 9, 1944. He would be a fire-fighting bear in a ranger's hat, a furry big brother with a deep voice and a solemn message. Albert Staehle conceived the first cartoon renderings, then was replaced by Kansas artist Rudy Wendelin in 1946. Smokey the Bear was a favorite cartoon character before flames orphaned the real bear in May 1950.

After getting the hungry cub out of the tree, volunteers gorged him on candy and canned milk, then arranged temporary lodging with a nearby rancher. The little guy, whom they already were calling "Smokey," was in a bad mood with his painful burns and unbearable tummy ache. At this point, Ray Bell of Santa Fe, chief field warden of the New Mexico Department of Game and Fish, lent a hand. Smokey bit it.

The next day Bell took the five-pound cub by airplane to Santa Fe, where he was treated by veterinarian E. J. Smith. During his three-day stay at the animal hospital, the pitiful, bandaged waif was photographed by Harold Walter, who released the shots nationally with frames from the scorched Lincoln National Forest.

As the wire services picked up the touching story, Bell and his five-year-old daughter Judy were worried: Smokey would not eat. Little Judy pleaded, Bell relented, and Smokey came home with them.

Bell's wife Ruth brewed a concoction of baby cereal, honey, and milk, which the little bear gobbled gratefully. Smokey got along well with Ruth, Judy, and the family dog, Jet, but not with Ray. Bell recalled in a 1981 interview with *The Denver Post*: "He'd go out of his way to bite me every time I changed his dressings."

Meanwhile, the public was hot for more information about the real Smokey. Californians wanted him to be *their* bear, but Santa Fe National Forest Supervisor Kay Flock and State Game Warden Elliott Barker, friends of Bell, had other ideas. After several communications with the U.S. Forest Service, Barker wrote to Chief Forester Lyle Watts on June 9, saying: "We are willing to release Smokey to you to be dedicated to a publicity program of fire prevention and wildlife conservation."

Uncle Sam agreed to provide housing in the National Zoo in Washington, D.C. Harried Ray Bell was a happy man, but Smokey had one more bit of devilment to pull. On the day before departure, the cub couldn't be found. An afternoon of panic ended after Smokey was found asleep in the washing machine.

Smokey finally set out for his new home early on June 27, 1950, in an aircraft donated by the Piper company. Bell accompanied Smokey on the trip, which attracted enthusiastic crowds at every refueling stop. Smokey would appear on a chain, acknowledge the faithful, then crawl back into the plane and go to sleep.

After a welcoming ceremony at the National Zoo, Smokey settled down to the caged life. An instant attraction, Smokey only left for personal appearances with celebrities of the day. He was a star of screen, posters, comics, and fabulous fifties merchandising, and his slogan "Only you can prevent forest fires" hung on the lips of every American.

In 1960, Smokey "married" an eighteen-month-old bear named Goldie. Mrs. Smokey was a public attention-getter but did little for her mate. In 1968, the Associated Press reported that "the unproductive sex life of Smokey the Bear has produced anxiety in high government and advertising circles since there as yet is no baby bear to take over the 'fire preventing' title when the original Smokey retires or dies." In 1971, Ray Bell brought another orphan to Washington, who was adopted as "Smokey Jr."

On May 2, 1975, an official retirement party was held for the aging Smokey Sr., who received so much fan mail (five thousand letters a week) that the post office had given him his own Zip code: 20252. Plans to return him to New Mexico proved to be too expensive in those inflationary days. On the night of November 8, 1976, having attained the equivalent of a ripe old age of over seventy years, Smokey died in his sleep.

He was flown back home the next day and was buried near the spot where he was found, in an area that had been renamed Smokey Bear Historical State Park. Services the following day were attended by Ray Bell and others who had helped create the legend.

In 1984, the Cooperative Forest Fire Prevention Campaign celebrated the fortieth anniversary of the Smokey concept. That advertising symbol received a great boost from the cantankerous cub. Based on fire losses before and after the campaign, officials estimate that Smokey saved $10 billion during his productive, captive life.

THE ATOM BOMB

The sixteenth-century conquistadors named the area Jornada del Muerto, the March of Death. A parched desert framed by New Mexico's Fra Cristobal Range and an assortment of jagged peaks had, in more recent history, served as the stomping grounds for outlaw Billy the Kid. For the Apache, it was a good place for ambushing settlers and miners. It was in this arid region that a new age would begin at dawn on July 16, 1945. Here, man would explode his first atomic bomb.

The seeds of "the best-kept secret of World War II" had been planted just six years previously, when it was learned that Nazi Germany might be trying to build a bomb. By December 6, 1941, the president of the United States, Franklin Roosevelt, decided America had to have the bomb, and it had to have it first.

British and American resources were pooled in what would become known as the Manhattan Project. On September 17, 1942, Brigadier General Leslie R. Groves of the Army Corps of Engineers was appointed chief of the supersecret project. Attacking the assignment with gusto, Groves established three secret sites. In Hanford, Washington, scientists would produce plutonium. In Oak Ridge, Tennessee, others would separate uranium 235. And Out West, in Los Alamos, New Mexico, they would build the bomb.

Julius Robert Oppenheimer, a brilliant but eccentric physicist with a penchant for Oriental philosophy, was picked to head the research and development of the atomic bomb. While inspecting sites for the atomic laboratory with Groves, the physicist recalled the Los Alamos Ranch School, a facility he had seen on outings from his nearby family ranch. The U.S. Army took possession of the school, and, in the spring of 1943, the top scientists in the country began to arrive there.

What was supposed to be a small community quickly grew to six thousand scientists, physicists, engineers, their families, and GIs. Living conditions were cramped and primitive. Indeed, the stellar personalities, who were given slightly better digs, lived in an area called "bathtub row." The poor conditions, combined with hot temperatures and a mission of such secrecy and magnitude, made for a very tense atmosphere.

Oppenheimer selected and received approval for the test site early in 1945, which he named Trinity, after a John Donne sonnet: "Batter my heart, three-person'd God; for you as yet but knock, breathe, shine and seek to mend." There were enough precious materials for only three atomic bombs, of which only one would be tested. Trinity lay 160 miles south of Los Alamos, near Alamogordo and Oscuro. Should a mishap occur in such a desolate place, only the scientists would perish.

The plutonium ingots that would serve as the nuclear core arrived and were installed on Friday, July 13, 1945. After several explosive charges were installed the next morning, the ten-thousand-pound monster was hoisted to the top of a steel tower, 103 feet above the ground. A sheet-metal casing protected it from the elements.

Sunday was a day for final preparations and prayer. Observers would view the blast from bunkers ten thousand yards away. Instruments to record the test, scheduled for dawn Monday, were arranged around the mesa. Three years and $2 billion worth of research and equipment, it was hoped, would go up in smoke successfully.

The countdown began at 5:10 A.M. At that moment, radio station KCBA in Delano, California, came in over the Trinity frequency with its "Voice of America" broadcast. Strains of "The Star Spangled Banner" echoed out across the yuccas. At 5:29:40 A.M. the countdown voice chanted a new ritual: "Five-4-3-2-1-NOW!"

The first flash of nuclear fire leapt up from ground zero, bathing the desert mountains in a blinding, white glow. Instantly, the steel tower was vaporized as the temperatures reached the hottest ever registered on earth, 100 million degrees Fahrenheit, ten thousand times hotter than the surface of the sun. A second later, the huge fireball pounded the ground. From there it expanded, turning the sand into a whirling cauldron of radioactive dirt, rolling and billowing ever wider.

Former *New York Times* science reporter William L. Laurence wrote in *Dawn Over Zero:* "It was a sunrise such as the world had never seen, a great green supersun climbing in a fraction of a second to a height of more than 8,000 feet. . . . At first it was a giant column, which soon took the shape of a supramundane mushroom."

Perhaps the wisest observation came from Oppenheimer himself, who quoted the *Bhagavad Gita:* "If the radiance of a thousand suns were to burst at once into the sky, that would be like the splendor of the Mighty One. . . . I am become Death, the shatterer of worlds."

The roar was heard for a hundred miles. The hellish glow was reflected in the sky throughout the Southwest. Mrs. H. E. Wieselman reported from 150 miles away that she saw "the sun come up and go down again." Windows were blown out in Gallup, 235 miles to the north-

west. Groves's wily dispatch to the press, however, reported an insignificant munitions accident.

But this was no such thing. The destruction was swift and complete. In addition to the tower, many instruments vanished. The steel structure's cement base was driven seven feet into the ground. The intense heat transformed the sand into a jade-green vitreous substance the scientists would later call "trinitite."

Every living creature in the vicinity—lizards, snakes, a herd of antelope, and all else—had disappeared without a trace. For a mile around ground zero, the cacti, bushes, and desert grasses were fried out of existence in what was figured to be an explosion in excess of the equivalent of twenty-thousand tons of dynamite. When the news reached Potsdam, British Prime Minister Winston Churchill whispered, "It is the Second Coming, in wrath." Three weeks after the test came the bombing of Hiroshima and Nagasaki. The Trinity was now complete.

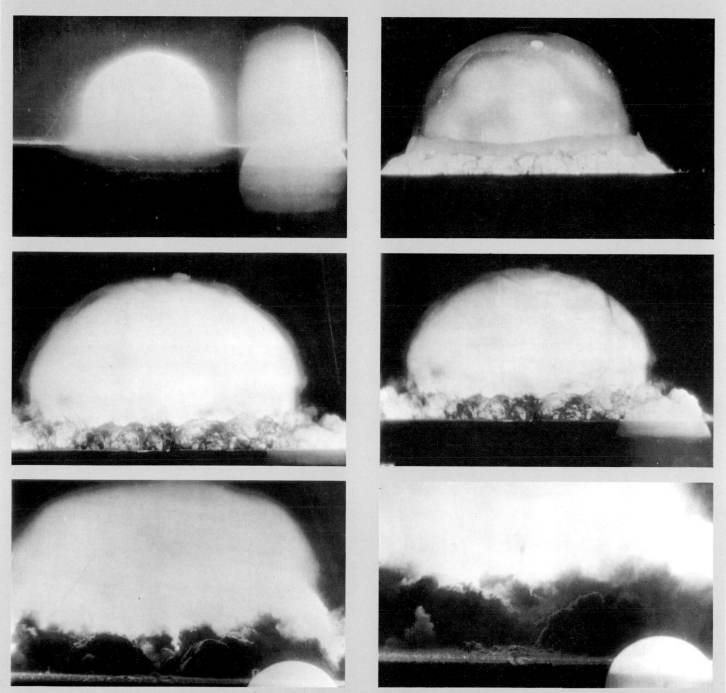

U.S. Army photos of the first atomic bomb explosion, July 16, 1945.

SUGGESTED READING

A wealth of information exists on the subjects in OUT WEST. A complete bibliography on every source available would make a hefty volume all its own. Here, instead, is just a sampling of some of the great books that have made retracing the trails of the West a welcome assignment.

Two fine one-volume encyclopedias are THE READER'S ENCYCLOPEDIA OF THE AMERICAN WEST, edited by Howard R. Lamar (Harper and Row, 1977) and WILD AND WOOLLY: AN ENCYCLOPEDIA OF THE OLD WEST by Denis McLoughlin (Doubleday, 1975). The Time–Life series "The Old West" provides vast knowledge spread out over many volumes. Ramon F. Adams's WESTERN WORDS (University of Oklahoma Press, 1968) offers a splendid introduction to the world of cowboy talk. One of the best collections of various writers' impressions of the region is LOOKING FAR WEST, edited by Frank Bergon and Zeese Papanikolas (New American Library, 1978). Also worth noting: THE GREAT AMERICAN WEST by James D. Horan (Crown, 1959) and TOUR GUIDE TO THE OLD WEST by Alice Cromie (Times Books, 1977).

HEROES

As for heroes, there is THE WEST OF WILD BILL HICKOK by Joseph G. Rosa (University of Oklahoma Press, 1968); CALAMITY WAS THE NAME FOR JANE by Glenn Clairmonte (Sage, 1943); BAT MASTERSON by Robert K. DeArment (University of Oklahoma Press, 1979); ROY BEAN: LAW WEST OF THE PECOS by C. L. Sonnichsen (Macmillan, 1943); ANNIE OAKLEY AND BUFFALO BILL'S WILD WEST by Isabelle S. Sayers (Dover, 1981); SITTING BULL, CHAMPION OF THE SIOUX by Stanley Vestal (University of Oklahoma Press, 1957); GERONIMO: THE MAN, HIS TIME, HIS PLACE by Angie Debo (University of Oklahoma Press, 1976); and DEATH SONG: THE LAST OF THE INDIAN WARS by John E. Weems (Doubleday, 1976).

The Parker saga is told in CYNTHIA ANN PARKER: THE STORY OF HER CAPTURE by James T. DeShields (self-published, 1886); QUANAH PARKER, LAST CHIEF OF THE COMANCHES by Clyde L. Jackson (Exposition, 1963); WHITE COMANCHE by Margaret Waldraven Johnson (Comet, 1956); and the glorious comic book COMANCHE MOON by Jack Jackson (Ripoff, 1979). One of the best Thorpe biographies is JIM THORPE, WORLD'S GREATEST ATHLETE by Robert W. Wheeler (University of Oklahoma Press, 1979).

VILLAINS

Billy the Kid inspired more books than you could shake a .45 at. A classic is A FITTING DEATH FOR BILLY THE KID by Ramon F. Adams (University of Oklahoma Press, 1960), but don't forget Pat Garrett's sensational THE AUTHENTIC LIFE OF BILLY THE KID (University of Oklahoma Press, 1954), originally published in 1882. BELLE STARR AND HER TIMES by Glenn Shirley (University of Oklahoma Press, 1982) is the most contemporary treatment of the bandit queen. ALFRED PACKER: THE TRUE STORY OF THE MAN-EATER by Robert Fenwick (Denver Post, 1963), ALFERD G. PACKER, CANNIBAL! VICTIM? by Ervan F. Kushner (Platte 'N Press, 1980), and THE CASE OF ALFRED PACKER, THE MAN-EATER by Paul H. Gantt (University of Denver Press, 1952) are enough to whet any appetite. The cannibal's story is also included in Dashiell Hammett's THE THIN MAN (Knopf, 1933). E. H. Cookridge provides an excellent study of THE BARON OF ARIZONA (John Day, 1967). The mysterious Butch Cassidy can be found on THE OUTLAW TRAIL by Charles Kelly (Devin-Adair, 1959) and IN SEARCH OF BUTCH CASSIDY by Larry Pointer (University of Oklahoma Press, 1977). The raid on Coffeyville is well covered in THE DALTON GANG: END OF AN OUTLAW ERA by Harold Preece (Hastings House, 1963). Tom Horn tells his own story in LIFE OF TOM HORN (Louthan, 1904); also see TOM HORN, MAN OF THE WEST by Lauran Paine (Barre, 1963).

FROM OUT OF THE WEST

Books on the subjects that came from Out West include CARRY NATION by Arnold Madison (Nelson, 1977); THE UNSINKABLE MRS. BROWN by Caroline Bancroft (Johnson, 1963); MOLLY BROWN, DENVER'S UNSINKABLE LADY by Christine Whitacre (Historic Denver, 1984); SILVER DOLLAR TABOR, LEAF IN THE STORM by Evelyn E. Furman (National Writers' Press, 1982); SILVER DOLLAR, THE STORY OF THE TABORS by David Karsner (Covici, 1932); and SILVER QUEEN by Caroline Bancroft (Johnson, 1959). Samuel Cody is G. A. Broomfield's PIONEER OF THE AIR (Gale and Polden, 1953), while BILL PICKETT, BULLDOGGER by Bailey C. Hanes (University of Oklahoma Press, 1977) is one of the great rodeo biographies.

Many books on Will Rogers can be found, but my favorite is WILL ROGERS: HIS LIFE AND TIMES by Richard M. Ketchum (American Heritage, 1973). Before he died, Jack Dempsey wrote his autobiography, with daughter Barbara Piatelli Dempsey, called DEMPSEY (Harper and Row, 1977). The works of Damon Runyon are always a pleasure to read, but I would also recommend a trip to THE WORLD OF DAMON RUNYON by Tom Clark (Harper and Row, 1978). The same goes for Gene Fowler's long list of books, especially TIMBER LINE (Comstock, 1974), originally published in 1933, and his sole biography, THE LIFE AND LEGEND OF GENE FOWLER by H. Allen Smith (Morrow, 1977). You might also take a look at GOOD EVENING EVERYBODY by Lowell Thomas (Morrow, 1976); FACES, FORMS, FILMS: THE ARTISTRY OF LON CHANEY by Robert G. Anderson (Barnes, 1971); BOUND FOR GLORY by Woody Guthrie (Dutton, 1943); WOODY GUTHRIE: A LIFE by Joe Klein (Knopf, 1980); SAN ANTONIO ROSE: THE LIFE AND MUSIC OF BOB WILLS by Charles R. Townsend (University of Illinois Press, 1976); OUT OF THE DARKNESS by Clyde Tombaugh (Stackpole, 1980); FLORENCE SABIN, COLORADO WOMAN OF THE CENTURY by Elinor Bluemel (Colorado University Press, 1959); and JACKSON POLLOCK by Francis V. O'Connor (The Museum of Modern Art, New York, 1967). No single biography exists on Mary Coyle Chase, but her play HARVEY (Dramatists Play Service, 1944) is always wonderful.

PASSING THROUGH

Many of the "Passing Through" stories were taken from early newspaper articles, but a few books should be noted. ROUGHING IT by Mark Twain, in any edition, is still one of the best first impressions of the Wild West. Much more civilized is Isabella Bird Bishop's A LADY'S LIFE IN THE ROCKY MOUNTAINS (University of Oklahoma Press, 1960). The definitive biography of Frederic Remington is by Peggy and Harold Samuels (Doubleday, 1982). Grand Duke Alexis's tour comes to life in Marshall Sprague's A GALLERY OF DUDES (Little Brown, 1967), while Theodore Roosevelt is the subject of David McCullough's MORNINGS ON HORSEBACK (Simon and Schuster, 1981). The ever-popular FATHER FLANAGAN OF BOYS TOWN by Fulton Oursler (Doubleday, 1949) leaves Irish eyes smiling.

LANDMARKS

For "Landmarks" reading, see TOMBSTONE: MYTH AND REALITY by Odie B. Faulk (Oxford University Press, 1972) and TOMBSTONE: AN ILIAD OF THE SOUTHWEST by Walter N. Burns (Grosset and Dunlap, 1927).

HEADLINES AND EPITAPHS

Everything you ever wanted to know about the American bison can be found in THE BUFFALO BOOK by David Dary (Sage, 1974). Many excellent Yellowstone books are around, but the best one on its discovery is THE DISCOVERY OF YELLOWSTONE, 1870 by N. P. Langford (University of Nebraska Press, 1972), originally published in 1923. Comanche is but a footnote to the Custer tale, which is probably the most written-about subject in the West. Of note: SON OF THE MORNING STAR by Evan S. Connell (North Point, 1984) and THE BATTLE OF THE LITTLE BIG-HORN by Mari Sandoz (Lippincott, 1966). The explosion of the first atomic bomb is well recounted in DAWN OVER ZERO by William L. Laurence (Knopf, 1946).

There are some classic studies on the American Indian that should be noted. Dee Brown's BURY MY HEART AT WOUNDED KNEE (Holt, 1971) is the best overview, but also see the works of Mari Sandoz that include CRAZY HORSE (Hastings House, 1942), THE BUFFALO HUNTERS (Hastings House, 1956), and CHEYENNE AUTUMN (McGraw-Hill, 1953). Another classic is LETTERS AND NOTES ON THE NORTH AMERICAN INDIAN by George Catlin (Crown, 1975), originally published in 1841.

Newspapers and magazines figure heavily in giving OUT WEST good sources. I used regularly the files of THE DENVER POST, ROCKY MOUNTAIN NEWS, DENVER TIMES, COLORADO SPRINGS GAZETTE, THE PUEBLO CHIEFTAIN, FRONTIER TIMES, OLD WEST, REAL WEST, TRUE WEST, and AMERICAN HERITAGE magazine.

PHOTOGRAPHIC CREDITS

The photographs included in this volume represent the diverse variety of work created by photographers in the West, whose careers very often coincided with the early history and development of the medium. The early photographs are usually the product of commercial studios which thrived throughout the frontier. The last century also saw the genesis of the field photographer, the diligent artist who carried bulky equipment by mule across the worst terrain in order to capture the scenery a heartbeat ahead of civilization. Over the past fifty years, the Western History Department of the Denver Public Library has been collecting these works, and their efforts in researching and cataloging these images are gratefully acknowledged.

When a proper credit for a photograph could be established, it has been given. Besides the Western History Department, photographs have come from various other archives and private collections. Also, the photo collection of *The Denver Post* has been used. *The Post's* archives include photographs specifically provided to the newspaper, as well as photographs generated by the newspaper's talented photographers. Again, every attempt has been made to properly credit the source, and we regret any omissions.

M. F.

All photographs are courtesy of the Denver Public Library, Western History Department, unless otherwise noted. Page numbers on which the pictures appear are listed after the source.

The Advertising Council, 200; Courtesy Amon Carter Museum, Forth Worth, 73; Arizona Historical Society, 156, 187; Author Collection, 193; Burlington Northern Railroad, 197; Estate of Olive Burt, courtesy University of Utah Press, 136; California Historical Society, San Francisco, 191; The Denver Post, 56, 100, 135, 168, 174; The Walt Disney Company, 36; Don English, Paramount Photos, 87; Father Flanagan's Boys Home, 140; Forth Worth Museum of Science and History, 75; Woody Guthrie Publications, Inc., 95; Laurence Laurie Associates, 170; Copyright © by Universal Pictures, a Division of Universal City Studios, Inc., Courtesy of MCA Publishing Rights, a Division of MCA Inc., 79, 97; The Miller Studio, 161; Copyright © 1945 by Monogram Pictures, Corporation, renewed in 1973 by Allied Artists Pictures Corporation, 32; Hans Namuth, 102; National Archives, 25; Photo courtesy of National Broadcasting Company, Inc., 81, 88; National Museum of American Art, Smithsonian Institution, 124; Oklahoma Historical Society, 42, 189; Photo courtesy Frederic Remington Art Museum, Ogdensburg, New York, 126; Theodore Roosevelt Collection, Harvard College Library, 129; Samsonite Corporation, 66; Photo by Harry Shunk, 148; Southbrook Entertainment, 34; Levi Strauss and Company, 61; UPI/Bettmann Newsphotos, 22, 29, 115, 166; U.S. Army, 203; U.S.D.A. Soil Conservation Service, 198; U.S. Geological Survey, 122; Underwood and Underwood, 195; Union Pacific Railroad Historical Museum Collection, 176, 180; Wellesley College Archives, 131; Wide World Photos, Inc., 31, 94; Winchester Mystery House, Gardens and Historical Museum, 164; Wyoming State Archives, Museum and Historical Department, 152; Jerry Yulsman, 146.

TEXT ACKNOWLEDGMENTS

Every effort has been made to acknowledge excerpts reproduced in the text.

Excerpts have been reproduced from the following:

"Union Maid," words and music by Woody Guthrie. TRO, Copyright © 1961 and 1963 by Ludlow Music, Inc., New York, New York; *On the Road* by Jack Kerouac. Copyright © 1957 by Jack Kerouac. Copyright renewed 1985 by Stella S. Kerouac and Jan Kerouac. Reprinted by permission of Viking Penguin Inc.

Visions of Cody by Jack Kerouac. Copyright 1960 by Jack Kerouac. Reprinted by permission of McGraw-Hill Book Company; *Woody Guthrie: A Life* by Joe Klein. Copyright © 1980 by Joe Klein. Reprinted by permission of Alfred A. Knopf, Inc. *McCall's* magazine, February 1951. Reprinted by permission of *McCall's*; *Dark Dolores* by Damon Runyon. Reprinted by permission of American Play Company, Inc; *The Grapes of Wrath* by John Steinbeck. Copyright 1939, renewed © 1967 by John Steinbeck. Reprinted by permission of Viking Penguin Inc.